# What Great Paintings Say

## Old Masters in Detail

### Volume I

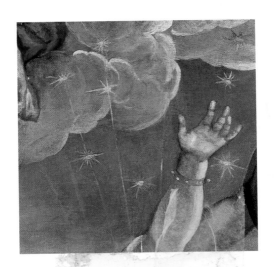

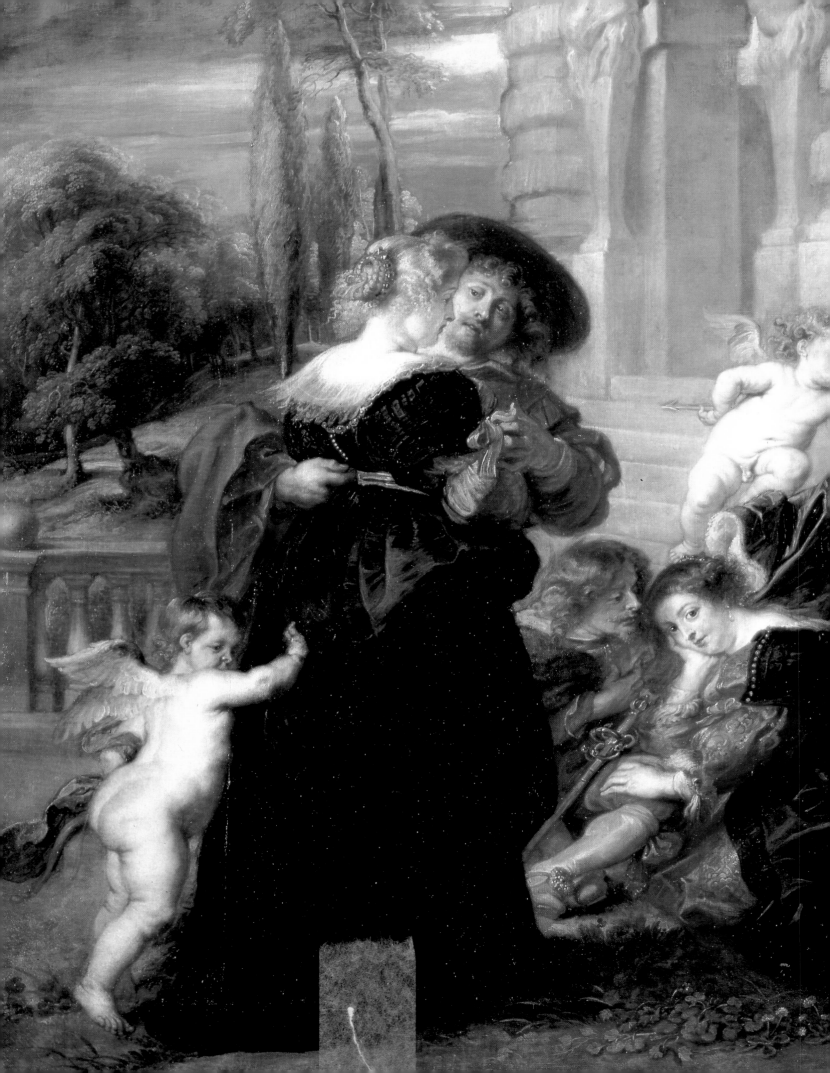

# What Great Paintings Say

## Old Masters in Detail

Rose-Marie and Rainer Hagen

## Volume I

**TASCHEN**

759
909237

**This book was printed on 100% chlorine-free bleached
paper in accordance with the TCF standard.**

© 1995 Benedikt Taschen Verlag GmbH
Hohenzollernring 53, D-50672 Köln
English translation: Iain Galbraith, Wiesbaden
Design: Angelika Muthesius, Cologne;
Mark Thomson, London

Printed in Germany
ISBN 3-8228-9057-X
GB

# Contents

7  Preface

8  **A deceptive idyll**
The Limburg Brothers: February miniature from the "Très Riches Heures du Duc de Berry", c. 1416

14  **May God help the Chancellor**
Jan van Eyck: The Virgin of Chancellor Nicolas Rolin, c. 1437

20  **The splendours of a small dynasty**
Andrea Mantegna: Ludovico Gonzaga and His Family, c. 1470

26  **Fairest daughter of heaven and waves**
Sandro Botticelli: The Birth of Venus, c. 1486

32  **The merchants of Venice**
Vittore Carpaccio: Miracle of the Relic of the Cross, 1494/95

38  **Composure in the face of misfortune**
Raphael: The Fire in the Borgo, 1514–17

44  **Careers in the king's service**
Hans Holbein the Younger: The Ambassadors, 1533

50  **The Lord sits at the table of lords**
Paolo Caliari (Veronese): The Marriage at Cana, 1562/63

56  **The Antwerp building boom**
Pieter Bruegel the Elder: The Tower of Babel, 1563

62  **Aspirations to immortality**
Jacopo Tintoretto: The Origin of the Milky Way, c. 1580

68  **Tyrannicide by tender hand**
Caravaggio: Judith and Holofernes, c. 1599

74  **Double-dealing hands and eyes**
Georges de La Tour: The Fortune Teller, after 1630

80  **Grateful for the gift of sensuous pleasure**
Peter Paul Rubens: The Love Garden, c. 1632/34

**86**   **The victor honours a defeated enemy**
Diego Velázquez: The Surrender of Breda, 1635

**92**   **Tho' our wealthy days be done, here's to a life of luxury**
Jacob Jordaens: The King Drinks, 1640/45

**98**   **An Old Testament family portrait**
Rembrandt: Jacob Blessing the Sons of Joseph, 1656

**104**   **Life: a drawing-room comedy**
Antoine Watteau: Love at the French Theatre, 1716–1721

**110**   **The proper combination of activity and leisure**
Thomas Gainsborough: Mr and Mrs Andrews, 1749

**116**   **The fine art of extravagance**
Giambattista Tiepolo: The Banquet of Cleopatra, 1746/50

**122**   **A German icon**
Johann Heinrich Wilhelm Tischbein: Goethe in the Roman Campagna, 1786/87

**128**   **The holy revolutionary**
Jacques-Louis David: The Death of Marat, 1793

**134**   **The black widow, beautiful and deadly**
Francisco de Goya: The Duchess of Alba, 1797

**140**   **A view to infinity**
Caspar David Friedrich: Chalk Cliffs on Rügen, c. 1818

**146**   **A Romantic's Asiatic tour de force**
Eugène Delacroix: The Death of Sardanapalus, c. 1827

**152**   **The greatest amateur musician of the nation**
Adolph Menzel: The Flute Concert of Frederick the Great at Sanssouci, 1850/1852

**158**   **A fragrance of women and the Orient**
Jean-Auguste-Dominique Ingres: The Turkish Bath, 1863

**164**   **Declaration of love for the capital of the world**
Edouard Manet: A Bar at the Folies Bergère, 1881

**170**   **Appendix**

**176**   **Acknowledgements**

# Preface

Naked and beautiful, a goddess of love rising out of the waves – that was how Renaissance artist Sandro Botticelli painted his famous Venus five hundred years ago. But how did a tanner's son, living in Christian Florence, become acquainted with a pagan legend? How could he dare break a thousand-year-old taboo and show the daughter of heaven naked? And why is she standing on a shell? Who was the banker who paid for the work? We have put questions like these to the paintings of Old Masters. The answers tell of people in whose midst the paintings were conceived: artists, forgers and models, patrons and princes, peasants and philosophers. Our intention has been to throw light on distant periods in history, thereby lending greater transparency to the works of art those periods produced. Our method, later refined in the pages of *art* magazine, was initially developed for a TV-series called "History in Pictures". Several powerfully magnified close-ups are shown of each painting, each close-up focusing on a specific detail of the work. The articles collected in this volume have recently been published in *art* magazine, to whose editors we are grateful for assistance and advice.

The authors

Rose-Marie and Rainer Hagen in a portrait by Hamburg photographer Leonore Mau

# A deceptive idyll

The reality was often harsher than the peaceful scene in the picture (15.4 x 13.6 cm): marauding soldiers, fear of wolves in extreme winters, bad harvests, famine and plague were all common features of French peasant life. The miniatures painted by the three Limburg brothers are nonetheless among our most important pictorial records of life in the Middle Ages. The *Très Riches Heures* is kept in a safe at the Musée Condé, Chantilly, near Paris.

A rolling snowscape beneath a low, overcast sky. In the background a village with a church spire, in the foreground a farm. A man drives a loaded donkey toward the village, another fells a tree. The house in the foreground is open to reveal three figures seated at a hearth. They have lifted their dresses to warm themselves at the fire. The portrayal of French peasant life in the February miniature of the *Très Riches Heures du Duc de Berry* shows a world of peace and harmony. All is well, it seems.

But the real world of the fifteenth century looked very different from ours, and contemporary spectators probably would not have found the illustration quite as idyllic as we might think it today. Snow, ice and cold were a threat to survival. During a hard winter wolves came out of the forest and attacked the cattle; firewood would be scarce. If a late frost nipped the seed in spring, and the harvest was meagre, famine left people more vulnerable to epidemics. Several hard winters in succession could decimate the population.

Most of the pages in the *Très Riches Heures* were painted between 1408 and 1416, and at least two winters during this period were extreme. Contemporary chroniclers also mention repeated floods and droughts, as well as hordes of soldiers, skirmishing and full-scale battles. Since 1337 France had been at war with England, whose kings laid claim to the French throne.

War with an external enemy was compounded by internal squabbles. The French king, Charles VI, had become insane in 1392, leaving the mighty of the land to fight among themselves and, often enough, call on the English to help them defeat their rivals.

France was thus in the grip of chaos, its inhabitants exposed to constant threats. Some protection could be found within castles or town walls, but those who dwelt on the land were left to the mercy of marauding soldiers. If they could, the population fled to the forests. To warn them of approaching danger they relied on lookouts posted on church towers who signalled the advance of enemy troops by sounding the bells or blowing horns. Church towers in those days were not only associated with prayer.

The chronicles of the time were commissioned by powerful lords. They therefore contain little or nothing about the life of the peasants; if they appeared at all, they were relegated to decorations in the margins, or to elaborately illuminated initials. Calendar miniatures were also painted for the rich and mighty. It was the peasants' way of life, however, which best helped illustrate the passing seasons. Thus the most lowly class found its way into European painting. In time, certain motifs became traditionally associated with each month. Some were taken from the courtly world of nobles, but most showed rustic scenes: in February they warm themselves at the hearth; in March they till the soil; in June they harvest the hay.

It has never been satisfactorily explained why the Book of Hours, which was intended for private devotion, should contain twelve calendar pages preceding the religious texts. Was it a reminder of the transience of all earthly things? Was its purpose to illustrate the will of God, manifest in the changing seasons? Perhaps it was merely that the rulers of the land wanted to see pictures of their own contemporaries, their own environment, as well as the more conventional biblical figures. Love of allusions to mythology and astrology may also have played a role. The only thing of which we can be certain is that calendar illustrations are among our most important historical records of the peasants' way of life

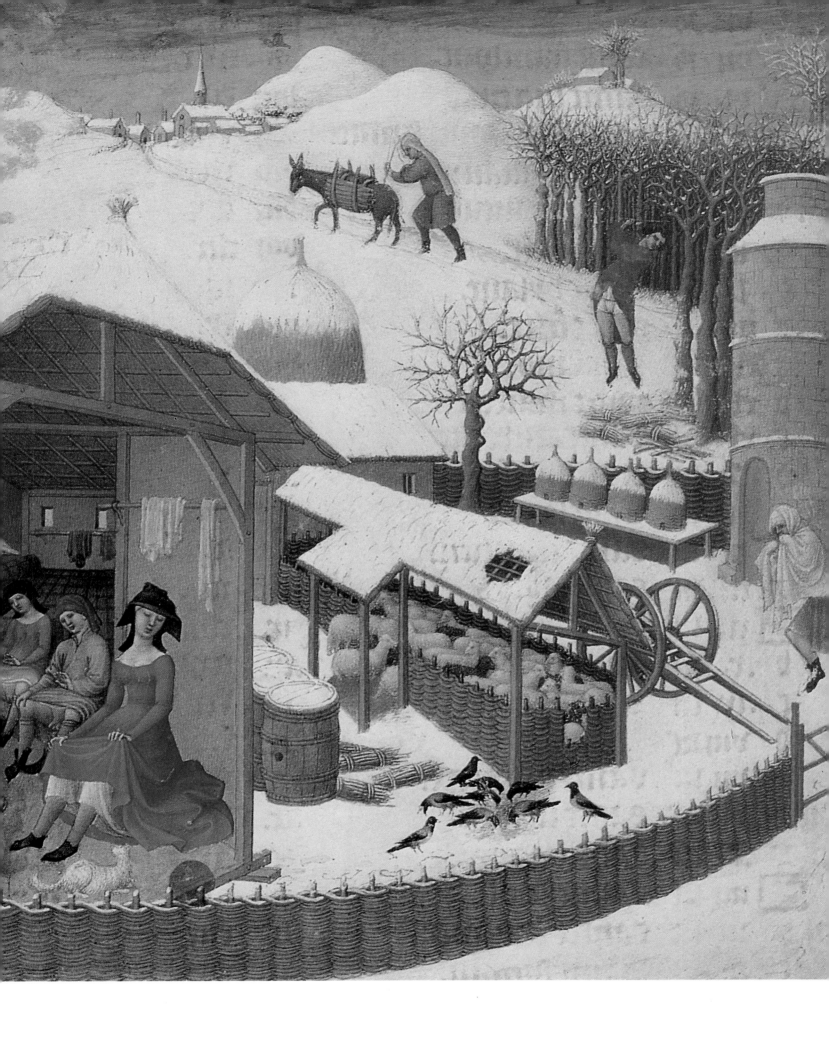

in the Middle Ages, especially those by the Limburg Brothers, Herman, Jean and Paul. Born in Nijmegen, they worked for the Duc de Berry from about 1405. By 1416, all three were dead, presumably the victims of an epidemic.

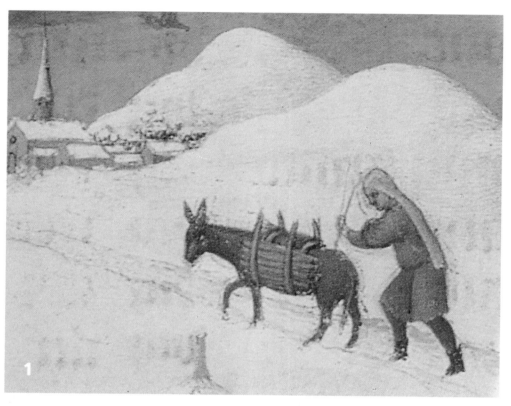

## A hard life on the land

It is difficult to make out the donkey's load, but it is probably wood. Only branches and brushwood were burned by the villagers for cooking and heating. Tree-trunks were reserved for the duke's own hearth, or were used to build houses.

The man driving the donkey is wearing a coarse smock, the usual attire of peasants and labourers at the time. He has probably pulled a sack over his head to protect himself from the cold. Unlike the burghers and nobles, he would not be allowed to wear fur; for even if he could afford it, he would be acting in contravention of the sumptuary laws which regulated dress. "The peasant works hard to provide purple for the king," a contemporary verse epic related, "but his own body is scratched by a hemp smock."[1]

Feudal society during the Middle Ages was divided into three orders – nobility, clergy and peasantry: those who fought and received land in reward for their services, those who prayed and preached, and those who produced food for everyone.

About 90 percent of the population were peasants and agricultural labourers, the lowest class, who served – much as the donkey served the peasant – as beasts of toil for the ruling classes. "Jacques Bonhomme" was the condescending term for a peasant – something like Honest John, where "honest" means both good-natured and simple-minded. But "Jacques" was not always good-natured. The first peasants' revolt took place in 1358, and was brutally suppressed.

The rebellion was not directed against the feudal order itself, since this was considered divine right: "The countryman is born to the sieve and the milking pail," as the verse epic cited above puts it, "while the king receives choice dishes and pepper, meats and wine." The reason for the rebellion was the heavy tax imposed by a war-worn aristocracy. Serfdom no longer existed in most regions of France. The peasants were allowed to own the land they worked, but were nonetheless obliged to pay taxes to their various masters: to landowning nobles, to the clergy, and also to the king.

In times of war, when their expenditure increased, the nobles and king not only squeezed more money out of the peasants, but also took corn, meat and fowls. "When the poor man has paid his taxes," the tax collectors return "to take his pots and his straw. The poor man will soon have not a crust left to eat."[2]

At the same time, the villagers were not all equally poor. Research on a village in Picardy shows that two out of ten landowning peasants had a relatively good standard of living, while four others had enough to eat. The remaining four eked out a meagre existence and, like unpropertied (and usually therefore unmarried) labourers, were constantly threatened by hunger.

The confusion of the Hundred Years' War added to their misery. The French Herald at Arms, in dispute with his English counterpart, might proudly proclaim: "We have many things which you do not have... Before all else, we have wine... so much, that our countrymen do not drink beer, they drink wine!"[3]

At the same time, however, an English general, plundering the French countryside with his army, wrote: "The peasants drink only water."[3]

# A dovecot: the landowners' privilege

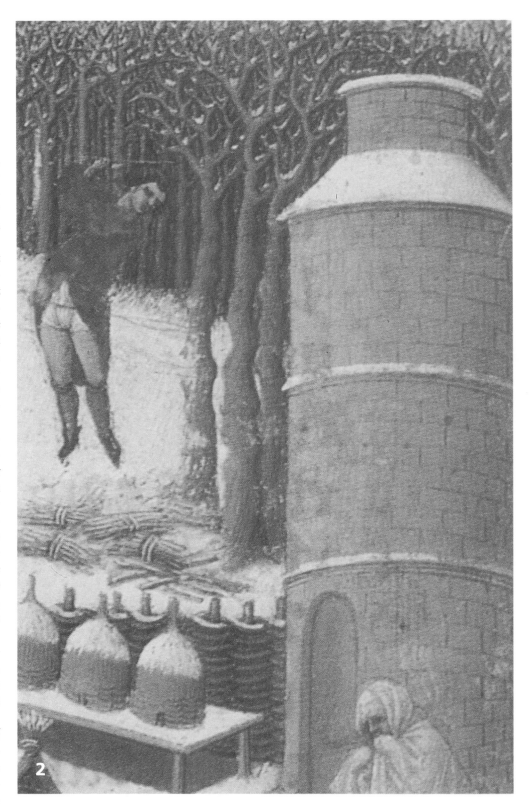

**2**

Another traditional February motif, besides peasants warming themselves by the fire, was the man cutting wood. However, the round, grey building on the right of the painting, a dovecot, was more unusual.

Doves were not there to be eaten, at least not primarily so. Nor were they particularly significant as messengers. Their most important function at the time was to produce manure. Pigeon dung, used to fertilise herb gardens, had a higher value than manure produced by sheep, pigs or cattle. It was also essential for sowing hemp. Pigeon manure did not really lose its significance in Europe until the appearance of artificial fertiliser.[4]

Dovecots were therefore fertiliser factories, built according to economic principles. The inner walls provided niches for the nests. The niches started at a certain height above ground level, where the droppings collected, and ended a certain distance from the flight-holes, since doves will not sit near heavily frequented exit-holes. Doves like quiet places which are not too windy; dovecots were therefore built away from the centre of the farmyard, in the lee of a forest if possible – like the one in the painting.

The artists have even included the typical, cornice-like rings around the walls. These were not decorative, but served to protect the doves by hindering entry to the dovecot by rats, weasels or martens.

Although important producers of manure, doves were greatly feared as grain-feeders. Huge flocks of them would descend upon the freshly sown fields and devour the seed. Their numbers were therefore strictly controlled. The simple peasant was allowed to keep only a few pairs nesting under his roof. A separate building for doves was the exclusive prerogative of the land-owner. However, he too was required to limit his doves to a number related to the extent of his lands. The rule was one nest per arpent: about one and a quarter acres. These regulations had emerged gradually during the Middle Ages and, by the Duc de Berry's time, the dovecot had become a status symbol: the size of a dovecot indicated the size of its owner's property.

The dovecot's size would have allowed contemporary spectators of the *Très Riches Heures* to deduce that its painters had not chosen a poor peasant's smallholding as their subject: the buildings shown here must have belonged to a noble landowner.

The law governing the right to dovecot ownership remained in force until the French Revolution. It was finally repealed, together with a number of other feudal privileges (of more far-reaching consequence), on 4 August 1789. Jacques Bonhomme had asserted his rights.

The beehives ranged on the wooden surface in front of the wicker fence were empty. Every autumn they were held over a smoking fire. The bees suffocated and the honey flowed out, followed by the wax.

At the time, honey was practically the only available sweetener, for only the very rich could afford imported sugar-cane. Wax was used to fashion candles, then considered the finest of all forms of lighting. In spring, the peasants would go into the forest to attract new swarms of bees.

The only herd animals to be seen in the painting are sheep. They were the most commonly kept domestic animals on farms in the Middle Ages, for they provided meat, milk and wool and, unlike cows, were able to graze poor ground.

## Bees and sheep

One of the few authentic contemporary accounts by a member of the peasant class[4] states that while hundreds of sheep were raised in a certain village, there were only a dozen milking cows. This ratio was probably fairly typical, and is mentioned by the narrator, Jean de Brie, in connection with an account of his own vocational training, which began when he was seven years old.

For it was then that his childhood came to an end and Jean was expected to look after the village geese. At the age of eight he was entrusted with the pigs: "raw beasts of low discipline". The memories he retained of these animals were anything but fond; he found life with them "unbearable".

At the age of nine he helped the ploughman with his oxen. Later, he looked after the village's twelve milking cows. Finally, at the age of eleven, he was given "80 good-natured, innocent lambs who neither jostled nor hurt" him. He saw himself as their "tutor and guardian", and soon a large herd of 200 ewes and 120 lambs was given into his keeping: Jean's task was to make sure they had food, to shear them, and to pro-

tect them from wolves. By the age of fourteen, when few of today's youngsters would even have begun their vocational training, Jean had completed his apprenticeship. Girls, too, were obliged to look after the animals. Joan of Arc was the century's most famous shepherdess.

Of course, the artist may have had quite a different reason – besides their greater numbers – for painting sheep rather than other herd animals. Sheep were loved, not only by shepherd-boys, or for their wide range of practical uses by the peasantry in general, but also by noble ladies.

This was the era of the first pastoral plays, a tradition which became very fashionable during the later Rococo: noble ladies had little, prettily-decorated sheep-stalls built, kept favourite animals, bound ribbons around the necks of their lambs. They played at being shepherdesses, sang songs and received their suitors in the meadows. The housekeeping books of the French court give an exact account of the sum spent in 1398 by Queen Isabelle of Bavaria on her sheep at Saint Ouen: 4000 golden thalers.

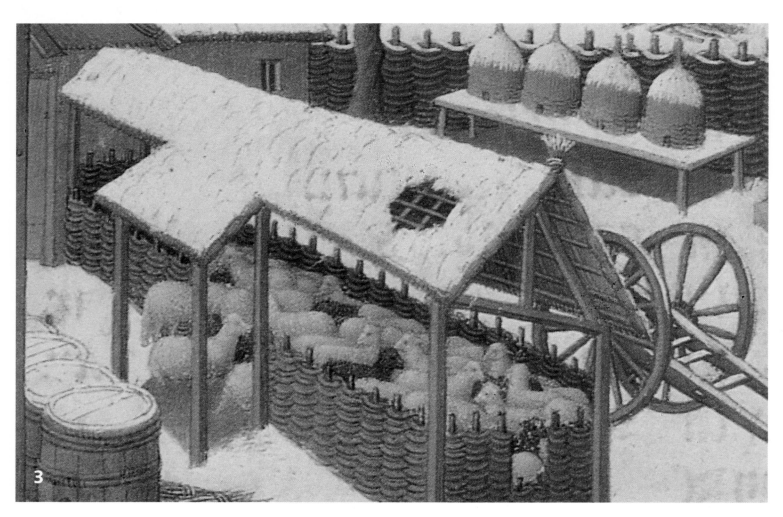

3

12

# The factor's house

Although the miniature depicts the property of a noble landowner, we see neither manor house nor castle. Nor does the painting show us many of the other buildings typically found on such an estate. According to an account written in 1377, a manor would include, as well as stalls and barns, a separate kitchen outhouse with servants' and farm-labourers' quarters, a chapel, and a farmhouse with two rooms for the the factor, or bailiff.

It is the factor's house we see here. Its inhabitants were evidently not poor. Labourers' huts had a fire in the middle of a single room, the smoke rising directly to the roof without passing through a chimney, whereas here a walled fire-place is visible on the left of the interior. Poor people slept on straw sacks, but here a bed is seen in the background. While the poor possessed only one set of clothes, here several pieces of spare clothing are shown hanging on bars along the walls. It is true that the interior contains very little in the way of furniture, but that was the case even in the houses of the very rich.

The three figures sitting in front of the fire have raised their dresses to warm themselves, the two furthest lifting them so high that their genitals are exposed. The Limburg Brothers were showing nothing out of the ordinary: "Folk in many communities go about almost naked in summer," a contemporary priest complained. "Though they have no hose, they do not fear the gaze of passers-by."[5]

Our own view of the Middle Ages is largely conditioned by pictures commissioned for churches by the clergy. Genitalia, of course, were concealed in these pictures. But Christian doctrines directed against the body and its pleasures were hardly concordant with the behavioural norms of the people themselves. Cramped living space made intimacy unthinkable; whole families sleeping in one bed left little opportunity for privacy. Nor did people show particular concern for the "gaze of passers-by" when relieving themselves. For centuries to come, codes of courtly manners would find it necessary to remind

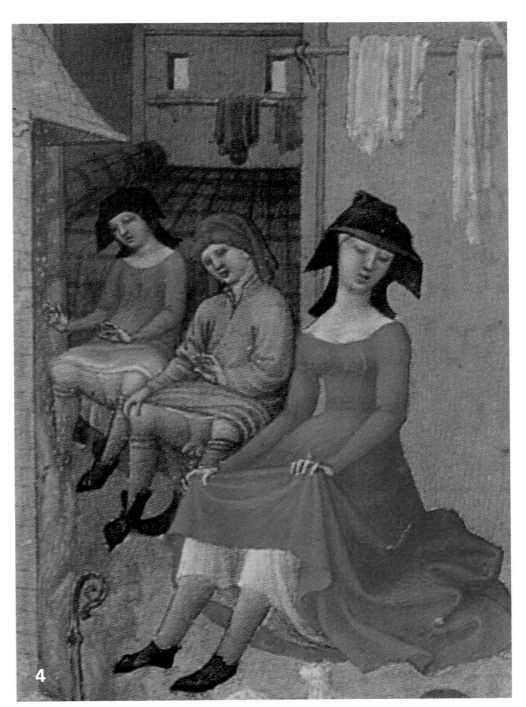

readers that there were better places to urinate than at a window, or on the stairs.

The threshold of shame is not innate, but determined anew in every era, usually by the members of the ruling strata, whose manners and behavioural norms the lower strata adopt. Undoubtedly, this also applied to the degree of nakedness considered appropriate for the lower abdomen. The figures in the background reveal their genitals without the least sign of embarrassment. The lady in the foreground, however, whose finer clothes and bearing suggest a higher class, has raised her dress only slightly. In time, the other two will follow her example.

The Limburgs knew nothing of subliminal processes at work in society. What struck them was the enormous difference between the nobility and the peasantry. Dangers to life and limb also remain largely outside the scope of their painting. Here they show the snow and the cold, but epidemics, armies and civil wars do not feature in their work. They spent much of their time in their chambers at the duke's castle, painting "idyllic" miniatures with the aid of a magnifying glass. Meanwhile, all around them raged a chaos to which they may eventually have fallen victim themselves.

Jan van Eyck: The Virgin of Chancellor Nicolas Rolin, c. 1437

# May God help the Chancellor

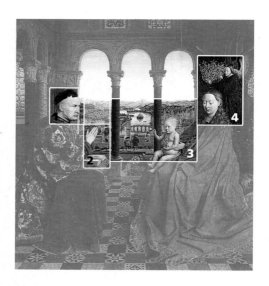

Although of low birth, Nicolas Rolin's cunning and lack of scruple helped him become chancellor of a realm. Under his strict rule, Burgundy became a major European power. Rolin sought to save his soul through acts of charity and ostentatious veneration of the Virgin Mary. In so doing, he struck an equal balance between humility and pride – as the portrait shows. The painting (66 x 62 cm) is now in the Louvre, Paris.

His hands folded in prayer, an ageing man kneels at a prie-dieu before the Virgin Mary. An angel bearing a golden crown floats above the head of the Queen of Heaven, upon whose lap the infant Jesus is enthroned. To document His majesty, the Holy Child holds an imperial orb of crystal in one hand, while blessing the kneeling man with his other. The pious scene, intended to remind the spectator of the hereafter, is lit by the setting sun. The painting is an example of the medieval donor portrait.

However, the picture is hardly devoid of earthly lustre. The man's mink-trimmed brocade coat shimmers more opulently than the Virgin's red robe. The setting is a magnificent palace, high up in the hills. The view through the arched loggia takes in distant mountains, a riverscape, the buildings of a town – the wealth of this world.

Dating from around 1437, Jan van Eyck's painting, now in the Louvre, departs from the medieval devotional tradition in a number of important points. While these herald the dawn of a new era, they also tell us something about the person who commissioned the work. The donor at prayer is not, as was usually the case, flanked by an intercessory patron saint. Instead he kneels alone, on a level with – and the same size as – the Virgin Mary herself. Rather than cowering in self-effacing deference at the lower edge of the painting, his figure occupies the entire left half of the composition.

In the life of the man shown kneeling, worldly values had always played a more important part than religion. He had every reason to be proud: according to the contemporary chronicler Georges Chastellain, Nicolas Rolin (1376–1462), Chancellor of Burgundy, had made his lord, Duke Philip the Good, the most glorious ruler on earth.

During his 40-year period of office, Rolin expanded the boundaries of Burgundy to include an area six times as large as the original province of that name, thus creating a powerful state that was feared throughout Europe. Its foundation stone was a royal wedding in 1369: the bride's dowry was Flanders, while the bridegroom's portion was the Duchy and County of Burgundy, as well as his considerable political skills. He and his two successors profited from the ruin of France, which had been occupied and ravaged by the English during the Hundred Years' War. They created a kingdom which extended from the Swiss border to the North Sea, from Dijon to Bruges. The union of a French ruling dynasty with the spirit of the industrious Flemish and Netherlandish townsfolk prepared the ground for a highly sophisticated blend of courtly tradition and bourgeois culture.

Rolin, a Burgundian by birth, and the Netherlandish Jan van Eyck (c. 1370–1441), a highly respected court painter, were contemporaries at the court of the third duke, Philip the Good (1419–1467). Both were of non-aristocratic origin. Van Eyck had been appointed to his post for life, his main task being to "execute paintings at the behest and according to the will of the duke". Unfortunately, not one of his court paintings survive. What we do have, besides several altarpieces, are a number of portraits of his contemporaries: a goldsmith, an Italian banker called Arnolfini, and Nicolas Rolin. The artist enjoyed a privileged position at court and was occasionally entrusted with political or diplomatic missions of a confidential nature. These brought him into contact with the chancellor, who, according to Chastellain, "was the supervisor of all things."[1]

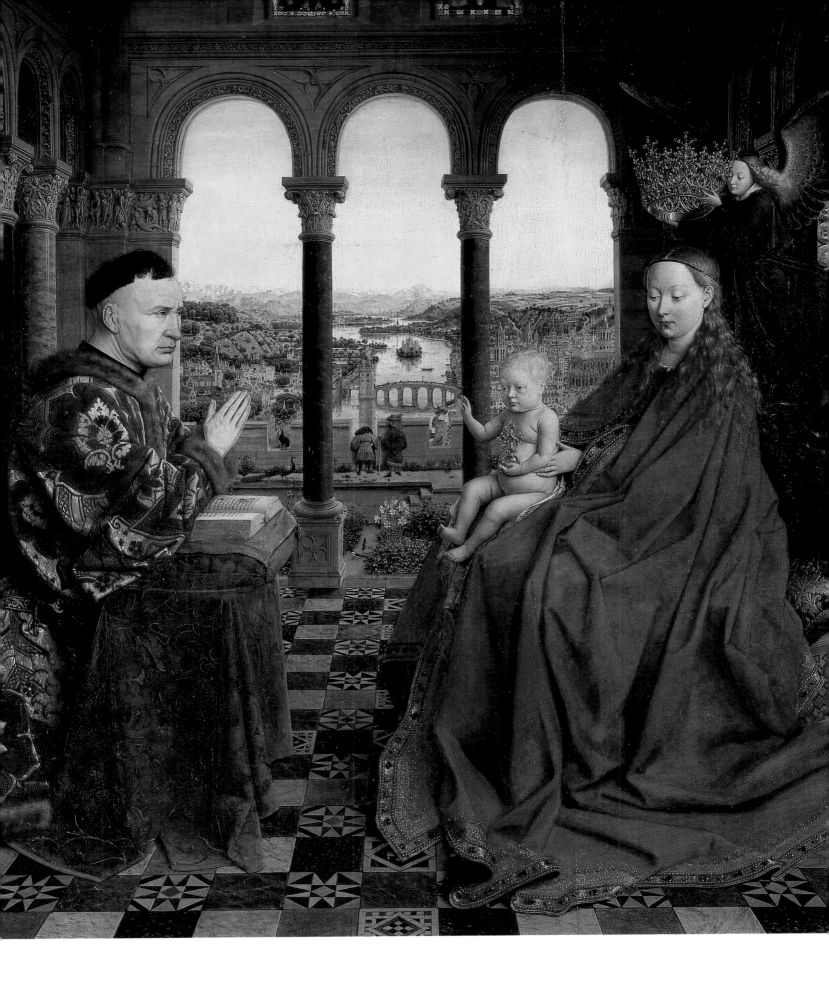

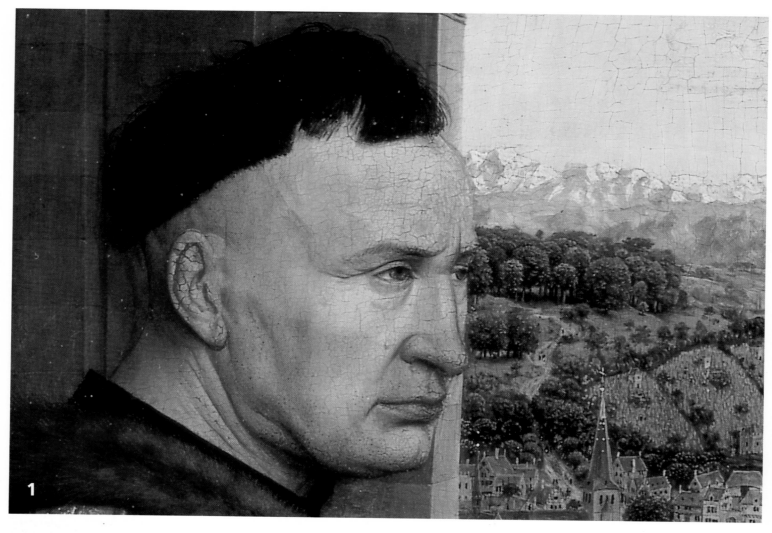

## The sly fox knew no kindness

A few years after van Eyck, another Netherlandish artist painted Nicolas Rolin. Rogier van der Weyden (c. 1400–1464) portrayed him in an altarpiece as the founder and donor of the hospital for the sick and needy at Beaune, in Burgundy. Even today, the hospice receives its income from the vineyards which Rolin donated. It is hardly surprising, therefore, that van Eyck painted stone vines carved on the loggia arches, or green vineyards in the landscape beyond the chancellor.

The gaze of the man, about sixty at the time, is solemn and withdrawn. "There was not one great prince," wrote one of his contemporaries, "who did not fear him".[2] This is perhaps surprising, since Rolin, born at Autun in 1376, was a parvenu of "humble origin".[2] The fact that his career should have been so successful at a court known for its obsession with chivalry and etiquette is due largely to qualities proverbial among the Burgundian peasantry: toughness, cunning and, above all, realism. "He was very wise… in the ways of the world," wrote the chronicler. "His harvest was always of this world."[2]

In 1419 Rolin's talents drew the attentions of the young Duke Philip of Burgundy, who had come suddenly to power following the murder of his father. Three years later Rolin was appointed chancellor. "It was his wont to govern alone," wrote Chastellain, "and everything, whether matters of war, peace or finance, passed through his hands." The chancellor used his great authority to increase the wealth of Burgundy through inheritance, marriage and purchase of land. He was thus responsible for the annexation of Namur in 1421, Hainaut, Friesland and Zealand in 1426, and the Duchies of Luxemburg and Guelders in 1443.

However, the different parts of the kingdom of Greater Burgundy were politically disparate and geographically separate. They were held together only by the duke himself, and by the cleverness of his chancellor, who had made the centralisation and consolidation of state power his leading concern. Rolin standardised administrative and judicial practice while curtailing the privileges of both the nobility and the burghers, particularly in monetary matters. In order to finance Duke Philip's displays of pomp, the chancellor procured vast quantities of money through a never-ending series of taxes. The rebellions of Netherlandish municipalities against this enormous fiscal burden were put down mercilessly.

If Rolin was the most important man in the kingdom, he was also the most hated, mainly because of his greed. He was given to pocketing a share of the royal income, and had no qualms about accepting bribes. X-ray photographs show van Eyck originally portrayed him holding an enormous purse. We can only speculate as to what may have moved the artist to paint it over.

# Hands for praying, hands for grabbing

A Book of Hours lies open on the hassock – van Eyck apparently also painted miniatures for manuscripts of this kind, already much sought after by collectors. The Book of Hours contained prayers appropriate to certain hours of the day. It is impossible to decipher the text of the open pages, with the exception of the initial D.

The chancellor's white and well-manicured hands are folded in prayer directly above the open pages. Just how fiercely these hands could strike out when it came to punishing defaulters or rebellious municipalities is documented by the French King Louis XI's remark on Rolin's charitable donation at Beaune: "It is only appropriate that one who has turned so many people into paupers while still alive should provide shelter for them after his death."[3] In a business transaction of not entirely unusual character for the times, Rolin attempted to buy his salvation through a spectacular act of charity. A description of the deal was recorded in the hospice's founding deed of 1443.

It is possible that van Eyck's painting is intended to commemorate a specific event in Rolin's life. Its execution coincides almost exactly with a climax in Rolin's career, the signing of the Treaty of Arras in 1435. This was a political masterpiece, reversing an entire system of alliances, ending a bloody civil war between France and Greater Burgundy, and further, exacting atonement from the French king for a murder which, though unforgotten, already lay many years in the past.

Under circumstances which have never been fully explained, John the Fearless, Duke of Burgundy, had been murdered on a bridge in 1419 by the heir to the French throne, or by the latter's friends and supporters. This had provoked Burgundy to seek an alliance with the English invaders during the Hundred Years' War, helping them to occupy France. However, following years of humiliation for the defeated French, national resistance flared up again under the leadership of Joan of Arc. She had the French successor crowned Charles VII, and used his army to drive the English out of the land.

To avoid finding itself suddenly on the losing side, it was necessary for Burgundy to reverse its alliances without losing face. Rolin's achievement was to give to this complete about-turn the appearance of a Burgundian triumph. He convened a general peace conference at Arras and, to the considerable applause of those present, disassociated himself from the English, who had decided to stay away from the conference. At the same time, the French king ceded several strategically important border towns to Philip the Good, offered a solemn apology for the murder of his father and promised several sensational acts of atonement.

There was no further mention of the girl who had prepared the ground for the treaty, however, not even by the king who owed his crown to her. She had been burned at the stake by the English. The Burgundian army, capturing Joan, had sold her to the English for a horrendous sum of money. It is not unlikely that part of this sum found its way into the chancellor's purse.

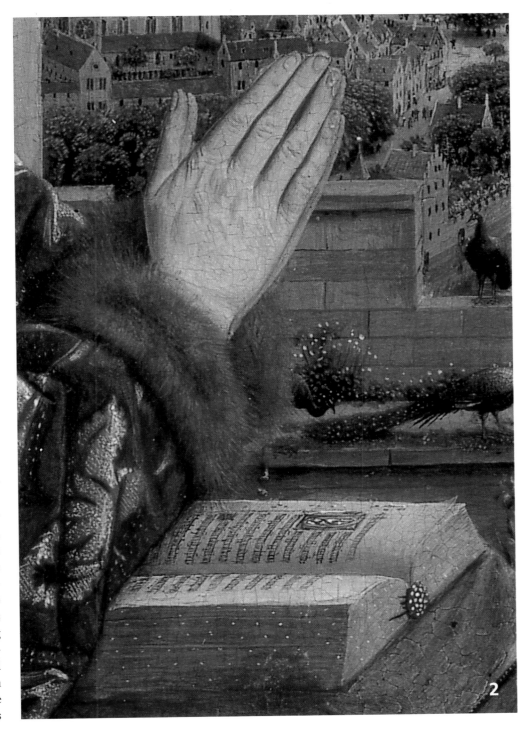

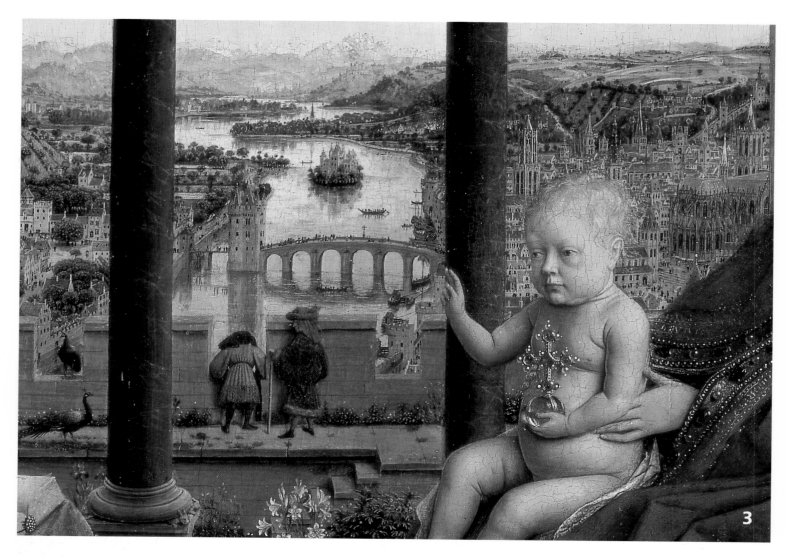

3

## A kingdom at a glance

One of the acts of atonement extracted from the French by Rolin was the erection of a cross at the scene of the murder, the bridge at Montereau. A similar cross is shown on the bridge in the landscape background of van Eyck's painting. This suggests that the picture was indeed intended to celebrate the Treaty of Arras.

Many unsatisfactory attempts have been made to localise the landscape with its intricate detail and population of some 2000 figures. The town on either side of the broad river has been variously identified as Ghent, Bruges, Geneva, Lyons, Autun, Prague, Liège, Maastricht and Utrecht. In fact, it is probably not meant to represent an authentic scene at all, but to gather together various impressions gained dur-

ing van Eyck's travels. Effectively, the view thus stretches all the way from the plains of the Low Countries to the snow-covered Alps.

Only a few details can be identified: the tower of the cathedral at Utrecht, for example, or St. Lambert's Cathedral at Liège. At the same time, there would have been many more wooden buildings and straw roofs at Liège than are shown in van Eyck's splendid townscape with its large stone buildings and countless spires. The latter, set in a perfectly balanced landscape, provide the appropriate background for a devotional painting, as well as for the representative portrait of a chancellor.

Perhaps the landscape is intended to show an improved version of the wealthy Burgundian towns supervised by Rolin. Or perhaps it is a higher, spiritual place: "a celestial Jerusalem", the "Civitas Dei", the Kingdom of God, the realm of the Queen of Heaven.

The little garden beyond the portico, with its roses, lilies and magnificent pea-

cocks, is equally ambiguous: it can be interpreted as an allusion to Rolin's luxurious possessions, or as the "hortus conclusus", or "garden inclosed", a commonly employed symbol for the Holy Virgin during the Middle Ages. The biblical scenes carved in relief on the capitals of the stone pillars also permit a number of different interpretations.

The ambiguity of the artist's "veiled symbolism" is intentional. Van Eyck was not only respected by the duke "for the excellent execution of his craft";[4] he was also considered a highly educated man, with some understanding of the obscurer aspects of humanistic learning. He wrote cryptographic Latin or Greek inscriptions on the frames of some of his pictures, painting hidden self-portraits as a kind of signature on others. It is therefore not entirely improbable that he painted himself and his brother Hubert as two figures leaning over the parapet at the bottom of the garden.

## Shortcut to Our Lady

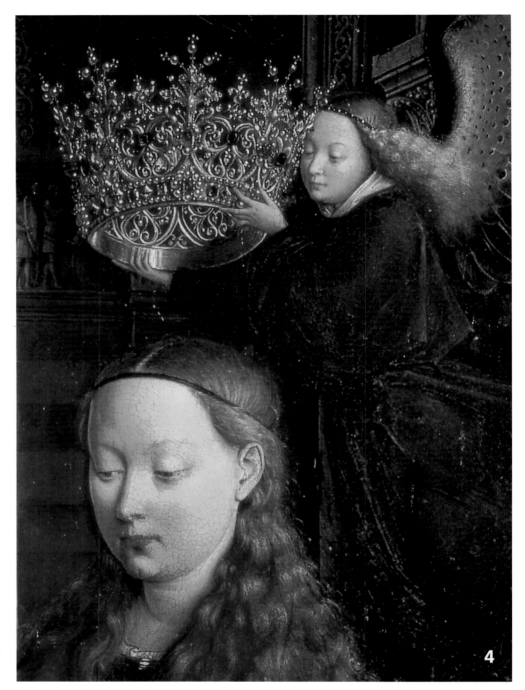

**4**

His honoured guest, the Holy Virgin, has settled on a modest cushion in the chancellor's portico. Her body serves as a throne for the infant Jesus, lending a gentleness to the scene, despite her crown and royal purple. Perhaps her appearance offers the sinner at prayer hope of understanding and forgiveness.

The Virgin is portrayed as a graceful young woman in eight of van Eyck's extant works: "She is more beautiful than the sun," he wrote on the the frame of one of these paintings, "and excels every constellation of the stars."[5]

This quotation from the aprocryphal Wisdom of Solomon is included in the Office of the Virgin, a collection of prayers to the Holy Virgin which lies open in front of Rolin. In the 15th century many people said these prayers daily. Indeed, many of them, including contemporary spectators of this painting, would undoubtedly have been so well-versed in the biblical similes and flowery metaphors frequently employed to extol the Virgin that they would have had little trouble piecing together the textual fragments which may be deciphered in gold lettering on the hem of the Rolin-Virgin's robe: texts dedicated to the Virgin, "exalted, as are the cedars of Lebanon",[6] and to the glory of God's creation.

All his life, Chancellor Rolin devoted himself to obtaining the Virgin's forgiveness. In 1461 he bequeathed a silver statue of the Virgin, weighing more than fourteen pounds, and a "gold crown made at La-Motte-Les-Arras" to the Church of Our Lady at Autun. Perhaps the finely wrought, bejewelled diadem presented by the angel in van Eyck's picture is an allusion to Rolin's intended donation, or perhaps Rolin's gift was copied from the painter's design, who, as court artist, would be required to have knowledge of the relevant craftsmanship.

Many documents testify to the chancellor's role as benefactor towards Our Lady at Autun. He had the church renovated and decorated and made a number of large charitable donations. Through a private passage, crossing a narrow street, Rolin was able to take a shortcut between his own house and prayers at Our Lady's. This was the church in which he had been christened, and it was here that he wished to be buried.

Van Eyck's painting was not originally intended as an altarpiece, but was hung commemoratively in the chapel where, as stipulated by Rolin's deed of foundation, a mass was to be held for his salvation every day until the end of time. This may, of course, be a sign of his great piety; it may, however, merely signify the shrewd precautions taken by a man of whom one of his contemporaries wrote: "As far as the temporal is concerned, he was reputed to be one of the wisest men of the kingdom; as for the spiritual, I shall remain silent."[7]

Rolin's political life-work, the state of Greater Burgundy, broke apart shortly after his death, ruined by the arrogance of its last duke, Charles the Bold. History is always the history of the conquerors: today, despite his position as one of the 15th century's greatest statesmen, and although, as the founder of an empire and loyal servant of its ruler, his stature can be compared with that of Bismarck, Rolin is practically forgotten.

His memory survives only in the work of his charitable trust, the hospice at Beaune, as well as in two works of art which, with unerring taste, he commissioned from the best two painters of the day.

Their country was "marshy and unhealthy". They suffered from gout, malaria, rickets and a chronic shortage of cash. But the proud Gonzaga commissioned their family portrait from the "most modern" artist of their time. The fresco can still be admired in the reception room of the Ducal Palace at Mantua.

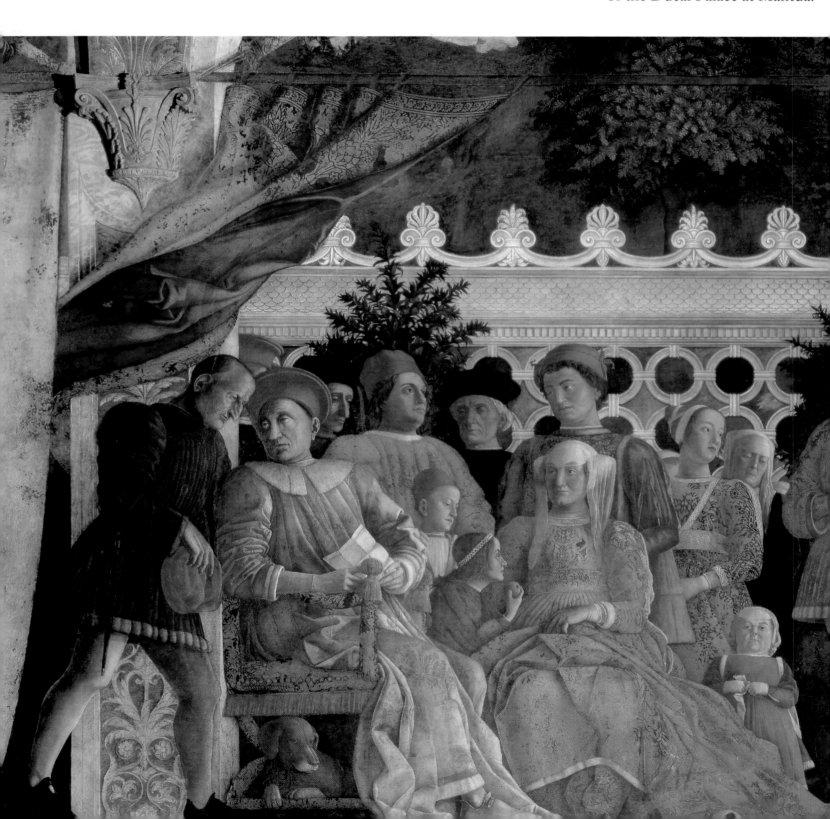

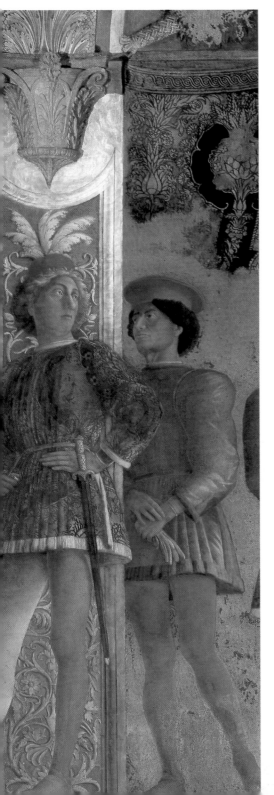

Andrea Mantegna: Ludovico Gonzaga and His Family, c. 1470

# The splendours of a small dynasty

Gold-embossed leather curtains are drawn back to reveal a terrace. Here, a distinguished company is gathered before a marble screen among the lemon trees: the family and court of Marquis Ludovico Gonzaga of Mantua, in northern Italy.

Only the reigning couple can be identified beyond doubt. Ludovico is shown with a letter in his hand, conferring with a secretary. Marchioness Barbara of Brandenburg has a little daughter at her knee; behind her may be one or two of her ten children. The sombre officials in their dark clothes contrast starkly with the arrogant-looking courtiers, possibly Gonzaga bastards, or masters of ceremonies. They wear stockings in the red-and-white of the reigning house. Rubino, the marquis's dog, and a dwarf complete the family portrait.

The Gonzaga, dressed in luxurious, gold-spun cloth and blessed with many children, present the image of a confident, successful clan. In the middle of the fifteenth century, the family had experienced a sharp upturn in fortune. In 1328, one of their predecessors, a simple but nonetheless wealthy landowner, had risen to the position of "Capitano" of the city of Mantua. The family had succeeded in retaining its foothold, amassing power and finally adding legitimacy to its position through the purchase of a ducal title from the emperor.

By the standards of the wealthy Florentine Medici, the income of the Gonzaga was limited. Their small territory on the Lombard plains was modest by comparison with the powerful states of Venice or Milan. Pope Pius II gave a bleak description of Mantua in 1460: "Marshy and unhealthy... all you could hear were the frogs."[1] Ludovico Gonzaga decided to find a remedy for this: he not only had the marshes drained and the town squares plas-

tered over, but did everything he could to attract the best architects and artists to his court.

The architect and early Renaissance theorist Leon Battista Alberti (1404–1472) designed churches for the marquis in the very latest style – after the model of antique temples.

In the Ducal Palace Mantegna's frescos transformed a relatively small reception room, later called – for reasons unknown – the Camera degli Sposi or Bridal Chamber; his illusionistic painting appears to extend the real space of the room via the ceiling into the sky, and through the walls on either side into a terrace and landscape.

The writing on the sheet of paper held in Marquis Ludovico's hand could tell us something about the occasion for the group portrait, which was probably commissioned to commemorate a particularly significant event. Since it is impossible to decipher the letter, we can only speculate. What is certain, however, is that the letter bears testimony to a favourite pastime at the court of Mantua: the writing, reading and preservation of manuscripts. Owing to the work of countless clerks and secretaries, a huge archive and precise record of the most important events at Mantua has been passed on to posterity. The life of the painter Mantegna, who spent 46 years there, is thus more thoroughly documented than the life of any other artist of his time.

The documents begin in 1457 with the voluminous correspondence undertaken to attract the 26 year-old painter to Mantua. Marquis Ludovico spent three years attempting to engage him. Andrea Mantegna (1431–1506) had made a name for himself with frescos in Padua. Their bold use of perspective and confident return to recently discovered antique models astonished his contemporaries. It was said that his portraits showed the sharply defined contours of Roman coins. Ludovico was determined to draw this exciting, modern man to Mantua, which lacked its own artistic tradition at the time. At least he could boast the presence of one other innovator: the Florentine architect Leon Battista Alberti had recently been entrusted with the building of churches and palaces.

Mantegna was hesitant to assume the obligations that accompanied the position of court painter. These included a vast amount of time-consuming, routine work: the decoration of country houses, the planning and staging of court festivities. Moreover, if the testimony of the Pope could be believed, Mantua was hardly an attractive proposition. What could be used to attract Mantegna? For one thing, the sum, agreed by letter, of "180 ducats per year, a house to live in, enough wheat for six persons and firewood".[2] Owing to their chronic lack of money, the Gonzaga payments were often overdue (because of this, Mantegna later was forced to write countless reminders and requests for payment). The Lords of Mantua found it much easier to reward their ambitious painter with status symbols. In the course of the years, they conferred upon him the fine-sounding titles of Count Palatine and Knight of the Army of Gold.

The real reason for Mantegna's decision to go to Mantua in 1460 was probably the marquis's cultivated understanding of art, his ability to appreciate the innovations of the Renaissance and, not least, the solicitous attitude exhibited by this busy ruler towards the artists in his service, a quality also documented in the correspondence.

In 1465, for example, the marquis personally ordered "two cartloads of lime with which to paint our room in the castle":[3] frescos were painted on a ground of fresh lime. In 1474 he sent for gold-leaf and lapis lazuli, paints so precious that they were usually added only as a final touch. These letters were separated by nine years, during which time Mantegna was evidently decorating the Camera Picta, or Painted Room, for the renovated palace. For in 1470 Ludovico complained about the slowness of the artist, "who started to paint the room so many years ago, and still has not completed half of it."[4]

## Three years to engage a painter

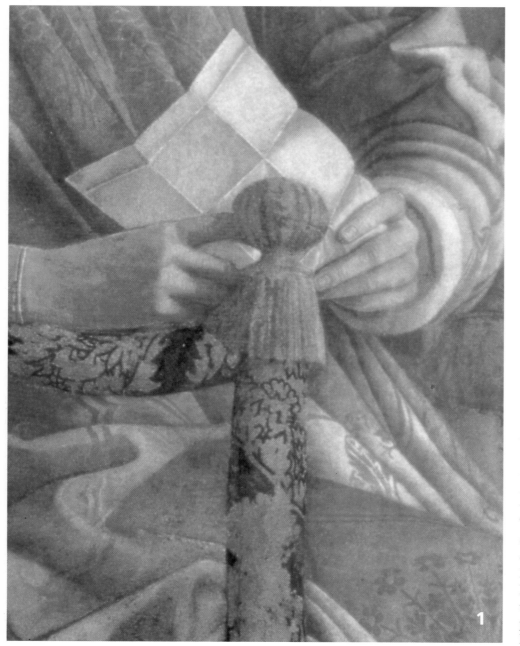

1

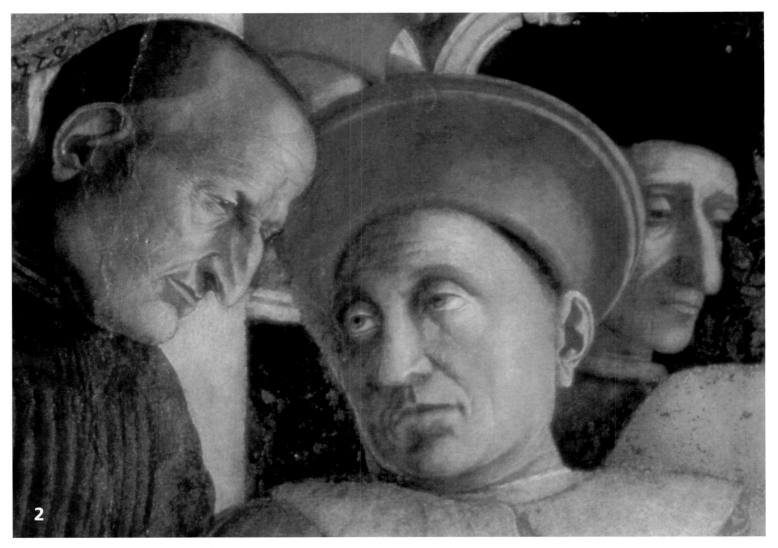

2

## A cunning man of peace

Marquis Ludovico's stockingless foot wears a slipper, and his simple housecoat contrasts with the ostentatious gold thread of his family's dress. When Mantegna finally completed his frescos in 1474, the potentate was 62 years old, worn out by thirty years of government, and in ill health.

Ludovico had held highest military office. Initially serving the Venetians, he had eventually become general commander for the Dukes of Milan, a position he maintained for 28 years. His reliability and loyalty towards those he served contrasted favourably with the vast majority of *condottieri*, the mercenary generals paid by Italian princes to fight their wars. Unlike his peers, he was not interested in booty, nor in war as an art. Ludovico was a man of peace. He did not owe high military rank to martial prowess, but to the geographic and strategic position of his small state.

The river Po, used for transporting goods, flowed directly through the land of the Gonzaga. Mantua also controlled the approach to the Brenner Pass. Connecting Italy with the north, this was one of Europe's most important trading routes. Mantua, protected on all sides by water, was considered impregnable. The rival neighbouring powers of Venice and Milan therefore attempted to secure an alliance with the marquis, or at least his neutrality, and he was clever enough to play the two off against each other.

In order to achieve a certain degree of independence from both powers, the Gonzaga sought foreign support by marrying beyond the Alps. Ludovico was married to Barbara of Brandenburg, a relation of the emperor. For his heir, he himself chose a bride from the House of Wittelsbach. He maintained good neighbourly relations with Venice and Milan, and always commanded the army of whichever was prepared to pay him most. His wage as a *condottiere*, in reality a disguised reward for his alliance, was considerable, indeed it would occasionally exceed the income generated by his entire kingdom.

Without a separate, external income he could never have afforded such a lavish life-style at home. His princely suite would sometimes comprise more than 800 persons. He also had an expensive hobby: horse breeding. Of course, his Milanese ducats also permitted Ludovico to patronise the arts, to commission buildings and paintings. His investment proved worthwhile. Shortly after Ludovico's death, a man who was probably the greatest art expert among the Renaissance princes, Lorenzo de' Medici, also known as the Magnificent, travelled specially to Mantua to admire its paintings and collection of antiques. Out of a swamp where "all you could hear were the frogs" had arisen a town whose fame, within a mere twenty years, had spread far and wide.

The white-haired man standing between two of Marquis Gonzaga's sons had been dead for some time when Mantegna came to paint his frescos. Vittorino da Feltre owed his place in this fresco to the gratitude of his former pupil. Without him, Ludovico Gonzaga would probably never have become quite such a remarkable ruler.

Vittorino da Feltre (1378–1446) came to Mantua as a teacher and court librarian. His pupils included not only Ludovico and his siblings, but also Ludovico's future wife, the German Barbara of Brandenburg, who had come to the Gonzaga court at the age of ten. With Vittorino's help this unattractive, but by all accounts clever girl became a ruling lady, fully capable of governing the state when her husband was away commanding foreign armies.

The reputation of Vittorino's "School for Princes" attracted pupils to Mantua from all over Italy, and many important figures of the Renaissance were educated

## A teacher who formed Renaissance Man

there, among them Duke Federico of Urbino. All lived together, with 60 poor, but gifted pupils who received a scholarship from the Gonzaga, in Vittorino's "Ca' zoiosa", or "house of joy". The contrast between this more modern institution and the grim monastic schools of the Middle Ages, where pupils had lived under the rule of rote-learning and the cane, was not solely atmospheric. Vittorino's educational ideas, derived from Classical models, were revolutionary for their time. He paid great attention to physical education, for example, and attempted to awaken in his pupils both a Christian sense of duty and a healthy respect for Classical virtues. His ideal was the "uomo universale", combining vigour and spirit to form a harmonious whole.

Ludovico Gonzaga came very close to Vittorino's educational ideal. He was an intellectual of high artistic sensibility, and a man of action who was single-minded in improving the fortunes of his family and town.

The marquis owed his political success to an inspired move: in 1459, following extensive preparations, he convened a conference of sovereign princes at Mantua, attended by the pope and by dignitaries from both sides of the Alps. Although this plunged Ludovico into debt for many

years, it also gave him an opportunity to spin the threads of a cardinal's robe for his second son Francesco (1444–1483). Following Francesco's elevation to the rank of cardinal in 1462, Ludovico greeted his son, according to one of his contemporaries, "with tears of joy";[5] it is possible that this was the triumphant occasion Mantegna's painting was intended to record. The paper in Ludovico's hand may be a letter of appointment bearing the papal seal.

Ludovico's two eldest sons, standing to the left and right of Vittorino da Feltre, although not educated by the great teacher himself, were brought up in his spirit. Cardinal Francesco, on the left, laid the foundations for a famous collection of Classical antiques. His older brother Federico, Ludovico's heir, despite spending the greater part of his few reigning years (1478–1484) on battlefields, was also a patron of the arts. Mantegna even worked under a third generation of Gonzaga. Ludovico's grandson, Francesco (1466–1519), had great respect for him: "an extraordinary painter, unequalled in our time."[6] He, too, had learned that "a ruler becomes immortal by knowing how to honour great men."[7] It was a lesson Vittorino da Feltre had taught Francesco's grandfather.

## Gout, malaria, rickets: complaints of the Gonzaga

**4**

Dwarfs and other human freaks were much sought after as court fools; at some Renaissance courts they were systematically "bred", a practice otherwise restricted to dogs and horses. Marchioness Barbara, too, is said to have kept a Beatricina and midget Maddalena to amuse her. However, more malicious tongues have it that the dwarf in Mantegna's fresco was a daughter of the reigning couple. The proud ruling family of Mantua – according to retrospective medical diagnosis – not only suffered from gout and malaria, but also from arthritis and rickets, which often led to curvature of the spine.

The boy and girl at the marchioness's knee look pale and thin; only two of ten children enjoyed perfect health. Two, including Cardinal Francesco, suffered from obesity; one had rickets, and four, among them Ludovico's heir Federico, had an unmistakably hunched back, although the fresco hides this. Since little is known of the remaining Gonzaga children, it cannot be excluded that they were dwarfs.

The defect probably entered the family through Ludovico's mother Paola Malatesta, who had come to Mantua from the renowned ruling house of Rimini. Two of her children were deformed, and even her eldest son Ludovico hardly demonstrated Vittorino da Feltre's ideal of a healthy mind in a healthy body. He suffered from obesity, and was often ill. It was possibly only the strict diet and regular exercise imposed on him by his teacher that prevented him from developing curvature of the spine as well. His heir Federico was not so lucky: he was described by one of his contemporaries as an "amiable, engaging man with a hump".[8]

The Gonzaga bore their ailments with composure, accepting humiliation when necessary. In 1464 the Milanese heir, Galeazzo Maria Sforza, refused to marry Ludovico's daughter Dorotea with the words: "these women, born of the blood of hunchbacks, only give birth to new hunchbacks and other lepers".[9] His first engagement, to Dorotea's elder sister Susanna,

had been broken off at the first sign of developing curvature of the spine. Susanna had thereupon entered a convent, leaving Dorotea to take her place as the Sforza heir's bride. But as soon as the opportunity of a more advantageous match arose – with an heiress from the house of Savoy – Sforza made public knowledge of his feelings of disgust for the Gonzaga.

The insult threatened to cause a reversal of existing alliances, almost driving Ludovico into the service of Venice. In the end, however, the link with Milan proved stronger; over the years the marquis had become "like a son, … like a brother" to successive dukes: a true "guardian of the state of Milan".[10] On three separate occasions, when the fate of the troubled house

of Sforza lay in Ludovico's hands, the loyal general commander hurried to their immediate aid.

Perhaps Ludovico Gonzaga took secret revenge on the Sforza family by commissioning Andrea Mantegna to paint a fresco showing the moment of triumph when a missive containing a cry for help had reached him from the impertinent Milanese. Of course, he would not grant the Sforza name itself a place in the picture. For they were to have no part in the immortality which the lords of Mantua hoped to secure for themselves through Mantegna's art.

Venus, a life-sized human figure, steps ashore from her shell; the female nude, banned for 1000 years, has returned to take its rightful place in art. Like Venus herself, the nude had been seen as the incarnation of sinful lust. The Renaissance rediscovered the beauty of the human body. The painting is one of the greatest treasures of the Uffizi, Florence.

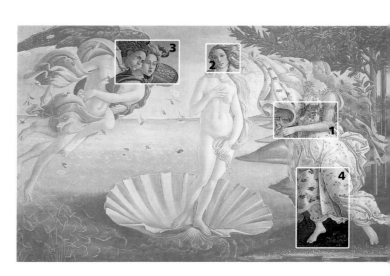

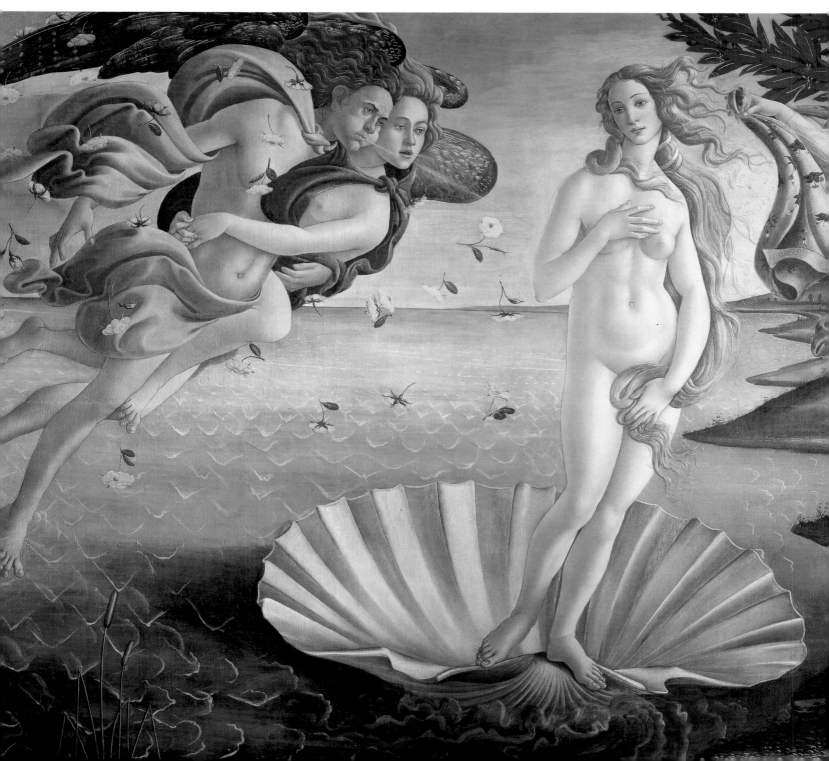

## Sandro Botticelli: The Birth of Venus, c. 1486

# Fairest daughter of heaven and waves

It had been a thousand years since anyone in Europe had seen the like of it: an almost life-sized nude, the representation of a naked woman, a picture of perfect corporeal grace – Aphrodite, the Greek goddess of beauty and love, whom the Romans called Venus, reborn in Renaissance Florence. Arisen from the waves, borne on a breath of wind, she approaches the shore on a shell.

This pagan scene was painted around 1486 by the Florentine Sandro Botticelli, a devout Christian, whose studio concentrated largely on satisfying the enormous demands of the public for devotional pictures: saints, gentle-faced Virgins and the Holy Child. Practically all art had a religious content at the time. It has been calculated that only 13 percent of art works had secular themes, the majority of them portraits.

At the peak of his career, Botticelli, the renowned painter of Virgins, decided to turn his hand to something new: four large-scale "mythologies" based on the pagan tradition of Classical myths and legends. One of them was the *Birth of Venus*.

The first male nude of the Renaissance, a young bronze *David,* had been modelled from life in 1430 by the Florentine sculptor Donatello. The fact that the *Birth of Venus* did not appear until over fifty years later is a testimony to the lasting effect of the Christian taboo against the portrayal of the naked female body. Previously, the only female nudes to dare appear in works of art had been Eves with snakes and apples; punished for their sins, they had quickly been expelled from paradise, stooping under the burden of their shame.

Unlike these heavily stylised, Gothic figures of Eve, Botticelli's Venus is patently the product of anatomical studies, as well as the artist's adherence to Classical models. The influence of Greek Classical sculpture is visible in the way the weight of the goddess rests on one leg, in the attractive curve of her hip, in her chaste gesture. The Renaissance artist has drawn her proportions in accordance with a canon of harmony and ideal beauty developed by artists such as Polyclitus and Praxiteles. This included the measurement of an equal distance between the breasts, between the navel and breasts, and between navel and crotch. The canon helped form countless nudes, from Classical Greek statues to figures on late Roman tombs. However, it later fell into disrepute and, eventually, oblivion, where it remained until its rediscovery by the Renaissance. It has influenced our taste ever since.

Botticelli's goddess of beauty is one of the great stars of the Uffizi, Florence. Only with difficulty can she be protected against the storm of her admirers. The situation has become worse since restoration of the work was concluded in the spring of 1987. A layer of varnish, added some time after the work was completed and darkened to a yellowish-brown patina with age, was removed from the 184 x 285.5 cm canvas. The heavens, waves and deities now shine out boldly and brightly in their original tempera.

Where the goddess of love lingers, roses fall from the sky. In the place where her foot first alighted on land – according to the Greek poet Anacreon (who lived from 580 until after 495 B.C.) – sprang the very first rosebush. There are pale red roses, too, wound around the waist of the girl waiting to receive Venus on the shore. Perhaps she is one of the three Graces, thought in Classical antiquity to belong to the entourage of the goddess, or one of the three Horae, the seasons. The anemones at her feet and her cornflower-bespangled dress suggest she is the Hora of spring – the time of the year when Venus restored love and beauty to the earth after a hard winter.

The *Birth of Venus* could almost be called *Primavera,* or *Spring,* the title of Botticelli's other great "mythology" in the Uffizi. Here, too, a (clothed) Venus holds court in a garden, surrounded by gods of the wind, flower-girls and semi-nude Graces.

## Decorative blossom for a cool villa

The painter and art biographer Giorgio Vasari mentions the paintings for the first time in 1550, when they hung together at Castello, a country villa near Florence belonging to Cosimo I de' Medici. Vasari, who was Duke Cosimo's architect, describes one as "The birth of Venus, and the skies and winds who lead her to the Earth, escorted by the gods of love; the other, Venus crowned by the Graces with flowers, announces the advent of Spring."[1]

Art historians have generally assumed that Botticelli painted the works for the owner of this villa. In 1486 the owner was Lorenzo di Pierfrancesco de' Medici, also known as "Lorenzo the Younger" to distinguish him from his cousin Lorenzo the Magnificent, the uncrowned king of the Republic of Florence. However, while a recently discovered inventory has verified the younger Lorenzo's ownership of *Primavera,* there is no trace in the inventory of the *Birth of Venus.* It is therefore not known who commissioned it.

A link has naturally been sought between the painting and the two most famous Medici of all, Lorenzo the Magnificent and his brother Giuliano. The splendour, extolled by the poets, of their pageants and banquets has never ceased to fire the popular imagination. The *Birth* thus came to be seen as an act of homage to Simonetta Vespucci, the wife of a Florentine merchant. She had been the "Queen of Beauty" at a tournament organised by Giuliano in 1475, a fact which led various commentators to conclude that the nature of their relationship had been romantic; and since Simonetta was born at Porto Venere (Port Venus) on the Ligurian coast, Botticelli's goddess was said to bear her features. Both died shortly after the pageant: Giuliano stabbed by his political enemies, and Simonetta of consumption, adding a tragic note to the popular appeal of this account of events. Unfortunately, however, there is no real evidence to support the story.

Nor has it ever been explained how the painting later entered the possession of the Medici family. It is quite probable that it was intended for a country house outside Florence. The owners of these cool villas, bankers recuperating from business, noise and epidemics, preferred frescos and canvases with light-hearted themes to religious panel paintings. Botticelli probably painted the goddess for one of his Florentine contemporaries, many of whom were capable of combining an understanding of money and politics with a refined sensibility for the arts. His patron may even have been able to appreciate Anacreon in the Greek original.

# Relatives:
# Venus and Mary

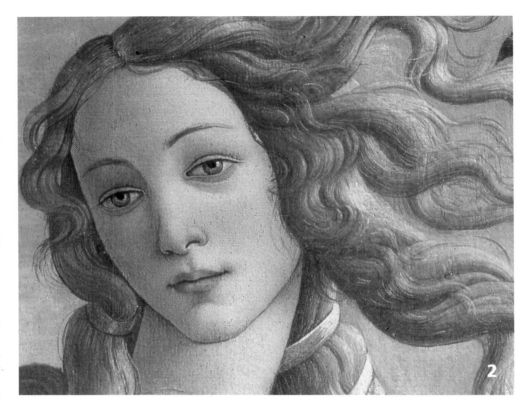

Aphrodite, or Venus, was held in high regard by the Greeks and Romans. With the triumph of Christianity she fell into disgrace. During the Middle Ages she was seen as the incarnation of sinful lust and depravity.

The distrust in which she was held until well into the 14th century is documented by the Florentine sculptor Lorenzo Ghiberti (1378–1455). He wrote of an antique statue of Venus, a work "of great perfection", found in the neighbouring town of Siena. The citizens showed great reverence for the statue, placing it on the town well. But when the town was afflicted by war, the mood changed dramatically. "Since idolatry is forbidden by our faith," warned one public speaker, "there can surely be no doubt who has caused our misfortunes."[2] On 7 November 1357 the councillors decided to "smash" the statue of Venus "to pieces" and to "bury its fragments within the precincts of Florence" in the hope that they would bring similar misfortune upon the heads of their enemies. The same Ghiberti was lucky enough to witness the rediscovery of a second Venus, which came to light in Florence "while they were digging under the Brunelleschi Villa". However, this statue did not suffer the fate of its Sienese cousin, for the religious climate in Florence had now changed. Tired of the conventions propagated during the Middle Ages, the Florentines sought new models. They found them in Classical antiquity: the movement which came to be known as the Renaissance had begun.

It is not known what inspired Botticelli, one of the second generation of Renaissance artists, to paint the *Birth of Venus*. He was undoubtedly acquainted with the Medici family's collection of antique gems with their Roman depictions of nereids and sea-goddesses. It was also at this time that translations by Florentine humanists first appeared in printed editions in Botticelli's native town. The *Homeric Hymns,* for example, were published in 1488: "Aphrodite, beautiful, chaste, of her shall I sing… who holds sway over the sea-washed embattlements of Cyprus, where the moist breath of Zephyrus gently bore her… to be greeted by the Horae with golden diadem and joy…"[3]

In his *Theogeny*, written in the eighth century before Christ, Hesiod tells of Aphrodite Anadyomene – i.e. "rising out of the waters": During the battle of the gods, Cronos defeats and castrates his father Uranus, the heaven; his seed flows into the sea, the union of water and heaven producing the goddess of love. The secret of her birth was considered a sacred mystery and was linked to a cult, whose symbols appear in Botticelli's painting. Thus the purple gown, held ready for the goddess on the shore, has not only an aesthetic, but also a ritual function. Its first appearance was on early Grecian urns, where it symbolised the border between two regions: both newly born babies and the dead were wrapped in cloth.

During the Middle Ages, the traditional attributes of Venus, her roses for example, were passed on to another dominant figure, whose role was utterly opposed: the Christian Virgin Mary. This is also true of her shell. In connection with the pagan goddess, the sea-shell, like water, represented fertility. Its resemblance to the female genital organs made it also a symbol of sensuous pleasure and sexuality. But as the dome above the Virgin's head in Botticelli's St. Barnabas altarpiece, it can only symbolise virginity: it was thought that various kinds of mollusc were fertilised by the dew. The ambivalence of the symbols suggests that the dominant mythical female figures of Classical antiquity and the Middle Ages overlap. In any case, Botticelli evidently had no compunction about using the same model for both.

3

## Zephyrus makes their robes flutter

Homer's story of Venus refers to the chubby-cheeked god of the wind. His name was Zephyrus, the Wind of the West, on whose breath spring came to the land. The Roman poet Ovid tells of his companion Chloris, whose white legs and arms are clasped around Zephyrus' brown body: after he had raped her, the West Wind made her his wife, turning her into Flora, the goddess of flowers.

Where did the Florentine craftsman and tanner's son Botticelli receive his education in mythology? He was described in childhood as a sickly boy who spent much of his time reading.[4] But could an apprenticeship to a goldsmith, and later to a painter, really leave him as well-versed in Ovid and Homer as some of Florence's richer merchants? It seems unlikely, given the size of the library which belonged to the Maiano

brothers. These artists came from the same town, the same generation and the same class background as Botticelli. According to an inventory compiled in 1498 they possessed a mere 29 books, half of them religious. The only Classical texts were a biography of Alexander and an edition of Livy's works. The scope of Botticelli's library was probably comparable.

"Required to execute a history painting," the Renaissance architect and art historian Leon Battista Alberti (1404–1472)[5] recommended "… asking friends for advice." Through his neighbour, Giorgio Antonio Vespucci, Botticelli was well connected with the intellectual élite of Florence: scholars who, under the aegis of the ruling Medici, had set about rediscovering Classical antiquity.

Botticelli occasionally collaborated with the humanist and poet Angelo Poliziano (1454–1494). For example, he decorated a jousting banner for Giuliano de' Medici with allegorical motifs devised by the scholar. In a poem written in honour of the same tournament, Poliziano describes a

*Birth of Venus* not unlike that by Botticelli. Possibly, the painter's "mythologies" benefitted from Poliziano's expert advice.

However, Botticelli's adviser could just as easily have been the philosopher Marsilio Ficino (1433–1499). Ficino's life-work was an attempt to reconcile Classical philosophy with Christianity (even humanists attended daily mass!): a new doctrine sprung from the union of pagan ideas with medieval theology. "Celestial Venus", as opposed to the pagan earthbound goddess, was given a highly positive role in Ficino's system: she stood for humanity, charity and love, and her beauty led mortals to heaven.

Even if Poliziano or Ficino did not advise the artist directly, their society must have made the ancient divinities acceptable in his eyes, ensuring that a devout Florentine painter in 1486 could portray a naked Venus in good conscience, without having to fear that his work would be "smashed to pieces and buried".

## Cornflowers of lapis lazuli blue

**B**ecause we take pleasure "at the sight of flowing garments," the theorist Alberti advised painters to show the face of Zephyrus blowing down through the clouds and "robes fluttering gracefully in the breeze".[6] Botticelli followed his advice. In his *Birth of Venus* everything is in motion: the waves, the branches of orange trees in the backgound, the roses floating to earth, the robes of the different figures. It was also true of the figures' hair: Alberti had demanded that hair be shown "in flowing curls which appear to form rings, or to surge like flames into the sky, or to be intertwined like snakes."[6]

The representation of movement as an expression of life and natural energy in rediscovered Roman statues and reliefs greatly impressed the artists of the Renaissance. They considered it important to take up the idea in their own work. In 1434, Alberti wrote a "modern" aesthetics based on Classical principles, entitled *On Painting*. Although unpublished until the following century, it was already known in Florence much earlier, probably becoming Botticelli's theoretical bible. Cennino Cennini's *The Craftsman's Handbook* had appeared in 1400 and would certainly have been used in Botticelli's studio. It explained how to crush lapis lazuli to extract blue colouring for the cornflowers on the Hora's robe, for example, or how to apply extremely thin gold-leaf to Venus' purple gown. However, Botticelli was an innovative craftsman in his own right. His *Birth* is not painted conventionally on poplar. Unlike the *Primavera* it is not a panel painting at all, but the first large-scale Tuscan work to be painted on canvas.

Although Botticelli still painted with tempera (Cennini advised using eggs from town hens, since country eggs made the colours too bright), he added extremely little fat to the pigment, achieving exceptional results. His canvas has remained firm and elastic ever since, the paint itself showing very few cracks. Removing a layer of oily varnish that had been added to the painting after its completion, restorers discovered that Botticelli had applied his own, very unusual protective layer of pure egg-

white. It was this, together with the "lean" tempera, which made the painting resemble a fresco, making it suitable for a country residence. Indeed, the fact that she was hung in a villa outside Florence may have saved this Venus from oblivion, for it soon seemed as though all the efforts of humanists to rehabilitate the goddess had been overtaken by history. The defeat of the Medici led to the monk Savonarola's strictly enforced Florentine theocracy from 1494 and 1498. On the night before

carnival, Shrove Tuesday 1497, he ordered make-up, jewellery and false hairpieces of all kinds, as well as "lascivious paintings", to be burned on a "bonfire of vanities." Botticelli is said to have become a follower of this fanatic monk. True or not, he certainly stopped painting pagan mythologies and naked women.

4

# The merchants of Venice

Carpaccio marginalises the healing of the possessed. The object of his religious adoration is not a miraculous relic, but his own city: Venice. He shows the Rialto, the city's business centre, where the great trading nations owned houses and wealthy burghers paraded in their finest clothes. The painting (365 x 389 cm) is in the Galleria dell' Accademia, Venice.

A procession in Venice: filing across the bridge, it disappears between the houses, then reappears from the left. The brethren at the head of the procession ascend the steps to a loggia, where they are met by the patriarch, the spiritual leader of the city-state. The brothers have brought him a reliquary containing a splinter of the holy cross. The patriarch holds it before a man who is possessed by a spirit – the man is immediately healed. Or so the story goes.

The relic, which belongs to the Brotherhood of San Giovanni Evangelista, was also responsible for a number of other miracles. In one case the splinter was supposed to accompany the funeral procession of a brother who had refused to recognise the sacred nature of the relic, whereupon the splinter, in turn, refused to enter the church where the dead man lay. The scene was painted by Giovanni Mansueti (c. 1485–1527). On another occasion, during a procession, the relic fell into a canal. Several brothers jumped in after it, but the splinter permitted only the leader of the brotherhood to remove it from the water. This incident is recorded in a painting by Gentile Bellini (c. 1429–1507). The work hangs beside Carpaccio's painting in the Accademia, Venice.

The patron of the works by Carpaccio, Bellini and Mansueti was the owner of the relic: the Scuola Grande di San Giovanni Evangelista. There were several such "schools" in Venice, societies devoted to charity, and named after churches, or patron saints. The Scuola di San Giorgio degli Schiavoni, for example, another of Carpaccio's patrons, represented the interests of a group of foreigners: Dalmatians who worked in Venice. The great Society of John the Evangelist (Giovanni Evangelista) looked after the old and sick, for whom they built a hospice. In 1369, they received a present from the High Chancellor of the King of Cyprus: a splinter of the Holy

Cross. The gift was kept in a reliquary of quartz and silver. However, relics were not only significant in religious terms. The more valuable the relic, the greater the respect shown to the society or town that owned it. Conversely, the more powerful a society or municipality had become, the less it could afford to be content with a second-rate relic. Venice herself is a good example: in her early days she had managed to get by with a patron saint of local origin; as a powerful city state, however, Venice decided to make St. Mark the Evangelist her patron saint. St. Mark's bones were stolen from Alexandria and, according to tradition, smuggled out of the Muslim country wrapped in pork. Thus the Venetians came into possession of one of the most highly-prized relics in Christendom.

By 1500, the cult surrounding relics was less widespread than during the Middle Ages, at least among the upper classes, or among those who had enjoyed the benefits of a humanist education. To the latter, the original manuscript of a Classical text would have been just as meaningful as the most important Christian relic.

Carpaccio executed his painting in 1494 or 1495. In 1544, probably to accommodate new doors, several paintings, including Carpaccio's, were shortened by removing a section from the bottom. Before this was done, however, the Giovanni Brotherhood consulted an expert for advice. A document now in the Venetian State Archive records the following: "The very wise Master Titian, the painter, a man whose great experience is known to all, was taken to the place. He recommended cutting some off the bottom of the said canvases… saying the cut would not damage the said canvases in any way."[1]

A century later, the painting was lengthened again by 27 centimetres, an addition it is impossible to overlook.

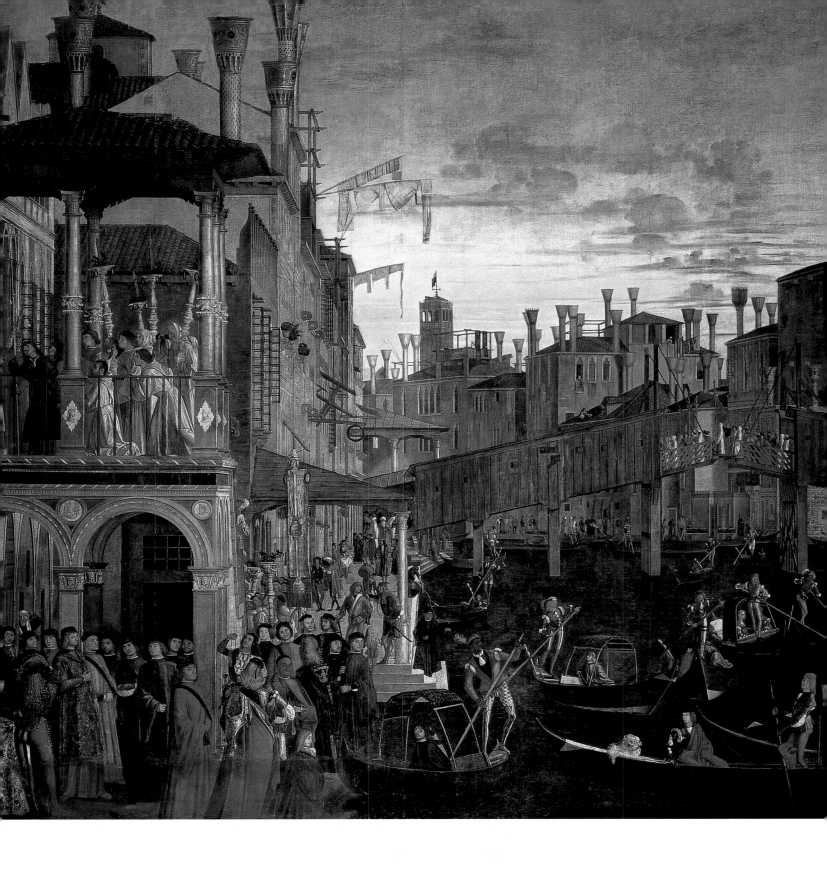

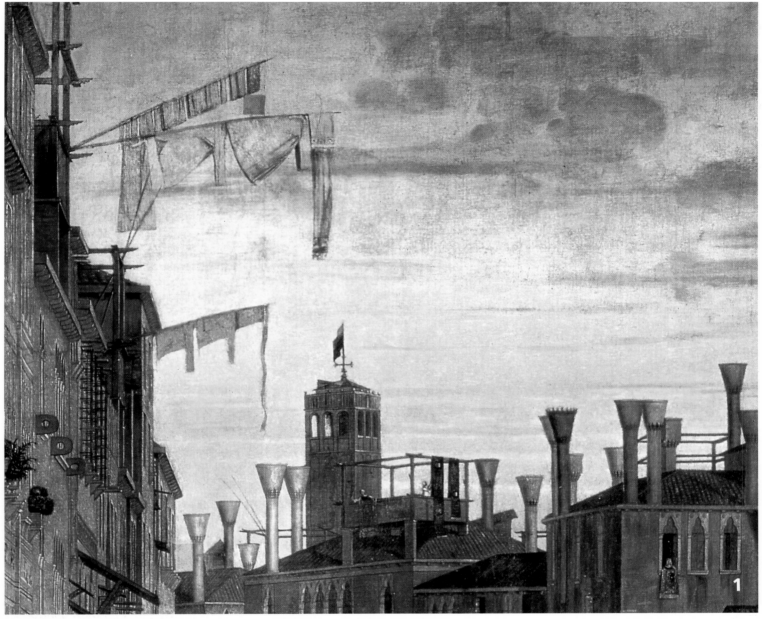

## The rooftops of Venice

Domestic life in Venice partly took place on roof terraces high above the town. More simple terraces were of wood; others had brick walls. Some were even embellished with marble cladding.

It was here that the Venetians would beat carpets, or that women and young girls would bleach their hair; here, too, families would sit out on summer evenings and enjoy the cool air. Roof terraces provided an alternative to gardens, for space was severely restricted at ground level in the town centre.

Only on the nearby islands did people have small gardens. The wealthier Venetians made up for land shortage in town by buying a villa or palazzo on the mainland. At certain times of year they would move to the country, where normal life would continue in different surroundings.

In the 15th century, washing and clothes were not hung out to dry or to air on washing-lines, but on poles. In Carpaccio's painting these are shown protruding from the houses. However, the poles usually ran through rings which were fixed along the walls beneath the windows. The rings, too, are shown in Carpaccio's painting.

The funnel shaped chimney was a typical feature of the Venetian skyline. There is no practical reason for its unusual shape. Chimneys were probably given broad tops for aesthetic reasons, since this allowed their owners to embellish them. Chimneys were considered decorative objects. It is said that the poorer Venetians, like the rich, went to great trouble to paint their chimney-funnels, hoping, even if only in this detail, to compete with their wealthier fellow-citizens.

## Two Turks and a Knight of St. John

A man in a black coat with a white cross leans back casually in his gondola: a Knight of St. John. Like two other orders, the Knights Templar and the Teutonic Knights, the Knights of St. John had come into their own during the crusades, a mass movement from which Venice, with its large fleet of transport ships, had greatly profited.

The Knights of St. John were the oldest of the three orders. Founded in 1070, two decades before the first crusade to the Holy Land took place, its purpose was not to fight, but to help. A small number of men had come together to found a hospital for pilgrims. They took monastic vows and called themselves the Brotherhood of the Hospital of St. John at Jerusalem. Forced to defend their property against the "infidels", they took up arms and became knights. They were sent presents and donations from all over Europe, becoming a large organisation who supported pilgrims not only upon their arrival in the Holy Land, but also during their pilgrimage. Like other orders, they owned houses in most of the large ports – Venice included.

The hospice of the Knights of St. John was near the Church of San Giovanni dei Friul. The Teutonic Knights kept their hospice near the Church of the Santissima Trinita, while that of the Knights Templar was near the Church of the Ascensione.

But all that had been many years before Carpaccio's time. In the meantime, the Christians had been driven out of the Holy Land, the Templars dissolved by the French king, while the Teutonic Knights had become totally insignificant. Only the Knights of St. John had managed to retain their organisational structure and power. They were based on the island of Rhodes, where they continued to foster their ideal, begun in the Middle Ages, of a life combining knighthood and monastic vows. It was not until 1523 that the island fell to the Turks, 30 years after Carpaccio had painted a Knight of St. John sitting casually in the middle of Venice. The main enemies of the order, and of Venice itself, were the Turks, two of whom, standing at the foot of the bridge in white turbans, are shown in the painting. Perhaps they were merchants, or diplomats. The Turks had conquered Greece and Albania, thereby occupying bases on the Adriatic, a region of primary strategic importance to the Venetians.

Competition sometimes led to hostilities between the two powers, sometimes to treaties; but trade between the two flourished whenever the opportunity arose. The governments of other states often found this difficult to understand.

The State Chronicles refer to an incident in 1496, when a horse, presented by a Turkish pasha, was led into the reception hall of the doge's palace. In 1500 there is a reference to Turkish ambassadors in Venice. However, in the same year the Venetians were defeated by the Turks in two sea-battles. A peace treaty was (provisionally) concluded in 1503, and by 1509 the Venetians were pleading with the Turks to help them fight their European enemies…

"The Venetians are more like Turks than Christians: shopkeepers with no religion!" said their European opponents. However, the Venetians had their own motives for entering the fray: "In fear of God, in the best interests of Christendom, for the honour of the Republic, for the benefit of the merchanthood!"[2] Although the "merchanthood" is mentioned last, its interests undoubtedly came first. The merchants were the Venetian aristocracy. Their success benefitted not only the ruling class, however, but the entire Venetian population.

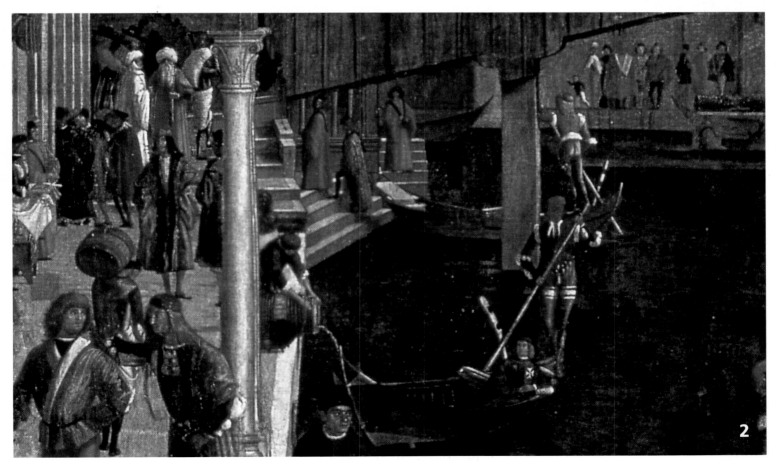

# Rialto

Venice was governed from the district of San Marco, with the doge's palace and procurators' offices on St. Mark's Square. The business world met in Rialto, the district painted by Carpaccio. Rialto was the site of the great Venetian markets; it was here that sailing ships unloaded their cargoes and that great trading nations kept their warehouses. Rialto was also the site of the only bridge across the Canale Grande. Behind the Rialto bridge, on the right, is the Persian warehouse. The German warehouse (Fondaco dei Tedeschi) was not built until 1505, ten years after the painting was executed. It still stands in the immediate proximity of the bridge, where today it houses a post-office.

The houses kept by various nations served foreign merchants as both warehouses and hostels. The Venetians treated foreigners with suspicion, while capitalising on their own misgivings: foreign traders were forced to contract weighmasters, balers and real estate brokers from the government in San Marco. The position of broker, especially, brought a large quantity of money for very little work; it was therefore a sinecure for deserving Venetians. The broker at the Fondaco dei Tedeschi in 1516, for example, was the painter Titian (who allowed Carpaccio's painting to be shortened).

The middle section of the Rialto bridge could be raised, allowing larger ships to navigate the Grand Canal; the ropes attached to the drawbridge can be easily identified in Carpaccio's painting. On the wooden bridge were tiny stalls with counters on the inside and small windows looking over the canal. In 1502, the bridge almost collapsed because of the number of pedestrians. In 1591, almost a century after Carpaccio painted the scene, a new, stone bridge was built; it stands there to this day. Sculptors and architects like Michelangelo, Palladio, Vignola, Sansovino and Scamozzi all drew up designs for the project; in the end, the work was commissioned from a lesser-known architect by the name of Antonio da Ponte.

Why the job was finally given to him, nobody knows. Perhaps it was because his plan suggested preserving the little shops and stalls on the bridge, whereas Palladio wished them removed.

Not only foreign trade was regarded

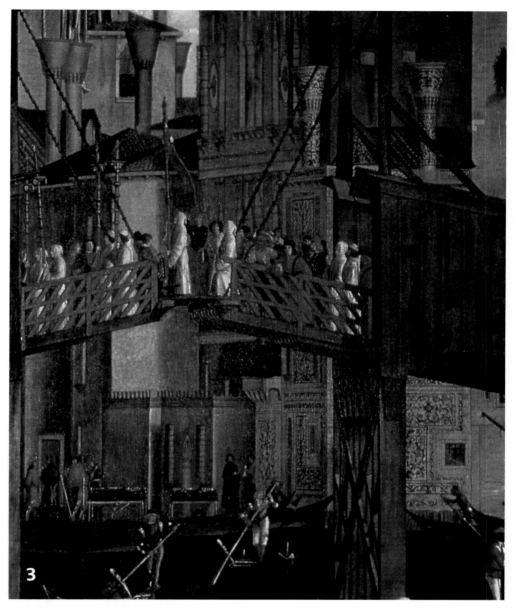

3

with suspicion in Venice; a watchful eye was also kept on the practices of local businessmen. Meat, fish, cereals and oil were sold at fixed prices. Only fishermen over 50 were allowed to sell fish, an early form of insurance for old people. Any person selling bad fish was whipped the length of the Merceria, a street stretching from the Rialto bridge to St. Mark's Square. The culprit was forced to pay a fine, imprisoned for a month and forbidden to carry out his profession for four years. Dishonest innkeepers could expect similar treatment. The round sign of an inn can be seen hanging from one of the houses on the left. The inn is called "The Sturgeon"; an inn of that name is known to have stood here.

Hygiene was taken particularly seriously in Venice, the first town in Europe with a public health authority: the Magistrato della Sanità. The office opened in 1486, exactly

ten years before the picture was painted. Its main task was to fight the plague, which broke out about every eight years. The authority attempted to prevent its spread by isolating its victims in state-run hospitals where the sick were kept in quarantine.

The cause of the epidemic was unknown, but was thought to lie in refuse and filth. For this reason shopkeepers were prohibited from throwing their rubbish out on the street. From 1502, it was forbidden to let pigs on the streets of Venice; this contrasts with Berlin, where pigs were still permitted on the streets under the Great Elector (1620–1688). Scavenging was practised in Venice at the time of the painting, and the tidal canals provided a natural means of waste-disposal. But that did not always work. In the summer of 1494, for example, temperatures were so high and the tides so weak that the fishes died in the canals.

## The Moor

Officially, trading slaves was forbidden in Venice at this time; in practice, however, it continued until the end of the 16th century. At the end of the 15th century, a healthy boy between the ages of twelve and sixteen, or an untouched, healthy woman, would cost about 50 ducats. Men usually cost more. The slaves were generally North African or Levantine prisoners. Moors were considered highly fashionable.

Judging by contracts, slaves, like pieces of furniture or plots of land, entered the estate of their owners unconditionally upon purchase. They were christened and given a new name. Despite their lack of freedom, they were sometimes better off than hired servants, since the master was obliged to provide for them even after his death. A final will might read as follows: "The slave shall remain in my widow's service for six years, whereupon she shall release him with a legacy."

Whether slave or servant, the dress of the gondolieri in the painting is magnificent, indeed often more so than that of their masters. Servants were frequently used as a badge of family wealth. Exhibitions of wealth and ease were a popular pastime among the Venetian upper classes in 1500. Once, they had devoted their energies to consolidating the power of the Republic and increasing the profits of the merchants, but those days were over. Venice was now on the defensive. The Ottoman Empire had grown powerful in the east, and Venice could not hope to compete with Spain and France in the west. The discovery of a sea passage around the Cape of Good Hope was also a factor in Venice's demise, for it meant that new trade routes could be opened between Europe and Asia. Spices, carpets and precious woods no longer had to be transported on camels to the Mediterranean coast before they could be loaded on ships; merchandise was shipped to the west directly, its destination no longer Venice, but Lisbon. It was from Lisbon and Seville that expeditions put out to sea for South America, too. Trading routes had changed; merchantmen no longer put in to Venice as a matter of course. The town had lost its leading position, and its merchants had nothing to do. They preferred being rowed about Venice in gondolas than sailing on the high seas.

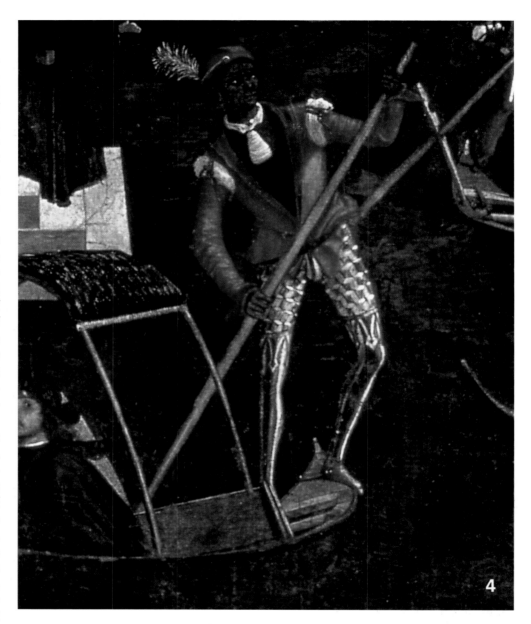

4

## The Republic

Astonishingly, Venice continued to exist as a Republic for another 300 years. It was neither conquered from without, nor overthrown from within. This made it unique in Italy. There were three main reasons for its exceptional stability. The first was geographical. Its insular position made it difficult to attack. It was not until it had finally become too poor to employ a proper army that Napoleon's troops entered Venice without resistance. That was in 1797. The Republic had survived more than 1000 years.

The second reason for the long life of the Republic was its clever system of checks and balances. In Florence, Genoa, Milan and Rome, individuals frequently succeeded in usurping total power. This was not the case in Venice. Public office was made the subject of regular elections. Only the doge had life tenure, and he was usually an old man by the time he entered office.

The third reason for the stability of the Republic was a feeling, an attitude: reverence. The Venetians revered their town, their state. When they prayed to St. Mark, their patron saint, they were praying, through him, to a communal body which they inhabited.

We sense this reverence in Carpaccio's painting. He was commissioned to paint a miracle. But Carpaccio marginalises the legend, using it as an excuse to paint a panorama of the Rialto. The pious brotherhood, also citizens of Venice, did not object.

A papal miracle – painted to reinforce papal authority. The latter, undermined by a deep crisis in the Church, needed propaganda to support it. In the year Raphael completed his fresco, the Reformation began in Germany with Luther's 95 theses pinned to the door of the palace church at Wittenberg. The base of the fresco, in the former Vatican dining room, measures 6.97 metres.

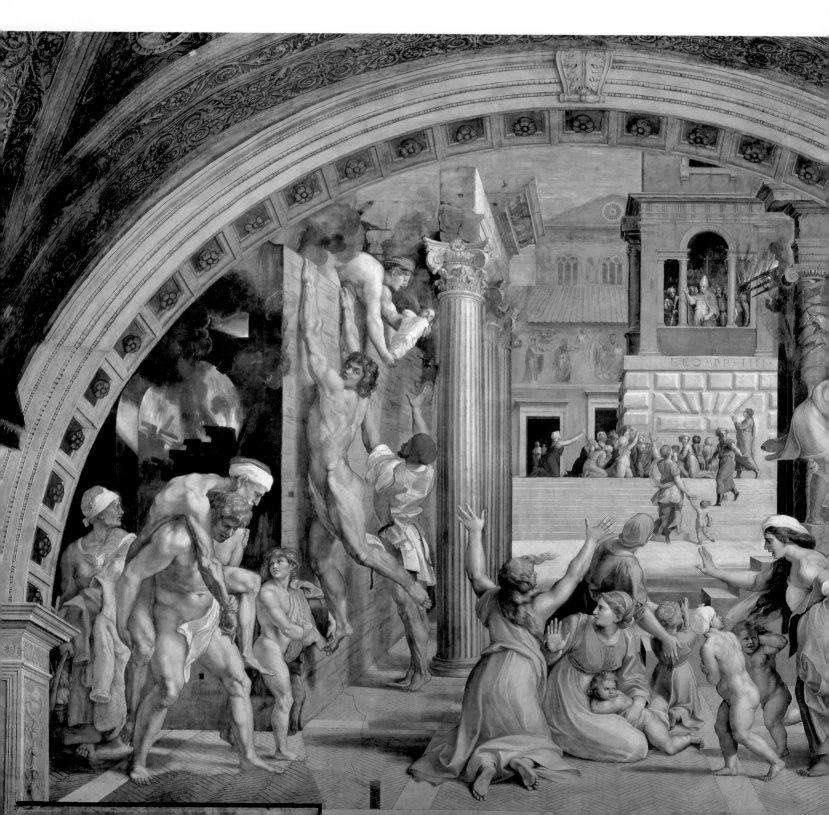

## Raphael: The Fire in the Borgo, 1514–17

# Composure in the face of misfortune

Pope Leo X was much given to sensuous pleasure. During long banquets, he would close his eyes and hum along to the music. When he opened them, and his gaze rested on the walls of his dining chamber, he could enjoy frescos by Raffaello Sanzio of Urbino, the most popular and well-paid painter in Rome.

Raphael's frescos show scenes from the lives of previous popes called Leo. A fire was said to have broken out near St. Peter's, in the Borgo San Pietro, during the time of Pope Leo IV (847–855). The fire raged until the local population sought the pope's help. The Holy Father made the sign of the cross, whereupon the fire immediately went out: a papal miracle.

Little is seen of the dangerous fire in Raphael's monumental fresco (base: 6.97 metres; top arched by domed ceiling). One or two figures are shown fighting it with vessels of water; others, barely dressed, try to escape. The arms and faces of the figures in the backgound are raised in supplication to the pope. He alone can save them from catastrophe. He alone can command the hostile elements.

The image was undoubtedly appreciated by the patron of the fresco. Weakened by internal disruption, Italy was in desperate need of a pope who could perform miracles and protect it against the French, Spanish and Imperial armies struggling for European hegemony.

Leo X wished to be remembered as a pope of peace. The motif of a legend from the life of a previous Leo served his cause very well. He showed great interest in the progress of the fresco. "The pope summons us every day," reported Raphael, who started work on the papal dining chamber in 1514, "and discusses the work with us a little."[1]

The three other walls also show topical papal feats. The dining chamber was the first room painted by Raphael for Leo X. Raphael had also enjoyed the great respect of Leo's predecessor, Julius II, pope from 1503 to 1513.

The artist was born in Urbino in 1483. In 1508 he began work for Julius in Rome. His cartoons for frescos in three new Vatican apartments, known as "stanze", had pleased Julius so much that he ordered all work by other artists to be removed from these rooms. Only Raphael was to paint them.

When Julius died, only two of the rooms were finished. The new Pope Leo X gave Raphael so much work that the young artist was increasingly forced to rely on assistants for completion of the Vatican frescos. *The Fire in the Borgo* was the last fresco to be executed by his own hand. The dining chamber was completed in 1517. The appartments "owed their distinctive beauty to unique works of art," wrote Leo's secretary, and to the fact that they were "almost always full of cardinals".[2]

## An Epicurean on St. Peter's throne

Pope Leo IV appears at the window of a loggia, surrounded by attendants. His features are those of Raphael's patron, Leo X. At his first Easter procession, Leo is said to have almost collapsed under the weight of his golden ceremonial gowns and tiara. A weakly man, he was no longer in the best of health at the age of 37, when the painting was executed. His health had influenced his election. Many cardinals had hopes of succeeding him; none of them had wished a "strong pope".

Leo's predecessor on St. Peter's throne, Julius II, had been known as "il papa terribile": "the terrible pope". His portrait, too, can be found in Raphael's Vatican frescos.

During his ten years of office, Julius had been at war almost continually. He had taken the field himself, swearing like a trooper, commanding battles, besieging towns. He saw himself not only as the head of the Christian Church, but as a worldly ruler.

With his battle-cry "Fuori i barbari" ("Out with the barbarians"), Julius had attempted to drive the great foreign powers from Italian soil, constantly forging new alliances in the process. Italy was divided, its towns and princedoms at war with each other. Julius wanted to unite them under papal leadership – a dream, shared by many patriots, which he took with him to the grave. His successor had other interests, and the system of electing popes made it difficult to realise long-term political goals.

Leo X was more interested in family politics than war or empire-building. He had been born in 1475 as Giovanni de' Medici, the second son of Lorenzo the Magnificent, the uncrowned ruler of Florence. It was decided when Giovanni was very young that he should crown the family fortunes with papal dignity. Given a tonsure at the age of 7, he received a cardinal's hat at 14. "God has conferred the pontificate upon us," Leo is known to have said after his election, "we therefore intend to enjoy it!"[3]

The glory of the Holy See under the highly educated humanist and Epicurean Leo X knew few limits. Furthermore, the enthusiastic patronage of the arts begun by Julius continued under Leo. However, since he had practically no background in financial management, he exhausted – according to the French historian Paul Larivaille – the "treasuries of three popes" during his own period of office: the wealth accumulated by Julius, his own income, and that of his successor.

Despite his desire to be a man of peace, he could not avoid involvement in the struggle between the leading European powers. With his diplomatic intrigues and timid tactical opportunism, he could do little to match leaders like Francis I of France, or Charles V, Spanish and Holy Roman Emperor.

Like other popes, Leo X was unrestrained in his nepotism, surrounding himself with relatives and close friends from Florence. This was essential for his own protection. Rome was a dangerous place, especially after the death of a pope. While the cardinals met in conclave, there were regular riots in the city. The people marched through the streets, plundered the palaces of the dead pope and cardinals, and set them on fire.

Raphael's fresco shows a part of the old city of Rome that was demolished during the 16th century: the original facade of St. Peter's with its Romanesque window arches and mosaics on a golden ground. The basilica had been subject to building work for some time. The church, begun by Emperor Constantine in A.D. 324 over the grave of the apostle Peter, was no longer safe, and its simplicity no longer appealed to High Renaissance taste.

Renovations began under Julius, the "terrible pope". In fact, Julius merely

## The master builders of Rome

wished to build a grand monument to himself in St. Peter's. But when Michelangelo's monument proved too large, Julius decided to extend the church to accommodate it. While plans were being drawn up, however, Julius concluded that only the total reconstruction of Christendom's most important church constituted an adequate monument to his period of office. It was to be a building which could compete in size and magnificence with the "Holy Wisdom" (Hagia Sophia) in Constantinople.

Julius entrusted the architect Bramante with the plans and, on 18 April 1506, ceremoniously laid the foundation stone under St. Veronica's choir-pillar, behind the old facade. The facade itself was left standing, while parts of the basilica were pulled down and renewed.

It was in this half-demolished church in 1513 that Pope Leo X was forced to celebrate his first Easter. He had Bramante continue the building works, appointing Raphael Master Builder of St. Peter's in 1514 after Bramante's death, because, as he said: "We have no greater wish than that this temple be completed in the most splendid manner, and as quickly as possible."[4] The new St. Peter's cathedral was completed in 1626 – 19 popes later.

It was not unusual for painters to engage in architectural work. To meet the Renaissance ideal of "universal man", the artist had to be an "all-rounder". He only had to deliver the plans, after all; the rest was taken care of by experts with the necessary practical experience. "What place… in the world could be more dignified than Rome, and what work confer more dignity than St. Peter's,"[5] wrote Raphael to his uncle. His interest in architecture is reflected in *The Fire in the Borgo*. Architectonic features are not merely intended to be decorative. Here, space is used to great effect, and with evident understanding of perspective. The building, with its mighty square stones and loggia on the church facade, probably reflects plans that Raphael had already drawn up for a Borgo Palace.

The "universal" artist Raphael also designed villas for bankers and palaces for cardinals; he participated in the architectural reconstruction of Rome as a leading city, then fully underway. It was during Raphael's lifetime that the Holy City overtook Florence as a centre of art.

The immense sums of money needed for these works were procured by means of "spiritual" transactions by the popes themselves, not least by Julius and Leo. They sold ecclesiastical offices to the highest bidders, and papal indulgences for every sin in the book. "Thus the material construction of St. Peter's was responsible, to a large extent, for its spiritual deconstruction," as one Catholic historian at the Council of Trent (1545–1563) put it, "for in order to collect the millions swallowed by that colossal work, Julius II's successor was forced to engage in practices which provoked Luther's heresy, which, in turn, has made the Church poorer by an even larger number of millions of souls."[3] In 1517, the year the papal master builder Raphael completed his fresco, Luther had pinned his 95 theses to a church door in distant Wittenberg.

2

3

## The Classical heritage

St. Peter's, the Vatican and other palaces were built largely from the ruins of antiquity. This had been a well-tried method ever since the feudal lords Orsini and Colonna had used the remains of the Colosseum to build fortified towers for themselves and their families. The popes of the Middle Ages had held heathen monuments in disdain. Their humanist successors in the late 15th century, on the other hand, liked to think of themselves as Caesar's heirs, collecting antique medals and sculptures (Julius II, for example, is known to have paid huge sums for the statue of Laocoon, found in the vineyards in 1506). But even these popes exploited ancient remains when it suited them.

During Raphael's lifetime, it gradually dawned on the Romans that something had been lost, irrecoverably, with these buildings. On 27 August 1515, Leo X made the master builder of St. Peter's "praefect over all marble and masonry unearthed from this day forth in Rome and within a compass of ten miles."[6] Anyone finding "marble or other stones" was now obliged to inform Raphael immediately. No "inscribed stones" were to be cut or broken without his permission.

Following their registration, the majority of these "inscribed stones" probably became part of the stonework of St. Peter's. There was little the artist could do to alter this practice, despite regrets to the contrary, expressed in a letter to the pope in 1518. In the previous twelve years, he wrote, he had "witnessed the destruction of the triumphal arch of the Diocletian thermal springs, the temple of Ceres in the forum and Constantine's basilica…" He found it "…extraordinarily painful to have to behold the cadaver, as it were, of such a venerable and noble town".[7]

But Raphael not only tried to preserve ancient Rome; he attempted to reconstruct a picture of it from texts and excavations. In the year Raphael complained so bitterly to the pope, highest honours were conferred upon him for his contributions to acrchaeology. According to an epigram dating from 1519, he had "sought and found Rome in Rome". "Great is the man who seeks, but he who finds is a god!"[8] While excavating the Latium marshes, Raphael fell ill with swamp fever. He died in 1520.

The painter and architect was greatly celebrated in his own lifetime. Raphael's personality came as close to the ideals of his time as his art. He was modest, well-mannered, widely read and exceptionally charming. His extraordinary career was aided by the fact that the two other major artists of his time did not compete with him: after finishing the ceiling of the Sistine Chapel in 1512, Michelangelo returned to his work as a sculptor; Leonardo da Vinci left for France in 1516.

Success brought him riches. From 1513, Raphael lived in a palace of his own in the Borgo, with a large studio on the ground floor where his assistants did much of the work. Raphael knew how to delegate and organise. He was also an excellent businessman: "…our lord, His Holiness, gives me 300 golden ducats for the building work at St. Peter's which I am to receive as long as I live… Moreover, I am paid for my work as I see fit…"[6]

He received many different honours, almost, indeed, becoming a cardinal. In this, low birth and lack of religious qualification would have proved no hindrance. In 1517, Leo appointed 31 cardinals at a time, inviting all of them afterwards to celebrate the event with him at a huge banquet in the Vatican, under Raphael's frescos.

Raphael's *Fire in the Borgo* is not only a monument to the basilica, it also depicts ancient columns of dark, Africano marble with Ionic capitals, and white columns with Corinthian capitals. There had been columns like these in the basilica at Constantinople. Raphael planned to use them again in the new church. He painted them with cracks and fractures: like the remains of a bygone age.

Gaping in amazement, a beautiful woman, bearing water to extinguish the fire, pauses in mid-stride to marvel at the pope's miracle. Her whole bearing expresses nobility, a posture frozen in wonder. The wind plays with her timeless, antique robe to reveal a strong, fully-formed figure. Raphael painted her "with voluptuous brush",[9] according to one of his contemporaries. In a letter to Count Castiglione of Urbino, the artist himself regretted that there were "so few beautiful women available" in Rome as models.[10]

"We lack nothing but women at court,"[3] complained Cardinal Bibbiena. Women in paintings undoubtedly had a special significance at the Vatican. Women were no longer admitted to papal banquets as they had been under one of Julius II's predecessors, the Borgia pope Alexander VI. It would have been thought unseemly for the concubines of the prelates to enter the Vatican.

Raphael, too, is reputed to have kept a mysterious mistress at his palace; he ensured a financially secure future for her through a passage contained in his will. Besides graceful, "sweet" Madonnas, he also painted – like Michelangelo – strong heroines who were capable of maintaining a thoroughly dignified air – and an elaborate coiffure! – while fighting a fire. These women were fully consistent with contemporary taste for what came to be known as the "maniera grande".

The "Grand Manner" was thought by leading humanists at the Holy See to be an appropriate form of homage to the Classical ideals of proportion and harmony. Self-composure was of paramount importance, even during a disaster. It was not only the water-bearer's physical beauty that attracted the admiration of the painting's spectators, but her equanimity, her poise. An open mouth was permissable; distorted facial features were not. Nothing was to be allowed to disturb the spectator's aesthetic pleasure.

The most eloquent contemporary expression of the rules of refined behaviour was Count Castiglione's book *The Courtier*. As its title suggests, the manners it codified applied only to behaviour at court, among the nobility, who were thus able to distinguish themselves clearly from the lower classes. To an aristocratic sensibility, refined manners were a form of real, visible beauty.

These ideals were propagated at a time when Italy, and Rome especially, was threatened by one catastrophe after another: whole streets would be engulfed by flames during fighting between the rival Colonna and Orsini families; the Tiber burst its banks and flooded the lower-lying areas of the city; earthquakes shook the buildings, and after the death of a pope, the mob ruled. While the people prayed fervently to the golden Archangel Michael high up on the Castel Sant'Angelo, the ruling class would strive to maintain its sense of equanimity – not always successfully, however: on the night before Raphael died on 6 April 1520, an earthquake is said to have made Pope Leo flee in panic from the very Vatican appartments where Raphael's frescos pay such impressive homage to the ideal of composure.

## In the Grand Manner

4

# Careers in the king's service

A young French bishop visits a young French diplomat in England. They were friends, and the artist shows us some of the interests they shared: music, mathematics, astronomy. Death, too, is concealed in the painting. The double portrait (207 x 209 cm) is in the National Gallery, London.

An official portrait: two men whose bearing, respectability and earnest mien make them look about 40 years old. But they were both much younger; the man on the left was 29, the man on the right 25. Life expectancy in the 16th century was shorter than today; people tended to enter important posts at an earlier age. One of the men is already a bishop, the other is French ambassador to the English court.

The churchman, himself occasionally entrusted with ambassadorial duties by the French king, is visiting his friend, the diplomat. The two represent different sectors within the diplomatic corps, named after their styles of dress: "l'homme de robe courte" and "l'homme de robe longue". Men of the short robe were worldly ambassadors; those with long robes were clergymen.

To be sent on a diplomatic mission by the king was an honour, but seldom a pleasure in the 16th century. Above all, it was expensive. The king granted fiefs, benefices and allowances to both clergy and nobility. In return, these were obliged to perform services, a duty extending to the disposal of their incomes. They were thus expected to pay for their stay in foreign lands out of their own pocket. Once there, they were generally treated with due politeness, but also with suspicion. Diplomats were thought to combine their official duties with spying. In 1482, for example, it was strictly forbidden for Venetians to talk of public affairs to foreign diplomats; and one Swiss ambassador reported from London in 1653 that a member of parliament who spoke to a foreign ambassador risked losing his seat. Certainly, it was one of the ambassador's main tasks to collect as much exact information as possible about the country he was visiting. Newspapers did not exist at the time.

Contemporary manuals and memoirs give us some idea of the abilities expected of a diplomat: First of all, he should cut an appropriately representative figure, wearing clothes that were fine enough, and expensive enough, to be worthy of his master. He should be eloquent, have an excellent knowledge of Latin (the *lingua franca* of the day), and be educated to converse with scientists and artists. His manner should be urbane, charming, never too curious; he must be able to retain full composure while listening to the worst of news, and be skilled in slowing down or speeding up negotiations whenever necessary. His private life should be impeccable, precluding even the slightest hint of a scandal. His wife must stay at home, of course; after all, she might gossip. It was considered of the utmost importance to retain an able cook; good food is often a ticket to the best information.

The 16th century was the cradle of modern diplomacy. Previously, the affairs of European states in the Holy Roman Empire had been regulated centrally by the Emperor. This system had lost much of its authority. Instead, bilateral agreements had grown in significance, and with them the art of diplomacy. However, permanent embassies remained an exception; diplomatic missions lasted only a few weeks or months. It was not yet essential, as it later became, for foreign policy to direct its energy toward establishing relationships of mutual trust over long periods. Short-term success was more important. If a contract no longer served a country's interests, it was simply broken. These were times of great insecurity. The balance of power changed from month to month. There was one means alone of securing an alliance of real duration – marriage.

The changing structure of alliances in the 16th century is reflected in its record of engagements and their dissolution, its his-

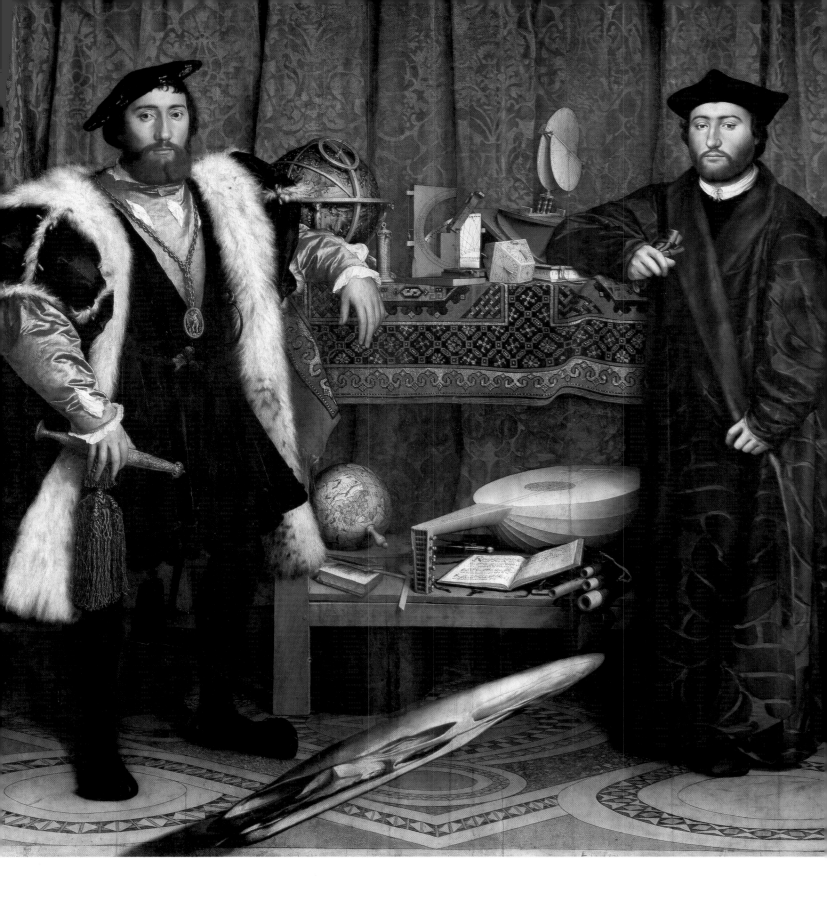

tory of marriages and their annulment. As a young man, the English king Henry VIII had married Catherine of Aragon. She was an aunt of the powerful Spanish king, Charles V. Henry and Catherine had a daughter, Mary, who herself became engaged to Charles V of Spain. However, while Mary was still a child, Charles V dissolved his engagement to her, for he wished to marry Isabella, the Infanta of Portugal, a match which would directly increase his wealth and sphere of influence. Henry, meanwhile, in whose opinion Charles V was becoming altogether too powerful, sought to ally himself by marriage with France. Before remarrying he needed the pope to declare his marriage to Catherine null and void. But the pope had been dominated by Charles V since 1527. He was therefore unabale to annul Henry's marriage. The matter was made even more complicated by the Privy Council, who wished to see the English noblewoman Anne Boleyn, rather than a French princess, on the throne of England.

It was against this background, in the spring of 1533, that a French ambassador was sent to London. While there, the diplomat had his portrait painted in the company of his friend. Hans Holbein documents execution of the painting on English soil by means of the mosaic on which his subjects are standing; the design is that of the mosaic laid by Italian craftsmen in the sanctuary floor at Westminster Abbey. Today, the floor is heavily worn and covered by a large carpet. Only at the carpet's edge is it possible to see the original ornamental work.

## Nobleman on a delicate mission

The French ambassador is Jean de Dinteville. Born in 1504, he resided at Polisy in Champagne. As a manorial lord, he had the right of jurisdiction; he was also King's Proxy at the provincial capital of Troyes, an office held by his father before him. Jean de Dinteville did not belong to one of the great noble families of the land, nor was he one of the great historical figures of his time. He was, however, an archetypal Renaissance nobleman: a humanist with an interest in music, painting and the sciences. He was active in the king's service, and dependent on the king's goodwill. His greatest gift to posterity was his decision to have himself portrayed with his friend by Hans Holbein.

The artist portrays the nobleman with the Order of St. Michael hung on a long golden chain around his neck. This was the French equivalent to the Spanish Order of the Golden Fleece or the English Order of the Garter. The 16th-century royal orders had nothing to do with the orders of the late Middle Ages, brotherhoods dedicated to a way of life combining monastic and chivalric ideals. Instead, they were a means of endorsing the allegiance of a loyal subject, awarded to capable men in the hope of ensuring their devoted service to the throne. Their prestige derived partly from their limited membership. There were only 100 holders of the Order of St. Michael at any one time.

1

Francis I, the French king, had sent Jean de Dinteville to London for the first time in 1531. In the spring of 1533, he was sent to London again, for in the meantime, the alliance between the two countries had become even more confused. Henry VIII had secretly married the pregnant Anne Boleyn in January, though the pope had not yet annulled his previous marriage.

Francis I offered to use his influence in the Catholic Church on Henry's behalf. A meeting was arranged between Clement VII and Francis I; but Henry procrastinated. He had the Archbishop of Canterbury declare his old marriage null and void, thereby encroaching upon papal rights. He obstructed negotiations between the French king and the pope.

On 23 May 1533, Dinteville informed his master by letter that he had asked Henry VIII "if it should please him to make a secret" of the archbishop's decision, "so that our Holy Father is not informed of this matter before Your Majesty speaks to him of it. He replied that it was impossible to make a secret of this, and that it must be made public even before the coronation."[1]

Anne Boleyn was crowned at Westminster Abbey on 21 June. High honours were conferred upon the French ambassador during the festivities that followed. In the meantime, however, the subject of negotiations between Dinteville's sovereign, Francis I, and the pope had changed: the French king now sought to marry his son to the pope's niece. His aim was to win over Milan. Henry's interests were forgotten. There was therefore little left for Dinteville to do in London. He left on 18 November 1533.

Dinteville was present in London not only for Anne Boleyn's coronation, but also for her execution. He was entrusted with three further diplomatic missions to England, before his family fell into disgrace. Apparently, his three brothers had plotted against Francis I. Jean de Dinteville died, aged 51, at Polisy. Before his death, he conducted renovations at his castle, employing – like the English kings and Francis I – Italian craftsmen to execute the work. A tiled floor in the Italian style exists at Polisy to this day. Holbein's painting hung at the castle for many years. Today it is in London's National Gallery.

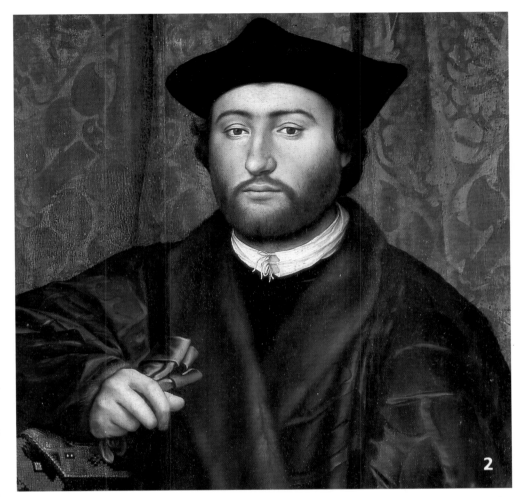

2

## A pious man fears for the Church

Unlike his worldly friend, the bishop does not hold an ornamental dagger in his right hand, but a pair of gloves. His arm rests on a book, on whose fore-edge part of a sentence may be deciphered: "aetatis suae 25". If we add the word "anno", the sentence, rendered into English, reads: "in the 25th year of his life". Dinteville's age, incidently, is written on his dagger. Facts like this helped identify the figures. The bishop was Georges de Selve.

As can be expected from a representative portrait of this kind, the subjects' faces are almost expressionless. Without their different styles of beards, the two friends might even look quite similar. Their eyes, on the other hand, are distinctive. Those of the bishop are smaller, with their pupils more heavily shadowed by the lids. Accordingly, the bishop does not appear to concentrate quite so intently on his immediate surroundings as the worldly ambassador. A similar distinction may be made in respect of their dress and bearing. Dinteville's puffed up fur makes his shoulders twice as wide as those of his friend. The diplomat wears his fur coat wide open; the clergyman is holding his coat so that it completely covers his body. The life of one is more outward-going, the other's more introspective. Their different personalities allow Holbein to characterise two castes: *robe longue, robe courte*.

Georges de Selve's father, president of the *Parlement de Paris*, had been rewarded for his many services to the crown by the bestowal of a bishop's fief upon his son. Georges, then aged 20, was made Bishop of Lavaur in the southwest of France. Although the minimum age for this office was 25, a dispensation from the pope rendered exceptions possible. These were frequent enough. Bishops who were too young for office received an income and title, while their clerical duties were performed by priests.

Even after Georges de Selve was permitted to take up ecclesiastical office, he

spent most of his time outside his diocese. In the autumn of 1533, following a private visit to London, the French king sent him as an ambassador to Venice; later, he was entrusted with a mission to the pope in Rome, and then to Charles V in Madrid. In 1540 de Selve requested to be relieved of his offices for reasons of health. In April of the following year he died, aged 33.

Georges de Selve's writings bear testimony to his piousness. He saw the solution to the problems of his time, including those of a worldly nature, in a total regeneration of religious life. He criticised not only the condition of the Church, but also the selfish machinations of kings and princes. De Selve evidently had some sympathy for Luther's endeavours as a reformer; he nevertheless opposed the division of the Church. In all probability, De Selve was France's delegate at the Diet of Speyer in 1529, holding a great speech there in favour of confessional re-unification.

Holbein refers to the notion of re-unification by means of a hymnal lying open on the lower shelf. The book is neither French nor English, but the German Johann Walther's *Book of Hymns*, printed at Wittenberg in 1524. The book lies open at two of Luther's hymns: "Kom̄ Heiliger Geyst Herregott" and "Mensch wiltu leben seliglich". The first is a German translation of "Veni Creator Spiritus", the second points to the importance of the Ten Commandments. In content and tradition both are good "catholic" texts, emphasising the common ground between the new Lutheran and old Roman Catholic standpoints.

small, portable globe, a level, and a compass lying under the neck of a lute. Music, too, was considered a mathematical art at the time. The tubes probably contained maps.

It might seem strange to us today that a display of instruments of measurement should be considered fitting attributes for a diplomat and a churchman, but it would not have seemed so at the time. Both men had been to university, where mathematics had become one of the most important academic disciplines of the Renaissance. This contrasted with the Middle Ages, when a religious explanation of the world had been considered more appropriate than the study of natural sciences, and mathematics had consequently fallen into neglect. However, as times changed, scientists began to search once again for laws of mathematics and physics which would make it possible to explain how the world functioned. Even painters occupied themselves with the study of mathematics. In his *Instructions for Measurements taken with the Level and Compass*, Holbein's compatriot Albrecht Dürer had celebrated geometry as the true foundation of all painting. Perhaps the inclusion of these two instruments in Holbein's painting was a reference to the older artist's work.

The level is inserted between the leaves of a book, which, like the *Hymnal*, has been identified: *A sound instruction in all calculation for merchants, in three volumes, including useful rules and questions.* This was a textbook on the principles of calculation in business, written by Peter Apian, a university teacher at Ingolstadt, and printed in 1527. Apian begins with the fundamental operations of arithmetic and guides his reader via a series of steps to the extraction of square roots. With the aid of practical examples, he shows how silver value equivalents can be converted into gold value, or how to convert currencies. Then come the "useful questions", which are not much different from those used in schools to this day: "A messenger leaves Leipzig and takes 18 days to reach Venice; another messenger leaves Venice at exactly the same hour and takes 24 days to reach Leipzig. The question is: how many days pass before they meet?"[2]

The globe behind Apian's book has been attributed to Johann Schöner of Nuremberg. Holbein himself came from Augsburg, and it may be supposed that the ob-

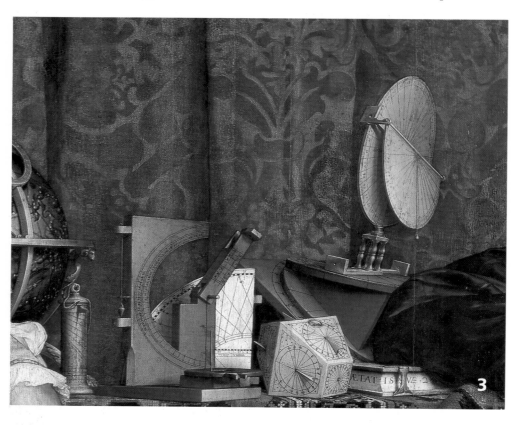

## Central role of mathematics

The figures portrayed in 16th-century double portraits are usually shown close together. Not so Dinteville and De Selve. Holbein sets them as far apart as possible, placing them right at the edges of the painting. Between them, a plain, two-storeyed cupboard displays a large number of books and instruments. It is almost as if Holbein wished to indicate that the bachelors' friendship was based on a common interest in natural science.

All of the instruments are linked in some way or another to applied mathematics. On the left there is a celestial globe; next to it, a cylindrical sundial, or shepherd's timekeeper. There are several sundials on the faces of the polyhedron; these were used for travel. Then there are two different types of quadrant, and on the lower shelf a

jects from southern Germany which are exhibited in the painting were introduced by the artist rather than the patron. However, Holbein has altered Schöner's globe to suit Dinteville's wishes. This is evident from a comparison of the names on the painted version with those on the original. They both have about 100 names in common, but there are also 20 names which appear on Holbein's copy only. These names all have some bearing on the lives of Dinteville and the members of his family: Burgundy, Avern, or Polisy, for example.

## Death concealed in a puzzle

Everything in Holbein's painting, whether persons or things, is represented more or less realistically, with one exception: the skull suspended above the floor. At first glance it is hardly identifiable. It is only recognisable as a skull when seen from the right or left edge of the painting, and only when it is viewed through a lens which alters its proportions altogether does the image become quite distinct.

Anamorphoses, or distorted images of this kind, were a well-known trick at the time. They were usually applied to portrait drawings, and were achieved by means of a ruler and length gauge, that is by the use of mathematical instruments. First, the artist would draw the contours of a normal portrait, over which he would then draw a grid of lines. On a second sheet of paper he would distort the grid, squashing it flat in one direction, and exending it in the other. He then transferred the portrait to the dimensions of the corresponding grid-squares. A mathematical picture puzzle.

There is yet another skull in the painting: a very small one set in the brooch on Dinteville's beret. The double appearance of the skull cannot be put down to chance; Holbein's painting is too well thought out, its effect too precisely calculated. Their meaning may become clearer if we consult two paintings by Fra Vincenzo dalle Vacche, painted around 1520 for a church in Padua. The paintings do not contain anamorphoses, nor do they even contain figures; however, like Holbein's painting they show a number of different objects on shelves. One of the paintings, entitled *The Vanity of the Worldly Power of the Church and Laity*, shows a bishop's staff, a crown, an hour-glass and a skull. The objects shown in the other painting, entitled *The Vanity of Science*, are a celestial globe, a sextant, a mathematical textbook, a sheet of music and a viola with a broken string. Holbein's lute also has a broken string. His own arrangement of instruments seems deliberately to combine the effect of the two Italian paintings. The common theme is vanity, or *vanitas.*

The notion of *vanitas* had wider connotations at the time than it does today. It meant blindness towards the most important things in life; also, the futility of human endeavour. A vain person forgets all too easily that he must die. A vain person believes that science can give him knowledge of the world. In a pamphlet in Latin in 1529, shortly before Hans Holbein executed his painting, the German writer Cornelius Agrippa complained of the "uncertainty and vanity of all art and science". Art and science, he continued, "are nothing but the laws and imaginings of human beings"; the truth, on the other hand, is "so great and free that it cannot be grasped by the musings of science, but by faith alone…"[3]

We must conclude that Holbein's painting is not merely a double portrait. At first glance, its subject seems entirely worldly, entirely temporal: the official portrait of two young men surrounded by instruments of scientific and mathematical research. Even the composition of the painting, with its emphasis on powerful horizontals and verticals, seems arranged according to mathematical principles. Only the anamorphosis, apparently floating diagonally through the picture, contradicts this regime of calculated rectangularity, giving the work an aura of contemplation and suggesting the presence of some hidden commentary on human affairs. After comparing the painting with Agrippa's text, or with paintings like those by Vincenzo dalle Vacche, one might conclude that its message was the vanity of art, science and high rank. In order to make such a statement, however, Holbein need not have disguised the skull. He therefore seems to be saying: Study of the arts and sciences need not be vain at all. On the contrary, it may lead us to a deeper, more comprehensive appreciation of the world. Indeed, it is sometimes only by scientific means that we can make visible the presence of death behind phenomena, behind the pleasing appearance of things. That, after all, is what the painting achieves.

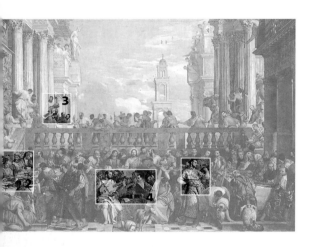

Despite rules forbidding them to raise their eyes from the plate while eating, the Benedictine monks at the monastery of S. Giorgio Maggiore decorated their refectory walls with the painting of a sumptuous feast. Their excuse was that the work illustrated a miracle: Christ's turning of water into wine at the marriage in Cana of Galilee. Napoleon had the painting (6.69 x 9.90 m) removed to Paris, where it now hangs in the Louvre.

With its 6.69 x 9.90 metres, this is one of the largest works ever to be painted on canvas. The contract concluded between the monks of the Venetian monastery of San Giorgio Maggiore and the painter Veronese (1528–1588) on 6 June 1562 specified "a painting as wide and as high as the wall"[1] for the end wall of their new refectory.

During the 16th century, while the rich Venetians built one splendid Renaissance palace after another, the Benedictine monks of Venice added a new dining-hall (refectorium), cloister, library and church, thereby greatly embellishing their island opposite St. Mark's. Since many were the younger sons of the lagoon-Republic's ruling families, they had access to wealth and could therefore afford building works on this scale.

The refectory of the Benedictine monastery made its architect Andrea Palladio (1508–1580) famous. Palladio took his inspiration from antique temples, and his cleverly calculated proportions imparted a rare sense of harmony to the large, simply decorated hall. The background of *The Marriage at Cana* is strongly reminiscent of Palladio's architectural style. Veronese draws the spectator's eye through to palaces, a campanile and balconies – in other words into an ideal Renaissance townscape, set against a bright and cloudy sky.

The open square with the marriage feast in progress is framed on either side by columns in antique style. Servants scurry back and forth on a gallery, while the guests sit around the banquet table in the foreground.

Christ presides at the centre of the painting, surrounded by his mother and disciples, while some of Veronese's patrons, the Bendictines of San Giorgio, sit at the right. These elderly gentlemen with their rich robes and well-fed faces do not seem at all disinclined to partake in the feast of life. Nor does it seem beyond the bounds of credibility that they took great pleasure in Veronese's portrayal of the feast during their own mealtimes – despite a strict rule which forbade Benedictine monks to raise their eyes from the plate while eating.

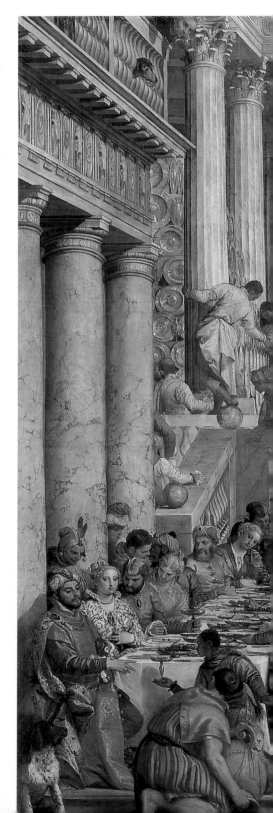

Paolo Caliari (Veronese): The Marriage at Cana, 1562/63

# The Lord sits at the table of lords

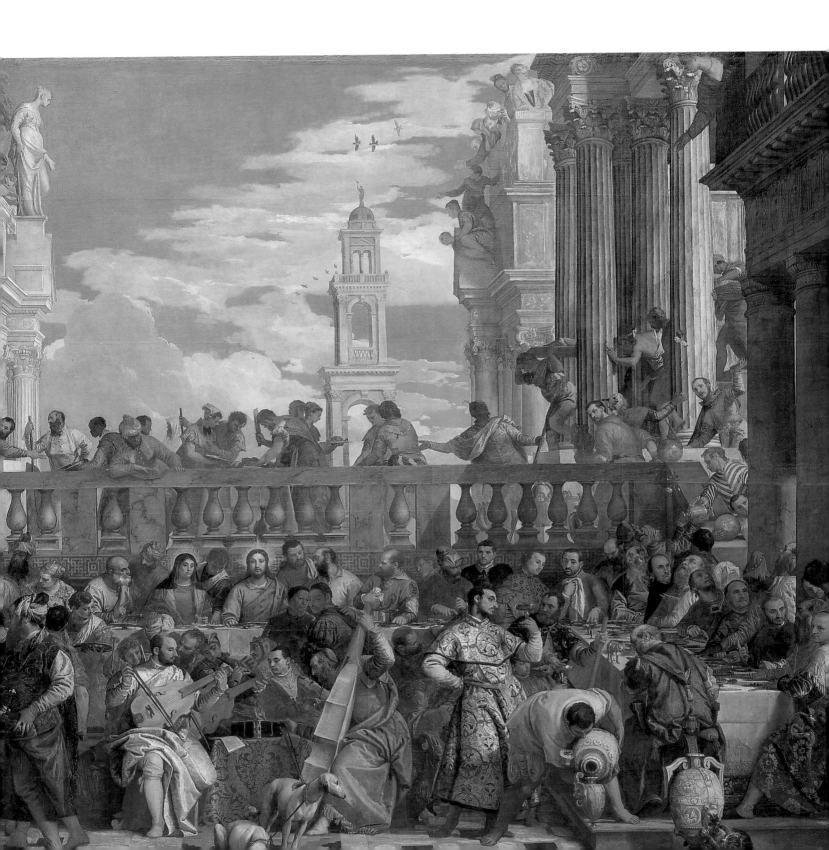

Large-scale canvases like *The Marriage at Cana* were only possible as the collective work of a studio. According to Veronese's sketches, his brother Benedetto Caliari, a nephew, and a host of nameless assistants and apprentices all worked in his *bottega* at the time.

Benedetto was responsible for the execution of architectonic aspects of the painting, and occasionally sat as model. His striking face with its characteristic Roman nose appears in many of Veronese's paintings. Here, Benedetto is portrayed as a Master of Ceremonies, raising a glass of wine to his expert eye.

## Enough wine, but hardly any water

This glass is the site of a biblical miracle – the changing of water into wine (St. John 2,1): "This beginning of miracles did

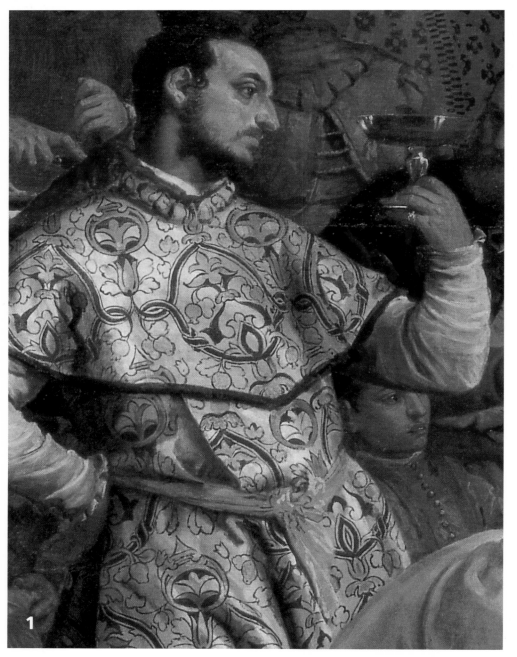

Jesus... and manifested forth his glory" at "a marriage in Cana of Galilee". There was no wine left, and "Jesus saith unto them, Fill the waterpots with water... Draw out now, and bear unto the governor of the feast... When the ruler of the feast had tasted the water that was made wine," he was astonished, asking the bridegroom why he had "kept the good wine until now".

Veronese's richly-clothed majordomo does not seem to be asking any questions, however, but to be examining the colour and taste of a wine, an everyday event for a Venetian connoisseur. Consumption of wine in the city in the lagoon was considerable, partly because of the shortage of drinking-water. The Venetian historian Marino Sanudo, writing in 1533, mentions this paradox: "Venice in the water has no water."[2] Although the senate occasionally looked at plans to bring water to Venice by aqueduct, the inhabitants had to make do with rain-water. Collected in a large number of marble cisterns distributed around the town, the water is reputed to have left an unpleasantly muddy, or sandy, aftertaste, so that the Venetians tended to prefer wine.

The biblical miracle of the changing of water into wine does not appear to have found many admirers among the guests of Veronese's *Marriage*. Instead, they seem fully preoccupied with food, music and each other. Certainly, Christ's figure is the focal point of both the banquet and the painting. The cruciate halo shines around his head, while the activity on the gallery immediately above his head is presumably intended to be ambivalent: servants are butchering meat, though they might equally be slaughtering a sacrificial lamb.

Nonetheless, the significance of the miracle goes unrecognised in the hubbub of the feast, and Jesus is only one of well over 100 figures. Worldly things seem to have displaced the spiritual dimension; the guests are more interested in present enjoyment than in the afterlife. This was hardly an unusual state of affairs in Venice at the time, and one that was frequently described. The Venetians were trying to "turn the world into a pleasure garden," wrote the German pilgrim Felix Faber after visiting Venice in 1480: "The Turks and other infidels who see these gleaming palaces say the Christians who built them cannot esteem the afterlife, nor can they expect to gain very much from it."[3]

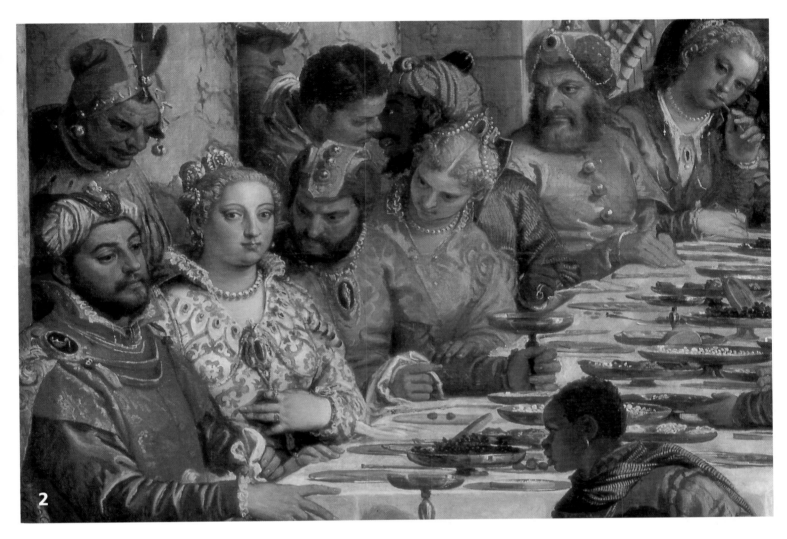

2

## Exotic splendour of the banquet

Goblets and bowls of finest glass, gold and silver sparkle on the damask table-cloth. The ambassador of the Republic of St. Mark to the Imperial City of Augsburg in 1510 expressed his astonishment that even the rulers of the Empire ate from earthenware dishes, whereas gold and silver dishes had been in widespread use in his own home town for some time. Even the toothpicks – a lady in the painting is shown raising one to her mouth – are said to have been made of gold. The guests at one noteworthy banquet, held in 1574 in honour of Henry III, were amazed and delighted when their Venetian hosts presented them with some highly inventive, and very costly decor: cutlery, crockery and table-cloths of pure spun sugar.

The government of the city, whose preferred tone was generally inclined to discretion and understatement, used state functions and feasts as a means of demon-

strating that Venice was still the richest and most luxurious city on earth. The more dubious Venice's role as a great power, the greater the need for such demonstrations became.

The patricians gathered around the festive table in the painting evidently still conceived of themselves as rulers of the waves. Almost all of them wear robes of rich and exotic materials. Their services to the Republic will have taken most of them to posts in the Levant as diplomats or colonial administrators. The Venetian Empire itself had included Istria and Dalmatia, and had extended to Constantinople. At its zenith in the beginning of the 15th century, it had held sway over the Adriatic and Aegean, over Crete and Cyprus. Eventually, however, it began to disintegrate. Bit by bit was lost to the Turks. At the same time, the discovery of a sea-route to India in about 1500 broke the Venetian trade monopoly on pepper and spices. By then, the Venetians were no longer in a position to redress such political and economic setbacks. Instead of pumping more and more money into ad-

venturous trading expeditions, as they had done in the past, they preferred the security of investment in property on the Italian mainland, leaving trade on the high seas to up-and-coming cities like Antwerp and Amsterdam. A Venetian visitor, Tommaso Contarini, saw "neither luxury nor pomp" in these cities, neither silver nor silk robes, noting that "these were unknown in our own town at the time of our forebears."[4]

Shortly before Veronese painted his *Marriage at Cana*, an especially sumptuous feast had been held to celebrate the coronation of the Venetian dogaressa Zilia Priuli on 19 September 1557. Following nine heads of state who were all bachelors, Doge Lorenzo Priuli had at last set a woman beside him on the throne. His reputation for meanness had made him particularly concerned on this occasion to display his magnificence. Perhaps the memory of the feast is reflected in Veronese's painting. According to one contemporary chronicler, nothing like it had been seen for over a hundred years.

**3**

## Veronese brings on the servants

The kitchens and other rooms where food was prepared were generally situated in a separate building or cellars, far from the banqueting-hall, or at least out of sight of guests and spectators. Kitchens and those who worked in them therefore rarely appeared in paintings.

Veronese broke with this convention. He painted a third level between the guests seated around the table in the foreground and the spectators looking down at the feast from their balconies in the background: a gallery, joined to the dining area by two staircases at either end, stretches across the entire painting. This is the site of bustling activity: several porters are carrying a roasted ox. A black boy waits on the left with a tray for the roast which a

bearded man is holding out between the columns. Those not carrying food or passing it on seem equally busy making sure that everything happens according to plan.

The Venetians ate an astonishing amount at their feasts. No fewer than 90 different foods would be served to 100 guests at a banquet lasting about four hours. The artist's unconventional look at the trivial world of servants was not to everyone's taste, however. Some years later in 1573, when Veronese had again painted a large-scale picture for the refectory wall of a Venetian monastery, he was summoned before the Inquisition. He was accused of having crowded a biblical scene, *The Last Supper,* with vulgar and irreverent figures such as servants, common mercenaries and even dogs. "If there is room in a painting, I decorate it as I see fit," Veronese answered. "I painted a cook, thinking to myself that he would probably have come out to have some fun and see what was going on."[5] Veronese was aquitted, but instructed to change the title of the painting. The Inquisition demanded it be altered to *A Feast in the House of Levi.*

In *The Marriage at Cana,* too, the servants have come out "to have some fun" and are seen taking part in the general hubbub on the servant's gallery, taking time off to watch the festive goings-on over the balustrade. Their exotic dress and dark faces under turbans and feather-caps identify them as the natives of Venice's traditional trading partners. Saracen, Tartar and Circassian slaves served in almost every household in Venice. In Veronese's day, slaves were readily available at the public auctions held in the Rialto market.

Attempts by Holy Roman emperors, popes, patriarchs and doges to forbid the slave trade in Venice had always ended in failure. It was simply too lucrative. Countless female slaves worked in Venice as wet-nurses and maids. Without their labour, and without the enormous sums of money gained by trafficking slaves, the Venetians' very pleasant, very lavish life-style would not have been possible.

It is said that Veronese portrayed many of the famous figures of his time, including Francis I of France (died 1547), among the roughly 150 guests depicted in the *Marriage at Cana.* However, we do not owe this notion to the testimony of his contemporaries, but to art historians of the 16th and 17th centuries. Equally unproven, though more enticing, is the art theorist A.H. Zanetti's contention in 1771 that the little orchestra in the middle of the painting was composed of the most well-known painters in Venice. "Titian is playing the double-bass," he wrote, describing the man on the right dressed in red. "Paolo portrayed himself as the figure in the white robe with the cello," he went on, and, of the musician sitting next to him: "It is correct to suppose that this is Jacopo Tintoretto."[6]

If this is true – and comparisons with other portraits appear to corroborate the claim – then the unchallenged masters of 16th-century Venetian painting, the three great colourists, were gathered here to

**Painters play
for the guests**

make music. All three received major state commissions and worked hard to decorate Venice's churches and government buildings with their paintings. Paolo Caliari was the youngest of the three, born in 1528 at Verona, the reason for his nickname Veronese. His first success at the city on the lagoon had come when he was commissioned to decorate St. Mark's library. Already an old man in 1557, Titian is said to have rewarded the artist by hanging a gold chain around his neck.

Tintoretto (1518–1594) was an eccentric who, during his lifetime, did not achieve such great public recognition as Titian (c. 1477–1576), who was knighted and celebrated as a "divino", one of the divine.

Perhaps the painters met at Titian's house. He possessed an organ, bartered from an organ-builder in return for the latter's portrait. Music was played there just as it was everywhere in Venice in the 16th century. Even in 1506, Dürer had written of the city-state that he had heard people playing violins so sweetly there that the players themselves had been moved to tears.

It is quite possible that the music played at Veronese's feast would have been by Andrea Gabrieli, the organist at St. Mark's and leading composer of his time. His melodies were heard at the time in the salons, theatres and on public squares. Gabrieli's

studies in the field of harmony must have fascinated painters and sculptors, too: "Just as vocal proportions are harmonious to the ear," explained the learned monk Francesco Giorgi in 1525, "so physical proportions are harmonious to the eye. Such harmonies provide the greatest of pleasure without anyone knowing why, except for One who understands the causal connections between all things."[7]

The search for these "causal connections", and for perfect harmonies of tone, proportion and colour, was taken up by composers, architects and painters alike. As a result, 16th-century Venice entered a period of unparalled flowering of music and the arts, at a time when the city was long past its political and economic heyday. This was made possible by the continued wealth of the city, together with the artistic sensibility of its ruling class. Unwilling to risk adventurous journeys on the high seas or to engage in pioneering trading expeditions as they once had, the patricians of the Republic of St. Mark had become a class of highly educated, hedonistic humanists who were fond of spending large sums of money on the arts. The Benedictine monks of San Giorgio, who had their refectory built by Palladio and painted by Paolo Veronese, and who wished to eat to the accompaniment at least of painted music, are themselves an excellent example.

The unfinished tower warns against arrogance before God. Bruegel set the biblical scene against a contemporary background. For many years, the artist had lived in Antwerp, the new financial capital of Europe. The city was experiencing a building boom. The painting (114 x 155 cm), a testimony to the fears that accompany modernisation, is in the Kunsthistorisches Museum, Vienna.

The Old Testament Book of Genesis describes how God created the earth, the animals, the plants and eventually also man. It is a story of disobedience and punishment, revolt and suppression. God punishes man three times. The first punishment is the expulsion from Paradise of Adam and Eve after they have eaten from the tree of knowledge of good and evil. They lose eternal life in a world without work or need.

But God is also unhappy with the behaviour of their children and children's children: "God saw that the wickedness of man was great in the earth… And the Lord said, I will destroy man whom I have created from the face of the earth", and not only man, but the beasts, too. Only Noah finds grace in the eyes of the Lord. God commands him to build an ark in which to rescue himself, his wife, and two of every sort of living thing. God then destroys all other living substance by means of a great flood. When the flood abates, Noah prepares a burnt offering. God smells "a sweet savour" and decides not to destroy man again: "Neither will I again smite any more every thing living, as I have done."

But he certainly made life difficult when he thought man deserved another punishment. For in the meantime, Noah's descendants had decided as follows: "Let us build us a city and a tower, whose top may reach unto heaven; and let us make us a name, lest we be scattered abroad upon the face of the whole earth."[1]

Now, building a tower as a means of self-orientation and as a symbol of community was one thing; building one that reached into heaven was quite another. It was not the sort of challenge God could easily put up with!

Instead of killing them, he took from them their common language. They could no longer understand one another's speech and were scattered over all the earth. Their city and tower remained unfinished. The name of the city was Babel, like the Hebrew verb "balal", meaning "to confound".

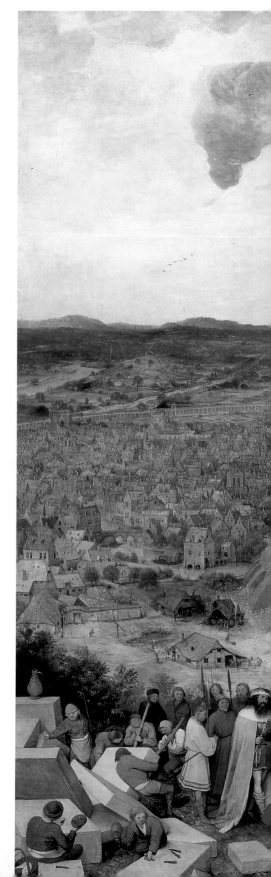

# The Antwerp building boom

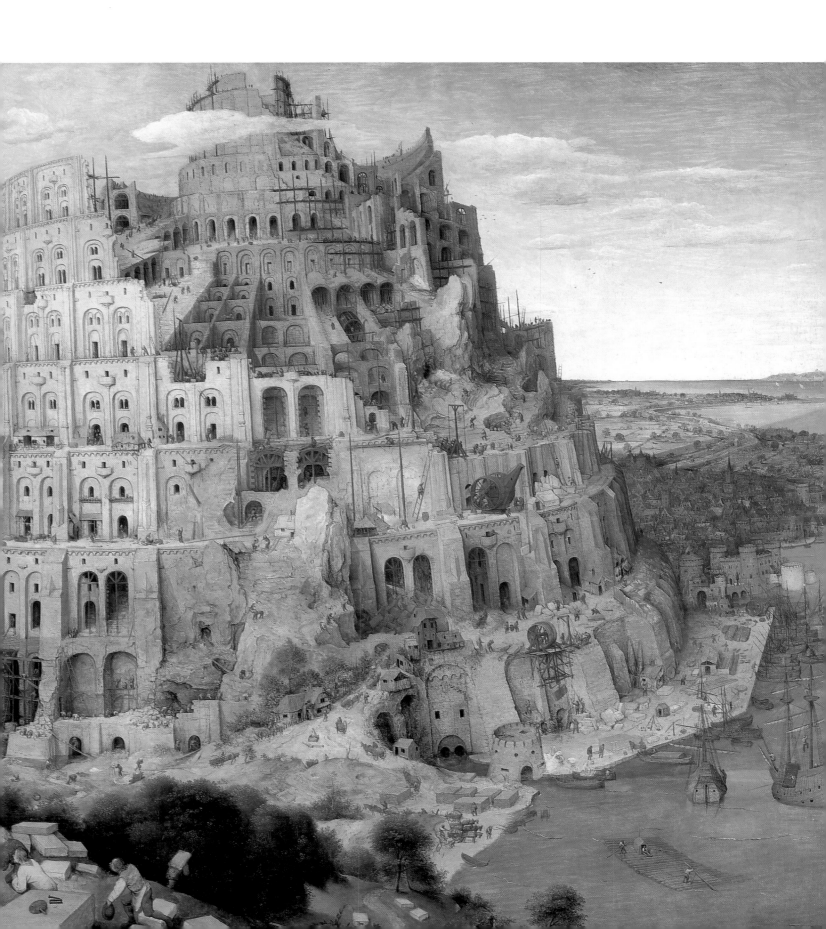

Two paintings of the Tower of Babel by Pieter Bruegel the Elder have survived, while a third, a small one on ivory, is lost. The theme must have interested him greatly. There are no records to tell us what led the painter to this subject, but life in the town where he worked for at least a decade must have constantly reminded him of Babel.

The town was Antwerp: few other cities were forced to accommodate such an inflow of people and so gigantic a building boom in such a short period of time. There were only two or three cities with over 100,000 inhabitants in 16th-century Europe; Antwerp became one of them. The Italian Ludovico Guicciardini's description of Antwerp in 1566 contains the following comment: "Today there are already about thirteen thousand, five hundred houses in Antwerp." If building work continued unabated, Antwerp would soon be considered "one of the most crowded towns in Europe".[2]

## The most crowded town in Europe

The main reason for the boom which changed a small port into the "most crowded town in Europe" was the reorientation of world trade following the discovery of sea-routes around the Cape to Asia and across the Atlantic to America. As a result, Venice and Genoa lost their leading positions, while ports on the west coast of Europe gained in significance. The Netherlands were favourably placed not only for transatlantic trade, but for traffic between the north and south, for imports of spices from the Orient, and for reloading wood and cereals from the Baltic. In the course of the 16th century Antwerp advanced to become the centre of Western European trade.

Foreign trade naturally brought a great babel of languages to Antwerp – and not merely to the immediate vicinity of its harbour, or to the public houses frequented by sailors. Foreign trading companies sent representatives to establish branch offices in the city. There were Italians, French and English merchants, traders from the Hansa towns and, most numerous of all, the Portuguese. In 1570, the Portuguese community included 102 households.

Foreigners were enticed to Antwerp with various privileges, but they were also treated with suspicion by the town's inhabitants. Though hardly very many in percentage terms, they were conspicuous: they spoke different languages, wore different clothes, had different customs. The majority of people at the time lived in small towns with stable populations, in which everybody knew everybody else. A town growing as fast as Antwerp, with new faces coming in all the time, was unusual enough, and an influx of people who also spoke different languages must have added to the confusion. The population of Antwerp probably experienced something similar to the inhabitants of Babel: a growing, tightly-knit family of man disintegrating into separate groups.

There was a similar development in Antwerp – and not only there – in the field of religion. For centuries, the Roman Catholic Church had succeeded in preventing attempts at secession and eliminating sects. Its unity was not destroyed until the Reformation, when not only Luther, Calvin and Zwingli, but also the Anabaptists and a host of other, since long-forgotten sects, established reformed Christian Churches. In 1563, the year in which he painted his *Tower of Babel*, Bruegel left Antwerp for Brussels. It has been suggested that one of his reasons for doing so was to escape the grips of a sect called the Schola Caritatis.

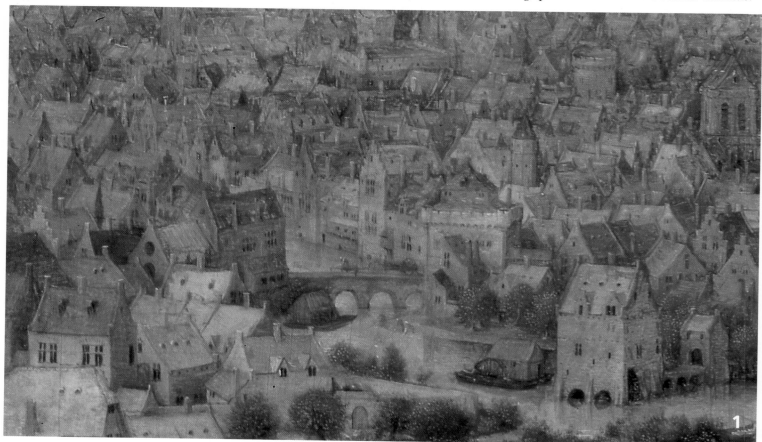

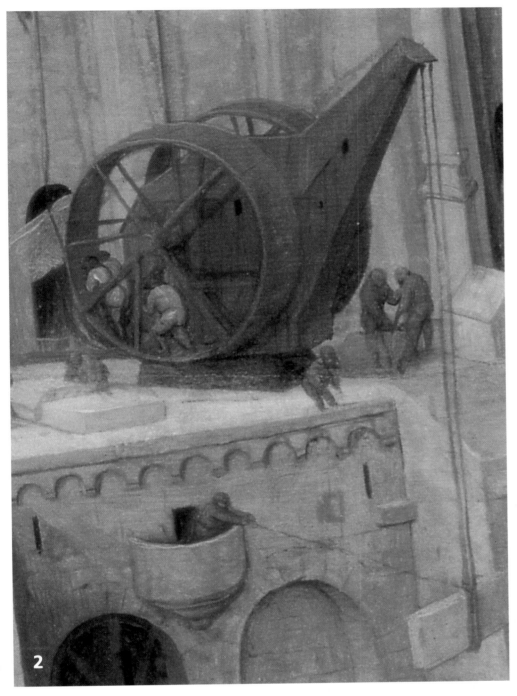

2

## Experience instead of textbooks

**B**ruegel has painted an enormous crane on one of the ledges of the tower. There are three men in the tread-wheel attached to the near side of the crane, and presumably three others in the drum at the far side. This enabled the builders to lift weights many times heavier than themselves. In this case, they are lifting a stone that has already been cut to shape. A man on a balcony is trying with a rope to prevent the stone from banging against a buttress.

A crane of this type is said to have stood in the market-place at Antwerp to help with the handling of goods. On the ledge below it, Bruegel shows a different, smaller kind of treadwheel crane; he also paints several winches. His technical drawing was very precise; perhaps this explains why he was commissioned to depict the building of the Antwerp-Brussels canal. His death in 1569 prevented him from executing this work.

Transport of materials on the building site was done by low-paid labourers. The stonemasons came at the top of the hierar-chy of building workers; Bruegel paints them at work in the foreground, cutting stones to size. Usually, this was not done on the site itself, but at the quarry. Long-distance transport was expensive; superfluous stone meant higher freight costs. At the same time, it was cheaper to carry materials by boat than to have them transported overland on an ox-drawn cart. Bruegel's decision to show building work in progress by the sea is not, therefore, merely reminiscent of the position of Antwerp as a coastal town, it is also a correct observation of economic reality.

Scaffolding on high buildings presented a particular problem. Only wood could be used. The wooden bars and planks were bound together, but they could not be made as high as the wall of a cathedral. The masons therefore had to attach the scaffolding to the wall as they built it. Bruegel has avoided this problem by painting his imaginary tower with ledges which served as ground-level supports for work on superior levels. His arrangement of the inner passageways, arches and steps is vaguely reminiscent of the Colosseum and Castel Sant'Angelo at Rome, sites which Bruegel had actually visited.

On the ledges spiralling to the top of the building are a number of huts. This is also concordant with contemporary building practice: each guild had its own hut, or lodge, built as close as possible to the building site. Here the builders took meals and kept their tools. The lodge was also the masons' winter workshop.

These huts were often surrounded with a great aura of mystery, an aura later transferred to the lodges of the freemasons. In fact, there was nothing more mysterious about them than the specialised knowledge of the master builders who convened there. There were no textbooks in those days, no written instructions; building knowledge was imparted orally from one generation to the next.

As far as we know, the mathematics of statics was still in its infancy. The enormous cathedrals of the day were built not on the basis of cleverly worked out calculations, but on tradition and experience. More than one of God's houses collapsed, like the cathedral at Beauvais; or remained unfinished, like Siena. Architecture had not yet become a fully-fledged profession. Usually, it was the master mason who directed the work on site.

It is said that the order to build the Tower of Babel was given by King Nimrod, a grandson of Noah and the first mighty ruler in the post-diluvian history of mankind. Bruegel depicts him here with sceptre and crown, and the masons before him on bended knee.

At least one of the masons has gone down on both knees, an unusual form of reverence in 16th-century Europe, at least outside the Church. Of course, anyone who wished to present something to

## The gods descend from heaven

Charles V or Philip II, the Spanish Emperors, was required to kneel, but only on one knee. Here, Bruegel demonstrates an Oriental custom.

Archaeologists have proved that the story of Nimrod's tower is based on a real precedent in ancient Sumerian culture, whose civilisation reached its zenith in the 4th and 3rd centuries B.C. It is thought that the Sumerians migrated from the mountians to the Mesopotamian plains and wished to take their gods with them. So that the gods would be more inclined to descend from the heavens to the plains, the Sumerians built mountain-like temples for them. The tower was essentially a later development of the high temple.

Alternatively, it has been suggested that the Sumerians thought the home of the gods was a mountain between heaven and earth; their tall temples were therefore imitations of the heavenly mountain, and were built in praise of the gods.

The ancient Akkadians and Assyrians inherited the celestial mountains from the Sumerians. Every town is thought to have had its own. Babylon – or Babel, as it was called in Hebrew – presumably had the greatest of all. Archaeologists discovered its foundations at the beginning of the twentieth century. It was square, and had sides that were 91 metres long. According to ancient scrolls, it had seven floors, each smaller than the one below it, and was about 90 metres high. The Greek writer Herodotus saw the tower (or rather, a later version of it) in 458 B.C. However, it was already a ruin during Alexander the Great's visit to Babylon some 130 years later.

The building also found its way into the Christian tradition. The oldest surviving illustrations of the Tower of Babel emphasise that the wrath of God was directed against the hubris of those who dared think in such dimensions. God is shown destroying the tower – an event that is not described in the Bible – or scattering its builders over the face of the earth. A mosaic, dating from about 1220, in St. Mark's cathedral in Venice shows two towers. While work is shown still in progress on one of them, the other is already deserted; angels in the sky around it are shown scattering people in every direction.

Whether in mosaics, Bible-illustrations or the illustrated Books of Hours of the 14th and 15th century, the tower is never particularly huge by comparison with the people around it: it is rarely more than three times the size of the builders. The reasons for this are less ideological than practical. If the artists had attempted to make the building appear gigantic by letting it fill the entire space of the work, they would have had to make the human figures tiny by comparison. In practice, however, the figures would then have been too small to depict with mosaic stones, or in miniatures. The situation changed with the advent of panel-painting and, more especially, with the flourishing of 16th-century Netherlandish painting: during Bruegel's lifetime, and in the decades immediately after his death, the theme found its most widespread treatment.

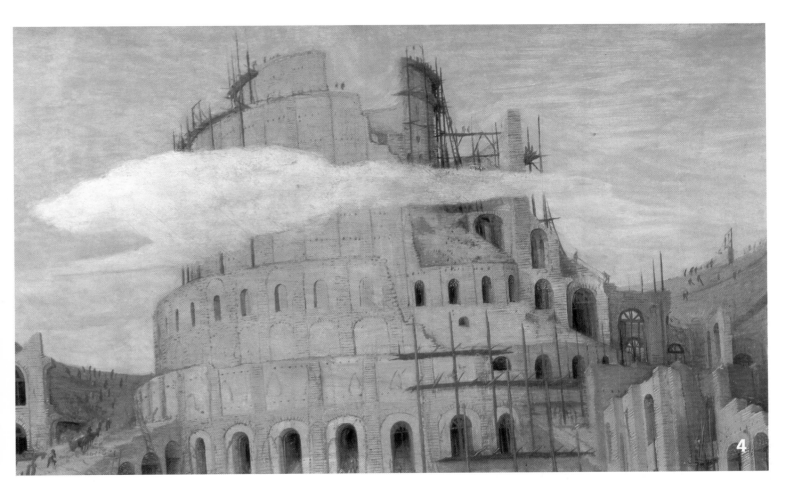

4

## A warning to the mighty

Painting the Tower of Babel became little short of a fashion in the 16th and 17th centuries. This was not merely due to the obvious parallel of Antwerp's rise to international fame, or to the spectacle of Christendom divided by the Reformation; it was also the attraction of painting imaginary architecture in realistic detail, depicting famous biblical edifices as if they were really situated in western Europe: in a Netherlandish port, for example. Realism of this kind was a comparatively new phenomenon and contrasted sharply with the previously dominant Christian world-view.

The work of a German Jesuit, Athanasius Kircher, who attempted to draw up exact calculations for a tower as high as the moon, serves as an illustration of the ex-

tremes to which realism could be taken some 100 years after Bruegel's death. Kircher worked out that the building of such a tower would require so much material that the Earth itself would be thrown off balance and dragged from its position at the centre of the cosmos.

Despite its "secularisation", the theme retained its moral force. The less familiar motifs in Bruegel's painting emphasise its message. The artist's contemporaries would have recognised everything they saw in it from their own environment, with two exceptions: the tower piercing the clouds and the mason's Oriental gesture of homage to the king. By contrast with other motifs in the painting – landscape, coast, ships, town, builders, construction technique – these point directly to hubris, vainglory and megalomania.

Bruegel also painted other warnings against hubris: fallen angels, the fall of Icarus, the death of King Saul. Few of these themes appear in his graphic work, however. His drawings were moderately priced, his paintings expensive – his warnings must therefore have been directed primarily at the ruling class. Among the representatives of this class were rich mer-

chants such as Nicolaes Jonghelinck, who is known to have offered his collection of paintings, including many Bruegels, as security against a loan of 16,000 guilders; or representatives of the Spanish government, such as the powerful Cardinal Granvella, who also owned a number of Bruegels. Apparently, the painter considered those with money and power especially vulnerable to hubris.

There may have been a further, quite specific reason for Bruegel to have painted the Tower of Babel in 1563. He had perhaps heard of yet another massive building project, begun in Spain the very year in which his painting was executed: the Escorial, an enormous, palatial monastery near Madrid. Philip II's motives for building it may have been extremely pious, but his Escorial was also a demonstration of power. Even if Philip could not be accused of throwing down the gauntlet to God, as Nimrod had done, his ideas were a challenge to humanity, and to the Netherlanders in particular, many of whom did not wish to be Catholics. Even if the Escorial itself has survived the passage of centuries, it was under Philip that the power of Imperial Spain began to crumble.

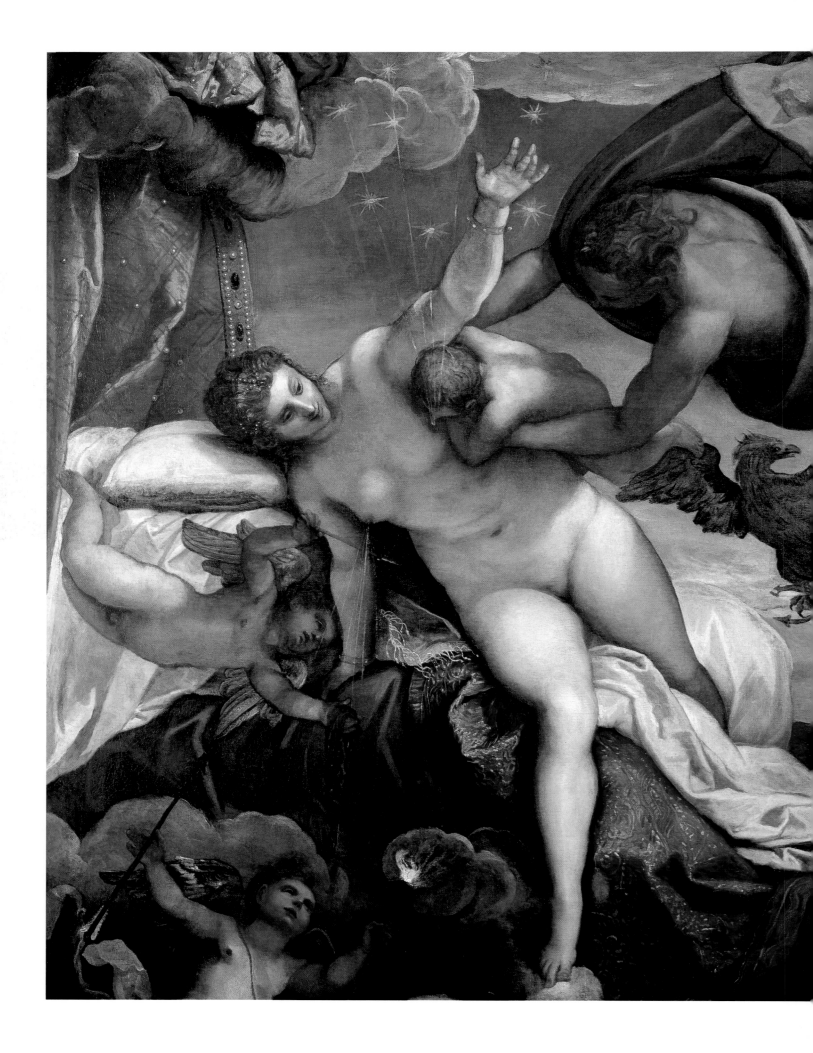

# Aspirations to immortality

Jupiter, father of the gods, is known to have loved a number of mortal women. One of these was Alcmene, with whom he begot Hercules. Taking advantage of his wife Juno's slumber, he held the baby boy to her breast, thus letting him drink the milk of immortality. The goddess started up in surprise, sprinkling milk into the firmament. The drops of milk immediately turned into stars. This explanation for the origin of the the Milky Way was given in the first century B.C. by Gaius Julius Hygienus, librarian to Caesar Augustus. Here, the Venetian Jacopo Robusti, known as Tintoretto, an artist of highly refined dramatic sensibilty, has painted the climax of the story, the moment of surprise. Lying on her heavenly bed of clouds, nude Juno starts up from sleep. A skilfully foreshortened Jupiter sweeps down towards her, baby on his arm. Putti and birds surround the two main figures.

Tintoretto's work normally shows angels or saints. He earned his reputation in Venice as a specialist in Christian miracles, rendering spectacular episodes from the Bible in large format. Erotic scenes from pagan mythology rarely feature in his paintings. Tintoretto was swamped with official commissions when – between 1578 and 1580 – he painted the (undated) Milky Way. Although he could not have met the great public demand for his work without the help of his busy studio, it has been established, not only that the Milky Way is from Tintoretto's hand, but that he actually painted it twice.

When the London National Gallery restored the 148 by 165 cm oil-painting in 1972, X-rays revealed that a first version of the work had been carefully painted over. The original version was a treatment of the same subject. However, it was executed in a much less sophisticated manner, in the "rapid and resolute"[1] style so characteristic of Tintoretto's work. Art historians have

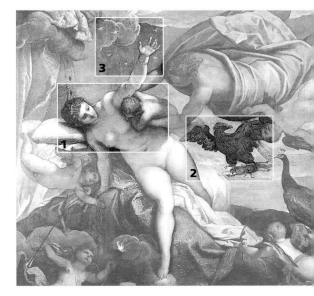

suggested that the potential owner of the Milky Way changed before work on the painting reached completion. The new owner was not just anybody, but a personage entitled to demand the highest standards: Emperor Rudolf II, who had decided to go about establishing a new collection of art.

The painting is not mentioned in an (unreliable) inventory of the collection, compiled during the emperor's lifetime. However, an Italian pamphlet, dated 1648, mentions that Tintoretto executed "four paintings of fables" for the emperor, among them "Jupiter holding a little Bacchus to Juno's breast".[2]

If we assume that the writer has mistaken Hercules for Bacchus, then the Milky Way probably hung in the Imperial Palace at Prague – although not for very long. For in 1648, shortly before the end of the Thirty Years' War, Prague was taken by the Swedes, whose soldiers looted Rudolf's collection of paintings, taking many away with them when they left Bohemia. In the confusion, about a third of the Milky Way canvas was lost.

## An ambitious doctor

The original appearance of Tintoretto's painting can be ascertained from a sketch, now kept in the Kupferstichkabinett at Berlin, executed in Prague by the imperial court painter Jakob Hoefnagel. In the sketch, there is a second female nude below the Olympian scene: probably Jupiter's mistress Alcmene, she is lying among long-stalked lilies, which, according to a later version of the legend, are supposed to have sprung from drops of Juno's milk which fell to Earth.

This version of the Milky Way legend was published in Venice in a Byzantine tract on botany in 1538, several decades before Tintoretto started work. It was perhaps here that he found the extravagant, and extremely rare iconography of his painting. In any case, there was one person known to the painter who was certainly acquainted with the theme: a medal struck in 1562 in honour of Doctor Tomaso Rangone showed Hercules at Juno's breast, as well as stars and lilies. As documented in a series of receipts, this Venetian doctor commissioned, and paid for, a series of paintings from Tintoretto in honour of St. Mark.

Born at Ravenna as Tomaso Gianotti, he had managed to rise from a poor background, take a doctor's degree and, probably through adoption, acquire the respected Venetian family name Rangone. Perhaps it was due to the reputation of the Milky Way legend as mythology's first example of an adoption, albeit an involuntary one, that Rangone chose it as a motif for his medal and coat-of-arms.

Juno sent two snakes to kill her "adopted" infant, but Hercules, by then already immortal, strangled them. Doctor Rangone also offered his patients a first step to immortality, selling them expensive "magic potions" which, so he promised, would help them live to at least 120 years old. He became immensely rich in the process. Besides medicine, he had studied physics and astronomy, and, clever charlatan that he was, operated a successful business, exploiting the widespread inability of his customers to distinguish between science and magic.

In order to ensure his own survival, however, Rangone put his trust in art. A spirited patron of the arts, he succeeded in having his bust mounted between a celestial sphere and a globe on a Venetian church facade for which he had donated the money, despite the fact that this form of immortality was officially reserved for nobles and persons born in Venice. Rangone also appears several times in Tintoretto's sequence of paintings on the life of St. Mark. Here, he is shown as a life-sized figure with a central role in the depicted events – much to the displeasure of the public, who demanded that Tintoretto remove the Rangone portraits. However, his striking head has remained a characteristic feature of the paintings to this day. The doctor, vain as he may have been, has achieved his aim!

It was for Rangone that Tintoretto probably painted the first, "rapid" version of the *Milky Way*. When the doctor died in 1577, the artist found a new buyer: Emperor Rudolf II, who had been crowned in 1576. However different the Venetian charlatan and the Habsburg emperor may have been in background and social standing, they did have one thing in common: both of them used alchemy, astrology and art in their attempts to fulfil their aspirations to immortality.

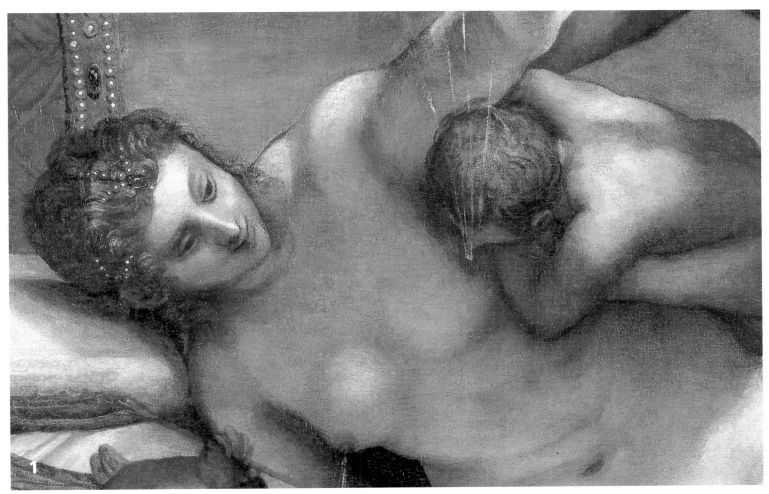

## Art for the sovereign

The Hercules legend was exactly suited to Emperor Rudolf's taste, for the ancient hero was already part of the Habsburg family tradition. At the beginning of the 16th century, Rudolf's predecessor Maximilian I had had himself celebrated as "Hercules Germanicus". A demigod who had strangled the Nemean lion, exterminated the many-headed hydra and cleaned out the stables of Augeas provided the ideal model for any temporal ruler. Rudolf, too, liked to have himself portrayed wearing a lion's skin and carrying a club, both attributes of Hercules. This was an indication of the emperor's political aims, showing him committed to following the example of his ancient model by protecting his subjects and securing peace and order in the Empire.

However, Rudolf II found it exceedingly hard to keep his promise. Born in 1552 as the son of Maximilian II, crowned Emperor of the Holy Roman Empire at the age of 24, he inherited an empire that was deeply divided, and threatened by the Turks from without. Ruling was made difficult for him by religious conflicts, regional disputes and Habsburg family feuds. During his lifetime, however, he managed to maintain an unstable balance of power. It was not until after his death that the Thirty Years' War broke out.

The vigorous man of action chosen by the ruler to symbolise his power was not in the least like Rudolf as a person. In 1583, he gave up Vienna and retreated to Prague. As a depressive "eccentric in the imperial palace", he did his best to ward off the demands made on him by a chaotic environment. He relaxed from the unpleasant business of ruling by collecting precious objects and works of art. "Whoever wishes to see something new," wrote Karel van Mander, a contemporary biograher of artists, "must seek an opportunity to visit Prague and the greatest living admirer of the art of painting, the Holy Roman Emperor Rudolf II, in his imperial residence."[3]

Tintoretto's completion of the *Milky Way* and Rangone's death in the 1670s were concurrent with Rudolf's decision to collect paintings in earnest. He was especially interested in works by Dürer. Following a extensive correspondence with the town coucil of Nuremberg, he was able to purchase Dürer's *All Saints' Altarpiece* in 1585. Rudolf also had a penchant for the Venetian colourists and, over a number of years, bought many works by Titian and Tintoretto. Several works were officially presented to the emperor as gifts by the Venetian Republic; others he bought through his ambassador, or under the guidance of official advisers such as the Mantuan Ottavio Strada, official "antiquary" to the imperial collection.

Ottavio Strada himself sat for Tintoretto in Venice in 1569. It is quite possible that he bought the *Milky Way* for his master ten years later, together with three other works showing the amorous adventures of Hercules. After all, it was not only the subject of these paintings that was suited to Rudolf's taste, but also their erotic qualities; although he steadfastly refused to marry and provide an heir for his throne, Rudolf was much given to "visual enjoyment".

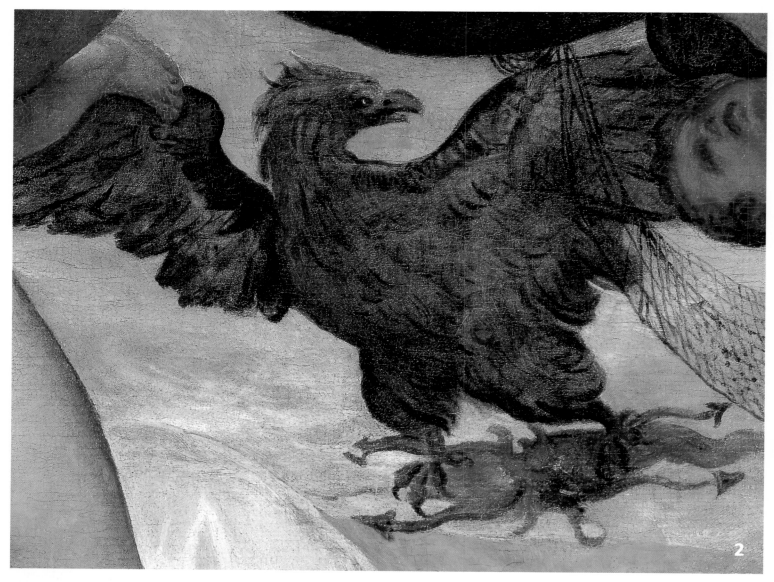

2

## Fascination of the enigma

A work of art was not only there to provide sensuous or aesthetic pleasure, however. To please the emperor it needed an aura of mystery, a hidden meaning which only the initiate could decipher. An élitist predilection for coded messages and arcane reference in art and literature was not unusual at the time. But it was cultivated particularly intensively by the imperial court at Prague, where the emperor, according to one of his contemporaries, "despised common life and loved only what was extraordinary and marvellous".[4]

In the course of his duties, the "antiquary" Ottavio Strada evidently advised the artists in some detail concerning their choice of subject and development of various artistic projects for the emperor. The imperial preference was for "mythologies" which, like the *Milky Way*, intimated to the spectator that the cosmos and human psyche were interrelated at some deep and hidden level.

At first glance, Tintoretto's painting seems easy enough to read; its different elements are derived from a relatively well-known repertoire. Two of the putti playfully circling around the Olympian figures carry erotic symbols: Cupid's bow and arrow and the flaming torch of passion (of Jupiter for Alcmene). The other two bear the chains of marriage (between Jupiter and Juno) and the net of illusion (whose powers so often came to Jupiter's aid). Juno's traditional pair of peacocks are seen at her feet.

Jupiter's eagle accompanies the king of the gods, a figure with whom the Habsburgs were no less inclined to identify than with Hercules, and whose bird they had long included in their coat-of-arms.

The creature held in the talons of Jupiter's eagle provides some grounds for speculation, however. Are its arrow-shaped extremities intended to suggest an embodiment of lightening, Jupiter's tradi-

tional weapon? Or does it represent a crab? Cancer was the sign of the zodiac under which Emperor Rudolf had been born on 18 July 1552. The arrangement of figures would seem to confirm this thesis: Cancer comes between Aquarius, represented in the painting by the putto with the net, and Sagittarius, whose incarnation here is the putto with the bow.

It is possible that Tintoretto has integrated into the painting's iconography details of a horoscope cast for Rudolf II by the famous French astrologer Nostradamus. It is said to have been none too favourable – a veritable disaster for a sovereign whose belief in the influence of the stars on human fate was no less powerful than that of his subjects. He was, for example, quite unable to make a decision without consulting his astrologers, and persons seeking his audience had first to be vetted by having their horoscope cast. In the hope of escaping his ruinous destiny and influencing by magic a reality he could not change, the emperor later decided to move his date of birth so that it fell under the more favourable influence of Taurus, a sign under which the Roman Caesar Augustus was thought to have been born. However, the ruse does not seem to have helped Rudolf much. Lonely, stripped of his power, he died in 1612 in his castle at Prague.

## Reaching out to the universe

**B**ut Rudolf was also a devotee of yet another occult science: alchemy. He would spend nights on end in his laboratory, bent over a glass flask in which mysterious substances bubbled over a fire. This met with disapproval in a report sent to Florence by the Tuscan ambassador: the emperor, he wrote, "neglects his duties of state in order to spend time in the laboratories of alchemists and the studios of artists."[5] The ruler, like so many of his contemporaries, was searching for the "philosopher's stone", which not only was a means of transforming base metal into gold, but could make its owner immortal.

Tintoretto's painting, in which everything circles around the subject of immortality, can be interpreted as a study in alchemy. It contains, for example, a number of symbols reminiscent of the vivid language of the "cognoscenti": the *prima materia* which they attempted, in long and difficult operations, to transmute, had first to be bathed in a mysterious substance called "Virgin's milk", also known as *succus lunariae* or "moon-juice". In the course of this process, the more earthy part of the prime material, the "toad", was united with the ethereal element, the "eagle". The arrows held by the putti were symbols of the alchemist's knowledge; they frequently decorate Rudolf's portraits and emblems. The *Milky Way* is so full of references to alchemy that one is inclined to suspect that those in Venice who referred to Tintoretto, the painter of so many devotional works, as a "necromancer", or sorcerer, did so with some justification.

The original patron of the work, Doctor Rangone, would naturally be acquainted with alchemy, too, as would most of the imperial physicians. Scientists and charlatans of different kinds made their way to Prague in large numbers at that time. Once there, they were safe from persecution by a Church that was determined to prevent the questioning of received dogma. The emperor's protection allowed them to explore nature and investigate its causal sequences. Most of them were searching for the *harmonia mundi*, the correspondence between the human microcosm and divine macrocosm, or universe with its stars and planets. They did so partly by occult means – and prepared the way for modern science.

Two mathematicians, both court astronomers to Rudolf, were largely responsible for the "disenchantment of the universe". The first, the Dane Tycho Brahe, had magic potions sold under his name, but he also set up an observatory near Prague and determined the position of 777 stars. His successor, the German Johannes Kepler, who cast horoscopes and wrote a "Warning to the opponents of astrology", made an important discovery in 1605: "The heavenly machine is more like a clock than a divine being."[6] This turned the traditional view of the universe on its head. It was in Prague, too, that Kepler evolved a theory of the astronomical telescope, an instrument which would, at last, enable scientists to explore the distant Milky Way. Hitherto, all explanation of this heavenly body had been limited to the type of conjecture made by the ancient Greeks, or it had taken the form of a mythological account of its origins.

Rudolf II's patronage of the sciences and arts won him everlasting fame. "The imperial star shines" was a hopeful motto thought up for him by Ottavio Strada: "Astrum fulget Caesareum".

3

The lovely Jewish widow Judith, who beheaded an Assyrian leader because he had threatened the lives of her people, was held up as a shining example by religious fanatics. Caravaggio's subject was highly topical at the time of the Counter-Reformation. Today, the painting (145 x 195 cm) is in the Roman Galleria Nazionale d'Arte Antica.

"Now when Holofernes was stretched out on his bed, and was drunk and asleep… Judith stood weeping at his bedside and said in her heart, O Lord, God of Israel, give me strength and look in this hour upon the work of my hands… She… took his sword… and held him fast by the hair of his head and prayed again… Then she struck his neck twice with all her might and smote off his head… Soon afterward she went out and gave Holofernes' head to her maid, who placed it in her food bag."[1]

This account is taken from the Book of Judith. It recounts an incident in the history of the Jews, but since the original manuscript is lost and the text itself is difficult to date, the Book of Judith is considered apocryphal (not accepted as canonical) by Jews and Protestants. It was, however, included in St. Jerome's Latin translation of the Scriptures, the Vulgate. Caravaggio's painting of the scene, executed in 1599, follows the biblical version, except that the maid does not wait outside but is painted alongside her mistress – her wrinkled skin offering the artist a welcome contrast to the peachy skin of his heroine.

The "very comely" and rich widow Judith, "of whom nobody could say ill", had put off her mourning clothes, dressed herself in her finest garments and entered the enemy camp in order to rescue her people. The Assyrian army, led by Holofernes, stood in arms before the city of Bethulia. The Jews had lost heart, were on the point of giving up, and yet this woman set out on her own to seduce the enemy. After her bloody deed, the enemy soldiers fled in panic; Israel was saved and Judith returned "unsullied by sin" from the libertine's tent.

"Thou art the glory of Jerusalem, thou art the great boast of Israel, thou art the great pride of our nation." Such were the high priest's words of praise for the heroine. "Exalted thou art in the eyes of the Lord for ever and ever! And all the people said Amen."

This episode has featured in the work of many artists throughout the centuries, many of whom may have been less attracted by the political and religious implications of the tyrannicide than by the violent eroticism which lends the biblical murder story its great narrative tension.

# Tyrannicide by tender hand

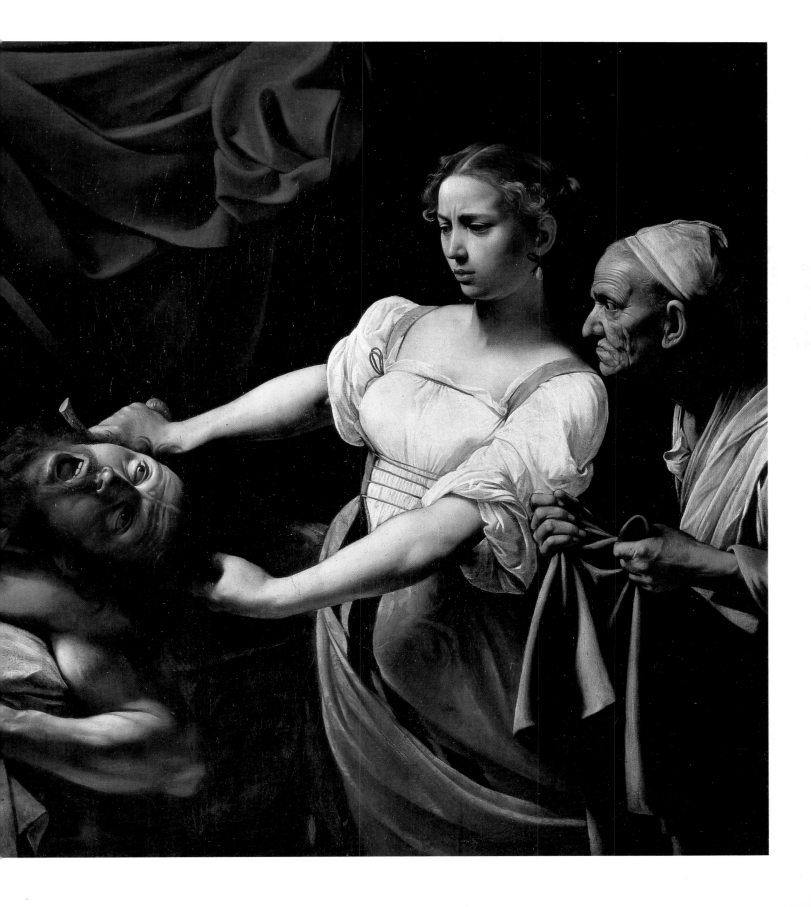

olofernes had to die because he had attempted to force the Jews to worship the Assyrian king Nebuchadnezzar instead of Jehova. He was a gentile, and Judith's fatal blow was dealt for the greater glory of her – only true – God. This made her deed highly topical when Caravaggio painted the picture in Rome at the end of the 16th century.

The struggle to repress heresy by whatever means possible, including fire and the sword, was the central preoccupation in the capital of the Papal States. It was the time of the Counter-Reformation. The Catholic Church was attempting to recover those dominions that it had lost during the first half of the 16th century. England and Sweden, and parts of the Netherlands, France and Germany, had followed Luther, Calvin or Zwingli. They no longer accepted the authority of the Pope and refused to pay taxes to Rome.

## A blow against the Protestants

It had taken some time before the Catholic Church and loyalist states (Spain, Italy, Poland and the heartlands of the Habsburg Empire) were capable of taking up the counter-offensive. The Council of Trent had met repeatedly between 1545 and 1563 before finally reaching a consensus on reforms: the removal of the worst forms of abuse leading to the schism, and the establishment of strict rules of faith. The assembled representatives of the Church thus succeeded in laying down the foundations of spiritual renewal, while turning the Church itself into a force to be reckoned with. The hierarchy was tightened up, the Pope's authority strengthened and the organisation of the Church in Rome was centralised. Several religious orders grew in power and influence, particularly the Jesuits, who, as defenders of the faith, were organised along military lines and set to work to convert the heretics – or exterminate them.

The most spectacular example of the persecution of heretics was the St. Bartholomew Massacre of thousands of Huguenots on 23/24 August 1572. But at a time when the faith of monarchs automatically determined that of their subjects, it seemed a far more practical business to strike a blow against the Protestant rulers themselves. Thus Pope Gregory XIII publically

denounced Elizabeth I of England as "the cause of so much damage to the Catholic faith and of the loss of millions of souls"; he could see "no doubt, but that he who dispatches her from this world with the holy intention of serving God commits no sin, but is deserving of reward".[2]

At the dawning of the age of absolutism and the divine right of kings, the authority of the royal sovereign was officially unquestionable; if a monarch left the one true faith, however, he was declared a usurper and an outlaw. This was Catholic doctrine in 1600; proclaimed from the pulpit and broadcast by countless pamphlets, it encouraged all kinds of fanatics and madmen who heard voices and thought they were heeding the call of God to take up daggers and firearms.

While Elizabeth I managed to escape countless assassination attempts, finally dying in her bed in 1603, William I of Orange, Stadtholder of Holland, Zealand and Utrecht, was shot in 1584, and Henry IV of France, who had survived a dozen attempts on his life and had even returned to the bosom of the Church in 1593, was stabbed to death by a religious fanatic. Judith was held up as a shining example by many fanatics: in contemporary pamphlets calling for the murder of heretics, Judith was celebrated as a paragon of virtue.

1

# A chaste heroine

Judith's features betray neither triumph nor passion, but determination and disgust. She slays the defenceless man without using force, keeping as great a distance as possible between her victim and herself. Nor does this demure heroine appear in a magnificent Baroque gown, like the Judith painted by Christofano Allori just a few years later, but in the best clothes of a woman of the people. Perhaps Caravaggio's model was a woman called Lena who is thought to have been his mistress and, according to a police report of 1605, was usually found "loitering at the Piazza Navona", which was tantamount to saying that she worked as a prostitute.

Travellers to Rome around 1600 generally found the large number of prostitutes worthy of comment: there were many unmarried men among the masses of pilgrims and Church servants who came to the Catholic capital. There were more than a million visitors to the Eternal City during the Holy Year of 1600. The innkeepers and tailors also did a good trade, the latter providing sumptuous robes for ecclesiastical dignitaries. Otherwise, there was neither trade nor industry in Rome; the majority of the city's inhabitants lived in poverty and were dependent on the charity of the Church.

It was at this time, too, that Rome, following its destruction by mercenaries in 1527, was being rebuilt – despite the greatly reduced income of the See – to the magnificent city we know today. The building boom was a product of the Counter-Reformation: it was intended that the capital city of the the Catholic faith should shine out for all to see and that its spiritual hegemony in the world be reflected in its material glory. It was hoped that the magnificence of the Roman architecture would impress the uneducated masses and reinforce their piety.

Pope Sixtus V (1521–1590) commissioned the construction of magnificent avenues, had viaducts built and had the huge dome of St. Peter's finally completed. Clement VIII (1536–1605) and his cardinals commissioned as many palaces, churches and chapels as they could, attracting architects, masons, sculptors and fresco-painters to Rome from all over Italy.

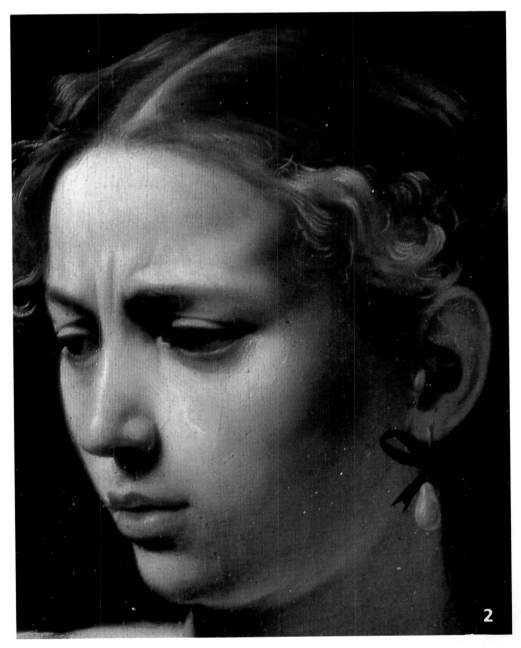

2

One of these was Michelangelo Merisi, born in 1571 in the Lombardic village of Caravaggio, near Bergamo, a village whose name he later adopted as his own. Arriving in the papal city at the beginning of the nineties, his life had initially been all but easy. A Sicilian art dealer had employed him to produce "three heads every day", and given him only salad at mealtimes. But his talent was discovered in 1596 by Cardinal Francesco Maria del Monte (1549–1626), who offered the painter food, wine, pocket-money and lodgings at his palace. Caravaggio painted for him in return: semi-nude boys making music, Bacchus with a sensuous mouth, adorned with flowers, gentle angelic figures. Such works appealed to the cardinal, who loved the company of young men.

It was not long before Caravaggio's fame spread abroad. On receiving his first noteworthy commission in 1598/99, the decoration of a chapel, Caravaggio left the homosexual milieu of the cardinal's palace, where he is thought to have lived with another painter.

It was at this time that he painted Judith, his first erotically attractive female figure, although in fact she is modestly dressed – Caravaggio never painted a female nude. Perhaps it was the image of Judith as both a devout heroine and, at the same time, a corrupter of men which so appealed to the artist. Like Delilah, who took Samson's male potency when she shaved off his locks, Judith appears, in the struggle between the sexes, as the incarnation of the male fear of ultimate vulnerability to a woman.

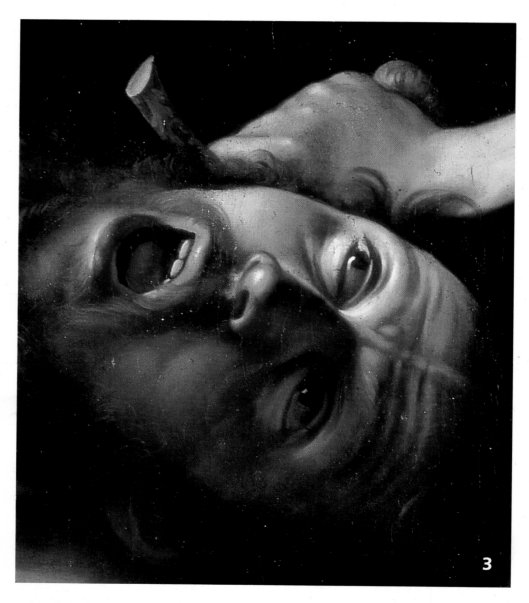

3

## Fascinated by decapitation

M ost artists painting this theme
have shown Judith after the deed,
holding up the head of the dead
Holofernes in her hand. By contrast, Caravaggio has painted the precise moment in
which he is beheaded: the victim is still
alive, his head only half-severed from his
body. His eyes have not yet grown dim in
death, but are staring out of his head, full
of mortal fear, and his mouth is wrenched
open in a scream. Caravaggio sought to
capture the moment of shock and horror,
an effect also loved by his English contemporary William Shakespeare. The latter's
plays *Macbeth* and *King Lear* with their

bloody murders and scenes of torture were
performed for the first time in 1606.

It was not only on canvas or on the stage
that such brutal scenes took place, however; artists were confronted with violence
of this kind every day, whether in Elizabethan England or in Rome during the
Counter-Reformation. There were said to
be more severed heads nailed to the Ponte
S. Angelo over the Tiber than melons on
the stalls of Roman markets. The "Avvisi",
a kind of handwritten newspaper, reported
in 1583: "The Papal States are in chaos…
The countryside is in the hands of bandits… who murder… rob the couriers, lay
waste to towns and houses."[3] These bandits were political outcasts from everywhere in Italy, peasants ruined by papal
taxes and bad harvests, monks fled from
their monasteries and other social misfits.
It was reported that the Papal States were
imperilled from time to time by as many as

27,000 brigands. In Rome they performed
the function of armed bodyguards; known
as *bravi*, the "daring", they accompanied
any citizen or visitor who could afford
their services, always ready to defeat their
employer's enemies, or to engage in a street
battle with the papal police, the *sbirri*.

"Practically no day passes," the Venetian ambassador to Rome reported in 1595,
"without our seeing the heads (of dead
bandits) they have brought into the city,
or of the men they behead at the Castel
Sant'Angelo in groups of 4, 6, 10, 20 and
sometimes even 30 at a time. It has been
calculated that over 5000 persons have died
a violent death in the Papal State since the
death of Sixtus V (1590), whether condemned to death, or murdered by bandits."[4]

Decapitation – a form of execution
reserved for criminal members of the aristocracy – was generally linked to a number
of macabre rituals. The severed heads were
publically exhibited at the Castel Sant'Angelo, displayed on a black cloth between
two burning torches. When the twenty-
two year-old Beatrice Cenci was found
guilty of patricide and beheaded in 1599,
Caravaggio may have attended the execution. A contemporary textbook on art advised painters to accompany the condemned to the scaffold in order to observe
their twitching eyelids and rolling eyes. It
was at this time that Caravaggio was working on *Judith*.

Decapitation must have fascinated the
artist. In 1603 he painted the *Sacrifice of
Isaac* by Abraham; his *Beheading of St.
John the Baptist*, painted in 1608 and now
in Valetta Cathedral, Malta, bears Caravaggio's sole extant signature. The words "F
Michel A" can still be read on the badly
damaged painting; they are written in the
paint he had used for the blood dripping to
the ground from the martyr's neck. The
head of the Baptist in Salome's hands reappears in a work executed in 1610, while another, later painting shows a young David
holding up Goliath's head. Contemporary
spectators noticed the similarity in looks
between Goliath and Caravaggio himself,
who was said to be "dark-skinned, with
grave eyes and thick black eyebrows and
hair".[5]

Holofernes' screaming, suffering face
may also have been a self-portrait, letting
Caravaggio act out a masochistic fantasy of
himself as the victim of brutal violence.

Caravaggio, whose fame had grown so quickly, was patronised by Monsignori and cardinals. He found it difficult to adapt his work to their taste, however. In decorating churches he frequently departed from the conventions laid down by the Council of Trent, which had stipulated that while paintings of the Scriptures were to be used to educate the ignorant masses, the artwork itself must remain dignified and aloof. Caravaggio's work offended against this "decorum" by showing saints with dirty feet and a drowned Virgin Mary whose corpse had swollen in the water.

At the same time, his style broke with the Renaissance ideal of beauty. His vision and aesthetic were novel and realistic, and his works, treasured by a small circle of supporters who paid high prices for them, shocked many of his contemporaries. Instead of copying conventional models, Caravaggio painted directly from life. In so doing, he suppressed neither the furrows and lines on a face nor the wrinkles produced by a life of toil on the hands of an old woman. "Too natural", was all the artist Annibale Carracci could say about his contemporary's painting of Judith.

It was here that Caravaggio first used a device that was to become characteristic of his work: figures, accentuated by artificial, almost subterranean lighting effects, standing out against a dark, nocturnal background.

The fact that darkness and violence were themes to which the artist continually returned may possibly derive from his character. Various incidents show Caravaggio to have been a rowdy and a thug. On 28 May 1606, he mortally wounded a certain Ranuccio Tomassoni in a brawl over a wager on a tennis match. This was by no means his first brush with the law, however, as the numerous demands for sentences recorded in the Roman archives show. On one occasion, the painter threw a plate of artichokes at an impolite waiter at the Osteria del Moro; on another, he insulted a policeman who had asked to see his licence to carry a weapon.

Caravaggio led the adventurous life of a Roman *bravo.* Although he delivered his paintings on time, his biographers say that he rarely stuck it out at work for very long before setting out with his gang of toughs, attending one tennis match after the other, "always ready to fight a duel or engage in a brawl".[6] The sword he carried at his side on these occasions is said to have been conspicuous for its size.

Swords, daggers and knives may be seen in almost all Caravaggio's paintings. Like blood and decapitation, they constitute a kind of sadistic leitmotiv in his work. In the artist's everyday life, they were not only the means of self-assertion, but status symbols. The offence taken by Caravaggio at the policeman's demand to see his licence to carry such a weapon is explicable: wearing a sword was considered a nobleman's privilege, and, despite the torn and dirty clothes he usually wore, it was as a nobleman that Caravaggio wished to be seen. He was a social climber, and his aggression was most likely a means of compensating for a social inferiority complex.

Parallel to the refusal of several of his best works on grounds of theological incorrectness and the consequent reduction in the number of his official commissions, Caravaggio's aggressive behaviour increased, climaxing in the murder of 1606, which forced him to flee Rome. He spent the rest of his life tormented by a persecution complex, driven from one place to another, leaving behind him a trail of masterpieces that were to have a lasting influence on 17th century European art. He died, a lonely man, in exile in 1610 – "as miserably as he lived", as one contemporary noted.[7]

## Undaunted by reality

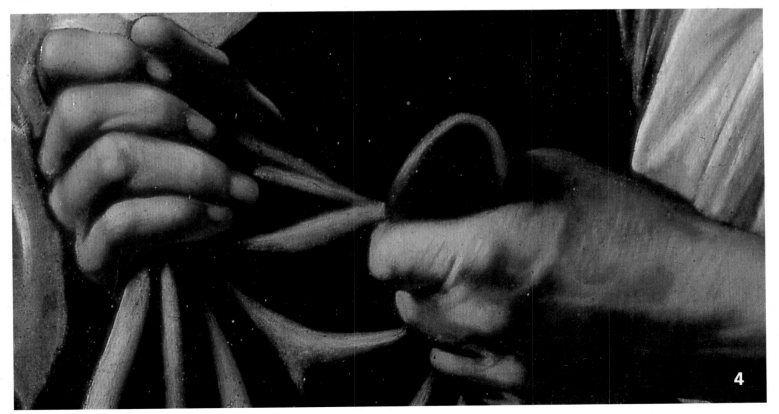

# Double-dealing hands and eyes

A French masterpiece was once secretly smuggled out of France. In 1960 the New York Metropolitan Museum bought *The Fortune Teller*, a work attributed to Georges de La Tour (1593–1652), for an unknown but "very high sum of money". When the affair became publicly known, critics raised their voices in the French press against this sordid victory of the dollar, complaining of irretrievable loss to the "national heritage". The Minister of Culture, André Malraux, attempted to explain to parliament how the Louvre had let the opportunity to acquire such a treasure slip by unnoticed. It was never fully explained how a licence to export the painting had been acquired in the first place; the head of the Louvre Old Masters department at the time remained silent.

Hardly anyone had seen the painting before 1960, and the story of its discovery is mysterious. In 1942, so the story goes, a monograph on the works of La Tour entered the hands of a French prisoner-of-war. The reproductions in the book reminded him of an old painting which hung at his uncle's castle. When the war was over, he had the painting examined by a priest who had an expert understanding of art. The latter, concluding that the painting was a genuine La Tour, informed the Louvre. Secret negotiations were then con-

ducted to arrange for the purchase of the work. However, the art dealer Georges Wildenstein outbid the Louvre, finally buying the *Fortune Teller* in 1949 for 7.5 million francs. The painting then remained in his possession for the next ten years, accessible only to a small number of experts. In 1960, the Metropolitan Museum presented its sensational acquisition to the public for the first time.

It portrays a 17th-century picaresque scene: four sly thieves in the act of robbing a young man. The latter's attention is fully occupied by an old woman who is about to tell his fortune by reading his palm. He is thus unaware that he is the victim of a plot: while one girl is removing his purse from his pocket, her accomplice's hand is already held out to spirit it away; at the same time, a pale-skinned beauty is cutting a gold medal from the chain around his neck. The protagonists are turned to face the spectator like actors on a stage; indeed, it is quite possible that the artist borrowed the scene from a play.

According to experts at the Metropolitan Museum, the oil painting is in "excellent condition".[1] The sweeping calligraphy of the signature "G. de La Tour Fecit Luneuilla Lothar" in the top right of the painting proves it to be the original work of the artist, who spent most of his life in the small Lotharingian town of Lunéville. The details of his life are obscure. At the beginning of the twentieth century only his name and two paintings were known. In the meantime, however, several dates and various other facts have been found in archives, and in 1972, at the first major La Tour exhibition at Paris, 30 paintings were attributed to his hand. The *Fortune Teller* is one of the few spectacular "daylit paintings" of an artist whose reputation, until the thirties, rested entirely on his execution of candle-lit "nocturnal scenes".

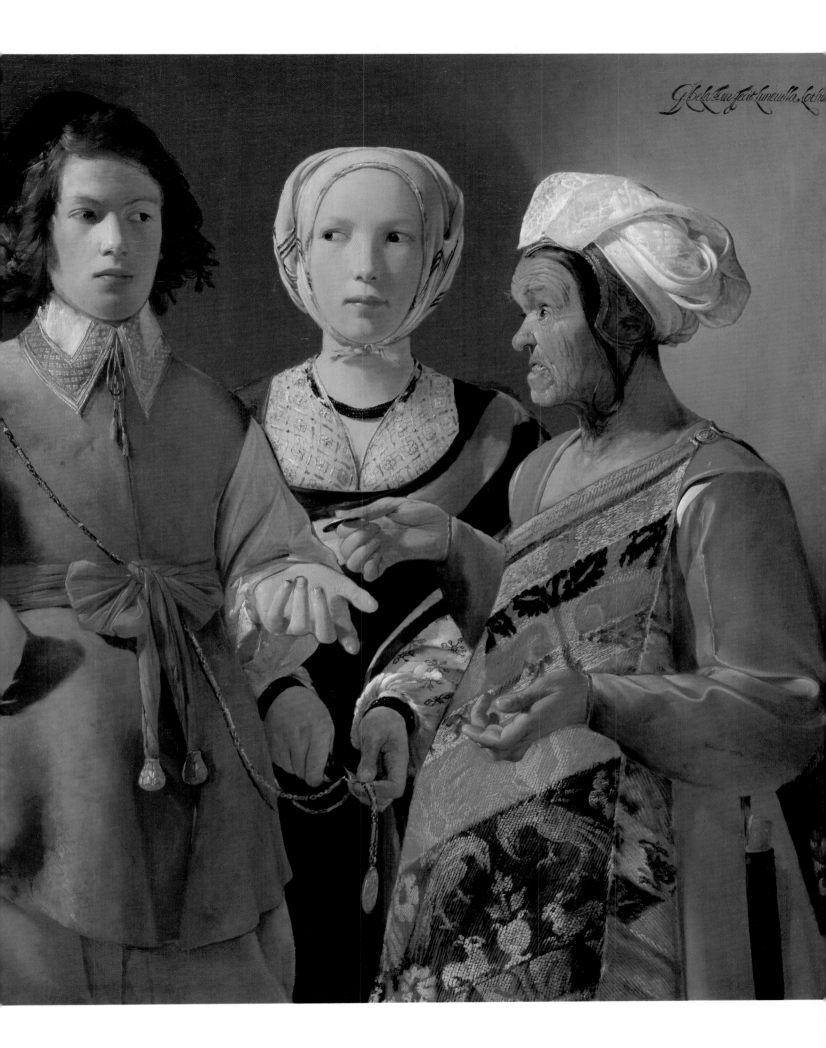

1

Callot is reported to have accompanied a band of gypsies as far as Rome after running away from home at the age of twelve. He was discovered there by merchants from Nancy and sent home to his parents.

The other two great "daylit" paintings attributed to La Tour show similar scenes. In the paintings *Card-sharper with the Ace of Clubs*, and *Card-sharper with the Ace of Diamonds* a young victim is about to lose the pieces of gold piled up before him to a cunning card-sharper and his lovely accomplice. Perhaps all three pictures illustrate episodes from the biblical parable of the prodigal son who "took his journey into a far country and there wasted his substance with riotous living".[3]

This story from the Gospel of St. Luke was a favourite among the painters of the 16th and 17th centuries, since it allowed them to portray popular, low-mannered scenes with drinkers and brothels. Such subjects were only tolerated by the Church in conjunction with warnings against "vice".

La Tour's message appears to have been more serious than that of many of his contemporaries; he refrained from painting gay scenes of "dissolute" life. The faces of victim and thieves are less cheerful than concentrated. Fortune-telling and robbery were dangerous businesses. If caught, the youth could theoretically expect to be excommunicated – although he would be more likely in reality to be given a good hiding by one of his teachers. Watch-thieves usually had both ears cut off in the 17th century; they were tortured with red-hot pincers and branded, or even hung, drawn and quartered. For the slightest offence gypsies were publically whipped and banished without trial.

In this painting, whose protagonists form a close group and yet are nonetheless isolated from one another, the Lotharingian artist, like his contemporary, the scientist and philosopher Blaise Pascal, appears to be warning the specatator against the dangers of an evil world: a world full of greed, selfishness and traps.

---

In spite of his military-style doublet, the richly-dressed young man has rather a baby face. He is probably still a student at one of the colleges visited by wealthy, upper-class boys until – at the age of fifteen – they were introduced to the world of adults.

Contact with the adult world must have started for many of them at an early age, however, for "before they even reach Aristotle's lessons on restraint," according to the essayist Michel de Montaigne, "a hundred school-boys already have syphilis."[2]

There would certainly be no shortage of places to contract such diseases – inns, hostelries and brothels – within even a short distance of the college gates. La Tour has not defined where the scene in his painting is taking place; perhaps the old woman will not be content with her fortune-telling, but will attempt to prostitute one of her young accomplices to the young man. Their dark skin, black hair and richly coloured Oriental dress show the old woman and two girls on the left to be gypsies.

La Tour's contemporary, the Lotharingian artist Jacques Callot, made similar portrayals in his *Gypsy* etchings of 1621.

## A palm crossed with gold

A gold coin twinkles in the old woman's deeply lined hand. It is both the reward for her work and an essential part of the ritual of fortune-telling. Before looking into the future, she must cross the soft, white hand that the youth so trustingly holds out to her with the gold coin.

The custom is described by Preciosa, the "little gypsy girl" in the "Exemplary Story" of the same title by Cervantes, published in 1613. "All crosses are good," she explains, "…but silver or gold crosses are the best, and crossing the palm of the hand with a copper coin, you must know, reduces good fortune, at least, the good fortune I foretell."[4]

It was usual for a fortune teller to retain the coin used for this ritual, and to keep it for herself; unlike everything else that she earned, begged or stole, which the unwritten laws of her people – according to popular lore on gypsies – required her to share with the other members of her clan. This would apply to the youth's purse, for example, or to the medal cut from its chain by the deft fingers of the pale young woman. In performing the latter, the pale beauty observes her victim from the corners of her eyes. Movement in the painting is restricted to fingers, or to eyes, whose lines of vision cross, or appear to avoid meeting.

Tension in the painting derives from its inherent contrasts: pretended calm and concealed activity; innocence and cunning; the girls' youthful vigour and the weathered features of the old woman. It is this tension – including its erotic aspect – which appears to have interested the artist most; neither the rich materials, the elaborate clothing nor the gleam of gold in the diffuse light can distract from it. In his later "nocturnal" works, La Tour dispensed with such decorative trimmings and reduced his saints almost to their abstract corporeal mass, lit by the glow of a single candle.

Recent expert opinion has placed the origin of the undated *Fortune Teller*, as well as that of the two *Card-sharpers*, between 1630 and 1639 – a time when the Thirty Years' War had broken over the border country of Lorraine, bringing with it pestilence and famine. Lunéville, the small town where La Tour spent most of his life, was besieged, plundered and pillaged on several occasions. The painter himself is said to have profited from these times, making a fortune in grain speculation and rising to the station of a land-owning squire. Thus gold coins played as important a role in his real life as they did in his paintings.

## An ostracised people

Under one of his etchings illustrating the life of the gypsies, Jacques Callot wrote a warning: "If they, with their words, you spellbound hold,/ Keep an eye on your silver, your guineas and gold!"[5] Gypsies are rarely mentioned in old documents without some accompanying allegation of their lack of respect for other people's property. Because they did not accept Christianity, a sedentary way of life or property, the basic values of Western societies, but insisted instead on retaining their own laws, gypsies were discriminated against and ostracised as "vagabonds and crooks" wherever they went in Europe, where they had first made their appearance in the 15th century.

Cervantes, otherwise well-disposed to the gitanos in his *Little Gypsy Girl,* writes: "Gypsies seem to have been born into the world for the sole purpose of being thieves: they are born of thieving parents, they are brought up with thieves, they study in order to be thieves, and they end up as past masters in the art of thieving."[6]

Court records refer to the existence of "Egyptians and Saracens" in the Duchy of Lorraine. They contain reports of torture, banishment and execution as punishments for robbery, blasphemy and witchcraft. The sight of "travelling houses" passing through Lorraine would have been common enough during the Thirty Years' War; some would have belonged to the armies, others to gypsies. Callot's etchings record both their hardships and the more roman-tic, colourful aspect of their lives. La Tour, who had become a rich landowner, would probably have viewed them with distrust; the court records at Lunéville also betray that he would flog anyone with his own hands who trespassed on his property.

In younger years, the artist may have accompanied travelling people some of the way to Italy, where he possibly underwent part of his training. At least one detail in the painting bears testimony to his knowledge of their customs: the hair of unmarried women and girls was worn loose, while that of married women was tucked under a bonnet, or into a scarf knotted at the nape; a scarf knotted under the chin, however, like the one worn by the beauty at the centre of the painting, was a sign that a woman was neither a virgin nor married. Perhaps she worked for the bawd on the right.

Pale-skinned gypsies were considered particularly attractive, since they were closer to contemporary ideals of beauty than their dark-skinned, black-haired sisters. Like Cervantes' Preciosa, they usually turned out – at least they did in comedies and novels – to be Christian girls who had been abducted as children by travelling people. It is possible that La Tour's figures are acting out a plot of similar content on the stage, which would also explain their unusual richness of clothing for travelling people.

The costumes they are wearing are products of the imagination, entirely inconsistent with expert opinion on 17th-century Lotharingian fashion. Leather doublets of the type worn by the youth in the painting, for example, were always tied at the front. In rendering the old woman's shawl with its Oriental design, the painter, usually at pains to reproduce textiles in meticulous detail, has been astonishingly lax: the weft of the folded-back inside of the fabric runs in a different direction from that of the outside. The shawl itself is conspicuously similar to a carpet lying at the Virgin's feet in the Netherlandish Joos van Cleve's 16th-century work *Virgin and Child,* even down to distortions of perspective. It was these discoveries at the end of the sixties that began to puzzle the English art historian Christopher Wright. His suspicions increased when he found the French swear-word MERDE (shit) woven into the scarf worn by the second girl from the left.

# An ingenious forgery?

In the La Tour monography published by Benedict Nicolson and Christopher Wright in 1974, the *Fortune Teller* was listed among works known to be from the painter's hand. Ten years later – Nicolson had died in the meantime – Wright revised his opinion that the work had been painted in the 17th century and claimed that the painting exhibited in the Metropolitan Museum was the work of a twentieth-century forger who had been intelligent enough to use an old canvas and mix his paints with the help of old recipes.

Why this change of mind? In a book entitled *The Art of the Forger*, published in 1984, Wright described how pressure was brought to bear on him as a young academic to suppress his doubts as to the authenticity of the painting. Finally, he had submitted to the reputation of international experts and to pressure from the powerful authority in matters of art of Sir Anthony Blunt; Blunt, frequently consulted by the art dealer Wildenstein, was later exposed as a Soviet spy.

The authenticity of the *Fortune Teller* had originally been proved in 1972 at the Paris La Tour exhibition by comparing it with the other two "daylit" paintings, the two versions of the *Card-sharper*. These two paintings had been discovered in the 20s; having remained since then in private collections, they could now be examined for the first time. One of them had just been purchased by the Louvre. According to Wright's later opinion, this had been a case of several forgeries confirming each others' authenticity. He nevertheless kept silent. In his book in 1984 Wright attributes several of the other "daylit" paintings to an unknown master, while calling the authenticity of the two *Card-Sharpers* and the *Fortune Teller* into question.

Wright's hypothesis was that all three may have been the work of a French restorer called Delobre who had worked for Wildenstein in the USA; according to Wright, the first two were probably painted at the beginning of the century, the third during the 40s. Delobre died in 1954. In Wright's opinion, the forged *Fortune Teller* replaced an older painting with a similar theme which had hung in the castle and could be traced back as far as 1879. The painting was of inferior quality, so that the Louvre had not bid especially aggressively for it at its auction. It had therefore been easy enough to obtain a licence to export such a work.

It is entirely understandable, according to Wright, that experts and museum directors should not be swayed in their opinion of the authenticity of a painting they have helped "discover" themselves, or whose purchase they have advised, or for which they have had to pay millions. Not one of them acknowledged the bizarre detail brought to light by Wright: the French swear-word "merde". Could it have been a forger's joke? In 1982 the Metropolitan Museum made it known that this "later addition" – in whose existence nobody but Wright had previously shown any interest at all – had been removed during the cleaning of the canvas.

The museum still stands by its version of the work's authenticity. However, there is a certain piquancy in the proximity of Wright's hypothesis of the painting as a forgery to the shady double-dealing shown in the *Fortune Teller* itself: we evidently live in a world of lies and deception in which not only immature youths, but also museum directors can be fleeced by cunning rascals.

4

## Peter Paul Rubens: The Love Garden, c. 1632/34

# Grateful for the gift of sensuous pleasure

Peter Paul Rubens married his second wife in 1630. He was a 53-year-old widower, his wife a mere sixteen-year-old. Although the age difference would have been considered more than unusual even in those days, it was hardly a matter to worry Rubens: he was a man in his prime, a respected, wealthy gentleman, a painter at the height of his fame and fortune.

The painting, now in the Prado at Madrid and known as *The Love Garden*, was executed shortly after the wedding. Experts have dated it to between 1632 and 1634. Unlike most of his work, it was not done for a wealthy patron, but for himself. Nor was his own intervention restricted to the initial sketch and finishing touches, as was the case with so many of the paintings that left his busy studio, including those executed during the same period for the Banqueting House in London.

In spite of its great size – 198 by 283 centimetres – it is an unusually private painting. It expresses the feelings of a man who is already advanced in years and has regained a happiness thought for ever lost. "I have regained a life of contemplative tran-

quility," he wrote to a friend, adding: "How gladly we accept this gift of sensuous pleasure! And how gratefully!"[1]

The painting tells of the pleasures of wealth and good company, of sensuous joy and love of life. The gentleman on the left, his arm placed tenderly around his blonde companion, is trying to persuade her to lay aside her reserves; a magnificently dressed couple descends from the staircase on the right, while the ladies in the centre of the painting listen to a lute player.

The swords are a sign that the gentlemen belong to the nobility or at least to the upper bourgeoisie, while the ladies in their finery reveal as much shoulder and bosom as permitted, or rather demanded, by the latest French fashions. The only nude figures in the painting are its many cherubs: winged, mythological creatures. Here they are shown strewing flowers, caressing the splendily dressed, politely chatting figures or giving them an encouraging little shove – to help them, in various ways, to enjoy "this gift of sensuous pleasure", which is, after all, what they are there for.

Comparison of the female heads reveals that all of them have the same straight noses, very round and slightly protruding eyes and fair hair. They all resemble the artist's new wife, so that several art historians think that Rubens may have painted her in the company of her sisters. However, the men, all of whom wear moustaches and beards, are also similar in looks. They resemble the artist himself. In painting the picture he probably was thinking of his wife and himself. On the other hand, a self-portrait painted not long afterwards shows that Rubens already looked much older at the time. He has rejuvenated for the *Love Garden,* adapting his age to that of his young wife, or showing himself as his new marriage made him feel.

A painting that overflows with the joys of love:
the widowed artist had married a sixteen-year-
old. Rejuvenated, he filled an entire canvas with
images of himself and his wife. Cherubs and
Classical architecture make their happiness time-
less. The intimate work (198 x 283 cm) is in the
Prado, Madrid.

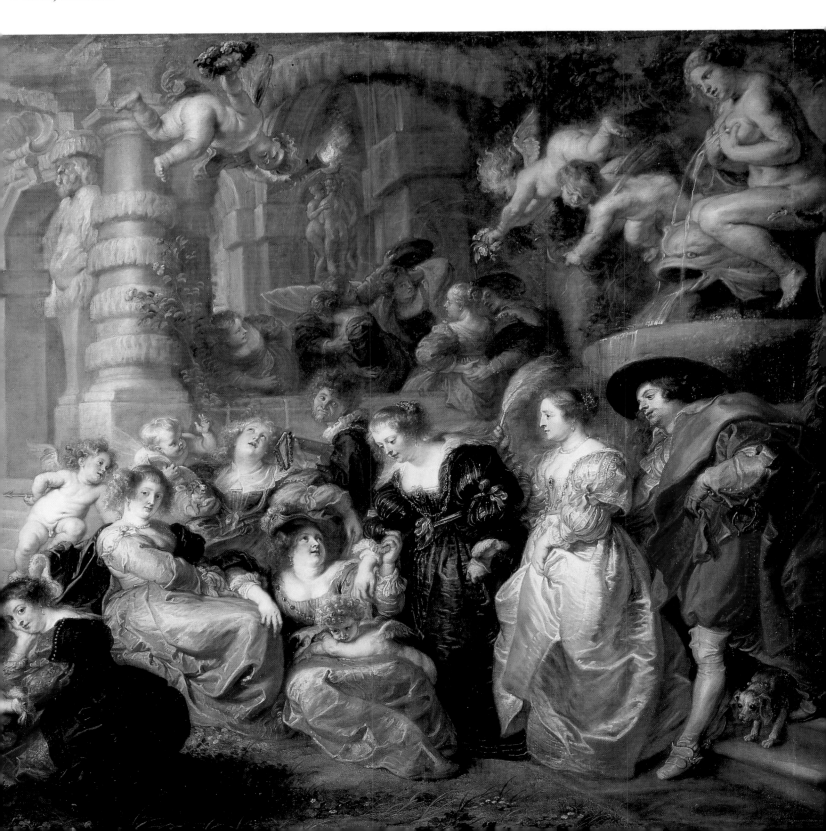

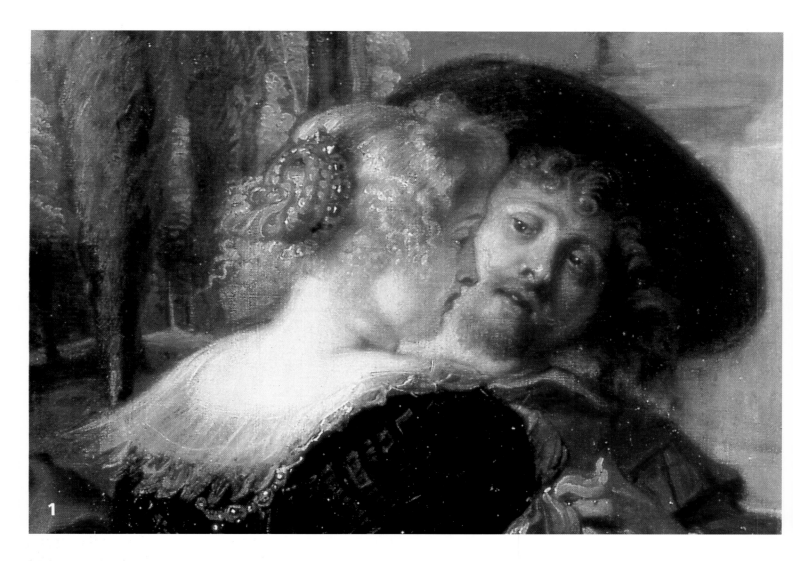

## The artist as a nobleman

Shortly before his wedding, Rubens had been knighted by Charles I. The English king had given as a present to Rubens the sword, set with diamonds, which he had used for the ceremony. Rubens was now permitted to call himself Sir Peter.

He was probably knighted less for his artistic than for his diplomatic services. But it was his art which had provided him with a significant diplomatic advantage: unrestrained access to European royalty. While other emissaries had to haunt the antechambers and seek a path between hostile intrigues, Rubens gained admittance without effort. Easy access would have brought him relatively little advantage, however,

were he not also a man of discretion, charm and considerable persuasive powers. The German painter and art historian Joachim Sandrart had this to say of him: "He … was polite and extremely friendly to everyone, a welcome and much loved guest wherever he went."[2]

Rubens undertook most of his secret diplomatic missions in the service of the Spanish vicereine of the southern Netherlands. It was here, too, in the seaport of Antwerp, that Rubens lived. The vicereine also recommended him to the Spanish king in Madrid, who sent him to London in 1629 to find out whether the old hostilities between Spain and England could be laid aside.

A peace treaty was concluded, and Rubens wrote: "I can honestly declare that my travels in Spain and England have been crowned with the greatest possible fortune. Matters of great import have been settled to the full satisfaction of my lord, indeed to the satisfaction even of the opposing party."[3]

Rubens was sent by the Spanish vicereine on several occasions to carry out secret missions in the northern Netherlands, the so-called States General. These provinces had gained independence from Spain in 1579, since when there had been war between the two parts of the Netherlands, interrupted only by highly unstable periods of truce. The Netherlands formed a subsidiary theatre of the larger European conflict: the Catholic Habsburgs in Vienna and Madrid versus the Protestant states and France.

Rubens succeeded in enlisting England for the Catholic cause, but he was unable to do anything to promote lasting peace or the reunification of the Netherlands. It was the fact that he felt unable to achieve anything for his own country that finally prompted Rubens to give up diplomacy following his triumphant mission to London. After the death in 1633 of the vicereine, whom he had greatly admired, he declined further missions abroad. He wanted to paint.

He had begun to find courtly life quite "repulsive": "In that labyrinth, beleaguered day and night by bothersome crowds of people… under obligation to attend… without cease."[3] His Spanish contemporary, the painter Diego Velázquez, decided otherwise, accepting offices at the Spanish court, shutting himself away in the corridors of the royal administration, rarely, in later years, returing to his work at the easel.

It was not easy for Rubens to leave. He had to force himself to "sever the golden knot of ambition,"[3] as he wrote. The freshly knighted widower rejected advice to marry into a noble family: "I feared that notorious quality of the aristocracy, their self-conceit, especially so in someone of the opposite sex, and thus I am more attracted to a woman who does not blush when she sees me lift the tool of my trade."[3]

He did not reveal in this letter to a friend that his young wife Helene Fourment was considered a beauty, indeed as "one of the most beautiful women here", according to the newly appointed Spanish viceroy.[4]

## Majestic proportions

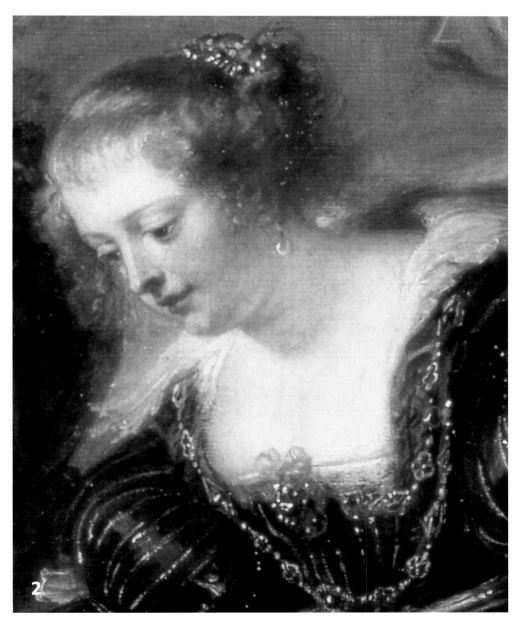

2

Unlike today, the ideal female body in Rubens's day had an ample layer of fat beneath the skin. Visible or indeed palpable bones were considered inappropriate; opulent curves were much in demand, as was a plump neck and a large bosom. Furthermore, a beautiful woman was required to have "a majestic deportment, fine proportions, a luscious head of thick ash-blonde curls… and sweet white hands".[5] Thus the description in a book printed in 1655 and entitled *Le Mérite des Dames*.

Rubens had been painting this type for decades. Even the facial features in this painting are found in his previous work: perhaps one of Helene's elder sisters had sat for him, or perhaps the artist simply found this the most comely of female forms. Some art historians have maintained that in painting the *Love Garden*, Rubens illustrated a process: Helene's progress from a young girl and bride to a wife and mother.

According to this hypothesis, the hesitant girl on the left is invited by a careful lover and cherub's encouraging push to lay aside all reservation and sit down on the grass. The next scene shows her doing exactly that, with her hand on her lover's knee and her dreamy gaze staring out of the picture, as if looking into the painter's eyes. Finally, the scene on the far right shows her as the confident wife, stepping majestically down from a staircase on the arm of her husband.

The three women seated at the centre of the painting would then represent different kinds of love: ecstatic love, companionship, motherly love. The figure of maternal love with the cherub on her lap is drawing the young woman down to her.

This interpretation of the painting is supported by the suggestive objects brought by the little Cupids. Accompanied by turtledoves, the symbol of conjugal love, they hold up the torch of Hymen, the god of marriage, strew bridal bouquets and bear the yoke of matrimony. The peacock at the far right of the canvas is an attribute of Juno, the patroness of marriage.

The artist's second marriage was as happy as his first. "In your arms, damsel, he shall grow young again," it said in a poem for his wedding, for she would not let him him suffer "the perilous burdens of ageing".[6] He was to father five children in the ten years left to him, the last born after his death. Helene became a rich widow; she married again, too.

3

## Venus rules the garden

Having "severed the golden knot of ambition," Rubens retired from the public stage. The theme of the painting suggests he had followed the advice of his mentor Justus Lipsius, Professor of Philosophy at the University of Leuven. Lipsius extolled life on the land and the cultivation of gardens. Only far from the golden fetters of court life was it possible to live happily and do as one wished.

Rubens, of course, had a garden of his own; in 1635 he even bought an estate with a small castle. His garden was in the grounds of his house at Antwerp, an imposing building to which he added an extension, built in the style of the late Renaissance and containing his studio.

In order to connect his studio with the main house, Rubens also built a portico; it had three passageways and was supported by massive columns, similar to those in the painting. A balustrade decorated with stone balls, like the one just visible on the left, divided the domestic area from the garden.

Gardens were important in the 17th century, partly because they were considered status symbols. Gardens were divided into four categories.

The common people, if they had one at all, had a vegetable garden in which they might also cultivate medicinal herbs. Besides containing a vegetable patch, the garden of a somewhat more prosperous family would be designed with little paths for walking and contemplation.

A nobleman, or a wealthy burgher like Rubens, would have a landscaped garden with grottos, arbours and summerhouses; the parklands of princes and kings would further contain artificial lakes and smaller castles. The most luxurious example of the latter was to be the later palace at Versailles.

The fact that the artist has restricted meadows and trees to a relatively small section of the canvas is entirely in keeping with contemporary views of Nature. There was little demand for wildness at the time. Hedges and flowerbeds were designed to accord with a perfectly calculated, geometrical scheme.

Only domesticated Nature was considered beautiful or inviting, and gardens therefore contained as many wells, balustrades, statues and artificial grottos as possible. A garden was seen as a kind of open-air salon.

According to Justus Lipsius, this provided the ideal background against which a sophisticated gentleman might stroll and, whether alone or in conversation with a friend, draw lofty distinctions between the important and less important things in life. In upper-class society it was fairly common for ladies and gentlemen to conduct their rendezvous in the "park", where they could promenade, picnic, listen to serenades or participate in pastoral plays.

Gardens and love went hand in hand in the 17th century. There were practical reasons for this. Palaces and large houses offered little opportunity for intimacy; too many people lived in them; there was a constant toing and froing of servants, and most of the rooms served as passages to adjoining rooms. It was far easier for lovers to share their intimacies in little groves, behind hedges, or in the seclusion of a grotto.

Besides such practical considerations, the idea of the Garden of Love, or pleasance, has a place in cultural tradition and can be traced back to notions of paradise where human beings could live together in happiness, surrounded by a permanently clement, natural world. Each era had its own version of the paradisial Garden of Love: in the 16th century it became the evil garden of lust, whereas in Rubens's circle, the Garden of Love probably symbolised the harmony of physical and spiritual love.

The artist has included the figure of Venus on a well in the top right corner of painting. Water is sprinkling from the breasts of the goddess, a sign of fertility. She is riding a dolphin, the incarnation of playful and tireless pleasure in love. The shell on the portico is an attribute of Venus, and the many cherubs, brothers of Cupid, could be her sons: indeed, "Venus' court of pleasure" was another title given to the painting.

The painting's title, *The Love Garden*, probably dates from the eighteenth century. During the artist's lifetime, works of this kind were usually referred to in a mixture of Flemish and French as "conversatie à la mode".

## Women take command

*Conversatie* was conversational discourse, and it was *à la mode* since discourse of this kind between men and women, the easy interchange of thoughts and opinions accompanied by flights of flirtatious wit, was considered a particularly worthwhile pursuit.

The new fashion of conversation had originated in Paris as a reaction against the rude, military tone that had dominated the court of Henry IV. Thus it was women who decided the new rules and determined what was to be considered appropriate behaviour in society.

The importance attached to elegant, witty conversation can be deduced from the countless references to individual manners found in contemporary letters and memoirs. Rubens was frequently praised for the "infinite sweetness of his conversation".

But the new vogue of conversation was not the only fashion to change. For almost a hundred years the ceremonial black of Spanish conventional decorum had dominated women's clothes fashions at the majority of European courts. Women were forced to wear stiff, uncomfortable dresses which veiled from sight all but the hands and face and hid away their necks behind a broad, stiff ruff. Over twenty years had passed since Rubens had painted his first wife, dressed in the Spanish manner, "in a bower of honeysuckle". In *The Love Garden* he presents his second wife, Helene, in soft, flowing robes which reveal her neck, nape and busom, and evidently please her husband.

Like the new style of conversation, the latest clothes fashions also came from Paris, both attesting to a view of female roles that departed radically from the behaviour traditionally expected of women in Spain. Spanish women were locked up at home, their reading restricted to religious literature. They remained uneducated and were closely protected. French women, by contrast, had a certain freedom of movement, and were using it to gain a dominant position in society. One of the women in the painting by Rubens has the air of conducting social affairs with her peacock feather.

The liberated, confident behaviour of women at Brussels and Antwerp must have greatly irritated the Spanish in the Netherlands, as well as leading to occasional misunderstandings, as may be illustrated by a letter written to Madrid by the new Spanish viceroy: "They are so free and easy, and this allows us much opportunity. But their careless manner of intercourse is reserved solely for society; at home they are difficult, and nothing can be got out of them."[7]

The influence of French fashion was a reflection of the growing political power of France. Spain was still a world power, but a weak and disorganised one. France would determine the styles and politics of the future. Thus even a very private painting betrays something of the changing balance of political power in the era of its origin.

# The victor honours a defeated enemy

The Catholic Spaniards had besieged Protestant Breda for 12 months before hunger forced the commander of the fortress to submit. The artist, commissioned to celebrate Spanish victory, was faced with a problem: few Spanish soldiers had been present at Breda and nothing particularly heroic had taken place. Velázquez chose a different subject: the noble attitude exhibited by general and commander. The painting (3.07 x 3.70 m) is in the Prado, Madrid.

The date: 5 June 1625. The time: ten o'clock in the morning. The commander of the Dutch fortress of Breda hands over the key of the town to his victorious Spanish counterpart.

Spain, at the time, was the "land on which the sun never set", with dominions in America, Italy and Burgundy; it comprised the whole Iberian peninsula, including Portugal. The Netherlands, too, were a part of the Spanish Empire; but only the Catholic south remained loyal to the king in Madrid, while the Protestant northern provinces rebelled. Breda lay on the border between the north and the south. For the Spanish, it was the "stronghold of Flanders" and a "sanctuary for traitors".

The war in the Netherlands had begun sixty years earlier; at the time, Philip II had sent the Duke of Alba to secure Spanish rule. Philip III then agreed to a truce. Sixteen-year-old Philip IV, mounting the throne in 1621, sought a decisive blow in the north. His commander in chief in the Netherlands, Ambrogio Spinola, had taken Jülich. But the king wanted Breda, too. His council of war advised against the move: a siege would be costly and bring little military advantage. But the ruler, now nineteen years of age, sent Spinola a note with the words: "Take Breda!" Signed: "I, the King."[1]

Spinola besieged the fortress town for twelve months. He repulsed two relief offensives mounted by the Netherlandish side. His own army meanwhile was decimated by epidemics. Then he received intelligence from a number of intercepted letters that the besieged were suffering from starvation; they were on the point of surrender. The capitulation was formally signed on 2 June. The garrison withdrew on 5 June. News of the surrender took ten days to reach Madrid; Te Deums were sung in every church.

Spinola offered the Dutch extraordinarily honourable terms of surrender: the commander and all officers and soldiers "shall, as befits brave men of war, withdraw fully armed in an orderly fashion; the infantry shall leave with flags flying to the beat of drums, their muskets charged and slow match lit (that is, ready to do battle); the cavalry, with cornets flying, shall leave to the sound of trumpets, armed and mounted as if to start a campaign". The conditions also permitted the commander of the garrison to take his furniture, and granted an amnesty to the inhabitants of the town. On 5 June Spinola met his adversary before the town walls. He "greeted and embraced the commandant of Nassau warmly and, with words more amicable still, praised the bravery and steadfastness of the defence". Thus the description of the event in a report published in Antwerp in 1629.

It was the form of the surrender which evoked the enthusiasm of the Spanish response. This is illustrated both in a play written by Calderón and in the painting by Velázquez. Calderón de la Barca was 25 years old at the time. His play, entitled *The Siege of Breda* was first performed in 1625, the year of the surrender. The poet celebrates the meeting of the two commanders in long, elegant dialogues: "The bravery of the vanquished honours the victor," says Spinola's stage persona. As for Velázquez, his chosen subject is not the depiction of Spanish troops as they repel an enemy relief force or enter the besieged town; nor does he paint Spinola's horse shot from under him; in fact, he does not include the fortress of Breda in his composition at all (it lies to the left of the depicted scene).

Instead, Velázquez shows an encounter between two human beings: one on bended knee, the other, in a consolatory gesture, resting his hand on the shoulder of the first. An utterly unwarlike scene amidst the weaponry and dogs of war.

## War:
## a chessboard
## with soldiers

**B**reda was not taken by bravery, but by stealth and stamina. The days of the Gueux, when the Dutch had terrorised the Spanish army with cunning guerilla-style tactics, were over. Now was the hour of the war of position, in which the fighting was more like a game of chess: units of troops shunted back and forth, each party attemping to force his opponent into checkmate.

The Dutch master of scientific warfare was Maurice of Orange. Knowing how exposed to attack Breda was, he had had the town turned into a model fortress. The commander of the fortress was the sixty-six-year-old Justin of Nassau; his oppo-

1

nent was not a Spaniard, but a Genoese: Ambrogio Spinola. Spinola was an ascetic: cool-headed, self-denying, always ready for action. Khevenhüller, the Austrian ambassador to Madrid, wrote: "He (Spinola) frequently went into seclusion with the engineer Giovanni de' Medici for many hours to work out what the siege would cost, how long it would last, what they would need to sustain the alertness of the army, and to prepare for every eventuality…"

Spinola was forced to wage war on two fronts: one against the army stationed in the garrison of Breda, the other against relief forces from without. For protection, he built two ramparts, or defensive mounds, almost entirely surrounding the town. Velázquez has painted them in the background. It took five hours to walk this double ring of fortifications. The Spanish army was encamped between the two walls. Spinola had some of the meadows flooded in order to provide further protection for his army. This is suggested in the painting, too. The boys beside the horse are probably cadets, in training at the military academy in Breda. It is said that young Protestants from all over Europe were sent there.

As predicted by the council of war, the Spanish investment of enormous sums of money and gold in the campaign, as well as the commitment of their army to the siege, did not ultimately decide the war in their favour.

However, military and financial questions were by no means the sole criteria in the eyes of 16th and 17th-century Spanish monarchs; for they saw themselves primarily as warriors of the Church. The provinces of the Iberian peninsula had been united by the crusade to expel the forces of Islam. This had a lasting effect: rather than expelling infidels, the new crusade was directed against the Protestants. What was worse, the Protestants had managed to gain a foothold on Spanish soil, for the Dutch provinces had fallen to Spain by inheritance. No king worth his salt could tolerate them. Freedom of religion? Quite unthinkable! Any monarch in Madrid who remained loyal to his heritage was impelled by his religion and Spanish tradition to take up the sword against those who had apostatised from the Catholic faith. Whether or not the struggle was ultimately successful was of secondary importance.

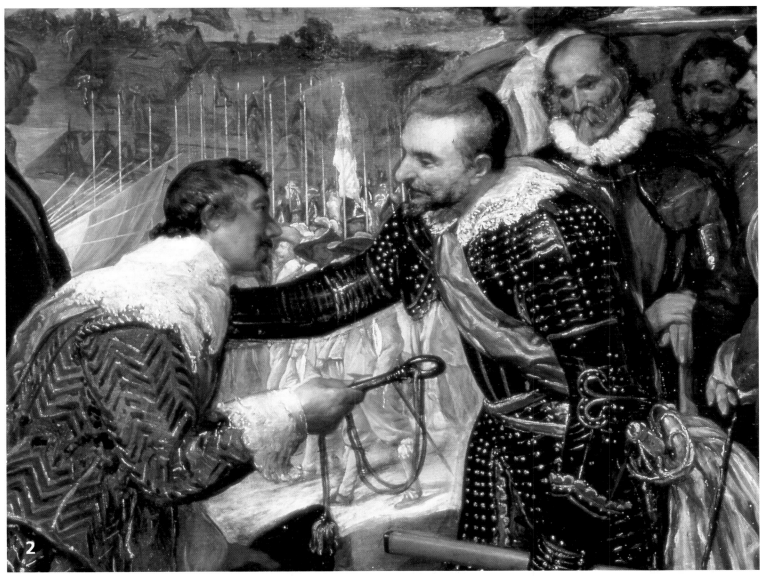

2

## Sosiego:
## a quality befitting
## the victor

Spinola had been born into a Genoese family of merchants and raised to the rank of Marqués de los Balbases by the Spanish king. This was a great honour, probably conferred upon him in gratitude for military services, and possibly also because Spinola himself embodied a virtue of which the Spanish thought most highly: *sosiego*.

One way of translating *sosiego* is "equanimity". It is no accident, for example, that Spinola was reported to have borne the trials of the siege with "serene equanimity". The quality of *sosiego* is therefore reminiscent of the philosophy of the ancient Stoics, according to which the world was imbued with an elemental, divine force. Everything that happened in the world was pre-ordained and therefore right. A human being was to bear his destiny without protest: to accept it with equanimity, in other words.

Calderón makes use of this idea in his Breda drama. He makes Justin of Nassau speak at the surrender about the pain of the moment, but also of defeat as the will of Destiny: a force which can crush even the proudest state into the dust.

The Spanish word *sosiego*, however, does not only mean equanimity; it also suggests a sense of superiority. The Spanish considered themselves the most powerful nation in Europe: they had driven the Moors from the Spanish peninsula, thereby expelling Islam from Europe; they had "christianised" America; they were the rulers of a large part of the European continent.

Their glorious history and (supposedly) vast power thus made it relatively easy for them – and their generals – to display magnaminity towards an adversary. After all, the latter could not ultimately damage Spain, which was great, and was fighting for the one true, Christian religion. The state was thus acting in full accordance with "divine force".

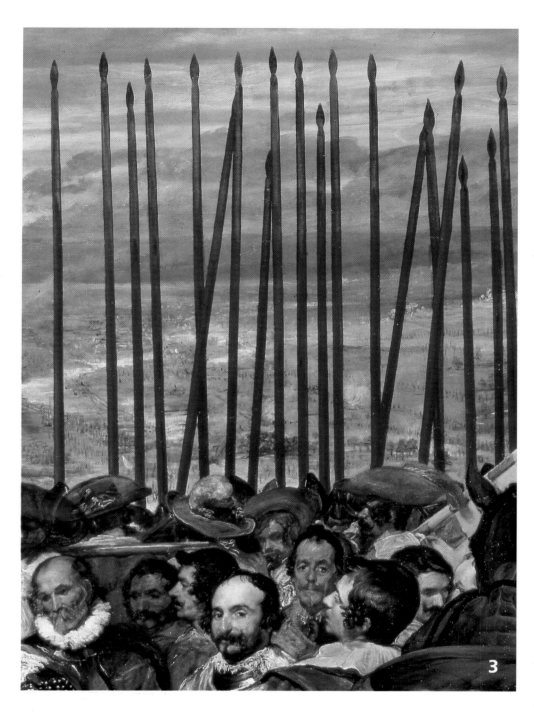

3

## The Spanish no longer wanted to fight

In Spain, the painting was often referred to quite simply as *Las Lanzas* – almost a quarter of the canvas is dominated by lances, or pikes, which, for many centuries, had been the symbols of military strength. By the time of the siege of Breda, firearms had not yet come into their own. The Dutch used short spears. The Spanish infantry approached their enemy in tight, oblong formations of several hundred pikemen. While Calderón compared the pike-formations with fields of corn, one French writer described them as moving towers, capable of immediately closing up holes in their own brickwork. The mere sight of such formations must have been enough to fill the enemies' hearts with dread.

Under Philip II, the grandfather of the king on the throne in 1625, Spanish soldiers had been famous for their discipline. Their perfectly vertical pikes held up in parallel had come to symbolise military order. Velázquez did not wish to paint a display of military prowess, however. Not all of the pikes are held up vertically. The heyday of Spanish discipline was over. By the time Velázquez came to paint this picture, the only Spanish volunteers were adventurers and criminals on the run. The Spanish ranks were largely composed of foreign mercenaries who changed sides regularly, were paid little, and placed all hope in booty. When a military campaign came to an end, they were dismissed, forming bands of marauders who were the scourge of the rural population. During the Thirty Years' War (1618–1648), central Europe was full of unemployed mercenaries looking for someone to lead them. Those in service were frequently worse off still. In 1629, four years after the triumphant victory at Breda, a letter from Flanders arrived at the Spanish court: "The soldiers are starving to death," it reads, "and go half-naked from door to door begging for alms. We have reached the end of our tether."[2]

Velázquez' pikemen are almost faceless. Unlike the officers observing the ceremony, they have kept on their hats. Perhaps they are watching the withdrawal of the Dutch garrison in the background. They would probably feel some bitterness at the fact that their hopes of plunder had been foiled by a gesture of *sosiego* for which they would not feel the slightest sympathy. *Sosiego* had nothing to do with the reality of their lives or needs.

Spinola's officers were Italians, Germans and perhaps even Flemings, but there was hardly a Spaniard among them. The Spanish noblemen no longer wanted to fight. They rejoiced at their monarch's military success, organised sumptous feasts for his and their own pleasure, but they no longer went to war themselves. That was a thing of the past. Special taxes imposed by the king on those who refused to take the field had no effect; the nobles preferred to pay up and stay at home, where at least they could enjoy life. In their minds Spain was still the greatest and most powerful empire on earth; merely to be a subject of the empire was enough to relieve them of all further responsibility. If they accepted a post at all, it was as governor of a South American colony, for those who returned from such posts were rich. In Europe itself, there was little gain to be made.

With the king's commission to paint the siege nine or ten years after the victory at Breda, Velázquez was instantly plunged into a quandary. There had not been a spec-

tacular battle worth commemorating; nor had the Spanish regiments excelled. The soldiers' main battles had been fought against hunger, cold and illness. Not even the commander had been born in Spain, let alone most of his generals, and Spinola had evolved his strategy with the aid of Italian experts. What was left? There was *sosiego* – a form of composure so highly thought of in Spain that it was assumed to be archetypically Spanish. In fact, it had very little to do with the reality of the siege campaign.

## Portrait of a self-confident artist

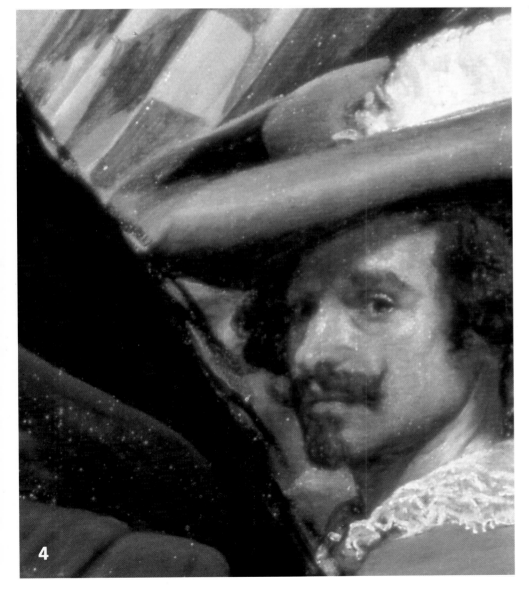
4

The soldier furthest right in the painting resembles the artist himself; many art historians take this figure to be a self-portrait. Velázquez was not present at the surrender of Breda. The panoramic military landscape was probably executed after an engraving by Jacques Callot. He had got to know Spinola during travels to Italy, but was unacquainted with Justin of Nassau. The Dutch commander probably looked older at 66 than he does in the painting.

Velázquez painted the "surrender" for the king's new residence in 1634 or 1635, nine or ten years after the historical event itself took place. One of the main rooms of the new palace was the Salón de Reinos, the Salon of Kingdoms. This contained a series of twelve large paintings celebrating the military triumphs of Spain in the reign of Philip IV. Spain's greatest artists competed, and the triumphal series attained mythical heights in a depiction of the famous twelve tasks of Hercules, the muscle-bound son of Zeus, by Francisco de Zurbarán (1598–1644).

What a contrast! A king who is unable to pay his soldiers – lack of money had meanwhile led to military disaster and death for Spinola in Italy, too – builds a residential palace with a hall devoted to his own fame, while his realm, incapable of defending itself, falls into economic wrack and ruin. The contrast was quite typical for Spain at the time: economic and political decline on the one hand, flowering of the arts on the other, with Madrid itself the cultural centre of Europe. Velázquez, Murillo and Zurbarán were all painting here during this period, as was an important representative of the previous generation: El Greco. Literature and the theatre were dominated by equally important figures such as Lope de Vega, Calderón de la Barca, Tirso de Molina and Miguel de Cervantes.

The power of a literary text is sometimes illustrated by the way fictional characters leave the written page and, like Don Juan or Don Quixote, take on a popular life of their own. Both figures originate from this period; Cervantes's *Don Quixote* was published between 1605 and 1615, while Tirso de Molina's *Don Juan* was first performed in about 1624. Furthermore, both figures are very much the products of this period in Spanish history. Don Juan is a noble who rejects all social convention and duty, devoting his life to pleasure and the seduction of beautiful women: a figure who would never have taken to the field in defence of Catholic Spain. Don Quixote is a dreamer whose head is full of old-fashioned Spanish chivalry; blind to realities, he takes up the fight against windmills.

Finally, both figures share an important quality with General Spinola, as painted by Velázquez; each, in his own way, demonstrates *sosiego*; each reveals that contempt for the real world which forms an essential component of *sosiego*. Don Quixote's failures to defend the old, chivalric values are borne with equanimity. Don Juan generously invites the stony-faced harbinger of his own death to eat at his table; he descends to hell without remorse. Spinola, meanwhile, comforts his adversary as if he were a friend, allowing his enemies to hold on to weapons which they will continue to use against Spain.

## Jacob Jordaens: The King Drinks, 1640/45

# Tho' our wealthy days be done, here's to a life of luxury

"The King drinks!" was a toast pronounced by the assembled company when an old man wearing a crown raised his cup to his lips – whereupon everyone drained their glasses. Such was the custom at the Twelfth Night feast in many Catholic countries of Europe. The 6th of January is still widely celebrated today, if not with the roistering gusto exhibited by the revellers in the painting. Some are shown yelling at the tops of their voices, others gesticulate wildly; one is depicted in the act of vomiting. It seems that none of the company takes umbrage at a proverb fixed to the wall at the back: "Nil similius insano quam ebrius", or "Nothing resembles the madman more than a drunkard."

Light at the window suggests a daytime scene. Feasts of this kind would last from noon until midnight, the revellers keeping themselves amused between courses with songs and games. The Twelfth Night Feast, also called the "Feast of the Bean-King", was an occasion to which relatives, special friends and servants were invited. Children would also partake and, like the blonde girl in the foreground, were sometimes allowed a sip from the wine-glass. Cats and dogs completed the scene.

Jacob Jordaens (1593–1678) probably used his family and servants as models for this scene, setting it in his own house in Hoogstraat, Antwerp. The picture was executed between 1640 and 1645. Business was good; the artist was highly successful, and paintings of this kind sold particularly well. Twelfth Night festivities had provided the subject for six of his paintings. He devoted a similar number of canvases to yet another company at table. These were entitled: "As the old cock crows, the young cock learns". Both sets of paintings celebrated values that were greatly cherished by his clientele: the family, prosperity, pleasure. Coarse detail, such as the drinker vomiting, was not considered inappropriate here. Other works depict children waiting for adults to clean their bottoms.

An imposing format was important to buyers; this work, now at the Kunsthistorisches Museum in Vienna, measures 242 by 300 cm. A large number of figures was also important. Most of Jordaens' commissions came from the wealthy bourgeoisie of the southern Netherlands, a region roughly equivalent to today's Belgium. At that time, it was part of the Spanish Empire.

Both the southern and northern provinces had attempted to gain independence from Spanish rule; following a protracted struggle, the north alone had been successful. As a result, the northern provinces flourished, while trade in the south stagnated. Jordaens' patrons had lost much of their business and were forced to draw on the amassed wealth of fatter years. This may explain their predilection for the artist's portrayal of them as folk whose zest for life appeared quite unbroken.

Ownership of this painting eluded them, however. Instead, it was acquired by a Habsburg: Leopold Wilhelm, the Spanish viceroy at Brussels. In 1656, he left for Vienna, taking the painting with him.

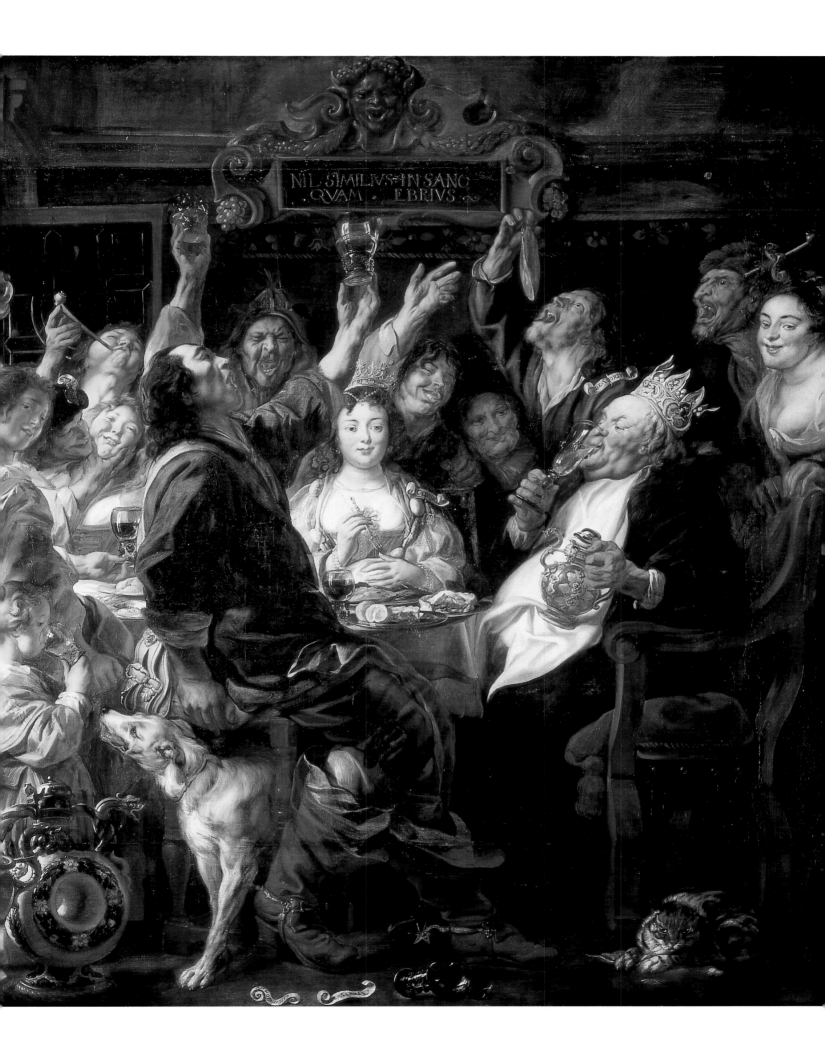

NIL SIMILIVS INSANO
QVAM · EBRIVS ·

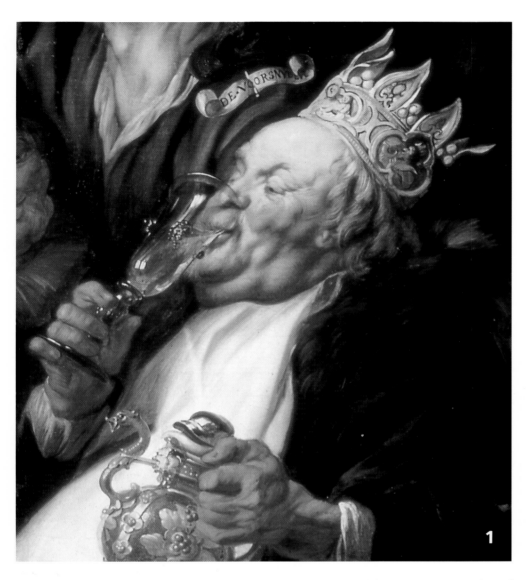

1

## A mediocre painter – but a great boozer

The popular figure of the old man wearing a golden, pasteboard crown is no stranger to Jordaens' work. He is Jordaens' father-in-law, Adam van Noort, a member of Jordaens' household until his death at the age of eighty. Although a mediocre painter, Van Noort became one of Antwerp's more wealthy citizens. His status in the history of art, however, is based solely on the reputation of his two famous pupils: Peter Paul Rubens and Jacob Jordaens.

The old man's crown distinguishes him as the King of the Feast. It was customary in Antwerp to determine the king and queen of the feast and members of their court by drawing lots. Lots, called "billets de roi", were hawked on the streets on the days before the 6th January. Two such tickets, inscribed "Sanger" (minstrel) and "Hofmester" (Controller of the Royal Household), are seen on the floor between the dog and the cat, while others are worn by the guests: the man with the fish is the Carver; the "billet" pinned to the hat of the vomiting drinker identifies him as a "medezijner" (doctor of medicine). The drawing of lots does not appear to have decided the "cast" of Jordaens' paintings, however; the oldest man is always the king, and the most beautiful woman is always queen.

In some parts, a bean or coin was hidden in a cake; whoever found it was king, and would choose his own entourage. The painting, like so many other depictions of the same theme – by Jan Steen for example – is also known as "The Feast of the Bean-King". Pieces of Twelfth Cake were cut not only for the guests, as the 16th-century German preacher and chronicler Sebastian Franck observed: "To honour God", he wrote, pieces were kept for Jesus, the Virgin Mary and the Magi. As soon as lots had been drawn, the new king was lifted into the air three times, to the applause of the assembled company. According to Franck, the king then went solemnly about the house chalking crosses on floorboards and beams to ward off evil spirits and ill luck. Ritual ceremonies of this kind were held throughout the Catholic countries of Europe; in some places, the tradition remains unbroken to this day.

The 6th of January had always been a significant date in the Christian calendar. The birth of Christ had originally been celebrated on this day. After a long dispute between various communities in the Christian world, the date had been brought forward to the 25th of December. The new Christmas was evidently intended to displace popular pagan festivals which had taken place on that day: the rites of the Egyptian goddess Isis, for example, or the Nativity of the "Sol Invictus", the Unconquered Sun, celebrated throughout the Roman Empire.

From now on, Christian believers no longer celebrated the corporeal Nativity of Christ on 6th January, but a spiritual birth. The day was now reserved for the festival of the Epiphany, the day of baptism and manifestation of Christ's glory. Christ had manifested himself to the Gentiles in the person of the wise men of the East. Popular belief saw the Magi not only as expert astrologers who had followed a star to Bethlehem, but also as scientists and magicians. They thus had practically become auxiliary saints with the power to ward off evil, guard against fire, sickness and bad weather, or, since they had come so far themselves, give protection to travellers. Their names, Caspar, Melchior and Balthasar, were sometimes invoked in blessings.

In the 9th century, the three wise men, now promoted to the status of kings, were adopted by the Christian liturgy. From the 11th century onwards, their day was marked by carol-singing and entertainments. The tradition of sumptuous feasting can be traced back as far as the 14th century: it was customary, following the service at Epiphany, for the deans of churches in the north of France to invite their chapter to a banquet at which they would preside as King of the Feast. Groaning tables were greeted as a presage of good fortune in the new year; left-over food met with disapproval.

Sumptuous banquets lasting several days at a time were also held on other occasions. These were expensive for the host and, since they frequently ended in excessive drinking and brawling, a thorn in the side of the authorities. The government did what they could to contain such dissipation, but even the "Decree against excessive behaviour at weddings and excursions for the purpose of banqueting" from 1613 was no more effective than previous decrees.

The Guild of St. Luke at Antwerp, a professional association of painters, had been founded to provide mutual assistance in time of sickness and distress. During the 17th century, however, the Guild was much given to the organisation of festivities. Practically its entire income was spent on an annual banquet held on St. Luke's Day. It is therefore hardly surprising that Jordaens attempted – in vain – to decline his election to the post of Dean of the Guild in 1621. He presumably felt that he would be unable to foot the enormous bill for expenses which he knew his new office would bring. Even death provided opportunities for revelry. No fewer than four funeral feasts were held at Antwerp to mark the occasion of Rubens's death in 1640: one by his friends and next of kin at the house of the deceased; another, at the Town Hall, by the members of the Town Council; a third, for the Romanist Brotherhood, took place at an inn called "The Marigold"; while the fourth, a feast organised by the Guild of St. Luke, was held at an inn called "The Hart".

Feasting was widespread even in monasteries and convents. On the occasion of one young lady taking the veil at the Falcon Convent at Antwerp on 10 February 1664, the convent archives report a celebratory feast attended by 19 guests who, between them, ate "20 half-stivers-worth of white bread, a boiled leg of mutton, two hams, two pieces of salted meat, three bowls of rice, three bowls of mutton stew with vegetables, sausages and dumplings, and three bowls of plum purée. That was the first course."[1] This was followed by two equally abundant courses, the whole feast being repeated on the following day. Even when festivals like the Twelfth Night were celebrated within the family, at least a dozen substantial dishes would usually be served. The guests in the painting have already eaten their fill, leaving the table almost empty, although one of the ladies is still shown picking at her food with a fork. The only other visible food consists of a half-eaten pie, a few pieces of orange and, at the other end of the table, a few prawns to go with the alcohol, or perhaps to encourage thirst, like the salted herring one guest is depicted as dangling above his open mouth.

A custom linked with the Twelfth Night feast was the practice of looking up at the stars through the chimney. The number of stars counted by the viewer determined the number of glasses of wine he was then permitted to drink. The rummers of the celebrants were probably filled with Rhine wine and Moselle. "Taking away a Fleming's glass," wrote one French traveller in the 18th century, "would be like cutting off the roots by which a tree draws up its sap."[2] Almost two thirds of Dutch genre paintings depict drinking scenes in the home or the tavern. Even ceremonial group portraits capture highly respectable town councillors in the act of raising their glasses.

## Occasions for revelry

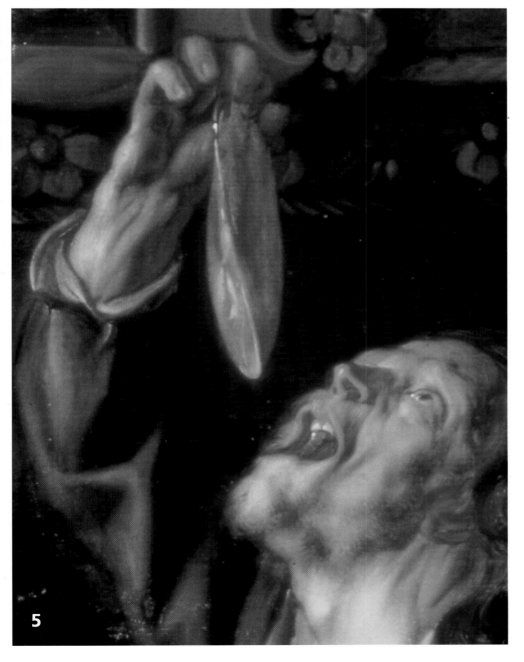

5

Cardinal Infante Ferdinand, a predecessor of Leopold Wilhelm as Viceroy of the Spanish Netherlands, once visited Antwerp's great fair. Filled with disgust, he reported what he had seen to his brother, King Philip IV. After the procession, he wrote, "the people sat down to eat and drink until eventually they were all drunk. It is apparently impossible to celebrate any other way here. They live like veritable animals."[3]

For the Spanish, concerned above all

## They live like veritable animals

things with posture and bearing, a drunk was someone utterly lacking in human dignity. "Drunkard" was considered so violent a term of abuse that its use could provoke a duel. The example quoted above reveals how distant were relations between the Spanish and the Dutch, who had been brought together by a royal marriage and inheritance. In the 16th century, the Spanish Habsburgs had inherited the 17 rich Netherlandish provinces (today's Belgium, Holland and Luxemburg) as part of Burgundy. King Philip II's policy of centralising power and his intolerance drove the freedom-loving, partly Protestant Dutch to rebel against their Spanish, Catholic overlords. After eighty years, the struggle was concluded by the terms of the Treaty of Westphalia in 1648: the northern provinces would receive their independence as a Calvinist "Republic of the United Provinces of the Netherlands"; the southern provinces, meanwhile, remained under Spanish rule – politically disabled, strictly Catholic and economically feeble.

Jordaens painted his Twelfth Night feast during the final phase of the struggle, between 1640 and 1645. The fighting had all but ceased, especially as far as the southern provinces were concerned. Spain, with its incompetent burocracy, chronic lack of money and demoralised army, had relinquished its former military power.

Even if it had managed to hold on to the southern provinces, Spain proved incapable of defending the strategically important Scheldt estuary. A blockade imposed by the northern provinces cut Antwerp off from the North Sea trade routes to which it owed its affluence.

An Englishman travelling in the southern provinces described the "devastated countryside, demoralised inhabitants… an impoverished nobility and degenerate merchant class… towns destroyed… general poverty".[4] This had been written some time before Jordaens painted his picture. In the meantime, however, Antwerp had largely been rebuilt and the causes of the acuter misery eliminated. A century earlier, the town had been one of the richest trading centres of the world; now it had lost half its inhabitants. The English and Italian banks had fled. In 1648, the Municipal Library moved into the empty Stock Exchange.

The cultivation of entrepreneurial skills was practically taboo in a country where aristocratic pedigree and land ownership were all that counted. The sons of once prosperous merchants now gave up their fathers' business and set about purchasing titles and estates.

Strict censorship by the Catholic Church inhibited art and cultural development; French became the dominant language, replacing the indigenous Flemish tongue, which was now thought fit only for "the tavern and the kitchen". At the same time, this had the effect of robbing the people of pride in their national independence and past achievements. All that was left now was retreat into the privacy of their own homes, where they could hold feasts, and talk, sing, yell and swear in Flemish as much as they liked.

## Bourgeois domestic scenes

The chubby-faced blonde drinking from a wine-glass with such abandon turns up repeatedly in the artist's work. She was probably one of his daughters. Jordaens would often use the same motif over and over again. He did this more often than other artists, finding it hard to paint from the imagination. Moreover, the constant stream of commissions he received during the second half of his life left him little time to invent new scenes. The demand for his services ran to altarpieces, pagan mythology and bourgeois domestic scenes.

Rubens, sixteen years Jordaens' senior, had spent decades of his life supplying wealthy patrons throughout Europe with the Christian genre pieces and mythological themes favoured during the age of absolutism and the Counter-Reformation. Like Jordaens, Rubens lived in Antwerp, and both artists had shared the same master. Jordaens occasionally assisted at Rubens' studio, for even a tireless genius like Rubens was only capable of meeting the great demand for his work with the aid of a workshop run almost along factory lines.

In 1637/38, Rubens was commissioned to paint a series of 56 allegorical paintings for the King of Spain over a period of 15 months. To meet this demand, a team of otherwise independent artists had to work under Rubens' direction. One member of this team was Jacob Jordaens, who was considered a competent, minor painter. One year later, in 1639, the English court considered giving a particularly large commission to Jordaens instead of Rubens. Jordaens, after all, did not charge as much.

Rubens died in 1640, one year before the other great Flemish painter of the period, Anthony van Dyck. Their deaths made Jordaens the pre-eminent artist of the southern Netherlands. As a result, he was able to take on more pupils. His wealth and reputation quickly grew, although his fame would never match up to that of Rubens. Jordaens lacked Rubens' international clientele, and his work was less sought after in aristocratic circles. Unlike Rubens, he had never left Flanders; nor did he share Rubens' experience of diplomacy or life at court. Whereas Rubens had risen to the ranks of the aristocracy, Jordaens remained

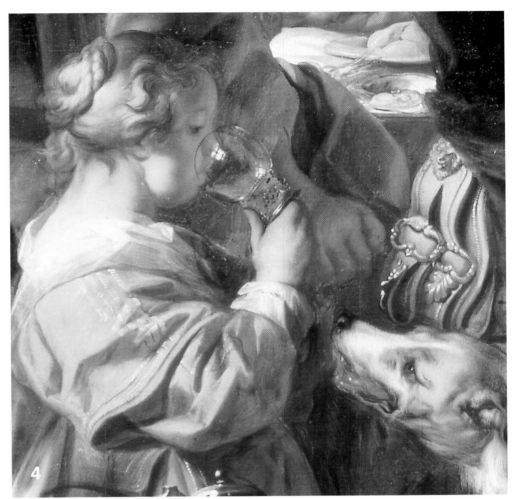

an ordinary citizen. His best customers were affluent townsfolk. Finally, unlike Rubens, he did not receive commissions from the most important churches in the land. The powerful, aristocratically-minded Jesuits, for example, had never sought his services.

At about this time, a new and highly idiosyncratic bourgeois art was emerging in the northern provinces, which had emancipated themselves from their Spanish, aristocratic overlords. Instead of the usual portraits of rulers, artists there were painting groups; and instead of mythological scenes, quotidian scenes from the limited world of the tranquil bourgeois interior were now considered worthy of art. Artists such as Gerard Terborch and Pieter de Hooch, and later also Jan Vermeer, painted small, unpretentious scenes from everyday life with very few figures. These artists formed the avant-garde in a Europe otherwise dominated by grandiose Baroque display.

Although executed under Spanish rule, Jordaens's images of boozing and gluttony also depict everyday scenes in bourgeois interiors. But Jordaens' works have nothing of the plain candour demonstrated by

his northern contemporaries. Instead, he favoured the lavish Baroque style so ably and peerlessly promoted by Rubens. However, Rubens had never intended his style to be applied to crude, everyday reality. On the contrary, he had chosen to paint fantasy worlds in which the fortunes of rulers were directed by the gods. His drunkards appeared in the guise of Sileni, frolicking in the company of Bacchantes.

The Baroque pathos of the style contrasts with the painting's somewhat banal subject. Jacob Jordaens has painted a small world in a grand manner. The sweeping gestures seem too large for the narrow interior, and the expression of mirth on some of the faces has a static, almost masklike quality. This contradiction reflects something of a dilemma in the southern provinces, whose citizens would have liked nothing better than to live in the grand style they had enjoyed in the old days. Only those days were over.

The economic centres now lay to the north. The citizens of the south had grown poorer. Their feelings of impotence and fear are hidden behind an emphatic display of vitality and *joie de vivre*.

# Rembrandt: Jacob Blessing the Sons of Joseph, 1656

# An Old Testament family portrait

Jacob was a Jewish patriarch. According to tradition, he was 147 years old when he died. On his deathbed he blessed his sons and asked for his grandsons, Manasseh and Ephraim, to be brought to him so that he could also bless them. Their father, Joseph, is seen here helping the old man to sit up, while their mother, Asnath, watches.

The event takes place in Egypt, though it is unclear whether the scene shows the interior of a tent or a building. Rembrandt Harmenszoon van Rijn (1606–1669) has painted Jacob in a cap commonly worn in the 17th century. He has given the boys' father a Turkish-style turban, while their mother is shown in a Burgundian bonnet, once fashionable in the Netherlands. The turban and bonnet are intended to suggest an ancient, Oriental scene.

It was largely unknown at the time what the Old Testament peoples wore. Knowledge of the Old Testament itself, on the other hand, was widespread. Its various stories and figures were common knowledge at every level in society. Rembrandt could take it for granted that his contemporaries would know all about Jacob's blessing.

People today have become estranged from the practice of blessing; if it is thought of at all, then as something performed by priests and ministers of the Church: an entreaty to God for provident care. In Old Testament times, however, a blessing meant more than that. A progenitor's blessing conferred upon its recipient a special status in the family. This, in turn, attributed to him a role within the history of his people, thereby also linking him with the history of his people's salvation. The people in the Bible saw life on earth as unfolding according to God's plan. God intervened directly in human affairs: by helping the faithful and punishing the faithless.

The custom was for the father or patriarch to lay his right hand on the head of the firstborn, thus appointing him head of the family. In blessing his grandsons, however, Jacob broke with tradition. He laid his right hand on the head of the younger boy, Ephraim. The boy's father, Joseph, attempted to redirect Jacob's hand. He thought his father had made a mistake, for the old man's eyes "were dim for age". But Jacob said: "I know it, my son, I know it", explaining that Manasseh would also "become a people", but that "his younger brother shall be greater than he, and his seed shall become a multitude of nations" (Genesis, 48).

*Jacob Blessing the Sons of Joseph* measures 173 by 209 centimetres, with a signature in the bottom left, below which the painting is dated 1656. It belongs to the Staatliche Kunstsammlungen at Kassel and hangs in the Old Masters gallery at Schloss Wilhelmshöhe. Rembrandt-experts are currently investigating the authenticity of all works attributed to Rembrandt, but results have not yet been published with respect to *Jacob Blessing the Sons of Joseph.* There can be little doubt of the painting's authenticity, however, despite manipulation of the signature.

98

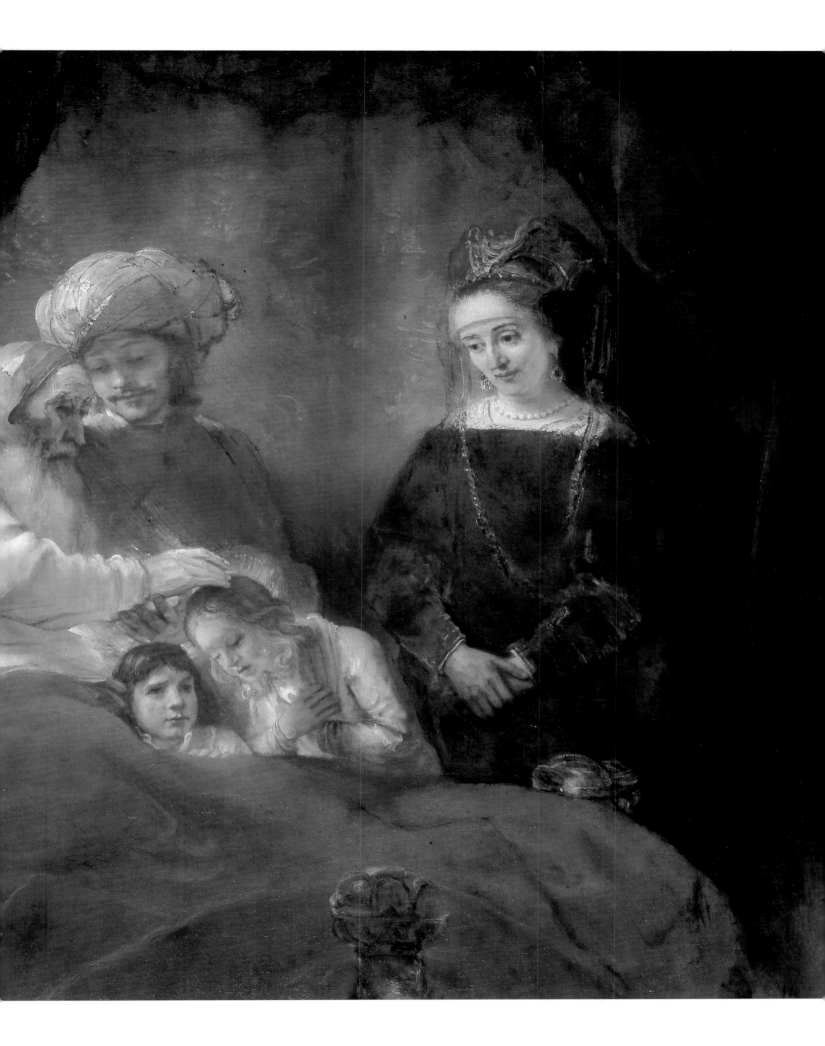

## Ephraim resembles Christ

Seventeenth century spectators well versed in the Bible would have been acquainted with the story of how this venerable old man had once deceived his own father, Isaac, into blessing him. Jacob had already tricked his brother Esau out of his birthright for a "pottage of lentiles". When it was time for Isaac, who was also blind, to bless Esau, his firstborn, Jacob crept into his father's tent disguised as his brother. His father blessed him with the words: "Let people serve thee, and nations bow down to thee."[1] Although Jacob's deceit was discovered, it was impossible to reverse the effect of the blesssing. Blessings, when spoken by the right person, laid down the law.

Jacob could therefore hardly be described as a paragon of virtue, but what counted for the authors of the Book of Genesis was that he had been chosen by God, and that he remained faithful to the Almighty. He wrestled with the angel until he, too, gave Jacob his blessing. He dreamed of a ladder to heaven with the Lord God above telling him that his seed would be spread to all the points of the compass, but that God would eventually lead "the families of the earth" back to Israel.

Motifs from the life of Jacob had often provided a theme for medieval and Baroque painting, and Jacob blessing his grandchildren was one of the most popular subjects. It was important to both artists and patrons that Jacob should be depicted with crossed arms. This was seen as an allusion to the Cross at Golgotha. According to Christian doctrine, Jacob's choice of the younger grandson anticipated the new faith: Ephraim stood for Christianity, whereas Manasseh represented the older Judaism.

In 1620, a few decades before Rembrandt executed this work, an Italian artist of the Bolognese school, Il Guercino (1591–1666), had shown Jacob in the act of blessing with his hands very obviously crossed in the middle of the painting. Rembrandt, however, attaches practically no significance to the motif of crossed arms or hands. It is suggested that Jacob's left fingers touch Manasseh's dark hair, but it is unclear whether Manasseh is crouched further to the fore than his brother, as would be necessary if Jacob's arms were to be seen as crossed.

Rembrandt uses other means to emphasise Ephraim's special role: he paints the boy as a young Christ, suggesting a halo around his head and portraying him with his arms folded across his breast. His omission of the traditional motif of Jacob's crossed arms may be due to his knowledge of a new translation of the Bible. The word "crossed" in the ancient Latin Bible used by the Catholic Church had been changed to "wittingly" in the new Calvinist and Lutheran translations. The meaning of the corresponding Hebrew word had been the subject of some controversy. Interestingly, the latest, revised versions have reverted to the words "crossing his hands".

Rembrandt lived in Amsterdam, which, like all the northern Dutch provinces, had embraced the Reformation and struggled free of Spanish-Catholic domination. Il Guercino, on the other hand, was painting in Catholic Italy within a tradition unbroken since the Middle Ages and wholly consistent with the aims of the Counter-Reformation. The rendering of Jacob's arms thus indicates the geographical and religious standpoint of each of the artists.

# Return to the land of the fathers

Rembrandt kept his distance from the Calvinist Church. It is unlikely that he belonged to any of the Churches or sects that were active in Amsterdam at the time. The municipal authorities maintained an astonishingly liberal attitude to the many religious groupings of the day, making life hard only for their old rivals, the Catholics.

Synagogues, too, were tolerated. There was a large Jewish community at Amsterdam, the majority of whose members had fled the Inquisition in Spain and Portugal. With them they had brought valuable commercial skills and trading contacts, thus aiding Amsterdam's rise to the foremost trading centre of 17th-century Europe. It may also have been Jewish influence that led contemporary artists, Rembrandt among them, to return again and again in their work to the great figures of the Old Testament.

It is known that Rembrandt had Jewish acquaintances. The street where he lived was also home to a large number of Jewish families, and the artist made friends with a rabbi who was named after one of Jacob's grandchildren: it was probably Manasseh ben Israel who introduced Rembrandt to the idea that the Jews were God's chosen people, and that a Messiah would one day lead them to the Promised Land.

The sense of Messianic promise had recently become especially intense for this rabbi in Amsterdam, for a traveller returning from South America had observed tribes of people there who lived like Jews. Now the scattering of the Jews to every corner of the earth was regarded as a precondition for their ultimate salvation. With the discovery of Jews in America, there was only one country missing: England. So Manasseh ben Israel submitted a petition to the English dictator, Cromwell, travelling to London to obtain permission for Jews to settle again in England. He died on the way back to Amsterdam in 1657.

Rembrandt had painted *Jacob Blessing the Sons of Joseph* in 1656 while the rabbi was in London. There is a connection between the theme of the painting and the rabbi's mission to England. During his dream of the ladder to heaven, Jacob had been assured by God that the Jews would return to the Promised Land; Jacob was therefore one of the most important figures of Jewish history, whose promise Manasseh ben Israel was struggling to fulfil. Even if the painter did not share Jewish belief in the prophecies of the Old Testament, they had been explained to him by people he knew and trusted.

An event which took place during the same year provides us with a further insight into the Jewish community at Amsterdam: the curse called on the philosopher Spinoza (1632–1677). Spinoza was a Jew who denied that the Jews were God's chosen people, an attitude for which he was expelled from the Jewish community: "Cursed be he by day and cursed be he by night; cursed be he when he lies down and cursed be he when he rises up... The Lord will destroy his name... We ordain that nobody shall communicate with him orally or in writing nor show him any favour... "[2] A curse is the opposite of a blessing, and the words chosen to drive Spinoza from Amsterdam show how great, during Rembrandt's lifetime, was the belief in the expression of divine power through the human word. Rembrandt's contemporaries will undoubtedly have seen the event depicted in his painting of Jacob as a true representation of reality.

The Calvinism predominant in Amsterdam at the time was similar to Jewish belief in a number of important ways: both conceived of God as vengeful rather than forgiving; a deterministic outlook was common to both; in both, material wealth could be interpreted as a sign of divine benevolence; Calvinistic and Jewish leaders were required to base their politics on religious doctrine.

# A new ideology of the family

I t is not known whether Rembrandt received a commission to paint Jacob's blessing. It is quite likely, however, that the artist chose the subject himself, and at his own risk. Rembrandt was one of a growing number of artists who were attempting to emancipate themselves from the traditional system of patronage. These artists wanted to develop their work independently of their patrons' inhibiting requirements, although many of them – including Rembrandt – fell into debt as a consequence. They probably hoped that their creditors would be forced to buy the paintings which thus accumulated in their studios.

Rembrandt's interest in the motif of Jacob's blessing can be traced not only to his acquaintance with the topical issue of God's Old Testament promise to the Jews, but also to his special preoccupation with the subject of blindness. An earlier work, showing the blinding of Samson, had been executed with gruesome realism. Blind beggars frequently appear in his drawings and sketches. He painted Jesus healing the blind, and several scenes illustrating the story of blind Tobias whose eyesight was returned to him by his son. Rembrandt probably witnessed his own father's loss of sight and was plagued by a lifelong fear that the same thing might happen to himself.

Age was a related theme; Rembrandt, after all, was 50 when he painted *Jacob Blessing the Sons of Joseph.* The painting shows three generations: youth, parents and the aged. Pictures comparing the different "ages of man" had been common enough in Classical antiquity. The medium for the portrayal of human ageing had been the male body, since men were thought to represent mankind. Classical themes enjoyed renewed popularity during the Renaissance, and the process of ageing was now demonstrated in portraits of female as well as male bodies. In the 17th century the subject of human age was linked to the depiction of family scenes, and the attempt to categorise different stages of the ageing process was relinquished in favour of their realistic integration into "lived" situations.

3

In order to show difference in age, Rembrandt alters his brushwork. The smoothness of Joseph's younger face is reflected in a smoothly finished canvas, whereas the wrinkled brow of the old man is achieved with rough furrows of paint.

At the time, family portraits were sometimes commissioned in the form of Old Testament scenes, but there is no evidence to suggest that *Jacob Blessing the Sons of Joseph* was painted to order.

Family portraits became increasingly popular from the mid-16th century onwards. This was an indirect consequence of the growth of towns, and of the Reformation. Unlike the majority of peasants, burghers were not enthralled to feudal lords; they did not have to ask permission to marry or move from one place to another. Their lives were also more secure, for they were not exposed to bands of marauding soldiers.

This enabled the more affluent among them to develop a more private lifestyle, a project which benefitted from the ideological support given to the family by the Reformation. Medieval monastic asceticism, the inward life spent in prayer far from the hue and cry, had reflected the highest ideals of the Catholic Church. Luther, by contrast, attached a far greater importance to the laity. The lay-world of the family, the patriarchal role of the father, the responsibility of motherhood, thus came to be seen in a new light. "It is true, the state of wedlock is humble," wrote Luther's supporter Melanchthon, "but it is also holy, and it is more pleasing to God than celibacy."[3]

The raised status of matrimony encouraged the cultivation of corresponding sentiments. This is illustrated by the text of a contemporary sermon: "It is impossible for a good Christian marriage to be lived without love," wrote a Rostock minister in 1668, for "all life without love is a form of hell," This was a new tone, by no means usual even in the late 17th century.

Rembrandt's painting contains something of the new familial sentiment. It has an intimate quality. The method Rembrandt employs to this effect – drawing the viewer's attention away from the indistinct setting at the margin of the painting – is nothing unusual in his work, only here he puts the method to new use.

## Transience and continuity

It was evidently unimportant to Rembrandt whether the bedposts squared with the perspective of the bed itself. Blankets and curtains function here as a kind of protective screen within which the figures are isolated from the outside world. The method heightens our impression that the figures in the painting are entirely absorbed by their own, personal affairs. Furthermore, he paints Ephraim and Manasseh as children; according to the Bible, however, they must have been at least 17 years old. He also has the children's mother watching on, although she is not mentioned at all in the Biblical scene. Other artists had altered the scene in a similar way, but none had so clearly intended to show the family as a self-enclosed unit. Theological considerations had dictated the inclusion of the children's mother in previous works. Since she was an Egyptian, it was important to legitimise her place within the Jewish line of succession.

The artist's intention to paint a family scene is nowhere more clearly expressed than in his portrait of Joseph. Joseph, after all, was the most important man in Egypt after Pharaoh. Joseph had had his father and brothers brought to him in Egypt to rescue them from famine. His brothers had wanted to kill him when he was a boy because he had dreamed that he would one day reign over them. But instead of killing him, they sold him to a caravan bound for Egypt, and it was there that Joseph's famous career began. Yet Rembrandt reveals nothing of Joseph's great power as a lord and governor.

In a painting executed twenty years earlier by Rembrandt, Joseph is shown as a powerful figure, vehemently protesting at Jacob's reversal of the conventional mode of blessing. In this picture, however, he is portrayed as a loyal son supporting his old father, looking gently on his children and willingly accepting his own role in the family.

This was not Rembrandt's original intention. X-ray photographs have shown that Joseph stood or sat further away from his father in the initial version of the painting, and that the children's mother was not included at all. It is not known why Rembrandt decided to alter his original conception of the painting and complete the family in this way. Perhaps there were personal reasons. In 1656, the year in which he painted this work, Rembrandt was declared insolvent. He was forced to sell his valuable collections and to move to poorer lodgings while his house was put up for compulsory auction. His wife Saskia had died fourteen years earlier, and he now lived out of wedlock with Hendricke Stoffels and his young son Titus. It is quite possible that in this period of existential crisis, the family painting was a comfort to him: a picture of security, but also a picture of transience and of continuity. One person parts, another arrives; an old man, dying, touches a child.

103

# Life: a drawing-room comedy

In Voltaire's opinion, the brief Régence had "turned everything to frivolity and jest". How right he was! Between 1715 and 1723, during Philip of Orleans's short period of regency government, the French enjoyed life to the full. Watteau's painting (37 x 48 cm), now in the Gemäldegalerie, Berlin, has captured the spirit of the times.

The Parisian theatres had never been so full. The enchanting fantasy world of the stage allowed an audience to escape the bleakness of reality for an hour or two. France was often a cheerless place at the outset of the 18th century. The country was exhausted after the costly war it had fought against most of Europe for almost 25 years. Louis XIV, the old Sun King, who was responsible for the disaster, had become strict and pious in the face of impending ruin. He had forgotten how he once danced at the centre of splendid ballets, or patronised dramatists like Molière. He no longer appeared at court entertainments, preferring instead to have the Italian Commedia dell'arte banned from Paris in 1697: they had dared allude in the title of a play to the prudishness of Madame de Maintenon, his companion in old age.

When Louis XIV finally died in 1715, the French breathed a sigh of relief and devoted themselves with renewed vigour to the pursuit of enjoyment – not merely in the interests of oblivion, but because they felt driven to make up for the misery of the past years. This was especially true of Philip of Orleans, the Regent, who governed France vicariously on behalf of the five-year-old great-grandson of the Sun King. It was the Duke of Orleans's official title, too, that gave the period its name: La Régence. The Regent's first priorities had been peace and economic recovery. He had also moved the court to Paris, exchanging the aloof formality of Versailles for the *joie de vivre* of the capital.

One of the first steps taken by the Regent had been to call the banned Commedia dell'arte back to Paris. They returned in 1716, immediately resuming their old rivalry with the official French stage: the Comédie Française. Antoine Watteau, born in 1684 as the son of a craftsman, painted both threatrical companies. Actors, minstrels and dancers were among his favourite subjects. These figures appear in many of his pictures, an often melancholy reminder of how short the regency era actually was (1715–1723), when, according to the philosopher Voltaire, "everything turned to frivolity and jest".[1]

## The role that brought fame and fortune

O nly one of the actors is looking straight at the audience. He is dressed completely in black, one hand resting on his sword, the other holding his hat. Very soon he will step out to the front of the stage and address his "most highly esteemed audience".

Every evening when the show was over, it was his job as "orateur", or spokesman of the troupe, to amuse the audience with a few well-chosen words and encourage them to come back again for more. Usu-

ally, he would speak off the cuff, and his "short, well-turned complimentary address," according to one contemporary observer, was sometimes "listened to with as much pleasure as the comedy before it".[2]

Molière (1622–1673) had doubled as director and spokesman of his troupe for many years. In 1716, the "orateur" at the Comédie Française was called Paul Poisson, and it is he whom Watteau has portrayed here. Poisson was a member of the "royal troupe", a company which was formed at the instigation of the court in 1680, several years after Molière's death, and which combined the talents of the three rival French stages in Paris. In fact, Poisson was better known alias Crispin II, a crafty servant, a role he played in countless comedies throughout his life.

In Watteau's painting he is shown wearing the traditional Crispin costume: a sword, a broad leather belt with a brass buckle, long, yellow gauntlet gloves and a starched-white rounded collar. His hat – worn over a small cap – doublet, hose and high, turndown boots are all in fashionable Spanish black, a reminder, perhaps, of his origin. This "comic" had made his first appearance on a French stage in the mid-17th century as Crispinillo in Paul Scarron's burlesque *Pupils of Salamanca.* He was so popular with the Parisian theatre-going public that various authors wrote a series of different parts for him: "Crispin, the doctor", "Crispin the censor", "Crispin the chaperone", and even "Crispin the Egyptian mummy". Crispin was cunning. He was forever running after the pretty maid Lisette, while at the same time assisting his master in the success of his own love-affairs. It was Crispin, too, who later inspired Pierre Augustin Caron de Beaumarchais's famous figure of Figaro.

Paul's father Raymond first played Crispin in 1654, after which the role remained in the family for five generations. The Poissons were not only endowed with a certain loudmouthed swagger that went with the part, but were also highly skilled in the figure's muddled stammering. In the course of time, the Poissons became a kind of theatrical dynasty and, not unlike monarchs, were given distinguishing numbers. Crispin I's comic accomplishment is underlined by Molière's testimony that he "would gladly have given everything he had to be blessed with the natural ability of this great actor".

When Raymond Poisson retired from the stage, Paul immediately gave up his highly respected position at court to succeed him as Crispin II. Paul's acting won him great esteem and wealth. In real life his unscrupulous behaviour is said to have matched that of the figure he played so well on the stage, and he became involved in dubious financial affairs in order to pay for his expensive lifestyle.

At times it was impossible for one actor alone to meet the great public demand for the Crispin-figure. From 1700, Paul's son Philippe therefore joined his father on the stage as Crispin III. Paul Poisson retired to the country in 1724, but was required to return to the stage once more at the age of 70: the young King Louis XV had demanded to see the legendary Crispin II.

The elegant gentlemen clinking glasses in the middle of the painting might easily pass as the guardian spirits of the age of regency revelry. Traditional attributes worn with their contemporary dress show them to be mythological figures. The actor on the left is wearing a crown of grapevines, with a leopard-skin slung over his shoulder. This was enough to distinguish him as Bacchus, the god of wine. Standing opposite him is a man with a golden quiver full of arrows: no commonplace hunter, this, but Amor himself, the god of love.

The presence of these two deities on the stage of the Comédie Française may help identify the play itself: it is probably *The Feast of Bacchus and Amor*, a pastoral by the composer Jean-Baptiste Lully, with content largely based on one of Molière's comedies. The play was performed twice during Watteau's lifetime, and there are records of "grapevines and a canopy of leaves" included among the accessories, as well as "musicking shepherds". One of the dance intermezzi was called "Le Professeur de la Folie" (The Teacher of Folly). Perhaps the pretty blonde with fool's bells sewn to her sleeve is imparting some kind of instruction in the fine art of tomfoolery to the two Olympians – a fool's sceptre can certainly be seen on the ground at the front of the stage.

A typical feature of this kind of stage production was the mixing of different genres: the two gods and the dancers are of operatic provenance; Crispin is a theatrical figure; the white-faced Pierrot really belongs in a fairground show. This blurring of distinctions was consistent with regency taste. La Régence, itself a period of transition, sought pleasure in the combination of normally separate forms of entertainment. Hybrids developed: the "comédie-ballet", for example, or the "opéra-comique" (an opera with spoken dialogues). Light comedy was especially popular. There was a return to the earlier stage tradition of providing a three-act comedy as light relief directly after a five-act tragedy. The length of the acts was determined by the life of the candles in the candelabra above the apron-stage. During intervals between acts the candelabra were lowered and the candles replaced.

Neither the candelabra nor the new stage lights, added in 1670, seem to interest Watteau; nor does he paint the genteel members of the audience who took seats on the stage to be close to the actors and show off their fine clothes, a luxury for which they paid more than five livres during the 1720/1721 season. The boxes were not quite so dear; standing room in the stalls, to which ladies were not admitted, cost only one livre. The performance at the Comédie Française began every evening at a quarter past five. Every evening, too, the actors went along to collect their share of the takings – once cleaning costs, the price of candles and a small levy "for the poor" had been subtracted.

## The age of Bacchus and Amor

The identity of the pretty dancer with the frilly white collar proposes no less of a riddle to the spectator than the stone head in a fool's cap grinning down on the scene like a sphinx. It is possible that Charlotte Desmares, whose passion – she was a collector – brought her into contact with many painters, sat for Watteau. In fact, she had won fame as a tragic actress, but she was not averse to

## The Regent's beautiful mistress

taking an occasional part as soubrette in a comedy. Like the Poissons, and indeed like most of her other contemporaries on the stage, she had been born into a family of actors and actresses, whose talent and technical skills were passed on from one generation to the next.

Charlotte Desmares was born in Copenhagen in 1682 – her parents were members of a travelling theatre group at the time – and first took the stage at the age of eight. Unlike many actors of her parents' generation, she decided not to hide her identity behind a stage name. The growing enthusiasm for theatre during the

18th century gave actors and actresses greater self-confidence. It turned many of them into stars who won the admiration of ladies of society and launched the latest fashions, the hooped skirt for example, on the stage.

It had become important for the actors to impress the audience with the richness of their costumes. If the supernumeraries were peasants who wore silk gowns and carried silver shepherd's crooks, then the main parts obviously had to be dressed even more lavishly: in satin, velvet and taffeta, with expensive ostrich feathers in their hats, and sporting gold and silver embroidery.

The two dozen or more members of the Comédie Française company had relatively high incomes (up to 39 times the wage of a labourer), a pension scheme, and enjoyed additional security through a royal pension which was paid in regular instalments to the company. The majority of actors and actresses nevertheless lived above their means. For this reason, Madame Desmares, like so many contemporary actresses, sought a generous "guardian". His name was Philip of Orleans, the later Regent.

He loved actresses "as long as they are good-humoured and shameless and drink and eat a lot",[3] noted his mother, Liselotte von der Pfalz. "The Desmares woman has given my son a little girl," she went on, "and she'd have liked to have saddled him with a second child, too, but he said: No, it's much too much of a harlequin... It's made up of too many different pieces. I don't know whether she's managed to foist it off on the Elector of Bavaria, who certainly had his share in its making, a privilege which cost him the prettiest, most expensive snuff-box you have ever seen...".[3]

Liselotte von der Pfalz was not particularly fond of actresses, a sentiment she shared with the Church: "Unhappy be those among you who laugh," the eloquent Bishop Bossuet thundered down from the pulpit, "for tomorrow you shall weep!"[4] Actors were given a Christian burial solely on condition that they renounced the stage in writing before they died. The king himself was forced to intervene before Molière could be buried in consecrated soil. Even in 1730, with the popularity of the French theatre at its climax, the police still had to bury the famous tragic actress Adrienne Lecouvreur under cover of darkness at the edge of the Seine.

4

## Musicians help create an illusion

**M**usicking shepherds" are said to have accompanied *The Feast of Bacchus and Amor.* On Watteau's stage they wear pink ribbons tied to their hats and shoes and play fiddles and wind instruments. The instruments are typical for a pastoral play. Before 1715, the violin was mainly used as an accompaniment to folk dancing; it was only later that its range extended to include virtuoso perfomances and chamber music. The musette, a type of bagpipes, had the advantage of being easy to use; moreover, its players did not have to blow into it and were therefore spared the necessity of pulling ugly faces.

Together with the oboe in the background, the lute leaning against the stone bench and the tambourine at the front of the stage, the little orchestra thus consisted

of five instruments altogether. It was officially forbidden for more than six instruments and two singers (here probably Amor and Bacchus) to appear on the stage at the Comédie Française at any one time during the 18th century. Although licensed to stage their popular plays with music and dance, they were required to limit the number of the cast, a regulation over which the royal opera kept a watchful eye. The composer Lully had – despite protest by Molière – been granted a royal monopoly for his sumptuous "musical theatre", with its large orchestara and chorus. From now on, the ordinary theatre was forced to limit its scope.

Music-making was hardly restricted to the theatre, however. Almost any gentleman or aristocrat worth his salt could play at least one musical instrument, the guitar being especially popular at the time. Musicians, besides actors and dancers, frequently appear in Watteau's paintings. With their costumes and masks, they populate his rural festivities and lonely parks,

lending them an aura of harmony and, at the same time, a hint of protean magic.

The young Antoine Watteau is said to have followed a painter of stage scenery from Valenciennes to Paris in 1702. He later worked for Gillot, a well-known illustrator of theatrical scenes and costumes. Thus Watteau's work constantly took him to the theatre. Strangely enough, little is known of the relationships, even closer ones, he presumably had with actors. Paul Poisson is the only one it has been possible to identify.

It also remains unclear when Watteau painted the French actors, or for whom. The painting was probably executed after 1716 with the help of sketches made some time earlier. The title of the painting, *L'Amour au Théâtre Français* (Love at the French Theatre) was not found on an engraving until after the artist's death in 1721.

In 1769, the work – together with *Love at the Italian Theatre* – turned up at Berlin in the collection of one of Watteau's admirer's: Frederick the Great.

A young couple, their cool gaze fixed on the spectator, poses before a broad country prospect. They are newly married. The woods, meadows and fields belong to their estate. Various details of the painting characterise their marriage, or comment on the state of contemporary agriculture. The work (70 x 119 cm) is in the National Gallery, London.

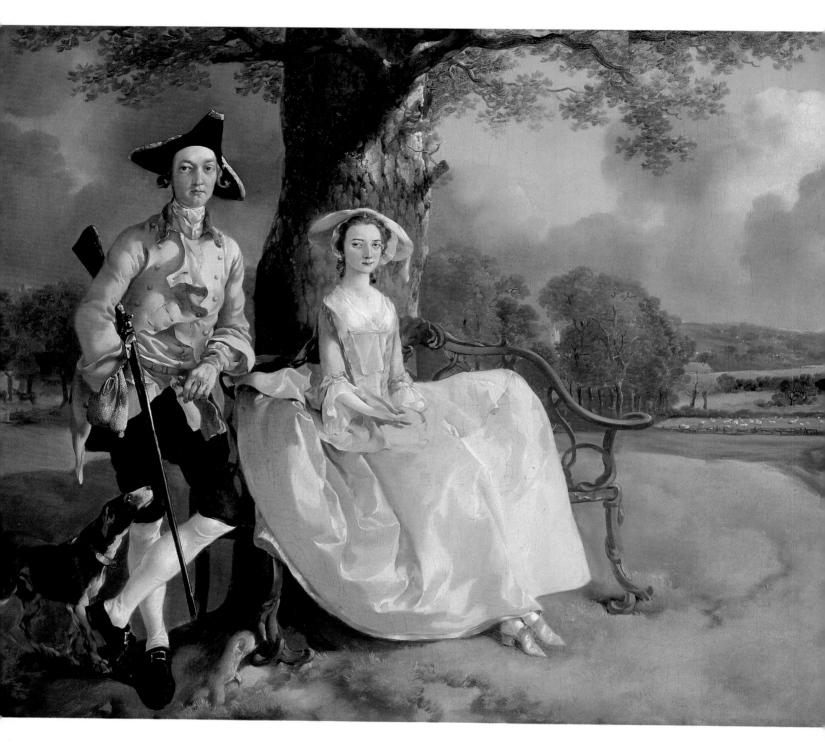

## Thomas Gainsborough: Mr and Mrs Andrews, 1749

# The proper combination of activity and leisure

A young couple, Mr and Mrs Robert Andrews, pose before the trunk of a mighty oak. The depiction of Auberies, their estate, with its fields, meadows and trees, takes up more space than the double portrait itself. No English painter before Thomas Gainsborough had chosen to allocate space in this way; nor did Gainsborough himself ever return to this pattern. Is it the experiment of a young artist? Or did the division of space correspond to his patron's wishes?

The identity of the couple has been passed down by the Andrews family, in whose estate the work remained for over 200 years. The 70 by 119 cm picture is now in the National Gallery. An entry in the parish register of the small Suffolk town of Sudbury records that Robert Andrews married Frances Mary Carter there on 10 November 1748. He was 22 years of age, his bride 16. Also newly wedded, albeit one year younger than the bridegroom he was to paint, was Thomas Gainsborough himself. In a London chapel notorious for its secret weddings, he had taken the pregnant Margaret Burr to be his lawful wedded wife.

After a number of years spent in apprenticeship in London, he then retuned to his native town of Sudbury. He probably painted the portrait only a few months after his patrons' marriage, in the late summer of 1749. The corn is cut, and the sheaves stand ready bound in the field.

Ripe ears of corn are a fitting fertility symbol for a wedding portrait. Gainsborough's realistic landscape also holds a number of other symbolic references to the couple's consummate marriage and hope of issue: a little tree grows between two larger ones on the right; the man's casually lowered shotgun and the bird lying in his wife's lap may also be seen as discreet erotic allusions. The bird, no more than a barely suggested outline against a lighter patch of colour, is possibly the victim of a certain nonchalance – towards finishing paintings that bored him, for instance – to which the artist was occasionally prone. "Painting and punctuality", he wrote to one patron, "mix like oil and vinegar", and "genius and regularity are utter enemies".[1]

The church spire of St. Peter's, Sudbury, a market town about two miles from Auberies, can be seen peeping out from behind the trees in the background. The Andrews had been married in the somewhat finer All Saints' Church. Sudbury had three churches, a reminder of more affluent times in which there was a flourishing textile industry. The bride's grandfather had made his fortune in the drapery business. He had invested his money in real estate, eventually becoming one of the region's largest landowners. His family were thus spared the consequences of the decline of the textiles industry. Its ruin was brought about by political instability towards the end of the seventeenth century, and wars at the beginning of the eighteenth. The latter had led to an increased tax-burden, the destruction of the home market and a sharp fall in all foreign trade. The writer Daniel Defoe, who passed through Sudbury in 1724, described the town as poor and highly populated.

## Garden bench with a Rococo flourish

The poor, according to Defoe, were on the point of devouring the rich – at least in number.[2]

The modest clothier's business run at Sudbury by Thomas Gainsborough's father was declared bankrupt in 1733. He was evidently not quite as astute in such matters as the Carters. The painter, born in 1727, and one of eight children, may well have inherited his father's lackadaisical attitude to property. More than earning money, he preferred to pick up his viola da gamba and walk out to a pretty village where he could paint landscapes.

By the age of 13, Gainsborough was already so skilled at drawing from the life that his family sent him, possibly with the support of a patron, to study in London. Under the designer and decorative artist Hubert-François Gravelot he learned the fashionable French Rococo style, which, in England too, had replaced the pompous solidity of the Baroque. Its influence can be seen in the elegant curves of Mrs Andrews's garden bench. It was in London, too, that Gainsborough became acquainted with the realism of Dutch landscape painting. Gainsborough made several essays in this

genre himself. However, landscapes were not in demand at the time. They were extremely badly paid and considered little more than decorative space-fillers, to be hung over doors or above fireplaces.

Gainsborough was therefore forced to earn his living with portraits – "face painting" as he called it – which he enjoyed far less than landscapes. In 18th century England, representative likenesses were the order of the day. Returning to his native Sudbury with his young wife in 1748, Gainsborough could probably reckon with a number of sitters among the wealthy squires of the region. Perhaps the Andrews-portrait, with its unusually generous accommodation of the surrounding countryside, was intended to give potential patrons a demonstration of his skills in realisitic landscape painting. To judge from the portraits he executed in the years that followed – in which his sitters were shown against a neutral background, or in conventional Rococo garden settings – his innovative proposal was taken up neither by the Suffolk gentry, nor by the members of society whose celebrated portraitist he later became.

1

# Upwardly mobile

2

There is not such a set of Enemies to a real artist" as the "damn Gentlemen", stated Gainsborough, railing against a class he was forced to portray all his life. "They have but one part worth looking at," he went on, "and that is their purse."[3] It is as a member of this species that Mr Robert Andrews, leaning casually on the garden bench with his legs crossed and his blasé expression, presents himself here. His ease of attitude, pale coat and pure white, fahionably bound neckerchief suggest, together with his shooting gear, a gentleman's proper combination of activity and leisure. His feet rest on the roots of an oak, a tree which traditionally symbolised stability and continuity, and sometimes even eternity.

Andrews poses as a member of the landed gentry, the freeholding class of squires and recent peerage, who not only owned most of the country, but had parliament in their hands, too. Without their consent, George II could neither impose taxes nor raise an army. "In my eye," as one contemporary statesman apostrophised this class, "you are the great oaks that shade a country, and perpetuate your benefits from generation to generation."[4]

The landed gentry is thought to have numbered some 8000 to 20,000 families (estimates vary considerably). The majority of these families owned estates large enough to bring them an annual income of some 1000 to 3000 pounds, allowing them to lead a life of leisure or enter politics. Of course, even larger estates were owned by the small élite of peers and lords of ancient aristocratic lineage.

The franchise was based entirely on land-ownership at the time. The great mass of the population, who owned no land at all, nevertheless enjoyed equality before the law, by contrast with their cousins on the continent. The shrewdest businessmen among them were also able to purchase land. It is probable that the Andrews family came to wealth and rank in this way. Robert is not as blue-blooded as he might appear. His father was apparently an artisan, a silversmith, in London. It is known that the young Gainsborough, during his

stay in London, was put up by a silversmith. Perhaps Mr Andrews senior was his unsuspecting patron.

Old bankbooks reveal Robert Andrews's father to have lent money at very high interest rates. There were many large landowners among his debtors. In 1743 he lent the substantial sum of 30,000 pounds to Frederick, Prince of Wales, and was later appointed "remembrancer" (debt collector) to his household. He ran a successful business from his house in Grosvenor Square, buying ships and trading with the colonies. He was one of a new generation of merchants and factory founders who paved the way for the Industrial Revolution. They had made England the world's leading trading nation and would soon hold the political reins in their hands: capital and factories had become more important than land.

In 1749, however, such days were still far off. Mr Andrews gave his son Robert, who was born in 1726, a gentleman's education at Oxford and, with the profits of usurious business deals, bought him an estate and a squires' daughter as a bride, thereby ensuring his son's entry to the upper classes. Robert, by all accounts, became a worthy member of his new class. Although he did not enter politics, and despite a long life (he died at the age of 79), his occupations are unlikely to have left him much time for rural recreation. With the death of his father in 1763, he took over the family financial empire. He did everything within his power to increase the family fortune and, if eight offspring are anything to judge by, to strengthen the family tree: a field of endeavour so suggestively symbolised by Gainsborough's ancient oak.

**3**

## A good match

**F**eelings had little sway in the matter of marriage between two wealthy families. The bride was often promised at a very tender age and, like Frances Mary Carter, married off at the age of 15 or 16. She was little more than a pawn in a business deal, in which each party was concerned to increase its wealth, property or influence by means of the most advantageous match. Family lawyers would haggle for weeks over marriage contracts, thinking up endlessly sophisticated clauses to insure family fortunes against every conceivable danger. It was imperative that the wealth whose accumulation had demanded such great care should be passed on undiminished for the benefit of generations to come.

As a final ditch against incompetent or reckless heirs, family trusts were set up which left successive heads of the family no more than usufructuary rights on the property they inherited. Moreover, the precaution was frequently taken of determining the younger sons' inheritance and daughters' dowries in advance, indeed before they were born, lest these prove an undue strain on family resources. The sum designated for the lady of the manor's private expenses, as well as her widow's allowance, were also the object of negotiation. For "the only hope that keeps up a wife's spirits", according to the cynical Mr Peachum, a character in John Gay's popular *Beggar's Opera,* is "the comfortable estate of widowhood", while losing her hus-band "is the whole Scheme and Intention of all Marriage Articles".[5]

Frances Carter was undoubtedly an excellent match. The estate of Auberies, upon which Gainsborough has painted the couple, was probably part of her dowry. Auberies bordered on Ballingdon, her father's estate. According to a description of 1769, Auberies consisted of "a modern regular and uniform building of bricks… situated upon an eminence… commanding a most delightful prospect… with gardens … and several ponds".[6] Gainsborough's painting includes none of these features. The Andrews may have had their mansion built later, of course, possibly even on the spot where their garden bench stood.

It may be assumed that the bridegroom will have gone to some expense in furnishing both his country seat and town house on Grosvenor Square. Unlike the established landed aristocracy, merchants and gentry attached great value to comfort and spared no extravagance in acquiring it. The material for Frances Carter's fashionable dress is much more likely to have come from London or Paris than from her family's local cloth mill. Its full blue silk over hooped, pale-yellow petticoats hardly has room on the Rococo bench. Unlike most of his contemporaries, Gainsborough did not employ a drapery painter. He devoted no less attention to the iridescence of shot silk than to the play of colours in a cloudy sky.

If we are prepared to accept the views of an artist who strove to go beyond mere likeness in revealing his sitter's character, then Frances Carter must have made a fitting companion for her businesslike husband. She died in 1780, 26 years before him. The cool gaze and tight lips of this young woman suggest that the accumulation and retention of property may have come quite naturally to her. In this, at least, the couple will have been compatible – unlike Gainsborough and his wife.

As an illegitimate, unowned child of the Duke of Beaufort, Margaret brought a life-long annuity of 200 pounds to her marriage. This provided the couple with a modest security. But Margaret's pettiness and greed were a cramp on Gainsborough's Bohemian lifestyle. She kept a tight control over his income, too, making sure he painted portraits and driving away his merrier and more distracting friends. The painter seems to have submitted calmly: "She was never much formed to humor my happiness."[7]

The view from the garden bench gives the appearance of a boundless idyll – not unlike the ideal parkland proposed by the most famous, 18th century landscape gardeners. It even includes an occasional cluster of trees: aesthetically indispensible for the interruption of vistas that would otherwise seem too wide, or too symmetrical. However, functionality in all its forms was considered inappropriate in one of the new English parks. Corn fields and herds of sheep, not to mention the byre just visible in the background on the left, would be quite out of place. Gainsborough, it must be concluded, has not painted Mr and Mrs Andrews in a park, but on a farm.

The inconspicuous wooden pen enclosing grazing land for sheep would have been equally unlikely to feature in a parkland

## Illusion of a pastoral idyll

scene. It is rather a testimony to the Agrarian Revolution, which changed England some 50 years before the Industrial Revolution by doubling agricultural produce. Enclosure, the fencing in of previously open land, had been a precondition of more intensive cultivation. For centuries, the old patriarchal feudal system had guaranteed access to the open fields. This meant that large areas of common land had provided a more or less subsistence holding. Any villager had the right to put his cow or geese to pasture on common land after the harvest. The right proved a fetter on the rationalisation and intensification of farm cultivation, and therefore had to be reversed. A new type of highly effective farming began in the middle of the 18th century when the more progressive landowners began to combine strips of land to create larger fields (in Nottinghamshire, for example, where 322 narrow strips were joined to form 23 pastures). They ploughed up land that had previously been infertile or forest, and they had the fields fenced in, thus preventing the villagers putting their own cattle to graze –

much to the disadvantage of the rural poor, who were ruined by the loss of their rights.

As far as the landowners were concerned, however, the "enclosures" proved one of the most profitable investments of the 18th century. Among the agricultural pioneers of the time were men like Mr Andrews, merchants who had recently bought themselves into land. Used to investing capital for profit, they were also more open to innovation than were the longer established, landed gentry.

It is therefore not beyond the bounds of possibilty that the young London financier, proud of his "model farm", asked for a generous depiction of it in his wedding-portrait, or at least reacted warmly to the artist's suggestion of the idea. Even in commissioning the portrait from Gainsborough, a mere beginner after all, Andrews proved his acumen for highly profitable investment in "future markets". For the gentleman at the foot of the durable oak undoubtedly contributed to the welfare of his descendents who sold the painting for 130.000 pounds at Sotheby's in 1960.

**4**

# The fine art of extravagance

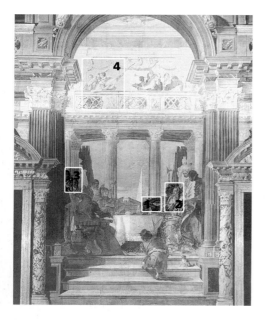

West meets East: the Roman general Antony dines with the Egyptian queen Cleopatra who, for dessert, eats a pearl. Tiepolo mounted the encounter, as if staging a scene from grand opera, on the wall of the banqueting-hall at the Venetian Palazzo Labia, where it can be seen to this day. Tearing down walls, his sophisticated optical illusion draws the spectator's eye into a world of luxury and fantasy.

Spellbound, the assembled guests gaze at a woman about to redeem a wager. Cleopatra VII, Queen of Egypt, had boasted to the Roman general, Antony, that she could devour a hundred times one hundred thousand sesterces at one meal. Now was her chance to prove it.

Judging the wager is the Roman consul Lucius Munatius Plancus. He sits at the table, clothed in Oriental robes, with his back to the spectator. Opposite him, clad in shining helmet and armour, is Antony, Caesar's heir and one of the most powerful men in the world. The Roman author Pliny the Elder, writing during the first century after Christ, had described the scene in his *Natural History*. Cleopatra, according to Pliny, had served up a banquet which, though sumptuous, amounted to little more than one of their everyday meals. Seeing this, Antony had merely laughed and asked to see the bill. Cleopatra had then assured Antony that he had seen no more than the trimmings, whereas the feast to come would certainly cost the agreed amount. She had then ordered dessert. However, the servants had placed before her only a single dish, filled with vinegar, whereupon the queen had removed one of her earings, dipped it into the vinegar, let it dissolve, and swallowed it.[1]

With her cunningly staged gesture of extravagance, the exotic queen had won a stunning victory over the astonished Romans. Her feast became world famous, providing the ideal subject for the banqueting-hall of an 18th century Venetian palazzo.

The banqueting-hall in question was new at the time. The noble Labia family had just had its century-old palace entirely renovated; for it had no longer corresponded to contemporary notions of comfort and representation. The result evidently more than repaid the cost. Even the high standards of the French traveller Charles de Brosses were satisfied. He praised the building in 1739 as "one of the most beautiful on the Grand Canal"; built "à la moderne", it was "the only one whose interior seemed to me to be well-designed".[2] It should be added that de Brosses had seen it even before the interior was painted.

It was only fitting that the painting should be executed by the most famous artist of his day: Giambattista Tiepolo. Born in 1696, Tiepolo had reached the peak of his artistic career by the middle of the eighteenth century. He had painted frescos in palaces and churches throughout the north of Italy, committing entire hosts of Christian saints and complete pagan mythologies to walls and ceilings. Between 1746 and 1750 (there is no documentary proof of this), Tiepolo and his assistants decorated the entire banqueting-hall, including the ceiling. The work thus covered some 500 square metres. Tiepolo turned the Labia banqueting-hall into a kind of theatre, on whose walls, as if acted out on a series of different stages, he produced his version of the Cleopatra story. The plot was well-known: a historic meeting between East and West, embodied in the persons of the Egyptian queen and the Roman triumvir Antony. The latter had come to plunder the satellite state of Egypt, but instead Cleopatra had seduced him and scored an important victory.

The accessories were borrowed from the opera: Moors, a turban or two and an obelisk in the background were sufficient to recreate a conventional, exotic stage setting. Armour, helmets and weapons suggested Roman antiquity; a Classical columned hall, open to the sea at the back, provided the perfect architectural stage design. Tiepolo has even included an orchestra playing for the guests from an airy balcony. To the Venetians, dining under the frescos by candlelight to the sound of real music, it must have seemed as if the Egyptian queen and the Roman general were there in person.

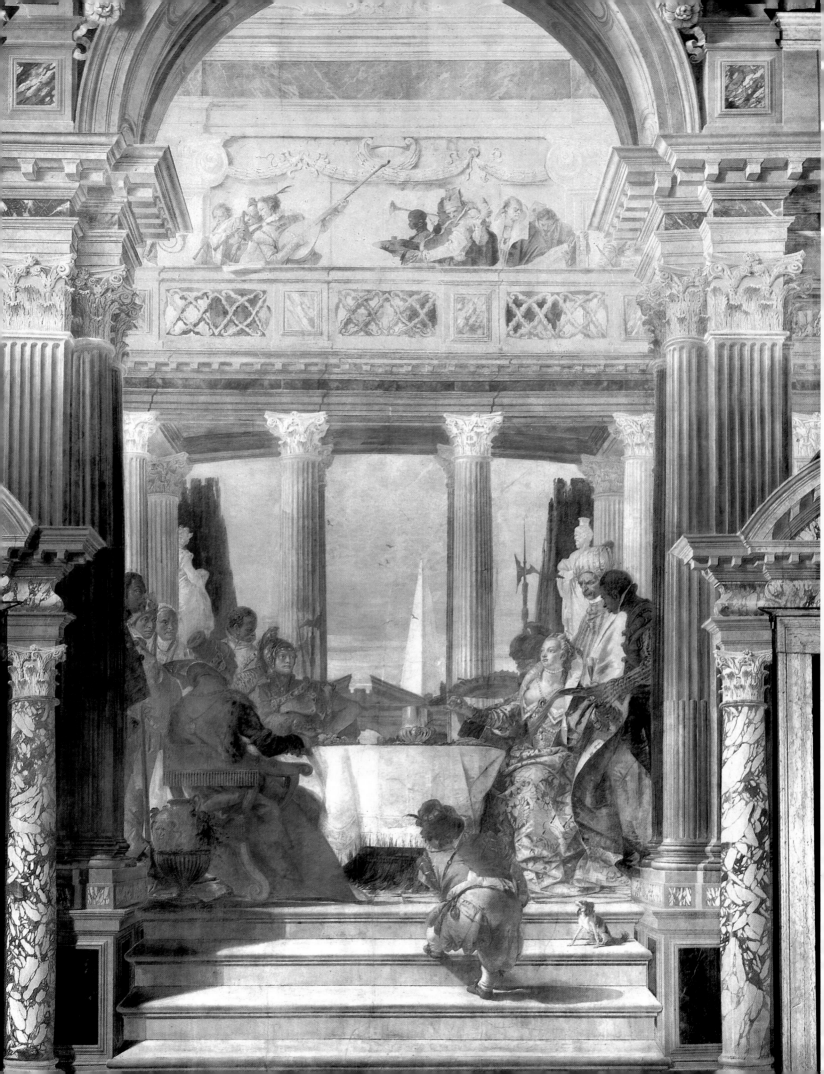

## A pearl as dessert

An extraordinarily large drop-shaped pearl shimmers between Cleopatra's fingers. The naturalist Pliny gives pearls the highest place among all things of value, but he also accuses the "family of shells" of thereby encouraging indulgence and moral degeneracy. He evidently disapproves of proud Cleopatra's wager, as both an outstanding example of luxuriance and the deliberate destruction of an unusually rare, Natural treasure by "a royal whore".[3]

Such are the thoughts of a strict moralist who cherished plainness and severity, the virtues of a male-dominated, highly militarised society. The Roman castigated luxury, self-indulgence and extravagance, characteristics typical of the rich and decadent Egypt of Cleopatra's times. Envy may have been an important factor too: the main reason for Caesar's and Antony's

Egyptian expedition had been to find money for Rome's costly military campaigns. Thanks to their powerful fleet, the Ptolemies had amassed great riches. Queen Cleopatra liked to be referred to as the "Queen of Plenty", and on coins she is portrayed with pearls in her hair and on her robes.

Tiepolo's contemporaries were probably in a better position than Pliny to appreciate Cleopatra's lifestyle. The Venetian Republic had lost most of its political and military power by the 18th century. At the same time, its citizens attempted to make up for their sense of loss by squandering the vast wealth they had accumulated during their glorious past. With a passion that took them far beyond their means, the Venetians cultivated extravagance as a particularly fine art.

The Labia family had excelled neither on the battlefield nor in the Venetian senate. Nor had they been members of the aristocracy for very long. During the 17th century, when the maritime republic had been desperate for money to fight the Turks, the Labia had used the opportunity to buy their way into Venice's exclusive patrician

circles. A legendary act of extravagance won them a mention in the annals of the town: at the climax of a banquet for 40 persons, a Labia, expressing violent contempt for all material possession, had commanded the golden plates from which the guests had just finished eating to be thrown out of the window into the canal. In choosing the extravagant Egyptian queen as the subject of their banquet hall frescos, the Labia were attempting to establish their own, admittedly rather tongue-in-cheek relation to tradition.

But all that glisters is not gold, and even the most fantastically frivolous and debauched gestures are often nothing but a fake. Thus it is said that the Labia recovered their costly plates by means of underwater nets stretched out in front of the palazzo. As for Cleopatra, chemistry has proved that pearls do not dissolve in vinegar! Are we to conclude that the "Queen of Plenty" did not swallow her precious jewel at all, but made it vanish by some sleight of hand? Is it really possible that a clever conjuring trick helped her to win a wager, keep her pearl, confound the Romans and deceive posterity?

# Portrait of
# an attractive
# widow

In Tiepolo's day, a Labia widow and her two sons lived in the palace. De Brosses describes her as woman who, though no longer young, "was once very beautiful, and had many love affairs".[4] Like the Egyptian queen, she had a famous collection of jewels which she was proud to show to visitors. Tiepolo would often make flattering allusions to his patrons in his paintings. His majestic portrait of Cleopatra may therefore bear some resemblance to the lady of the house. On the other hand, her ample charms were also consistent with the fashionable female figure of the day, and probably with the artist's own taste. The real women in Tiepolo's life and the female figures in his paintings all looked alike.

Cleopatra VII of the Ptolemaic dynasty was born in 69 B.C. She reigned between 51 and 30 B.C. "Her beawtie," according to the Greek writer Plutarch, "was not so passing, as unmatchable of other women, nor yet suche, as upon present viewe did enamor men with her: but so sweete was her companie and conversacion, that a man could not possiblie but be taken. And besides her beawtie, the good grace she had to talke... her curteous nature that tempered her words and dedes, was a spurre that pricked to the quick."[5] The queen used her words and deeds without scruple when it came to furthering her political aims: maintaining her power and Egypt's (relative) autonomy. At the age of 22 she had enchanted great Caesar; only seven years later she had Antony eating out of her hand. The Romans never forgave her.

Only the cool-minded Octavius Augustus resisted Cleopatra's charms (by which time she was nine years older), driving her to suicide. Since history tends to be written by the conquerors, Roman writers presented her as an "enemy of the state", a cunning seducer, a lascivious and degenerate "royal whore". Cleopatra remained a victim of Roman propaganda throughout the Middle Ages. The Florentine poet Dante banned her to the second circle of his *Inferno*, along with Dido, Semiramis and Helen of Troy: all of them "lascivious women". But the qualities that had seemed

2

so damnable to the "virtuous" Romans and to the Christians of the Middle Ages made the Egyptian queen attractive in the eyes of modern writers: between 1540 and 1905 she was the central figure of no fewer than 77 plays (the most famous of which was Shakespeare's *Antony and Cleopatra*), 45 operas and five ballets.

The hedonistic eighteenth century was particularly given to celebrating the fame of this great seductress. Aristocratic society considered the victory of woman over man, who was glad to be distracted from the call of business and duty, to be exemplary (at least in theory).

Besides extravagance, pleasure and luxury were the key words of the period. A ruler, an exotic one at that, who entered a struggle for power armed only with a woman's wiles, was bound to become a heroine on the stage and on canvas.

In 1762, only a few years after Tiepolo had painted his sensuous queen, Catherine the Great of Russia seized power on a very real political stage. Catherine was an unscrupulous ruler who employed female wiles in order to attain her ends. She would certainly have felt flattered by comparison with Cleopatra.

## The team pays homage to the master

The master and his assistants appear in the background as discreet observers of the banquet they have painted. Besides Tiepolo – whose sharp features are recognisable from his many other frescos – there is a black servant called Alim, who was probably an assistant. The man with the roundish face is said to be Girolamo Mengozzi Colonna (c. 1688–1766), an expert in painting architecture.

By the time Tiepolo came to decorate the Palazzo Labia, he was not only one of the most famous painters in Europe, he was also the most expensive. The King of Sweden was forced to abandon a commission intended for Tiepolo because, unlike the Labia, he was unable to afford the artist's fee. The Swedish Count Tessin had excited his king's interest in the project by praising the artist's "glowing colour", the "bravura of his brushwork" and his "fire".[6]

"Fire", in the language of the day, meant wealth of the imagination, spontaneity, virtuosity – qualities particularly useful to Tiepolo as a fresco painter when improvising on the wet, freshly laid plaster.

Before the master started on the figures, the setting was prepared by his expert of many years' standing, Mengozzi Colonna, who helped Tiepolo with the majority of his great frescos. The work of each was so perfectly attuned to that of the other that one enthusiastic contemporary compared their collaboration to "the harmony of bass and soprano".[7] Mengozzi built the stage on which Tiepola produced the banquet. As a specialist in matters of perspective, Mengozzi used similar techniques to those used in theatrical set design. By means of illusionistic architectural elements painted on the walls and ceiling, he transformed a real room – the Labia banqueting-hall was a straightforward cube – into an apparition of splendour, extravagance and endless space.

However, Mengozzi's contribution to the Cleopatra frescos was not confined to the backgound, or to the musicians' balcony supported by pillars; he was also responsible for various parts of the foreground, perceived by the spectator as "real", tangible objects in space: the stone steps up to the table, for instance; or the huge, fluted, pink marble pillars; or the black-and-white marble columns beside the doors. The imposing round arch which spans the scene is also fictive: the real ceiling is flat. The only real things in the room are the floor, the windows and the doors. The entire, sumptous majesty of the stately room is a masterpiece of *trompe-l'œil*, or optical illusion.

*Trompe-l'œil* technique was nothing new. It was based on the calculated use of perspective, on naturalistic precision in recording detail: in imitating marble, for example, or in observing the correct relation between shadowing and the incidence of light. According to Pliny, such *trompe-l'œil* effects were much loved in the Classical age. The Italian Renaissance, in applying modern science to the problems of perspective, gave the device a new lease of life. Paolo Veronese perfected its use in his 16th-century frescos in Venice. The small dog on the steps leading up to the banquet possibly represents an act of homage to this artist, whose works were full of hunting dogs and lapdogs. These were as much a part of *trompe-l'œil* tradition as the painter's habit of including his own self-portrait. If the effect of the illusion was not to be destroyed, the artist could hardly add his signature to a fresco.

The Labia would have been rich enough to panel their banqueting-hall with real marble if they had wished, or to decorate it with solid marble columns. It is possible, in any case, that this would have proved cheaper. But they were probably more fond of illusion than reality. After all, there were marble columns everywhere in Italy, whereas Tiepolo's architectural illusions were something quite exclusive: a highly skilled and baffling artifice which amused visiting spectators. The latter had to be willing to play along, of course, for the *trompe-l'œil* takes place only in the eye of the beholder. Contradictory messages passing between the eye and the brain induce a perverse, yet thoroughly pleasurable state of perplexity for anyone prepared to entertain the sensation. Optical illusions were a sort of game, indulged in by the Labia for their own enjoyment, and to the amusement of their friends.

## Architectural illusions baffle the eye

Walls panelled with real marble might have demonstrated wealth, but they could never have achieved what Tiepolo and Mengozzi enacted with such apparent ease: the extension of space into an imaginative seascape under a vast evening sky. Their illusionistic frescos tore down walls, drawing the spectator's eye into a marvellous fantasy world where seductive heroines could squander gigantic pearls with impunity.

Tiepolo's contemporaries, it seems, were only too happy to retire from the grey demands of reality. Angelo-Maria Labia, for example, the widow's eldest son, became an abbé – a very worldly ecclesiastic – in order to escape the troublesome duties of a Venetian noble. As an abbé, he was not required to take office, but could devote his time to renovating palaces, collecting paintings and commissioning frescos. His contemporaries spent their time at the theatres, opera houses or the carnival, and aristocratic tourists from all over Europe came to Venice to partake in what was essentially a non-stop orgy of escapism. But the turning-point was nigh. In 1750, when Tiepolo had ended his work and left Venice for Würzburg, Jean-Jacques Rousseau's essay *Discours sur les sciences et les arts* was published in Paris. In it, the author rails, not unlike Pliny once had done, against "moral corruption and luxury". The moralist made out culture and art as the main culprits for the seduction and perversion of mankind, counterposing the innocent virtues of artlessness and natural simplicity. Soon, the return to Classical values was in full swing, and concepts of virtue – in the period leading up to the Revolution – began to be synonymous with the "virtues" of the Roman Republic. Once again, a military-style, male-dominated society gained the upper hand. There was a demand for men of earnest, and, once again, Cleopatra fell into disgrace.

Why should Tiepolo fare better? The Rationalists accused him of painting that was lacking in simplicity, seriousness or truth. His ludic, extravagant art was discredited along with the aristocratic society to whose members it had once given such pleasure. His masterpiece, the banqueting-hall at the Palazzo Labia, was practically forgotten. One 19th-century traveller to Venice described it as "wretched and deserted". Although, in the meantime, the work has been restored several times, and though its once "glowing colour" has grown paler, Tiepolo's optical illusion is still as amazing as ever.

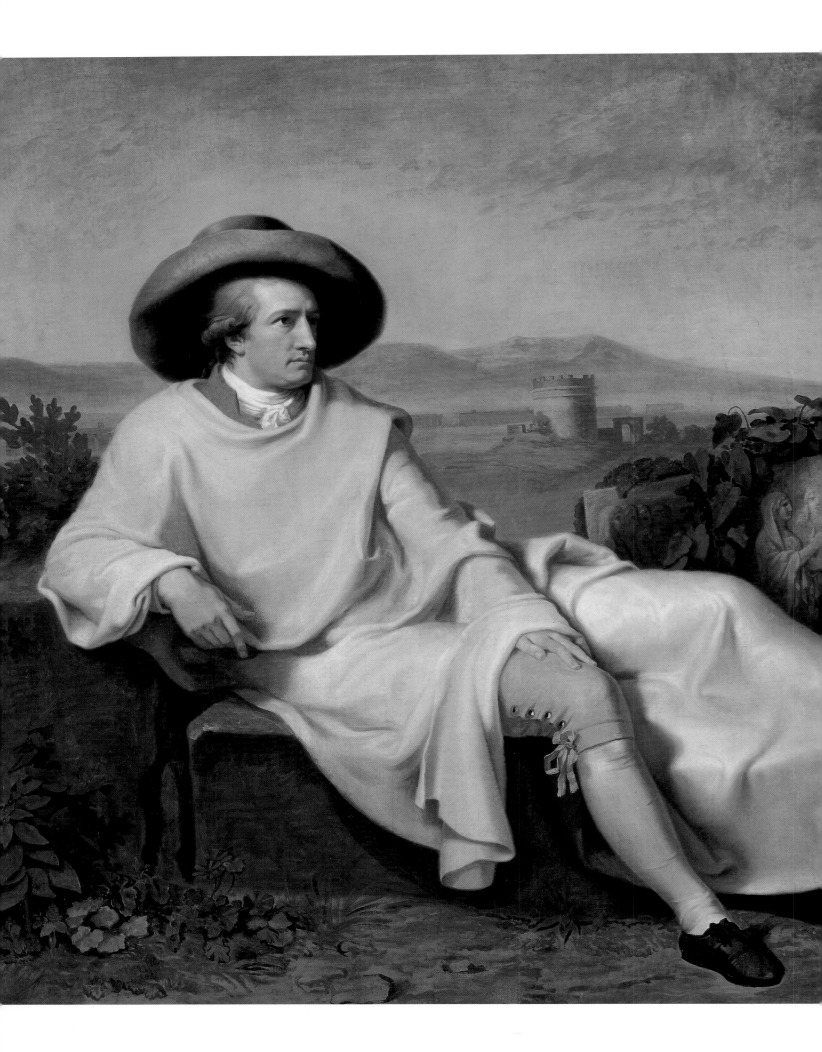

## Johann Heinrich Wilhelm Tischbein: Goethe in the Roman Campagna, 1786/87

# A German icon

Towards the end of October 1786, soon after Johann Wolfgang Goethe's arrival in Rome, Johann Heinrich Wilhelm Tischbein began his portrait of the poet. The painting is one of the most popular in Germany. Hardly a school-child escapes seeing it, a fact which makes it particularly well-loved by advertisers. *Goethe in the Roman Campagna* is as familiar as a trademark, as sacred as an icon. The work has come to symbolise Germany's Classical humanist ideal: German *geist*.

The painter admired Goethe – and it shows. He gives the poet a broad-rimmed hat, which has something of the appearance of a dark halo, enlarging the poet's head and showing his profile to advantage. The poet's facial features are idealised; his mantle is a timeless gown; his eyes are focused on infinity. This is no normal man with both feet planted firmly on the ground. Only one foot touches the earth, and his supine position makes him appear to float. He is evidently not of this world.

The painting was sold by a private collector to the Städelsches Kunstinstitut, Frankfurt, in 1887, when the Goethe cult was at its height. The citizens of a newly formed German Empire sought shining paragons among the generations of past Germans. Goethe and Schiller thus attained a national status far beyond their significance as writers. A distinction was drawn between the drab, low level of politics and economics and the higher life of the mind, of art, of culture. A vaguely floating Goethe, whose walking tour through Italy has not soiled his shoes, fitted into the picture perfectly.

Were it not for this painting, the artist's name would be known only to a handful of art historians. During the 18th century, however, the Tischbeins were a widely-known family of painters, working in Hamburg, Lübeck, Haina, Hanau and

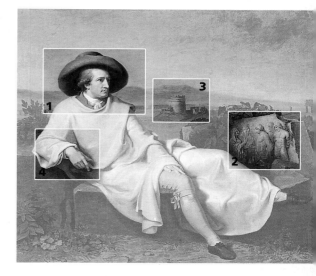

Kassel. Various uncles and cousins worked as portraitists, directors of art galleries and court painters. Johann Heinrich Wilhelm, born in 1751, received a stipend from the academy of art at Kassel to enable him to travel to Rome, where he wanted to study the Old Masters. When his funds were exhausted, he travelled to Zurich, where friends provided contact to Goethe. Tischbein then sent letters and sketches to Weimar, and Goethe used his good offices with Duke Ernst of Gotha to procure a second Rome-stipend for Tischbein.

Thus contact between the two was established. Then Goethe, poet and supporter of artists in distress, himself came to Rome: "... I'm here, and have sent for Tischbein," he wrote in his journal. Some time later, in a letter back to Weimar, he wrote: "We are so well-suited that it is as if we have always lived together."[1] It was during this period of close friendship that the portrait was executed, although Goethe never saw it completed. Divergent interests drew the two men apart, and Tischbein makes no mention of the work in his memoirs. The memory of the work must have harboured unpleasant associations for the artist.

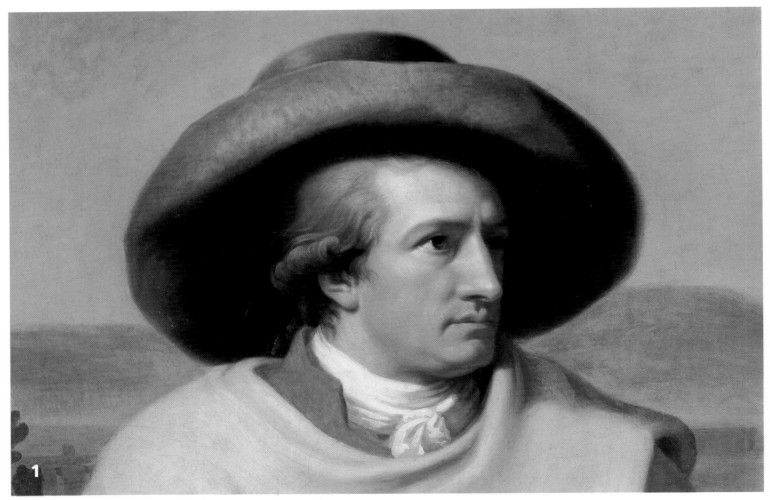

## My eyes are receiving the most unbelievable education

Goethe had left for Italy in secret. He had not asked the Duke of Weimar, whom he served as a minister, for a vacation, nor had he taken leave of his friend, Charlotte von Stein. Goethe, at the age of thirty-seven, had simply packed his bags and fled.

There are a number of explanations for this total breach of decorum and injury to his oath of allegiance. Firstly, Goethe was making no progress in his career as a writer. Early success with *Werther* and *Götz von Berlichingen* had made him the Germans' favourite author, at least among the younger generation. But since coming to live and work at Weimar, he had had no comparable success. *Torquato Tasso, Faust* and *Egmont* were either unfinished, or had not progressed beyond the planning stage. Neither Werther's sensitivity, nor Götz's lack of it, were particularly interesting to him any more. He was stuck.

Then there were his problems with Frau von Stein. She had taught him how to behave properly when he had first arrived at the court of Weimar; she had shown him that there were orders of precedence and all kinds of unwritten rules – at court and in love. They met daily, and Goethe sent a – sometimes passionate – note to her almost every day. But his physical desire for her remained unrequited, or at least unfulfilled. After ten years, flight was the only means Goethe could find of putting an end to his quandary.

The portrait betrays none of Goethe's restlessness or sense of crisis. Goethe appears in full command of his faculties, a prince of poets. What Tischbein actually knew of Goethe's state of mind at the time is not known. Like the other German painters living in Rome, however, he will have known that Goethe, the famous poet and Weimar minister, wished to remain incognito. He took refuge in Tischbein's rooms under the name of Filippo Miller, pittore. His first letters to Weimar carried no sender's address. When eventually it became impossible for him to maintain the credibility of his pseudonym, he none-theless declined invitations to aristocratic society.

Goethe also makes little reference to his private problems in his book of memoirs, *Italian Journey,* which was compiled almost thirty years later from his letters and notes of the period. He describes the 20 months he spent in Italy as an educational journey. Education, in the Goethean sense, does not mean adding to one's knowledge, but adding to one's abilities; it is a form of work on one's own person, the transformation of the self.

The faculty which interested Goethe most was that of seeing: "I have again seen outstanding works of art here, and have felt my mind clear and move in new directions," he wrote. "My eyes are receiving the most unbelievable education, and I shall work, lest my hand lag behind them."

He spent much time drawing, asking Tischbein and other painters to correct his work. He probably hoped his talent would grow beyond that of a mere dilettante. Tischbein has painted him as a man of vision, a man captured in the act of looking. His large hat was fashionable at the time among the German artists in Rome.

# Iphigenia recognises Orestes

Anybody who is acquainted with today's Rome will find it hard to imagine that Goethe should have travelled there, of all places, to find himself. If his wish was to escape the crippling narrowness of the Weimar court, he could easily have travelled to Paris, Vienna or London, or, indeed, have hidden himself away on some country estate. But he wanted Rome. Venice had managed to hold his attention for all of two weeks, Florence for only three hours: "The desire to get on to Rome was so great, and continued to grow so quickly, that I simply could not stay any longer…" He called this desire to reach Rome "a kind of illness". The only remedy was "the sight and presence of the place". And then: "I am here at last, and quiet, and it seems I shall have peace for the rest of my life."

Not only Goethe sought a cure at Rome. Tischbein, too, during his first journey to Rome in 1779, had expressed himself similarly: "The further we travelled," he wrote in his memoirs, "the more I returned to my self and the greater was the thought that I was to see the beautiful land of Italy, where vitality and the highest spiritual values dwelled among the people, and more than anything, it was the thought of beautiful Rome itself, the greatest city in the world!"[2]

Rome distinguished itself from Venice or Florence by its Classical monuments. Travellers went there in search of an ancient Roman and Greek sense of humanity; with its help, they hoped to recover their own strength and form their minds. Tischbein, already an expert on Rome, took the new arrival to see all the wells, portals and columns. He knew which collections held the most beautiful statues. Goethe purchased plaster casts of the heads of the gods and goddesses and took them back with him when he returned to the north. He also travelled to Sicily, but did not visit Greece, which was under Turkish occupation.

Enthusiasm for Classical antiquity was partly a reaction to the more recent styles in art: the ecstatic exuberance of the Baroque, and a Rococo tendency to belittle things by turning them into a harmless source of frivolity. Although there were wonderful examples of work from both periods at Venice, Goethe took no notice of them. He was searching for "noble simplicity and serene grandeur" – words the archaeologist Johann Joachim Winckelmann (1717–1768) had chosen to characterise the essential quality of Classical Greek art.

Goethe's *Iphigenia* bears testimony to this search. Begun in Weimar, set to verse in Italy and finished at Rome, it is a play about a priestess who releases her brother from the curse of matricide and pursual by the Furies. On 6 January 1787 Goethe wrote: "Yesterday, I found it very uplifting to place the cast of a colossal head of Juno in my room. The original is at the Villa Ludovisi. She was my first love in Rome, and now I possess her… But I feel I have earned the company of such noble society in future, too, for I am able to report that my *Iphigenia* is finished at last…"

In the evening, Goethe read the new work out aloud and was moved by Tischbein's reactions: "His strange, original views on the piece and manner of explaining to me the state of mind in which I wrote it have shocked me… There are no words for the depth of human feelings he has sensed behind the hero's mask." Goethe was worried. Had Tischbein discovered the extent to which Goethe's own feelings were expressed in the play. Tischbein: "In the evenings you read us your Ephigini. It is the only time a reading has entered me so deeply, and I ofttimes hear it still in my mind and thoughts surge that I should like to describe."[3]

Tischbein has left a monument to this reading in his portrait of Goethe: Iphigenia recognising her brother Orestes. At the same time, the relief is intended to symbolise Greek art, just as Roman art is symbolised by the ruined capital beside it. Egyptian culture was originally suggested by hieroglyphs on the block of stone to the left, but Tischbein removed these from the final version. Perhaps he found the effect, a kind of visual catalogue of ancient cultures, too academic.

## Life-sized

Tischbein, too, had turned away from Rococo style and the demands made of artists by the courts. "Portraits of powdered hair and rouged cheeks which cannot be painted from life because the sitters are too artificial…"[4] had become anathema to him.

He found inspiration not only in ancient Rome, but also at Zurich. It was there, in the literary circle around the famous history professor Johann Jakob Bodmer (1698–1783), that first attempts to formulate a national consciousness were made. Bodmer demanded that the "deeds of noble and great German men be presented to the nation as sacred in the works of poets and painters; for this will form the character of the people, awakening and nourishing in them a love of the fatherland…"[5]

"These were the paintings I felt I wanted to paint," recalled Tischbein, "paintings which had a strong effect on the minds of Germans, patriotic themes" or "persons… worthy of being held up as an example in a painting…"[6]

Goethe, though hardly a German patriotic theme, was "sacred" to Tischbein. He painted him life-sized; the portrait is 206 cm wide and 164 cm high. "A fine picture," Goethe noted down on 29 December 1786, "only it is much too large for our northern dwellings." The poet never saw the finished work, but wrote of a bust, taken by the sculptor Alexander Trippel, that it had been "executed in a pleasing and noble style, and I have nothing against perpetuating the idea that I should once have looked like this". He would probably have thought in much the same way about Tischbein's ennobling portrait.

Tischbein not only paints him in large format, he also portrays him large in relation to his surroundings of ruins in a Roman landscape. The very objects of Goethe's journey to Italy are here reduced to the status of appurtenances, mere decorations. Goethe's gaze is not one of admiration for these ruins, but is focused beyond them in "profound thought on the ephemerality of all things", as one traveller wrote in the *Teutscher Merkur* in 1788, adding that "the terrible thought of transience" seems "to float in his very face".

Comparing these words of veneration with Goethe's own diaries of the period, or with his *Italian Journey*, it is evident that the fugitive poet in fact spent relatively little time thinking about the ephemeral nature of things. He was much too interested in other things, much too involved in thoughts about his own development and ability to see things, about his changing personality and the regeneration of his creative powers. On returning home, his wish was to "let my friends find something in me to please them". He was taking himself back to Weimar as a present, or work of art.

# Repressed, forgotten

When Goethe arrived in Rome, he and Tischbein immediately became the best of friends. To Goethe, it felt as if he had always lived with his new companion. They lived in adjoining rooms, often eating together. Tischbein's drawing of his friend leaning out of a window bears testimony to their relationship.

But harmony between them did not last. After three months in Rome, they travelled to Naples, where their ways parted. Goethe wanted to go on to Sicily, while Tischbein, financially less secure than the minister from Weimar, remained in Naples in the hope of a position as director of the academy of art. That, at least, was the outward reason for their separation. The inward reason, however, was that they could not stand each other's company for any length of time. Critically, Goethe noted that Tischbein's mind was "jostled by a thousand different thoughts, and occupied by about a hundred persons", adding: "He is unable to share in another person's life because he feels so restricted in his own endeavours."

These comments reveal something about the writer, too. Goethe did not like the painter to spend so much time with other people; he wanted Tischbein's full attention. At the same time, he gives a fitting description of Tischbein's weakness of character. He was too indecisive, and not radical enough in pursuing his talents.

His talents lay in exact observation, and in his rapid grasp of a subject. A casual Goethe leaning out of the window, seen from behind – Tischbein's masterdrawing immediately puts us in the picture. In his paintings, however, Tischbein did not attempt to capture momentary, or natural attitudes; what he wanted on canvas – and what the times demanded – were grand, and highly significant poses. These constantly eluded him, however. His historical and mythological themes seem crude and dull. Their beautifully drawn lines and meaningful gestures are empty. Only his Goethe-portrait has retained its appeal; whether due to its quality as a painting, or simply to familiarity, is hard to say.

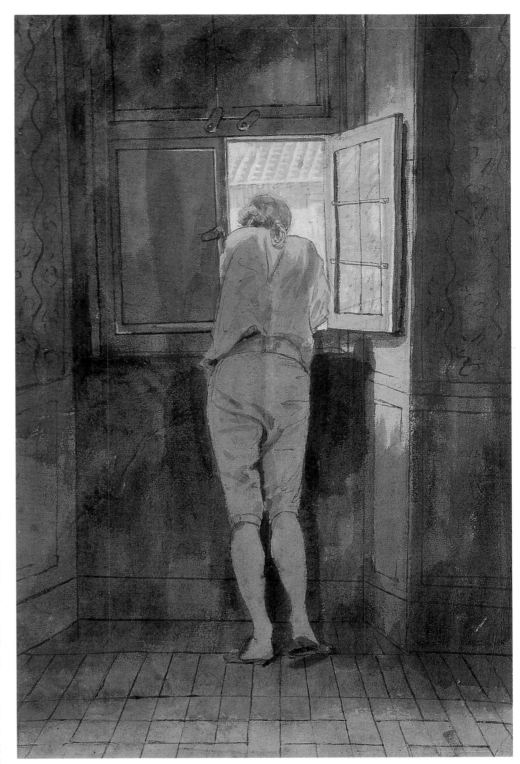

Unlike Goethe, Tischbein does not criticise his companion in his memoirs. He writes only of their trip to Naples, not of their meeting in Rome. The painting is not mentioned at all. The only explanation for this is that Tischbein himself wished to forget it. Goethe – whether on canvas or in real life – was probably too large a figure for him. Goethe took himself seriously; his great gift lay in giving full rein to his genius, in pursuing his personal interests and abilities to their utmost. This had always eluded Tischbein. Instead he remained subaltern to the dictates of fashion, a product of his time.

While living with Goethe, Tischbein must have found this difference between them depressing. He would presumably have felt hurt, too, had he known that it was for his portrait of Goethe, more than for any other work, that the Germans would remember him.[7]

# The holy revolutionary

In 1793, a young aristocratic woman stabbed the Parisian journalist Jean-Paul Marat in his bath: the French Revolution had its martyr. The painter Jacques-Louis David was officially commissioned to turn the murder into propaganda. His canvas (165 x 128 cm), painted in a suitably "grand" manner, was completed in the same year, and can be seen today in the Musées Royaux des Beaux-Arts, Brussels.

The writer Nicolas Restif de la Bretonne was strolling through the streets of Paris when he heard a shopkeeper talking to his neighbour: "She was about to flee. She was stopped at the door. He's dead." Soon, the whole town was buzzing with the news, and wherever he went, whether on the street or in cafés, the novelist heard "a hundred mouths talking of the terrible misfortune" that had befallen revolutionary Paris.[1]

A girl from the provinces, Charlotte Corday, had murdered the Deputy Marat in his bath, where he had retired to relieve his skin trouble and to correct the galley proofs of his newspaper. It was the evening of 13 July 1793.

Jean-Paul Marat was one of the most popular revolutionaries. The poor, whose rights he defended in his newspaper *L'Ami du Peuple* (The Friend of the People), worshipped him. The royalists hated him, but in this they were not alone. The moderate supporters of the Revolution opposed him for his leading part in the "September massacre" of captured opponents of the Revolution. Naturally, he had also voted for the king's execution in January 1793. Jacques-Louis David had done no less.

David was not only a painter; he was the director of the Fête de la Revolution. The festival was a massive spectacle, conducted in the interests of political propaganda. Its organisers based their plans on the example of Roman Catholic ceremonies, providing magnificent displays, like those which had been put on to honour Renaissance princes.

Now that the princes had been deposed and beheaded, the churches closed and the priests driven away, the valuable experience they had accumulated in the field of propaganda and indoctrination was put to new use. David turned Marat's funeral into a particularly ostentatious campaign.

Naked from the waist up, his body was laid out in state in a former church so that anybody who wished could see the fatal wound. In front of the pedestal was placed his bath, the wooden crate that had served him as a table, and, on it, his inkpot and quill. The objects were displayed like holy relics. During the funeral procession, which ended at the Pantheon, a cannon resounded at five-minute intervals. The staging of the funeral turned Charlotte Corday's victim into a martyr: a saint of the revolution.

David's festival displays are history, but many of his paintings have stood the test of time. His style was influenced not only by the Renaissance, but also by Classical antiquity. He had come to love Classical themes long before the Revolution. In 1784 he had painted *The Oath of the Horatii*, followed in 1789 by *Brutus and his Dead Sons*. Both works tell of the triumph of patriotism over individual happiness and family love.

Classical antiquity was *à la mode*, even in clothes fashions, but David's approach was more unremitting and he used Classical themes more convincingly than his contemporaries. He was a master of the "grand goût", as the "grand manner" of the day was called. He preferred large formats and grand gestures, leaving everything superfluous aside. Simple lines dominate; the structure is monumental. His works may be viewed from a distance, a quality also necessary for the success of a public spectacle.

Having tested his style on Classical themes, David turned his hand in 1793 to the depiction of a topical event: the death of Marat. He succeeded in turning a murder whose manner was far from "grand" – having taken place in a bathtub – into a painting of extraordinary political effect and artistic merit.

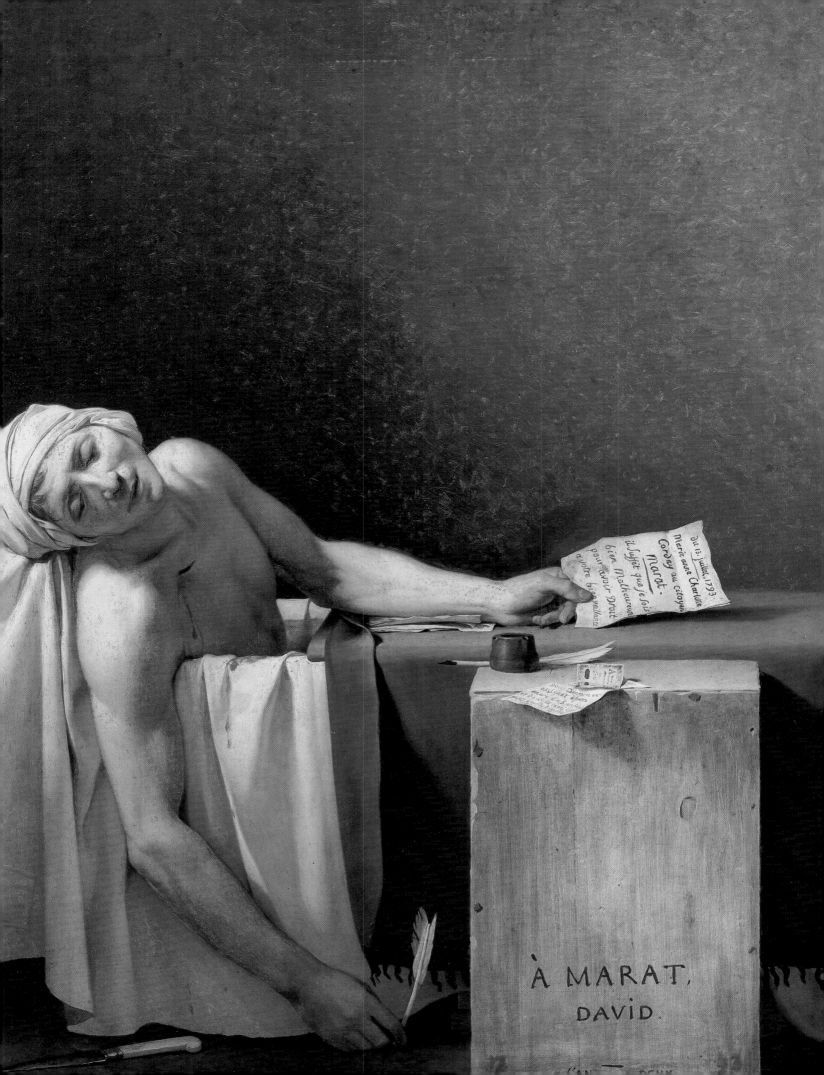

Du 13 juillet 1793
Marie anne Charlotte
Corday au citoyen
Marat.
il suffit que je sois
bien Malheureuse
pour avoir Droit
a votre bienveillance

À MARAT,
DAVID.

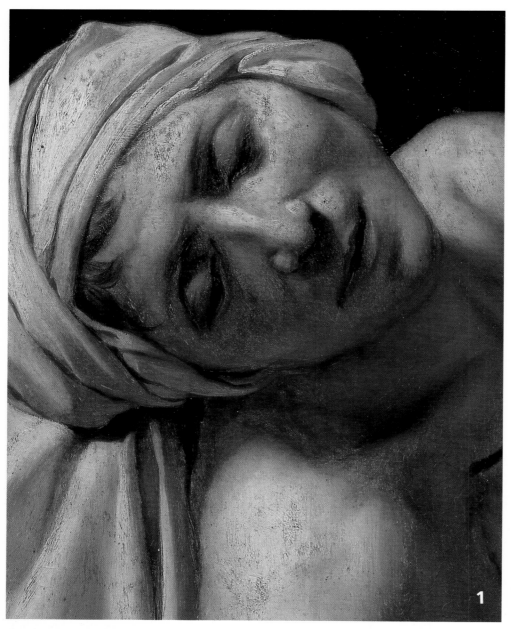

## The sublime features of heroism

Young Marat studied medicine and physics, writing a treatise on the spectral colours. Goethe later attested to his "insight and accuracy". However, his scientific work did not bring him the recognition which – in his opinion – he deserved. He remained poor. Feeling underrated, he saw himself as the object of unfair discrimination by envious colleagues. He also ruined his health by overworking.

The loner's radical ideas were undoubtedly a constant barrier to recognition. In 1774, 15 years before the Revolution, he published, in England, a tract entitled *The Chains of Slavery,* purporting to disclose "royalty's most unscrupulous attacks on the people". In 1789, during the first year of the Revolution, he founded the paper *L'Ami du Peuple* in Paris. Unlike most revolutionaries of the

period, his ideas had been firmly established from the outset. It was against the background of these ideas that he judged all future events. As the self-appointed censor of political affairs, his intention was to use *L'Ami du Peuple* to "keep the National Assembly under surveillance, to disclose its errors, to guide it unceasingly back to the correct principles, to establish and defend the rights of citizens and to supervise the decisions of the authorities".[2]

Initially, the Revolution was a bourgeois affair, a revolt against the king's financial sovereignty. The people stormed the Bastille, which brought them little benefit. "What use is it to us," wrote Marat, "that we have broken the aristocracy of the nobles, if that is replaced by the aristocracy of the rich?"[2]

He fought not only against the royalists, but also against bourgeois revolutionaries and profiteers, making enemies on all sides. As a result, his paper was repeatedly banned and Marat hounded by the authorities. He fled, returned, hid in cellars. In 1791, the King himself was forced to flee; the supporters of a constitutional monarchy were done for. Marat became a Deputy at the National Convention. He saw terror as a legitimate revolutionary weapon: society must "be purged of its corrupt limbs!" he wrote. "Five or six hundred cut-off heads would have guaranteed… freedom and happiness… A false humanity… will cost the lives of thousands".[2] Marat warned that bourgeois forces would triumph, and he was proved right. He wrote that only a dictatorship could help to overcome the crisis of the Revolution, and Napoleon's rule confirmed his prediction.

It was his violent death which turned this controversial revolutionary into a national hero. David painted him with a gentle face; nothing in his features betrays the zealous demagogue. The painter wanted to portray the "sublime features of heroism and virtue", as he put it in conjunction with another painting, an artistic apotheosis of the first martyr of the Revolution, Lepelletier: "I shall have fulfilled my task if one day my work moves a… father to say: Look, my children, this was the first of your representatives to die for your freedom; see his features, how serene they are! That is because a person who dies for his fatherland is beyond all reproach."[3]

The French revolutionary Jean-Paul Marat was born in 1743 in the domain of Neuchâtel, which, at the time, was a Prussian enclave in Switzerland. His mother was Swiss; his father, a former monk, hailed from Sardinia. His son must have inherited his father's desire to preach, to instruct, to direct.

A speaker at the National Convention calls upon David to paint Marat's portrait: "David, where are you now? Have you not passed down to posterity the image of Lepelletier dying for the fatherland? Now you have another painting to do!" Whereupon David answers: "Aussi le ferai-je!" The French words somehow contain more pathos than their English equivalent: "I'll do that too!"[4]

David had visited Marat on the eve of his murder. He describes the wooden crate beside his bath. On it, he says, were ink and paper, "and his hand, stretching out from the bath, was writing his last thoughts for the welfare of the people… I thought it might be interesting to show him in the position in which I saw him last."[4]

Marat was a sick man when he was murdered; he may even have been mortally ill. He had been unable to go to the Convention for weeks and had written very little for the newspaper. He had a constant fever

## Accessories as holy relics

and was tortured by a fearful rash. He sought to relieve his itching skin in water. He went back and forth between his bathtub and his bed, wound cloths soaked in vinegar around his head, took only fluid nourishment and drank inordinate amounts of black coffee.

It was David's task to portray this human wreck in a manner that aroused admiration. He removed all sign of skin disease and placed Marat's body in an imaginary space. In real life, the bathtub had stood before a papered wall with painted columns. Not so in David's painting. His largely dark background – taking up almost half the canvas – not only points to the frugality of Marat's ascetic way of life, but suggests that the space in which his figure is placed may be eternity itself. Its effect is reminiscent of the gold ground of medieval paintings.

The letter and banknote in front of the inkpot were probably the artist's invention. The letter reads: "Give this banknote to the mother of five whose husband died defending the fatherland."[5] At the trial

which followed the murder an exact inventory of the objects found in the bathroom was read out; but the letter and banknote were not among them. David used them to portray Marat as a friend of the people. Marat's newspaper wrote that he had spent much of his time "hearing the complaints of numerous misfortunates and giving weight to their demands by petitioning on their behalf". The benefactor's own poverty – a wooden crate instead of a table, or the mended patch of cloth at the bottom left of the picture – emphasised his magnanimity.

David has painted Marat's body in a pose whose effect is particularly resonant: his limp arm hanging down, head lolling to one side and body half-leaning to face the spectator, supported under one shoulder, the white cloths – this pose had been used for centuries to portray Christ's Descent from the Cross. Here, David was exploiting images that were stored in the public memory. He may also have responded to a widespread need for objects of religious veneration. His Man of Sorrows was Marat.

Du 13. Juillet, 1793.
Marie anne Charlotte
Corday au citoyen
Marat.
il Suffit que je Sois
bien Malheureuse
pour avoir Droit
a votre bienveillance

3

## She bought the knife that morning

As one might expect, some contemporary pictures include the figure of the murderess. David's subject was not the drama of the murder, however; it was the awed hush that followed it. He painted an icon, in which feud, disorder and passion had no place.

The only signs of the murderess in the painting are the knife on the floor and the letter in Marat's hand. It reads: "13 July 1793. Marie Anne Charlotte Corday to the citizen Marat. It is enough that I feel unhappy for me to have a right to your goodness."[5] Marat never received the letter, but Charlotte Corday had a similar note in her possession when she was arrested. The real letter did not include the word "goodness", however. Again, David has added it to underline Marat's philanthropism.

The murderess was 24 years of age at the time, and no less eccentric than Marat. Her full name was Marie-Anne Charlotte de Corday D'Armont. Her family were of impoverished aristocratic stock, but she had been brought up in a wealthy convent. She had become engaged to a man of noble, and equally impoverished, background. While he had joined the royalist cause, she supported the bourgeois revolutionaries. Her fiancé wanted to marry and emigrate; Charlotte refused. Patriotism may not have been her only motive, but it was certainly one of them. Following the Roman example, she declared the fatherland more important than personal happiness.

She might have found like-minded revolutionaries among the Parisian aristocracy, but in her native town of Caen there was nobody. She was ostracised and soon became estranged from her family. It was only when her father and an uncle who was a priest were forced to go into hiding, and when her fiancé and his brother were executed, that she turned against the increasingly bloody upheavals, deriding the "false demagogues… who drape themselves in the togas of people's advocates" to "establish tyranny and usurp the Republic".[6]

She meant men like Marat who held the majority in the Convention and persecuted the moderates. Several moderate Deputies had fled to Caen, where they organised an uprising. However, when they called for volunteers to fight against the Convention, only seven men turned up. Charlotte Corday had made up her mind: "Surely we have not survived these four years of affliction only to allow a man like Marat to rule over France!" she exclaimed. "Too long have agitators and scoundrels been permitted to confuse personal ambition with the welfare of the people!"[6]

She kept her decision secret. Buying herself a pair of good shoes, she took the mail coach to Paris on 9 July 1793, where she stayed the night at the Hôtel de la Providence. Her plan was to stab Marat to death at the Convention – hoping she would then be killed immediately by his supporters, thus maintaining her anonymity and avoiding any trouble for her family. She was disappointed to hear that Marat's illness had prevented him from appearing at the Convention for some time.

On the morning of Saturday, 13 July, she bought a knife; but she was turned away at Marat's door. She tried again that evening. Marat heard her voice and demanded that the unknown supplicant be admitted. She told him she had come from Caen. Marat then asked her about the Deputies who had fled there. Charlotte: "What do you intend to do with them?" Marat: "I shall have them all guillotined in Paris." According to Charlotte's later testimony, these words had sealed his fate.

## Full of grand gestures, but no guts

Charlotte Corday was arrested immediately. Four days later, during the morning session, she was brought before a judge. That same evening she mounted the scaffold.

She had been "a Republican long before the Revolution," she explained to the tribunal, adding that she had killed Marat "because he embodies the crimes that are devastating the country". As for herself, she had "never lacked energy". "What do you mean by energy?" the presiding judge had asked. Energy, she answered, was a quality demonstrated by persons who were "capable of setting aside their personal happiness and laying down their lives for their country".[6]

Thus she went to her death, as "sublime" a heroine as any admired in ancient Rome. Insisting on a right to curiosity, she pushed away the executioner who wished to spare her the sight of the guillotine. She laid her head under the blade herself. It was not long before she, too, was hailed as a martyr – by moderates who abhorred the Terror and defended the citizen's right to property. The royalists also championed her, generously overlooking the fact that she had been a convinced Republican.

David had acquired Marat's death mask for the portrait, and had Marat's bath, inkpot and the knife brought to his studio.

He wrote a modest-sounding dedication on the wooden crate in Roman style: "For Marat, David". At the same time, he painted his own name in letters that were not much smaller than the name of the dead hero. He dated the painting "Year Two", after the new revolutionary calender.

In October 1793, the painting was exhibited at his studio and in the courtyard of the Louvre. In November, he handed it over to the National Convention along with its pendant, the portrait of Lepelletier. "My colleagues, I offer you the homage of my paint brushes!"[7]

The Convention had both works hung in the assembly chamber and – a demonstration of their blind faith in the future – passed a decree which prohibited future legislative bodies from removing the paintings.

By June the following year the moderates had taken power, sending Robespierre and about 100 of his supporters to the scaffold. Sensing an imminent reverse in his fortunes, Robespierre had cried out in the Convention: "It remains for me to take hemlock!", an allusion to the death of Socrates. David, in a gesture as grand and noble as any ever seen in Rome, answered: "If you drink hemlock, then I shall drink with you!"[7] When Robespierre was removed from power in a tumultuous session the following day, however, David stayed at home. He did not reappear until well after the radical revolutionaries had been executed and the authorities had grown weary of the guillotine.

Five years later, in 1799, the artist declared himself willing to complete an earlier, unfinished revolutionary work, painting over the real historical figures and replacing them with new ones "who have come to the fore in the meantime and will therefore be of far greater interest to future generations".[7] No sign here of those celebrated Roman virtues! David had become a master in the art of adapting to new circumstances; it was not long before he was celebrating the new dictator, Emperor Napoleon. With the fall of Napoleon in 1814, however, David decided to go into exile. He took the Marat painting – removed from the Convention in 1795 – with him to Brussels. The portrait of Lepelletier entered the estate of his daughter, who, having meanwhile become a fanatical royalist, did away with it. It has not been seen since.

# The black widow, beautiful and deadly

Later, he would draw her as a witch. Here, he has written his name in the sand at her feet. "Goya" also appears on one of her rings. Did the deaf painter have an affair with the assertive aristocrat? The portrait (210 x 149 cm) belongs to the Hispanic Society, New York.

She is like a theatre star whose presence fills the whole stage. She needs no accessories, no props, no column to lean against, no tree to lend its shade. She stands alone before an almost monochromatic Andalusian riverscape. The solitude and confident pose are fully consistent with her character and social standing. Her name is María del Pilar Teresa Cayetana de Silva Alvarez de Toledo, 13th Duchess of Alba. After the Spanish queen, she is the first lady of the realm.

"Beauty, popularity, grace, riches and nobility",[1] the Duchess of Alba had them all, as Lady Holland reported from her travels in Spain at the end of the 18th century. Other women envied her; the people worshipped her. The blind street singers, competing with the gazettes in Madrid, had almost daily news of the duchess' latest extravagances. They bantered about her rivalry with Queen María-Luisa, enlarging on the details of permanent squabbles about fashion and lovers, bullfighters and popularity.

Today, the Duchess of Alba and her scandals would be known only to a handful of historians, had she not met the artist Francisco de Goya. His relationship with the beautiful aristocrat gave rise to countless legends. During the nineteenth century, romantic novelists turned it into a passionate, and tragic, love story. In 1951, Lion Feuchtwanger made it the subject of a thrilling novel. But even he was forced to invent most of the plot, for very little evidence was left by either of them, or by anyone who knew them. Besides a small number of drawings and prints, the most important piece of evidence is a large (210 x 149 cm) portrait of the duchess, painted by Goya in 1797. It now belongs to the Hispanic Society in New York.

Even today, there is much that remains in the dark – the duchess's death, for example, five years after the painting was finished. A rumour circulating at the time suggested that she had been poisoned in the course of a quarrel with the queen. In a country that was traditionally dominated by men, both women were vastly superior to their husbands in vitality and strength of will. The Duke of Alba was as weak in character as he was in constitution. María-Luisa was so much more powerful than her phlegmatic husband, King Charles IV, that she had little trouble in transferring state power to her lover, Manuel Godoy, in 1792. However, the muscular thighs of the 25 year-old officer were generally thought to carry greater conviction than his powers of statesmanship. He was hardly the right man to guide Spain through the troubled waters of European politics.

A minority of Spanish intellectuals had immediately saluted the French Revolution in the hope that it would bring reform to a country that was badly exploited by its aristocracy and Church and was too backward to help itself. The execution of the French monarch, Louis XVI, had led to a half-hearted and unsuccessful Spanish expedition to avenge the affront. Soon, however, Godoy had not only concluded peace with revolutionary France, but had allied Spain with France against England. As a result, Spain was embroiled in war, including a civil war, for the next 20 years.

Initially, the Spanish grouping in favour of France and the Enlightenment had quickly grown in popularity. Its luminaries had met at the Salon of yet another formidable lady, Countess Benavente, where they had forged plans for a modern state modelled on the French example.

The majority of the population remained hostile to foreign ideas and customs, and a counter-movement soon formed in the Spanish capital to defend Old Spain. These conservative patriots made a great show of imitating the *majos* and *majas,* the simple townsfolk of Ma-

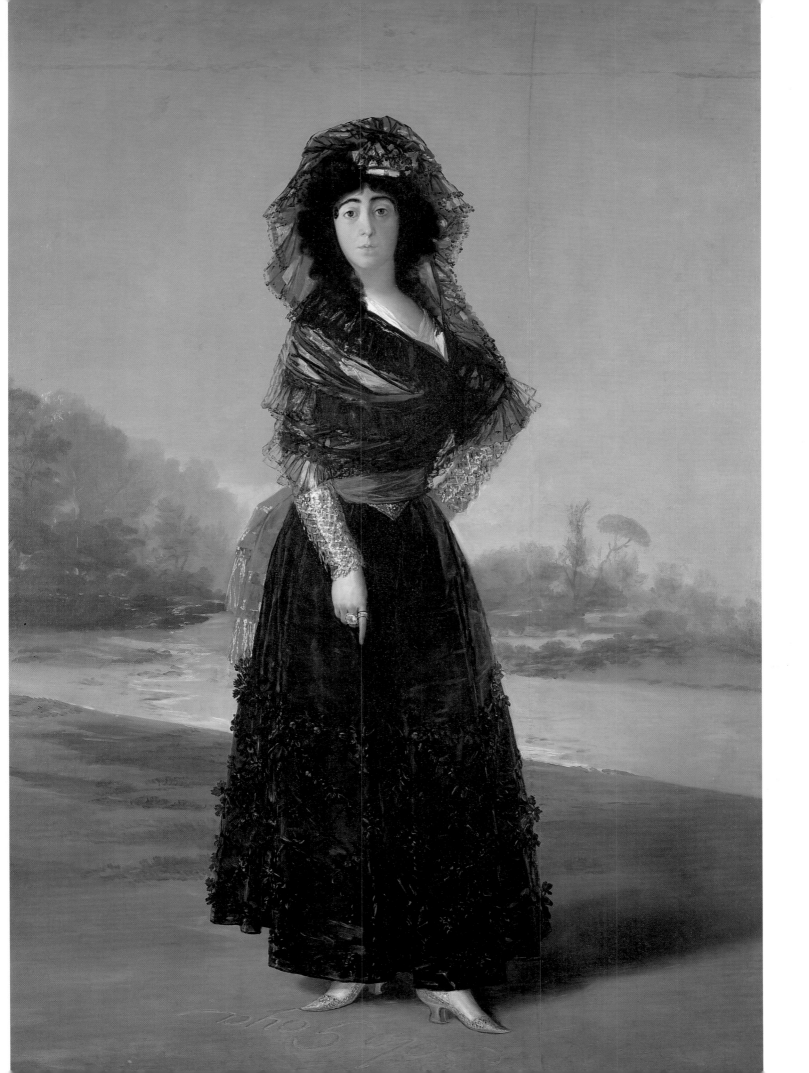

drid, and of going to bullfights instead of visiting the Salons.

The highly aristocratic Duchess of Alba placed herself at the head of this plebeian movement. She put aside her French wardrobe and posed in a black skirt and lace mantilla, her hand resting provocatively on her hip. For a *maja* had to be *salada* ("salty"): ready to answer a risqué compliment with a snappy, equally brazen comeback. Her face should give nothing away, her bearing should be proud, with her head held high. This was the correct Spanish pose – whether for a backstreet *maja* or for a noble duchess.

1

## As crazy as ever

**E**very hair on the Duchess of Alba's head arouses our desire,"[2] wrote one enraptured French traveller to Spain in the year 1796. In Goya's painting she appears petite and well-proportioned, with huge eyes under thick eyebrows and lush dark hair.

To those who knew how to read it, the large black beauty spot beside her right eye symbolised "passion". Her dress, too, is predominantly black. This was appropriate both for a widow – the duke had died in 1796 – and for a *maja*. The effect is brightened only by her gold-lace sleeves, a short jacket, a white and yellow ribbon and a red sash.

Goya's painting does not capture the duchess's spontaneity. "What a lively, quick, gay person she was!" one elderly lady recalled. Visiting the duchess when they were both young, she had found her completely naked: "If it disturbs you to see me naked," the frolicsome duchess had exclaimed, "I shall veil myself with my hair."[3]

The Duchess of Alba was 35 when she sat for the painting. She was therefore considerably younger and more beautiful than her two rivals, Countess Benavente and the queen. According to María-Luisa in a letter to Godoy, however, she was "still just as crazy as she was when she was a young thing".[4] Her biographers see these "quirks" as deriving from her childhood and sterility.

Born in 1762 as an only child, she grew up in the various Alba palaces surrounded by nurses, governesses, footmen and court fools. Her grandfather, the Duke of Alba, was renowned for his arrogance. As his granddaughter was his only descendant, his desperation to secure the continuity of the family line drove him to find a husband for the girl while she was still very young. At the age of 13, she was married to the 19 year-old Duke of Villafranca. The bridegroom was bound by oath to take the name of Alba.

The young duchess proved unable to fulfil her most important dynastic task: to provide an heir for the house of Alba. Bored and frustrated, she plunged into a hectic life of engagements and amusement. Twentieth-century psychologists have diagnosed her as infantile, frigid, labile and narcissistic.

The duchess remained a spoilt child all her life, expecting her every whim to be gratified whatever the consequences for other people. She was as haughty as her forebears, but did not allow class prejudice to spoil her fun: she loved to ruin a man, or at least make a fool of him.

One of her jokes, for example, involved flirting with a seminarist on a street in Madrid: enticing him into a cake shop, she deliberately ordered so many of the most expensive delicacies that the poor young man was unable to foot the bill and, to the amusement of the (incognito) duchess, ended up pawning his trousers.

## A top hat on a peasant's skull

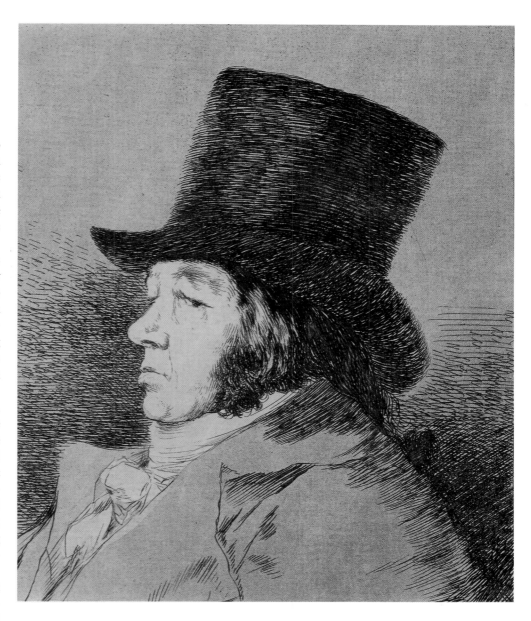

Francisco de Goya did not need to dress up as a *majo* – he was one, born and bred, even if the frontispiece of his *Caprichos* shows him wearing a top hat on his peasant's skull. He was a *majo* whose genius, diligence and single-mindedness took him to the top of his profession.

Born in Saragossa in 1746, Goya was brought up in modest circumstances. After a knife-fight, the young painter is said to have led a life of adventure, roving from town to town. He may even have performed as a torero in the bullfighting arenas. Goya held a lifelong reputation as an expert on bullfights, returning to them again and again as the subject of his work.

Even after moving to the capital in 1774, where he received commissions from the Church, aristocracy and royal family, the artist remained true to his inquisitive mind and natural *joie de vivre*. He felt most at home drinking with the *majos* in the back-street inns of Madrid. Like them, he loved flash clothes, music and dancing. A sturdy, carefree hedonist, Goya enjoyed drinking hot chocolate, partridge hunting and beautiful women.

Goya viewed painting above all as a craft which would bring him money and renown if he worked hard at it and knew all the right people. He had married into a respected family of painters and began work painting pictures for churches and providing large-scale cartoons for the royal tapestry factory. These mostly showed folksy scenes from the fashionable world of the Madrid *majos.*

Wealthy burghers and aristocats soon began to commission portraits from Goya. Although his realism pulled very few punches, he was nevertheless concerned to produce representative works, rendering his sitter's dress and attitude in a manner befitting his patron's position in society. The work brought him into everyday contact with people who were well-educated and acquainted with world affairs, several of whom became his friends. It also opened new perspectives, encouraging the painter to think more critically about the world and his place in it.

In the 80s, success came thick and fast. Goya became a royal painter in 1786, and three years later was nominated a court painter. He was celebrated effusively as the greatest of all Spanish painters. To crown his steep rise to fame and fortune he was to be elected to the coveted directorship of the famous Royal Academy at Madrid; suddenly, however, his solid and apparently secure existence collapsed.

In the years 1792 and 1793, the painter entered a period of crisis which took the outward form of a dangerous illness. Travelling in the south, he arrived at Cadiz "in very bad shape" and was laid low in March 1793 at the house of his friend Sebastian Martinez. Symptoms mentioned in his friends' letters were "roaring in the ears", loss of balance, deafness. One of them wrote that it had been "Goya's imprudence which has brought him thus prudence which has brought him thus far".[5] But beyond such remarks, very little is actually known.

By the end of 1793, Goya was back in Madrid. But he had gone stone deaf; not even the greatest noise could reach him. His illness, as well as the isolation deriving from his deafness, had turned the extroverted hedonist into a brooding sceptic who was tortured by bad dreams, evil demons and monsters.

It was apparently at this juncture in his life that the painter, now grown totally deaf, sickly and miserable, began his much-discussed "affair" with the Duchess of Alba.

2

## Evidence of a romance?

As far as we know, Goya painted the Duchess of Alba for the first time in 1795. Besides his portrait of the duchess in a white dress, he had also painted her husband. In fact, the artist had belonged at the time to a circle around the artistically-minded countess of Benavente, one of his earliest patrons. The idea of drawing the artist away from the countess must have appealed to the duchess, whose protégés were usually actors and bull-fighters. The manner in which she achieved this is recorded in a letter in which Goya tells a friend that the duchess came to him and asked him to make her face up, which "of course I enjoyed more than painting on a canvas".[6] The context of the letter helps date it to 1795; oddly, however, it is actually dated 1800, with a sender's address in London, although Goya had never been there. But this is by no means the only inconsistency in the affair.

It seems quite certain that the duchess and the painter spent several months in Andalusia in 1796/97. At the time, Goya had undertaken a second journey to the South, while the duchess, following the death of her husband in June 1796, had retired to her estates for the statutory period of mourning.

The fact that they met there is evidenced by the portrait itself, with its date 1797 written in the sand. The background shows the flat riverscape around Sanlúcar. There, the family of the duchess owned a large estate with comfortable hunting lodges and country houses, an appropriately solitary retreat for a widow in mourning.

However, the ring held out on the duchess's finger is not a memento of her dead husband. Beside the jewel carved with the word "Alba" is a gold band with a clearly inscribed "Goya". Furthermore, her index finger imperiously draws the spectator's attention down to the ground, where the words "Solo Goya" – "only Goya" – are written in the sand.

The word "Solo" was not rediscovered until the painting was restored several years ago. At some time or other, someone had gone to the trouble of painting it over, probably because the claim expressed in it by the artist seemed inappropriate, or compromised the sitter. In the foreword of a biography written in 1949, a later Duke of Alba expressed his opinion that an "ill-tempered, violent man" like Goya, whose "outward appearance was anything but refined, and whose language was extremely vulgar", could not possibly have become the lover of the sensitive duchess.[7]

It is possible that Goya added the writing without the duchess knowing; if so, his painting may be a wish-fulfilment fantasy. On the other hand, it is worth consulting a book of sketches, made during Goya's stay at Sanlúcar. One of these, showing the duchess during a siesta, suggests a highly confidential relationship between them. The deaf, ugly genius Goya may well have been attractive to a woman of extreme inclinations who had a penchant for men of the lower classes.

3

## "Flown"

Goya did not paint the duchess after 1797. Unlike her portrait in white, which is still in the Alba Palace at Madrid, the portrait of her in black did not enter her possession. Acccording to an inventory made in 1812, the portrait was still in the artist's studio at the time.

With the division of the artist's estate following his wife's death, Goya's son inherited the painting. The artist must therefore have let it go, perhaps because it aroused such bitter memories.

The artist's disappointment is also suggested by the negative context of the duchess's two later appearances in Goya's work, in the *Caprichos* (Caprices), published in 1799 and executed over a period of three years. A new, sceptical Goya expresses himself here in a series of about 80 satirical prints.

In one of the etchings, "Number 61", an unmistakable Duchess of Alba with outspread black mantilla flies across the sky like a witch on her way to the witches' sabbath where Goya assembled the demons and evil spirits who tortured him. Her white doll's face has an expression of haughty contempt; butterfly wings – symbols of fickleness – adorn her hair; three ugly figures, the bullfighters Costillares, José Romero and Pepe-Hillo, cower at her feet.

Goya wrote the caption "Volaverunt" – "They have flown" – under this etching. A savage form of leave-taking, perhaps?

The duchess died in 1802, at the age of 40. Immediately, some flimsy pretext was invented to justify impounding her estate. This gave the queen ample opportunity to purchase her dead enemy's jewels at their "estimated" value; Godoy, too, "bought" several of her paintings. Whatever remained after the estate was restored was shared out among the servants. A nine-year-old distant relative inherited the family name.

A rumour spread in Madrid that the duchess had been poisoned by her servants, or by "high-ranking persons". The king was unable to avoid ordering an enquiry to ascertain whether or not she had died of "natural causes".

The person he entrusted with this extremely delicate task, in a letter dated 30 July 1802, was – of all people – the art-lover and prime minister Godoy. As is to be expected under these circumstances, the report he compiled has disppeared. There is an inexplicable gap in the royal archives, as there is in the Alba family archives, starting just after 30 July 1802.

With speculation remaining rife well into the twentieth century, the Duke of Alba in 1945 was moved to throw light, by means of an autopsy, upon the mysterious circumstances of his ancestor's death. The pathologists discovered no sign of poison in the embalmed corpse; instead they found that somebody had hacked off the dead duchess's feet.[8] Oriental superstition attributed to this form of mutilation the power to prevent the return of the dead.

# A view to infinity

The boundless ocean, figures at the edge of a precipice, old-fashioned clothing, huge chalk cliffs as witnesses of the distant past – the painting (90 x 70 cm) by the Romantic C.D. Friedrich is evidently more than a view of a North German landscape. It belongs to the Stiftung Oskar Reinhart, Winterthur (Switzerland).

Caspar David Friedrich was born in 1774 at Greifswald on the Baltic coast. Across the bay lay the island of Rügen, where Friedrich liked to go walking. When he married in 1818 – by then he lived in Dresden – he showed his wife not only his native town, but also the island. His painting, set in the chalk cliffs there, was probably executed shortly after his honeymoon. It is not dated.

Friedrich frequently made drawings on Rügen, basing several of his later paintings on the sketches. His written references to the island (which was not yet linked to the mainland) are few and far between. However, an account of a walking tour on the island was made by Friedrich's friend, the doctor and art critic Carl Gustav Carus. The two men had become acquainted in Dresden, and it was presumably Friedrich's enthusiasm for Rügen that inspired Carus's trip to the Baltic coast. His visit fell in 1818, when Friedrich married and may also have painted his *Chalk Cliffs.*

"To put over to Rügen across the broad Greifswalder Bodden, we hired a little yacht," recalled Carus, "and I first set sail under a fine morning sky on 14th August." The island was entirely unprepared for tourism: "Instead of a well-appointed hotel to welcome the island's guests, there was nothing among the scattered blocks of granite but a fisherman's smoky cabin, where new arrivals could satisfy their most urgent needs."

The reader will learn little from Carus about the people who lived on Rügen, about their work or way of life. The features he describes are those which also interested Friedrich: "I came across an ancient oak right in the middle of the island. It was almost completely withered; its monstrous, grey branches stretched up worn and shining into the blue sky…"

Carus walks to Cape Arkona, "the most northerly point on German soil". He visits a place "where peculiar, old rune-stones enclose an ancient burial mound, or some kind of sacred hill". The withered oak tree, Cape Arkona, megalithic barrows – these were legacies of the past, symbols of a national history, and Friedrich returned to them again and again in his drawings and paintings.

However, by far the most moving spectacle for Carus was the view from the top of the cliffs that made Friedrich famous and turned tourism on the island into a mass industry: "Towards evening we took the forest path, listening to the distant roar of the waves mingling with the rustle of the wind in the leaves around us. All of a sudden, the forest ended and we were standing at the top of the sheer chalk cliffs at King's Seat, where the long, drooping branches of young red beeches swayed over the foaming surf far below, and the blue-grey mirror of the Baltic streched out in a broad sweep to the barely perceptible line of the horizon… "[1]

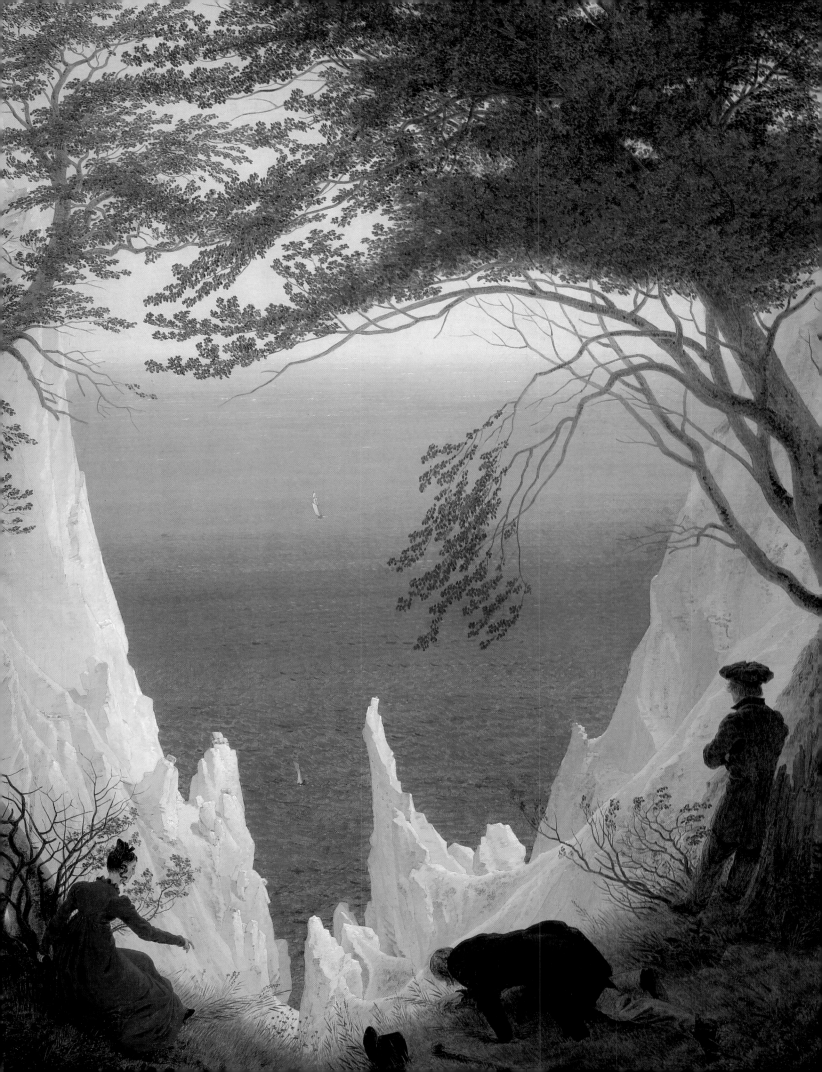

1

## At the seaside in a high-necked dress

At the time, swimming and sailing were not yet thought of as holiday pursuits. Visitors were drawn to the watering-places which had begun to spring up along the German coast, just as they were to the spas of the interior, solely on account of the healing powers attributed to water. Indeed, once there, they were more likely to bathe in a tub than in the sea.

The Mecklenburg court had made a start on the Baltic coast in 1793, near Doberan, the later Heiligendamm. Travemünde followed six years later, with a casino added in 1822. Like the famous spas at Karlsbad and Baden-Baden, the new seaside health resorts wished to offer their guests an attractive social life.

While Friedrich was painting his seascape, upper class families were discovering the pleasures of the seaside. In the interests of modesty, the English had invented the bathing-machine: "The bather mounts a two-wheeled vehicle, a carriage, upon which is a small wooden hut… Attached to the back is a kind of tent." The description is from an essay, entitled "Why does Germany have no large, public, seaside resort?" written by the Göttingen philosopher Georg Christoph Lichtenberg in 1793. To enable ladies to bathe in such tents, English seaside resorts offered special "loosely-fitting suits", which, "although they float on the surface, allow their wearers the security of feeling fully dressed". Ironically, Lichtenberg adds that this "security" will "be ever sacred to the innocent, whether on the ocean or submerged in total darkness".[2]

Traditionally, Christian doctrine decried the body as the adversary of the spirit; the female body, especially, was thought to be the devil's instrument of temptation. Hostility towards the body was particulary pronounced in 18th and 19th-century bourgeois culture. Washing the body was avoided; in pietistical circles, it was considered immoral for women to see even their own bodies naked. Friedrich was prudish, too, at least in his pictures. He was interested in Nature, not in the naturalness of the body. Like the woman in the painting, almost all his figures are fully dressed. Only their necks, heads and hands are visible.

The woman's long, loose dress, with its high waist girded just below the breast, was a development of the Empire gown. This had become fashionable in France at the time of the Revolution, at least in the upper classes. It was worn sleeveless, had a low neckline, and was generally made of transparent materials.

In adapting the dress for the German bourgoisie, however, everything free or transparent was removed. The style has more in common with Gothic than Empire style. This may be the reason why Friedrich painted this type of dress so frequently; the Gothic, after all, was supposed to be a German style. The pseudo-Gothic dress thus serves as a reminder of German history.

## Fashion as a pledge of loyalty

The man wearing a beret and leaning against a tree is also dressed in "old German" style. The so-called "national costume" was, in itself, a pledge of loyalty. Its origin lay in the wars of liberation against Napoleon. It was a pledge against foreign dictatorship, against the despotism of German princes, for a unified Germany and for human rights.

It had been middle-class burghers, not the princes, who had mobilised an army against the French occupation. The self-confidence this had generated now sought official recognition. Once the French had been expelled, however, the German princes attempted to re-establish absolutist structures of power. In 1819, their ministers passed a series of repressive laws: censorship of the press, prosecution of all "demagogues", banning of radical students' associations, prohibition of the "old German" costume.

The costume had been propagated by another of Rügen's native sons, Ernst Moritz Arndt, born on the island in 1769. In 1814, one year after the war of liberation ended, he wrote an essay entitled "Of Manners, Fashions and Costumes". Although he had few suggestions to make on the subject of women's clothing, Arndt insisted that a man's proper dress was a frock-coat buttoned to the neck and a wide shirt collar. Hair could be worn long and was to be covered with a velvet beret. From about 1815 onwards, the majority of men in Friedrich's paintings appear in this, or similar, dress.

In memoirs recalling his youth, Arndt also described what he wanted to abolish: "All that rigmarole with periwigs, that whole foppish way of dandified dressing with its jesuitical, arabesqued, Frenchified squiggles and twirls – a style which survived from Louis XIV to the French Revolution." Arndt had suffered under this style of dress: "It often took the best part of an hour until your queues were starched up and your toupet and curls were waxed down and you were properly smoothed over with pomade and piled with hairpins and powder."[3]

Arndt's fate was fairly typical for a man of his political persuasion. "The Rhine is

Germany's river, not Germany's border," he wrote in defiance of Napoleon. Under the latter's occupation he was forced to flee to Russia. Following Napoleon's defeat, he was made professor of history at Bonn university, but was dismissed as a "demagogue" two years later: "because I had acted in the spirit and best interests of what I understood to be – and, as it happened, actually were – the spirit and best interests of Prussia."

He was prohibited from returning to his profession for twenty years. The file compiled at the time of his removal from office contained a letter, dated 1814, from Caspar David Friedrich: one of many statements of the painter's political sympathies.

Friedrich wrote that he would like to paint a memorial to Scharnhorst, the Prussian military reformer: "I am not a bit surprised that no memorial has been erected, whether to honour the people and their cause, or to remind us of the noble-minded deeds of individual Germans. As long as we remain the minions of despots and princes, nothing great of that kind will ever happen. Whenever people are denied a voice, they are also prevented from feeling who they are, or from taking pride in their own achievements."[4]

3

## Beyond landscape

A view from chalk cliffs belonged to the category of "landscape paintings", a genre not thought particularly worthy of respect. The importance of a painting was decided less by its quality, than by its subject.

In 1802/03, the philosopher Friedrich Wilhelm Schelling reflected on the relative importance of subjects. At the top of his hierarchy was the history painting; at the bottom, the still life. Landscapes came somewhere in between. Acording to Schelling, landscapes lacked objective meaning: "Only the outer mantle is actually shown; the thing itself, the idea, is without form; it is therefore left up to the spectator what he makes of this flimsy, formless state of being."[5]

Friedrich would never have agreed with Schelling's point of view. His aim was not to show the "mantle", or to reproduce an actually existing landscape. When Goethe asked him to sketch cloud formations for his scientific studies, Friedrich refused. He did not portray nature *au vif,* as it were; he rearranged it. He introduced distance where there was none. He moved the ruins of Eldena monastery from its original setting near Greifswald to the Giant Mountains. He also changed the chalk cliffs until they fitted his idea of them.

Friedrich was not the only painter of his time to use landscapes to express "ideas". In Rome, his German contemporary, Joseph Anton Koch, was painting combinations of very different landscapes, attempting to illustrate different moods and states of mind.

This kind of thing did not interest Friedrich. It is not only his emphasis of things German that springs to mind when one looks for "ideas" in his work; tranquility and distance are equally important. He avoided stirring movement; wind, storms or battle scenes are not found in his work. The movements of the figures on the chalk cliffs serve to underline the general sense of peace and tranquility. Conversely, his version of Nature lacks the sequestered, leafy intimacy which Ludwig Richter so often extolled in his landscape idylls. The three ramblers on the chalk cliffs are quite clearly standing on the edge of a dangerous precipice.

Rather than intimacy, it is a sense of great distance which the picture evokes. With its dark foreground, bright middle ground and high horizon, fully framed by the trees and rocks, it is like a window with a view to infinity.

Besides tranquility and the infinite, there is a third idea which recurs in Friedrich's work: the past. He painted burial mounds, Gothic churches, ruins and churchyards. The chalk cliffs, too, are the legacy of geological events which took place millions of years ago. Men like Friedrich and Arndt found strength in the past; they looked to history for models of a better Germany. At the same time, Friedrich's motives for turning to the past were by no means solely political. He was a religious man. His writings show his belief that God revealed Himself through Nature. He attempted to convey this feeling of divine revelation in his landscapes, returning again and again to notions of tranquility, eternity and infinity.

The identity of the three persons on the cliff edge has given rise to much speculation. The woman may be Caroline Friedrich, with whom the artist visited Rügen in 1818. One of the men might then be Friedrich himself, the other possibly his brother, Christian, who, with his own wife, accompanied the newly-weds on their tour.

Or was the artist thinking here of his friend Carus? Why is one of the men looking down, while the woman appears to be pointing at something, or waving, as if warning of some danger? Perhaps she has lost her hat: like the men, she would certainly have worn one. Is their gaze into the depths symbolic?

Friedrich himself offered no explanation. What we do know is that the figures are painted more or less from behind, and that this is consistent with the figures in almost all of his paintings. Since individuals are generally recognised by their faces, it is logical to assume that Friedrich's rear views do not portray individuals, indeed that he was not interested in portraying individuals in his landscapes at all. Rather, he was interested in them as vehicles: they are shown in the act of gazing, thus inviting the spectator to do the same. It is not the figures themselves who are significant, but the object of their gaze.

Whether gazing at the moon, a mountain top or the sea's horizon, Friedrich's figures, like the man on the right, are usually shown looking into the distance. Their pose, in so doing, is almost always an expression of inner peace. They are meditative figures, seemingly lost in thought. According to Carl Gustav Carus, it was preferable to visit the island "alone", "entrusting oneself" to Nature. Once "alone", one's "gaze from the mighty chalk cliffs" could "accompany distant sailing ships across the iridescent ocean waves..."

The poet Novalis described the romantic notion of "entrusting oneself" to Nature as a difficult art: "The art of contemplation is hard. Gazing creatively at the world demands austerity, the ability to engage in uninterrupted, serious reflection; the reward will be... only the pleasure of knowledge and growth, of touching the universe at a deeper level."[6] Novalis died in 1801. Friedrich painted his self-portrait in 1810.

Friedrich's crayon drawing does not show the artist in contemporary dress, but in a cowl resembling, more than anything else, a monk's habit. The garment thus gives its wearer the exalted aura of someone who is used to "contemplation". A person who spends his time "touching the universe", or communicating with the Infinite, is no longer in touch with reality – with the social world of normal human beings. Social reality, for someone of Friedrich's political sympathies, was as oppressive in 1810 as it was later, in 1818. For if, in 1810, Germany was occupied by Napoleon's army, by 1818 the German nobility was firmly back in place. Friedrich did not flee to Russia; nor was he removed from office, like his fellow-Pomeranian Ernst Moritz Arndt. Friedrich fled to the Infinite. The narrowness of the political scene intensified his longing to "touch the universe".

## The art of contemplation

# A Romantic's Asiatic tour de force

A monumental bed forms the diagonal axis of the painting. Relaxing on it is a man. Apparently unconcerned, he watches the turbulent scene unfolding before his eyes: women's bodies in contortions of ecstasy, wild-eyed Orientals, a marvellously bejewelled horse surrounded by golden treasures.

The scene is an orgy of death. The dark-skinned Nubian has plunged his sword almost to the hilt in the horse's body; the naked women are either dead or being stabbed to death; to the right and left of the red-spread bed lie wooden beams, soon to be set on fire. The scene takes place on a funeral pyre.

The Assyrian king, Sardanapalus, defended his capital city for three years against a powerful enemy (according to the Greek author Diodorus, writing in the first century A.D.). But when the river Euphrates, in fulfilment of a prophecy, flooded its banks and tore down the wall of the city, he gave up and admitted defeat. "He had a gigantic funeral pyre erected in his palace, heaping upon it all his gold and silver and every garment in the royal ward-

robe. He then locked his concubines, his eunuchs and himself in a room that had been cleared in the middle of the pyre and committed everything, including himself and his palace, to the flames."[1] Nothing that had ever served his pleasure was to be spared.

The story has little in common with the life of the true historical figure. Sardanapalus' reputation was legendary: he was the incarnation of irresponsible hedonism. His epitaph is said to have read: "I have eaten, drunk and amused myself; nothing meant more to me than a straw."[2]

According to Diodorus, it was only Sardanapalus' bravery on the field of battle that proved he was a real man. Otherwise, "he surpassed all his predecessors in sloth and luxury… living like a woman and spending his days with concubines… He wore women's clothes, covering his face and whole body with cosmetics that made his skin white… so that he became more delicate than the most luxurious of women."[1]

It was precisely those qualities that would have been considered unattractive by bourgeois standards which predestined Sardanapalus as a hero of the English and French Romantics. Lord Byron devoted a tragedy to him, and Eugène Delacroix, almost 30 years old at the time, painted his 395 by 495 cm painting.

The painting exemplifies the most important features of French Romanticism: the unrestrained superman as hero; the combination of death and eroticism; Oriental decor; swirling movement rather than the repose and balance of an orderly construction; the predominance of colour over line.

The work was painted for the Paris Salon of 1827/28. It was intended to be provocative – and achieved its aim. Delacroix called it an "Asiatic tour de force".[3]

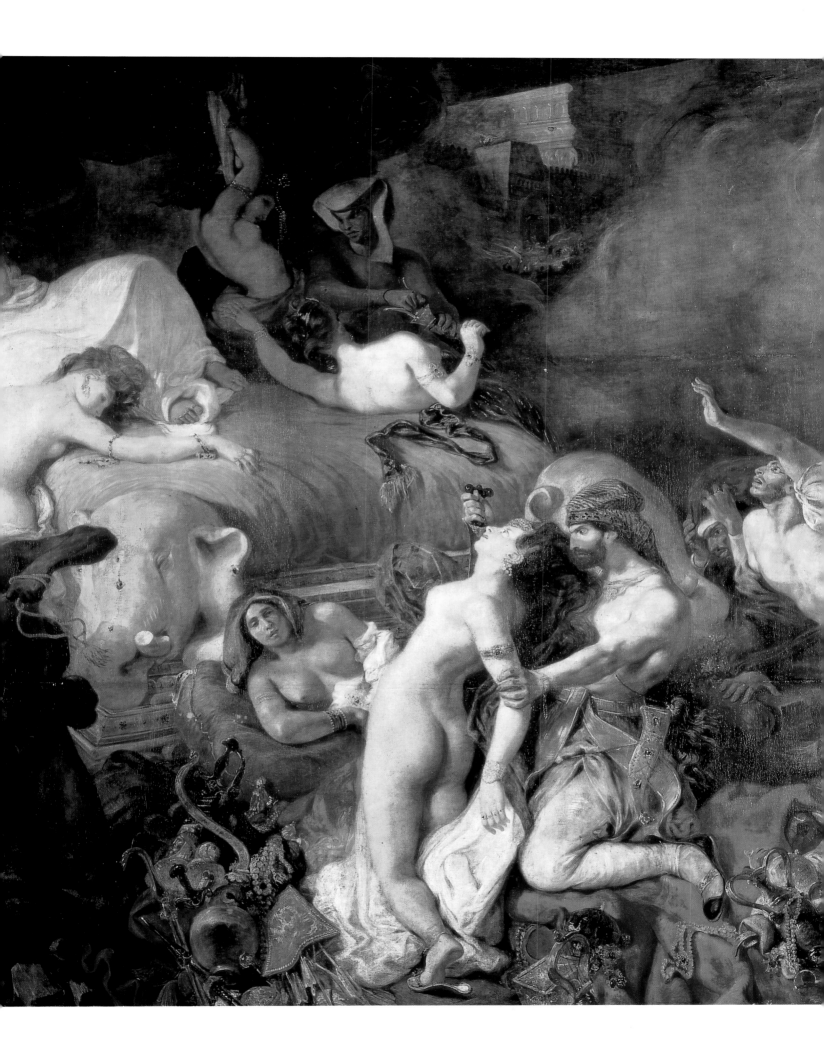

## Heinous heroes

George Gordon Noel Lord Byron (1788–1824), who rediscovered in Sardanapalus a figure for his own time, was one of the leading lights of the Romantic movement. His influence was felt throughout Europe and was not confined to literary circles, for it was not only Byron's works, but his personality that made him famous. The English aristocrat acted in constant defiance of social and ethical norms. He indulged in extravagant debauches, vaunted his incestuous and ho-mosexual relationships and died, in 1824, for the liberation of Greece – of malaria rather than wounds.

In his play *Sardanapalus,* published in 1821 and dedicated to the "illustrious Goethe", Byron did little to disguise his self-portrait. The hero of the story is a split personality: on the one hand "the despotism of vice, the weakness and wickedness of luxury, the negligence, the apathy, the evils of sensual sloth…";[4] on the other, heroism. Byron had similar views of himself: "I am such a strange mélange of good and bad",[4] he wrote. In this sense, he was both a Don Juan (the title of one of his most well-known works), hurrying from one love-affair to the next, and a freedom-fighter, chartering a brig and fighting the Turks in Greece.

Delacroix was a great admirer of Byron, and several of his paintings were inspired by the English poet. Delacroix, too, gave Sardanapalus features of his own: "his pale complexion, his full black hair… eyes, like those of a wildcat, thick eyebrows vaguely raised," wrote the French poet, Théophile Gautier, describing the artist. Gautier continues: "His face had such a strangely exotic, such a wild, almost worrying beauty, one might have taken him for an Indian maharaja, brought up the perfect gentleman in Calcutta."[5] To this picture of himself, the artist has added only the beard, and a distinctly muscular arm; he was, in reality, of rather puny build.

Eugène Delacroix (1798–1863), who was ten years younger than Byron, was the archetypal representative of the French Romantic generation. Born during the years of Napoleon's conquest of Europe, brought up to the sound of beating drums and tales of glory, his was a generation who had come of age in a society where "great" events no longer happened. "The world had been shaken to the core, and suddenly all was still," wrote the Romantic poet Alfred de Musset. "From then on it was as if there were two camps: here, expansive, soulful spirits whose hearts and minds overflowed; there, sober, down-to-earth types, inflexible, happy enough to be alive, content to count their money."[6]

In a society devoted to narrow-minded materialism, "expansive, soulful spirits" were easily driven to melancholy: "the sickness of the century". They became world-wearied, pessimistic through and through. Delacroix, too, complained in his journals of "boredom and melancholy"; everybody, he wrote, "goes about in a leaden cloak".[7]

Disappointment and ennui were the crucible in which the Romantic hero was fired: the prototypical rebel who, on behalf of author and reader, pitted himself against social norms and died a hero's death; the loner who challenged the gods, a Titan, a fallen angel. One such figure is Victor Hugo's *Hernani,* a robber who fights the emperor, and over whose life hangs a dreadful curse. Another, equally contradictory figure is *Antony,* the protagonist of a play by Alexandre Dumas, who is forced to murder his loved one. It is sullen-faced figures like these who populate the books and plays of the period: they were "beautiful as Satan, cold as snakes, haughty, bold".

Lord Byron, the "Bonaparte of poetry", came close to this ideal. The youth of France admired him as the century's second-greatest hero. The literary embodiment of the ideal was Sardanapalus (in Byron's version), who, in celebration of his own demise, draws the most pretentious comparisons: "In this blazing palace,… we leave a nobler monument than Egypt hath piled in her brick mountains o'er dead kings."[4]

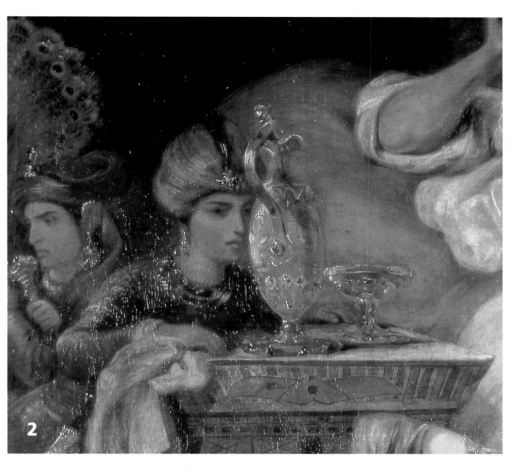

## Exotic accessories

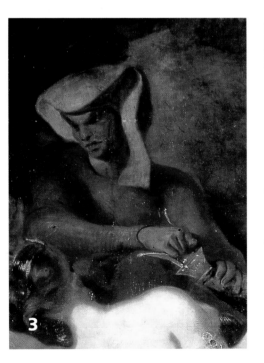

Beside Sardanapalus' bed is his young cupbearer, who, according to the catalogue of the Paris Salon of 1827/28, "will set light to the pyre and throw himself on the flames". Here, he is seen presenting the king with a cup of poison.

The carafe stands on a table that is decorated with an Egyptian winged sun. Delacroix gives the cupbearer an Indian or Turkish turban, while the Moor at the other side of the bed wears an Egyptian-style hood. The mighty elephants at the foot of the bed are of Indian provenance.

Delacroix thus assembles geographically disparate accessories and costumes whose sole common denominator is their non-European origin. They evoke a vague sense of "the Orient", a non-European realm of fables and dreams. Here, as well as in the distant Middle Ages, Delacroix and his friends took refuge from the oppressive restraints of contemporary reality.

Two men were responsible for the growing interest in the Orient at the beginning of the 19th century: Napoleon and Lord Byron. In 1798, Napoleon had led a spectacular expeditionary force to Egypt and won a victory near the pyramids over the Mamelukes. Although the expedition ultimately failed its purpose, it unleashed an intense, lasting interest in what, at that time, was a relatively unknown part of the globe.

In 1809, Lord Byron set off on his "grand tour", traditionally a part of every young noble's education. However, he could not visit France or Italy, because England was at war with Napoleon. Instead, he travelled to Greece and Turkey, composing a poetic travelogue entitled *Childe Harold's Pilgrimage* which soon became a sensational success. His motive for the pilgimage was this: "With pleasure drugged, he almost longed for woe,/and e'en for change of scene would seek the shades below."[4]

Nobody had ever written as colourfully of dervishes, pashas and mosques. Behind the colour, however, was a need to escape the narrowness of Europe, a desire for change at any price – including death.

Byron actually did risk his life. He reported on the liberation struggle of the Greeks against the Turks, commending the impressive heroism of the former and attacking the atrocities of the latter. The struggle attracted considerable sympathy in a Europe whose memory of the Revolution and Napoleonic Wars was still fresh. A philhellenist movement emerged which, in 1827, forced the European governments to send an international fleet in support of the Greeks.

Even as a schoolboy, Delacroix had drawn pictures of Turks and harems. In the Salon of 1824, he offended the establishment with his topical *Massacre at Chios.* It was not until several years after he had completed *The Death of Sardanapalus* that he travelled to the Orient himself. In 1832, he accompanied a French diplomat to Marocco and Algeria: "I feel completely overcome… moments of fascination, and of the strangest bliss!"[8]

Sardanapalus goes to the grave accompanied by his Arab horse. It has been dragged to his bed, bejewelled like a woman, with its braided mane and golden reins. Delacroix, too, loved horses. He had sketched them ever since his youth, and later on, they became a recurrent motiv in his work. Like other Romantics, he saw in the horse an embodiment of his longings.

The Classical ideal was self-control; the scale of human measurement was man. The horse of the Romantics, on the other hand, was unbridled impetuosity, a rearing beast, all movement, the incarnation of power and passion. Again and again, Delacroix painted horseback duels, lions and tigers falling on horses. He wanted "impetuosity" and "fluency"; wanted a "coat shimmering with the play of muscular reflexes" and, more than anything else, he wanted "the soul, the horse's eye".[9]

Géricault and Delacroix painted illustrations for *Mazeppa,* an epic poem by Byron. In the poem, the hero is driven into the wilderness, bound to the back of a horse. Here, man is not in control of his passions, but is carried along by them – an archetypal Romantic subject.

Delacroix's friends saw the emotional content of his work as deriving from his character. His upbringing and the demands of society had taught him to observe the rules of politeness, wrote one contemporary, but behind this façade he was only just able to conceal the violence of his mood: "a wild passion, whose fire shone in his eyes". The alternation of his mood between intense exhileration and severe depression was largely due to an organic complaint which eventually killed him: the painter was suffering from tuberculosis. Delacroix: "Always this light fever …" The poet Charles Baudelaire wrote: "One might be tempted to speak of a crater, elaborately concealed by flowers."[9]

## Unbridled passion

He not only had the character of a Romantic hero; his background, too, was shrouded in mystery. Talleyrand, the great French politician, who had succeeded in first serving Napoleon and then the Bourbon monarchy, is said to have been Delacroix's father. Delacroix's family were civil servants, with close links to the Empire. The family became impoverished during the Restoration and the artist was forced to turn his painting, initially a hobby, into a means of earning a living. Spectacular success came relatively quickly; by the time he was twenty-four, one of his paintings had been exhibited at the official Paris Salon. The painting was bought by the State, and the artist was celebrated as a "genius" by the critics.

During the following years, two of his paintings, both of them passionate interventions on behalf of Greek liberation, caused a sensation: *The Massacre at Chios* (1824), and *Greece Expiring on the Ruins of Missolonghi* (1827).

These paintings made Delacroix the leader of the Romantic movement in painting. As such, he took over from his older friend Théodore Géricault, who died in 1824 as a result of a riding accident.

The spokesman of literary Romanticism in France was Victor Hugo. While Delacroix presented *Sardanapalus* at the Salon, Hugo was demanding total freedom for art in the Preface to his play *Cromwell.* According to Hugo, traditional rules (such as the unities of place, time and action) should be abolished.

Delacroix did not compose a written manifesto, but *Sardanapalus* fully expressed the artist's opposition to the dominant Classical rules and precepts. The most important exponent of the style at the Salon of 1827/28 was Jean-Auguste-Dominique Ingres, with his *Apotheosis of Homer.*

Harmony and line are the dominant features of Ingres's aesthetic, while *Sardanapalus* is all colour and movement. Delacroix demonstrates his "rejection of academic principles" and demands "free expression of my own feelings". He sees his *Sardanapalus* as an "Asiatic tour de force, directed against all these Spartan imitations of David". Ingres, on the other hand, saw Delacroix as an "apostle of the ugly… replete with dangerous doctrines and inclinations". When Delacroix left the room, Ingres had all the windows opened to let out the "stink of sulphur".

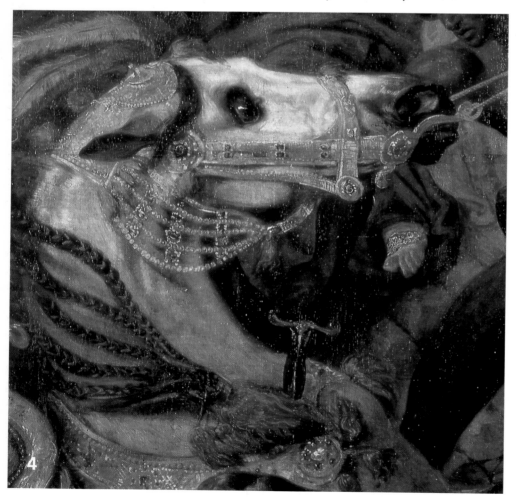

4

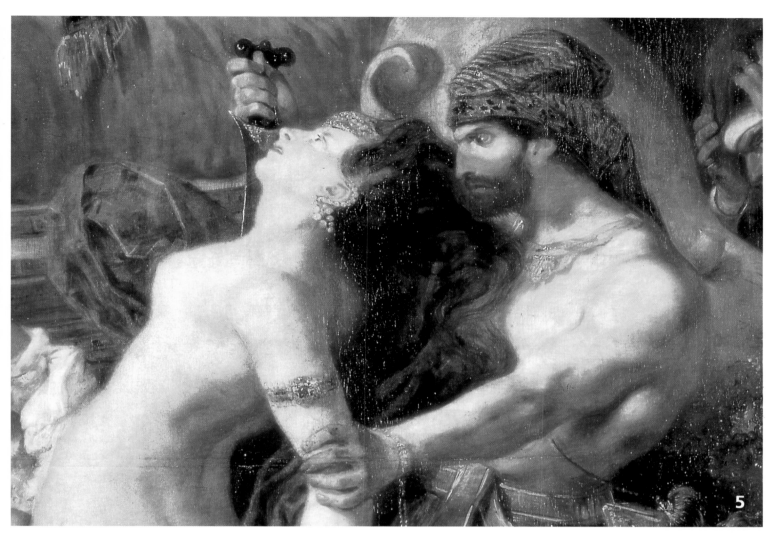

5

## Scandal at the Salon

Faced with *Sardanapalus,* even Delacroix's erstwhile supporters balked. "This time Delacroix has gone too far," one of them wrote. Aesthetically, his contemporaries were outraged; his combination of eroticism and death was considered utterly beyond the pale. In fact, this "black Romanticism", as it later became known, was typical of the widespread Romantic attempt to provoke a powerful emotional response with the aid of morbid or macabre subjects. In England there had been a wave of stories about vampires, and Frankenstein's monster.

In France, the portrayal of decomposing bodies on Géricault's *Raft of the Medusa* created a furore. Delacroix liked to paint victims of violence too – preferably female ones. Both his *Massacre at Chios* and *The Knights of the Cross Taking Constantinople* are full of suffering, tormented, dying

women. It is only women who are shown dying at Sardanapalus's bedside. Their eyes, which, according to the Romantics, were the mirror of the soul, remain hidden. They are naked, all body, while the Assyrian king lies fully clothed on his bed. He commands; his will is done; he is the subject. The others, the women very visibly so, are degraded to mere objects. In one of his novels, the Marquis de Sade writes: "Oh, what pleasure could even be compared with that of annihilation: I know of no more delicious thrill!"[10]

It is not unlikely that Delacroix's painting, too, is an expression of his lifelong problems with women. He needed women, and feared them. He was unable to commit himself to a steady relationship. Delacroix frequently expressed himself in comments like: "Such a pretty passion; she'd be the ruin of any man." Or: "When I go to work, it's like another man hurrying to his mistress…"[11]

*The Death of Sardanapalus* caused such a scandal that Delacroix was unable to sell anything, according to his own testimony,

for five years. The Salon, whose role was essentially to judge what was good art and what was bad, was dominated by the Classical works of Ingres and his pupils, or by the more moderate Romantics.

Success eventually returned to Delacroix with the response to a painting which, like many of his earlier ones, was inspired by political events – this time by the 1830 July Revolution. This work also shows corpses: not in a bedroom, however, but on, or in front of, the barricades. This time, the painting is not dominated by a man, but by Liberty: a woman, shown leading the people against the ruling class. The painting was bought by the State, but disppeared into cold storage only a year later. Delacroix was unable to sell *The Death of Sardanapalus* until 1846, when it was bought by an Englishman. Passing from one private collection to another, it remained invisible to the public until 1921, when it was bought by the Louvre. It can be seen there, in close proximity to his programmatic picture *Liberty Leading the People,* to this day.

Intending his picture to be as realistic as possible, Menzel painted one of the evening recitals given by Frederick II a hundred years earlier. At the same time, his rendering was entirely consistent with the expectations of his Prussian contemporaries. The latter lived in hope of a powerful monarch who would make use of their dormant "sense of nationhood". The painting (142 x 205 cm) is one of the most well-known works in the Nationalgalerie, Berlin.

The young King Frederick II, travelling to Holland, wished to remain incognito; but for two companions, he left his retinue behind and pretented to be a touring flautist. He ordered vol-au-vents at an inn in Amsterdam, but the landlady thought he looked too poor to pay the bill. His companions assured her that their friend, a virtuoso musician, could earn more money in an hour than ten vol-au-vents could possibly cost. The landlady then asked him to play for her, which he did. "So carried away was she by the beauty of his recital"[1] that she promised to bake the vol-au-vents without further ado.

There are many popular anecdotes about Frederick II as a flautist, and since anecdotes generally reveal a powerful sympathy on the part of those who tell them, it may be deduced that the Prussian king's music-making made him highly popular with his subjects. The flute-playing Frederick II even provided the subject of an opera. Entitled *An Army Camp in Silesia,* it was first performed in 1844 to mark the opening of the new Berlin Royal Opera House. The music was composed by Giacomo Meyerbeer, and the libretto is based on an incident in which Frederick narrowly escapes being taken prisoner by pretending to be a musician.

Menzel painted his *Flute Concert* between 1850 and 1852, shortly after the première of Meyerbeer's opera. The painting (142 by 205 cm) is one of the most popular in the Nationalgalerie at Berlin. This cannot be explained by its superior quality; there are other paintings, equally good. Its appeal is probably closely linked to the theme: the great king playing to friends and family. The setting is the music room of the palace of Sanssouci at Potsdam. The room is one of the finest examples of German Rococo. Beautifully restored, the room today looks much as it did when Menzel was alive.

Adolph Menzel: The Flute Concert of Frederick the Great
at Sanssouci, 1850/1852

# The greatest amateur musician of the nation

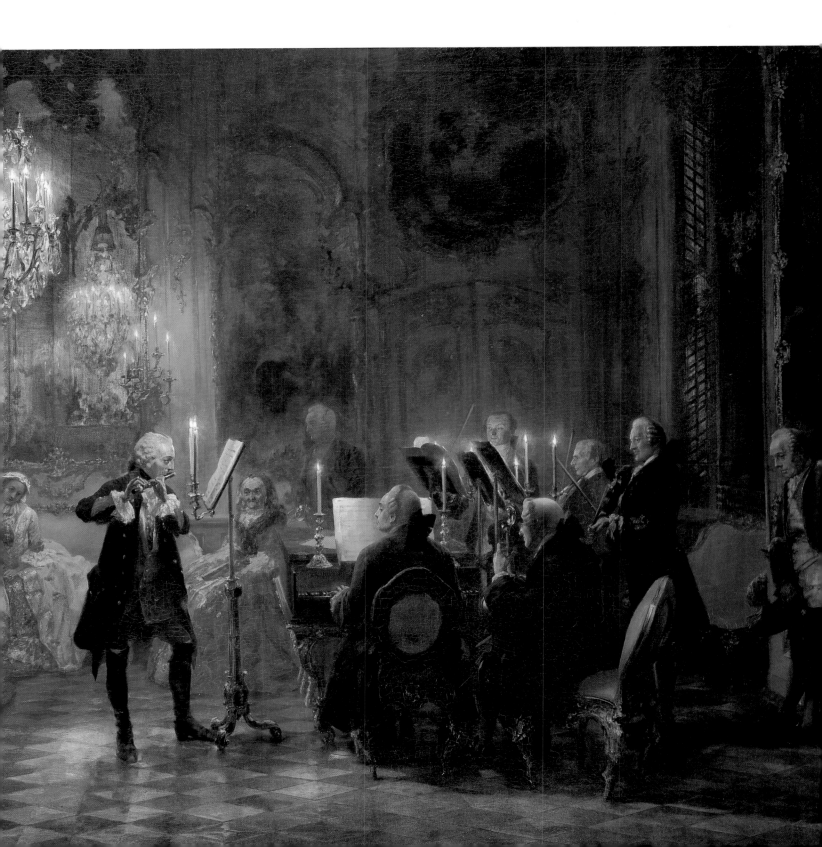

1

## Rapture and boredom

Three men stand and listen; as long as the king stands, no other male guest may sit. The concert in Menzel's painting is supposed to have taken place in 1750, a century before he started work on the picture. The artist also left a sketch identifying the figures. On the far left, an enraptured smile on his face, stands the spirited writer and courtier Baron Jacob Friedrich von Bielfeld. He had been a guest at Rheinsberg, too, Frederick's palace when he was crown prince. "Evenings are devoted to music," von Bielfeld noted.

"The Prince gives regular recitals at his Salon – invitation only, of course, and those who receive an invitation may consider themselves highly favoured. The Prince usually plays the flute. He has perfect command of his instrument: his embouchure, dexterity, fluency and presentation are unique. He has even scored several

sonatas himself. I have frequently had the honour of standing behind him when he was blowing the flute and was exceedingly taken with his adagio. But then Frederick is accomplished in all things…"[2]

It was an honour, too, to be invited to an evening recital at Sanssouci. Even those who were bored by the music felt obliged to attend. This, at least, would appear to be so in the case of the mathematician and geographer, Pierre Louis Moreau de Maupertuis. One of several French intellectuals whom Frederick had invited to Berlin, Maupertuis was the first scientist to show that the Earth's sphere flattened out at the poles. The king appointed him President of the Academy of Sciences. He had the reputation of a brilliant raconteur and entertainer, a master of the art of conversation, in which, it is said, he occasionally excelled Voltaire. Voltaire and Maupertuis, each convinced of his own superiority, and both in the small township of Potsdam-Berlin: it was obviously a recipe for disaster. They fought each other with articles, schemed against each other in the most underhand fashion and made each other the laughing-stock of the court. When Voltaire insulted the king, however, he had to go. Maupertuis stayed: the victor. In the

painting he looks boredly up at the ceiling. He would never have dared had the king been looking. Menzel's arrangement of the figures is revealing!

The portly gentleman with the old-fashioned periwig in the foreground is Count Gustav Adolf von Gotter, a hedonist and man of the world. He always had an eye to the main chance and was highly skilled in recommending his own services. After several years as Prussian ambassador to Vienna, he became Lord Marshall at Frederick's court and was often entrusted with missions abroad.

He was a courtier and diplomat, but could boast little in the way of personal achievement. Count Heinrich von Lehndorff, the queen's lord-in-waiting, recalled a coach-journey in his company: "Gotter, with whom I travel, thought himself about to die. He had such terrible hiccups that I, too, thought he might give up the ghost. A moment later, he was singing and blabbing about young girls. It has always been a riddle to me how this man could have acquired such wealth, rising from the middle class to polite Vienna society, where his only interest is to indulge himself. But what amazes me most is that the same man enjoys the King's favour."[3]

## His sister occupies the place of honour

Important ministers and officers were less likely to be invited to Frederick's evening recital than men whose company he found pleasing, those whom he had known since his days as crown prince, or who excelled in conversation. In the painting, not one of his brothers is present. There were six in all, of whom three were still alive. But Frederick's relationship to them was strained. He described them in his *Political Testament* as hybrids "who are neither rulers nor private gentlemen and who are sometimes most difficult to govern."[4]

Frederick's wife, too, is absent. Indeed, she never set foot at Sanssouci, Frederick's favourite residence. Frederick's father, the "Soldier King" Frederick William I, had forced the crown prince to marry. At the time, the bridegroom had predicted that the Princess would be "dismissed as soon as I am master".[5] He held his word. The provision of an heir to the throne was of no concern, since he considered himself impotent anyway; his doctor described his condition as "imaginary eunuchism".[6] The king was usually resident at Potsdam, the queen at Berlin. She took "afternoon strolls in the zoological gardens. The queen, who has so little pleasure in life, finds extraordinary enjoyment in things that leave us quite indifferent."[7] Thus her lord-in-waiting, Lehndorff.

The woman sitting directly beneath the chandelier is Frederick's sister, Wilhelmina, who was married to the Margrave of Bayreuth. Three years older than her brother, she had helped him survive his father's barbaric discipline, the unbearably repressive atmosphere at court, and the strictness of his military training. Their relationship remained close even when they were older, and it may be true to say that she was the only woman for whom he felt a deep and lasting affection. Menzel is quite right to give her the place that would normally be granted to the queen.

On the sofa to the left of Wilhelmina sits her sister, Amelia. She ran up debts, had an "affair", never married and, in 1755, became Abbess of the Protestant Ladies' Foundation at Quedlinburg. In giving her this position, Frederick had both provided her with a benefice and removed her from court. In his chronicle of events in 1756, Count Lehndorff writes that the Abbess is fond of a certain page "whom she has immediately made a gentleman, and, what is worse, she has made him head of the chancery at Quedlinburg. He'll make a splendid chancellor, I'm sure!"[8]

Menzel has included four women in the painting, placing them, with their colourful dresses, in the best light. They thus provide a marked contrast to the gentlemen, who, almost all turned out in black, stand in the shadows. The presence of women creates a false impression, however: there were few women at Frederick's court. The king kept them well out of his way and, unlike other rulers of his day, had no mistress. He liked to be surrounded by men, preferably soldiers and intellectuals.

Two ladies listening to the concert are maids of honour; life at court was probably hard for them. In his diary, Count Lehndorff recalls: "The King gave a dinner which ended in disaster. Fräulein von Brand, sitting down at high table, enraged the King so much that he almost sent her away. Then he began to talk in the most unbelievably impolite manner of the poor ladies, saying the dragons stayed on at court while the pretty ones married and left, and that you could smell the vile hags within a ten miles radius."[9]

## Bach's dispassionate gaze

Not only women had a hard time at court. Frederick was a misanthropist. There were few people whom he actually liked. One was his flute teacher, Johann Joachim Quantz, seen standing at the right in the painting. J.S. Bach's son, Carl Philipp Emanuel, here shown accompanying Frederick on the harpsichord, stood considerably lower in the king's esteem. Perhaps this was Bach's own doing; he was hardly suited to the role of a musical vassal and may well have showed it. Menzel has given masterly expression to Bach's predicament. At first glance, he appears to be giving the royal soloist his undivided attention; only at second glance does it become apparent how dismissive, indeed, how downright condescending his gaze actually is.

Bach accompanied his king for 28 years.

However, he was poorly rewarded for his troubles. Although Bach was one of Germany's most well-known musicians, Friedrich paid him far less than Quantz, or even one of his Italian singers. At the same time, he did not allow him to go elsewhere. Although Carl Philipp Emanuel, a Saxon by birth, was not bound by Frederick's consent, his wife and child were Prussian subjects, and the king could easily prevent them leaving the country. Bach's chance to take his leave finally came in 1767, when he was granted permission to take over from Georg Philipp Telemann as musical director of Hamburg's five principal churches.

A few years after Bach's departure from Berlin, the English music critic Charles Burney was granted the favour of an invitation to a royal recital. In his *The Present State of Music in Germany, the Netherlands and the United Provinces* (1773), published in German in 1772/73, Burney wrote: "Apart from beating time with a tiny motion of his hand at the beginning of each movement, Herr Quantz had nothing to do at this evening's recital but occasion-

ally call out 'Bravo!' at the end of solo parts and cadenzas. This seems to be a privilege which the other virtuosi in the orchestra do not enjoy."[10] According to Burney, Quantz had written some 300 pieces for his gifted pupil. The Englishman found "various passages in Herr Quantz's concertos are already old and quite ordinary... some were composed forty years ago."[11]

Frederick's musical inclinations did not develop beyond the taste he had acquired during his years as crown prince. He loved the nimble elegance of pre-Classical melodies. He admired Johann Sebastian Bach's technical skill, but was unmoved by his music. Although Frederick had a splendid Opera House built in Berlin, he allowed only older works to be performed there, long after the public had become desperate to hear something new. He is generally reckoned to have been an "enlightened" monarch; as far as religion was concerned, he thought each person should live "acording to his own fashion". But when it came to music, there was only one taste that counted: his own.

## German monarch, German music

**M**enzel's painting shows a scene from the past. There was nothing unusual in this at the time, for the Romantics had discovered history. Most artists painted imaginary scenes from the Middle Ages, but the realist Menzel chose a period which he could research and render true in detail.

There were topical reasons for Menzel's interest in German history. The political situation in Germany was depressing. Napoleon had humiliated the Germans at the beginning of the century. The demands of the liberationists of 1813 for a unified, liberal Germany had remained unfulfilled. In 1850, when Menzel began to paint his *Flute Concert,* the sense of defeat many felt with regard to the failure of the revolution of 1848 was still painfully acute. Menzel had begun a revolutionary canvas in 1848, entitled *The Fallen March Revolutionaries Lying in State,* but had laid it aside. This was symptomatic. Progress had come to a standstill (unless one counted the explosive development of industry). A powerful longing grew up for a vigorous leader to take Germany's fate in his hands. Frederick was seen as the model for this figure, although, historically speaking, he was entirely unsuited for the part.

The King of Prussia, who had only ever shown an interest in Prussian expansion, now came to be seen as a pioneer of German national unity. "He did honour to the German name," wrote Franz Kugler in his biography of Frederick, which appeared, with illustrations by Menzel, from 1839 to 1842. "He awakened his people to a sense of nationhood that had slumbered within them for over a century, so that once again, as of old, German deeds and German words might be known beyond our borders…"[12]

Beyond his own borders, however, Frederick was considered a belligerent aggressor during his own lifetime. Furthermore, "German words" could hardly be described as Frederick's strong point; he spoke and wrote French, showing nothing but contempt for the German language and its literature. But the music he cultivated at Sanssouci *was* German; and since, in the 19th century, orchestral and chamber music were considered especially German, a king with a flute was the image most likely to link nationalist sentiments and hopes with his person.

These hopes were undoubtedly intensified by the fact that violins, flutes and pianos were played in so many German middle-class families. Song recitals were equally common. Music was part of family life. Music provided a means of sublimating energies that were denied political expression.

In portraying the king as a musician, Menzel had therefore made him an accessible figure; by adding women to the audience, he had painted a scene with which his public would already be familiar. He showed them a king who was one of them: a bourgeois monarch (which he certainly was not!). Thus the painting tells us as much about Menzel's own time as it does about the era of the king he admired.

# A fragrance of women and the Orient

250 French artists had a medal designed in his honour, while Napoleon III appointed him "Representative of the Arts" to the Senate.

Ingres signed *The Turkish Bath* in 1862, but continued to work on it for at least another year. The painting, 108 centimetres in diametre and containing 20 figures, was the sum of his life's work. He did not need to call a single sitter to his studio, for he was able to fall back on the large collection of sketches and pictures he had made over the years. Thus the painting is a gathering of old friends: "women bathing", "women sitting", "odalisques lying" (white slave women in a harem), and exotic sultanas. He had returned to these figures again and again, with his pen, with his brush – usually as single figures lying on a couch, or painted from behind at the edge of a pool. They were a testimony to the painter's lifelong, sensuous response to the female nude.

It is not known exactly when Ingres started work on *The Turkish Bath*, but its figures, decor and atmosphere had certainly interested him half a century before he actually executed the work.

In a notebook that accompanied him to Italy for 18 years in 1806, there is a passage in his handwriting which includes the following description: "We came to a room full of sofas... Steam entered through pipes, bringing with it a pleasurable warmth and most agreeable fragrance... Here, a group of women were waiting for the sultana to finish her bath, so that they could dry her beautiful body with towels and massage her with precious oils... Here, the sultana could enjoy the most voluptuous relaxation."[2] The text, whose source has remained a mystery to this day, carries the title: "The Baths at Mohammed's Seraglio".

This gathering of nude young women was painted by an old man. AETATIS LXXXII:"at the age of 82", Jean-Auguste-Dominique Ingres wrote on the painting. And not without pride: for in the last years of his life – he died in 1867 – Ingres reported that he still felt "the burning passions of a thirty-year-old man".[1] He spent six hours at his easel every day and his work was received with success by fellow artists and the emperor alike. In 1862,

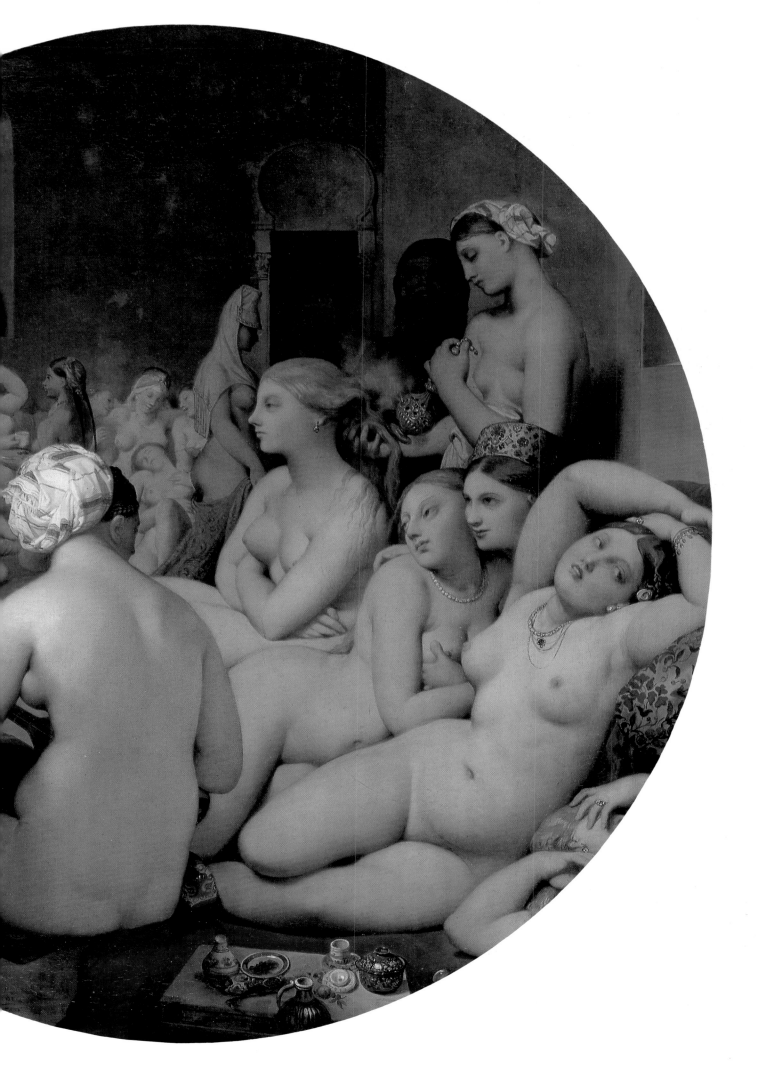

## Male fantasies

I think there were two hundred women in all," it says in a "Description of the Women's Baths at Adrianople" from which Ingres made notes some time after 1825. Perhaps he had already started work on *The Turkish Bath*. He found the text in Lady Mary Montagu's *Turkish Letters*. She had accompanied her husband, a diplomat, to Turkey. At the baths, "a women's coffeehouse, where the town's latest gossip is exchanged and scandals are invented", she modestly refused to undress. It was only with some trouble that she could be incited even to loosen her corset. Yet the atmosphere of the place was quite free: "Beautiful naked women in all positions… some talking, some at work, others taking coffee or sherbet, many casually reclined, while their slaves (generally attractive girls of 17 or 18) braided their mistresses' hair in the most playful manner."[3]

Lady Montagu's letters were reprinted eight times in France between 1763 and 1857. There was great curiosity about distant lands, with Rococo-style chinoiserie and turquerie already popular in 18th-century art. A military expedition in 1798 intensified public interest: Napoleon's invasion of Egypt. Although it ended in a fiasco, the adventure was fantasy-material for generations of restless adolescents, who, after Napoleon's abdication in 1814, took refuge from the dreary, everyday reality of France in dreams of a beautiful Orient.

The "Egyptian fever" received new sustenance from the Greek uprising against the Ottoman Empire in 1822. The Greek insurgents met with considerable sympathy in Europe. Poets and artists became involved in the struggle: Victor Hugo wrote his *Orientales*; Lord Byron hurried to Greece; and Eugène Delacroix, in 1824, caused a furore with his painting on the oriental war, *The Massacre at Chios*.

Ingres, with his paintings of odalisques – white, female, harem slaves – was thus fully in tune with the times. But while Delacroix at least travelled to Islamic North Africa for his "Oriental" studies, Ingres never got further than Italy. Nor did he support the Greeek liberation struggle directly. In fact, his notebooks, in which he describes various painting projects, show that he rarely took inspiration from politics at all, but rather from books. He used exotic elements sparingly in his work: at the most, his odalisques wear headdresses or scarves with oriental designs. Heavy gold jewellery, carpets or musical instruments merely suggest a setting.

For Ingres, it was only the reclining female body that was important. In the female nude, Ingres sought a degree of sensuousness that he and his contemporaries thought exinct outside the world of the *musulmanes*. Delacroix's visit to an Algerian harem had sent him into raptures: "Moments of fascination, and the strangest bliss… They were my idea of what a woman should be: not flung outward into life, but withdrawn to its very heart, to a place where life could not be more secret, more sensuous, more movingly consummate."[4]

# A celebration of Classical beauty

It was customary neither in Lady Montagu's nor Ingres' time to indulge in the pleasures of communal bathing. Parisians usually bathed once a year in the privacy of their own bedrooms, possibly in one of the 1059 bathtubs which 78 different firms delivered, along with hot water, to private homes. Some visited the Chinese or Turkish baths. These were to be found in the Rue du Temple. There was a magnificent half-moon over the entrance and the decor and equipment were "after the Asiatic form and fashion". For 30 sous, customers could have a bath "à la Mahomet" in water freshened with "perfumes of Araby", and with music in the background.

However, while Lady Montagu noted that it was forbidden on pain of death for a man to appear in the women's baths at Adrianople, the Parisian institution seems to have been a regular trysting-place for clandestine lovers: men would dress in women's clothes and creep into the little cubicles where their sweethearts were taking a bath. Even here, bathing was a private affair.

It was only through their knowledge of Classical antiquity that Ingres and his contemporaries were familiar with the notion of the communal bath at all. There had been thermal baths – with steam baths, sweat-rooms, cold-water basins and rooms for resting – everywhere ancient Greek and Roman culture had spread. All that remained of these baths in Europe were the ruins. In Islamic countries, the baths had been preserved; they were now rediscovered by educated Europeans as a sign that the Classical spirit had survived. Indeed, it was altogether fashionable at the time to draw comparisons between Classical antiquity and the Orient: a new translation of the *Iliad* accompanied Lady Montagu on her travels through the Ottoman Empire, and Delacroix found Algeria "as beautiful as in Homer's time".

Archaeological finds at Pompeii and Herculaneum during the 18th century had brought a new urgency to the study of Classical antiquity, and the "republican" Greeks and Romans were highly fashionable during the French Revolution. Their champion was the painter Jacques-Louis David (1748–1825). The young Ingres had been a pupil in David's studio before spending 18 years in Italy, where he studied the art of Classical antiquity and the works of Renaissance painters. The latter, in the 15th century, had rediscovered the ancient canon of ideal beauty: "Art should be nothing if not beautiful, nor should its doctrine be anything but beauty,"[5] exclaimed the Frenchman, declaring the Italian artist Raphael to be his "God".

An 1827 study for Ingres's work *The Apotheosis of Homer* shows the goddess Victory crowning the Greek poet with a laurel wreath. In *The Turkish Bath,* painted in old age, we recognise the same profile and the same Classical purity of line in the contour of her shoulder. Here she holds a costly vessel containing incense or perfume: an example of the close correlation between the world of Homer and 19th-century Turkey.

As far as Ingres was concerned, line was the "queen", colour her servant. Clarity of form and visual harmony were his precepts. If *The Turkish Bath*, in spite of its many figures, succeeds in avoiding irregularity and unrest, it is because the artist has employed the traditional "golden section", a formula known since antiquity. The painting is geometrically constructed and was originally square. Shortly before its completion, in 1863, Ingres gave it its round form, turning it into a "tondo".

2

ngres respected not only the great artists of the past; his own art was sacred, too. On discovering what he thought to be an excessive desire for dancing in the woman whom he had intended to become his second wife, he did not hestitate to dissolve the engagement. He had foreseen a threat to his art, which he placed above all else, including his private life. In order not to make the same mistake again, Ingres thereafter left the choice of his future wife in the hands of good friends, who sent a young relative, Madeleine, to Italy. The ensuing marriage lasted 36 years; his biographers have failed to attribute a single extramarital escapade to the artist. Madeleine was handsome, faithful, an excellent housekeeper and, above all, made sure he had peace to work. When they went walking together in Rome, Madeleine would protect her husband's eyes from the repulsive sight of a begger by covering them with a corner of her shawl.

## His motifs were often copied

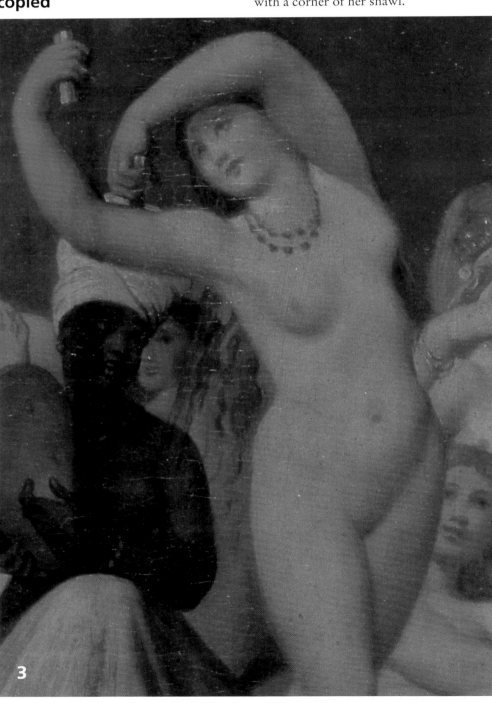

3

Ingres left Italy in 1824 and returned to Paris, where his work immediately received great critical acclaim. The timeless, Classical beauty of his paintings was considered a welcome contrast to the work which certain other, younger artists had dared exhibit. In 1819 Théodore Géricault had created a furore with his *Raft of the Medusa*, a passionate indictment of an incompetent government whose negligence was responsible for a shipwreck. Five years later, Delacroix's painting *The Massacre at Chios* showed Turkish atrocities during the struggle for Greek independence, exposing the indifference of the European powers. These were disturbing pictures by angry, politically engaged artists who were not afraid to show disorder, suffering and ugliness in their work.

None of these "Romantic" innovations were found in Ingres's work, however. Beside Delacroix's *Massacre* in the Salon of 1824 hung Ingres's *Vow of Louis XIII*, celebrating religion and the legitimacy of the monarchy. The painting was perfectly suited to the political landscape of the Restoration after Napoleon's downfall. The Parisian establishment welcomed Ingres with open arms, granting him official commissions and electing him to the "Académie des Beaux-Arts", which not only brought him honour, but asssured him a substantial pension until the end of his days. Ingres, who had painted a portrait of Napoleon before leaving for Rome, had no trouble adapting to the Bourbons, nor, later, to the Orleanists or Napoleon III. He had no interest in politics.

His commitment to art and painting, on the other hand, was intense. Many pupils described him as a strict teacher. He subjected them to a disciplined régime of copying old masters, for "art, if it will survive, must turn to the past".[5] He used material by other artists in his own work, studying pictorial documents in libraries and tracing them to make copies.

The Romantic artist Narcisse Díaz de la Peña accused Ingres of a lack of imagination: "Lock him up in a tower where he has no recourse to engravings and the man will end up at the end of the day with a white canvas. He is incapable of producing anything from his own head." But adopting motifs from other artists did nothing to diminish Ingres's sense of ownership: "My painting belongs to me; it's got my signature scrawled on it."[5]

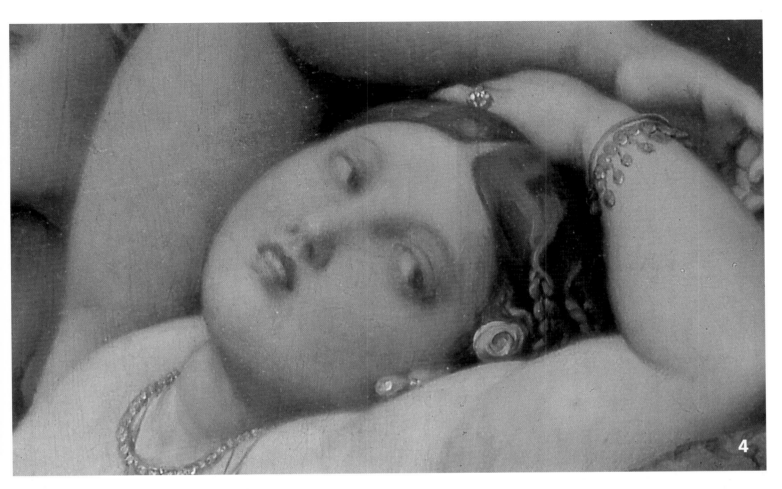

## The painter who loved women

Ingres was held in particularly high esteem as a portraitist by the rich and mighty of the Restoration and Second Empire. No other artist attained quite such a precise, empathic sense of the dignity of these imposing figures on canvas. The critic Elie Faure once made the derisive remark that Ingres had mastered the art of "weighing the bellies of the bourgeois gentlemen and the bosoms of their wives".[5]

Yet Ingres wished to devote himself only to "great and noble art", considering portraiture an unworthy genre for a man of his talents. It may well have been his predilection for the company of beautiful society ladies which finally swayed him to condescend. "One of the things that distinguish Monsieur Ingres," wrote the poet and art critic Charles Baudelaire, "is his love of women"; or: "Beautiful women of generous build, fully reposed and bursting with health are... his joy."[6]

However, the French doctor Laignel-Lavastine cast doubt on the health of Ing-

res' favourite models. On the contrary, he diagnosed insuficient function of the thyroid gland. The symptoms: "Thick necks, thyroid with two enlarged, protuberant lobes, the passive gentleness... of a face with full cheeks and thick lips... large, soft, melting eyes that have lost their sparkle... very round, fat arms, shoulders sunk into folds of flesh."[7]

In *The Turkish Bath*, the figure who best fits this description is the odalisque with raised arms, stretched out in the foreground of the painting. Ingres painted her after a sketch he had made of his wife, Madeleine, many years earlier, in 1818. Perhaps she, too, was one of those "submissive creatures" who, according to the doctor, "avoid thinking as much as possible and prefer lying about on sofas".[7]

Since most of the other women in the baths appear to confirm the doctor's impression, one detractor referred to the painting as a "heap of brainless cattle"; another compared it with a "bed of cultivated mushrooms"; while Paul Claudel described it as a "can of maggots". The artist's admirers, meanwhile, probably for the same reasons, described it as the "Ninth symphony of the Eternal Feminine".[8]

Above all, however, the *Turkish Bath*, with its risqué accumulation of nude bodies, was a shock – at least at the time. Its first purchaser, a relation of Napoleon III, was forced to return the work several days later, since his wife had found the painting too "unseemly" to hang in her salon. In 1865, the painting found a second owner; appropriately enough, he was a former Turkish ambassador, Khalil Bey. It then disappeared into the latter's private collection in Paris, and was seen in the ensuing years only by a small circle of friends. Perhaps it was for this reason that the painting did not cause a scandal like Edouard Manet's *Déjeuner sur l'herbe*, which was rejected by the committee of the official Salon of 1863 and publically exhibited at the Salon des Refusés instead. In any case, the Oriental scene continued to meet with disapproval. When art patrons in the early years of the 20th century bequeathed *The Turkish Bath* to the Louvre, the museum rejected the offer twice. It was only when the Staatsgemäldesammlungen at Munich took an interest in it that the Louvre finally, in 1911, decided to accept the unpopular work.

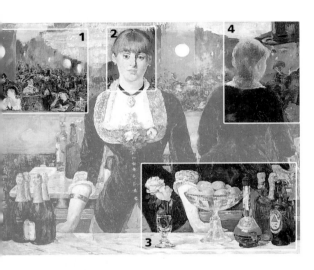

For his last great work, the artist, already seriously ill, chose a theme that was "poetical and marvellous": the mirrored bar in Europe's most famous amusement palace. The latter, with its bright lights and beautiful women, was the temple of Parisian *joie de vivre* and a favourite haunt of the dandy Manet. He completed the painting (96 x 130 cm), now in the Courtauld Institute, London, two years before he died.

The young woman with the blond fringe, her arms propped on the marble counter, wears a calm, somewhat detached look. On the surface in front of her are bottles of champagne, English pale ale and peppermint liqueur. Between the bottles are shining mandarin oranges and pale roses in a vase. She has put a posy in the neck-line of her low-cut dress, next to the white skin.

Only the large mirror behind the woman tells us where we are. It reflects a man in a top-hat looking intensely into the young woman's eyes, also a room full of people, lights, movement, lustre.

The young woman and her bar are in the famous Parisian cabaret Folies Bergère. No other theatre, according to an enthusiastic Charlie Chaplin recalling the place in 1964, "ever exuded such glamour, with its gilt and plush, its mirrors and large chandeliers".[1] Chaplin performed there at the beginning of the century in the "variety" programme of light music, ballet, mime and acrobatics. Indeed, the green shoes and legs of a trapeze artiste are just visible in the top left corner of the painting.

The entertainment palace was near the Boulevard Montmartre at the heart of Paris, which, not only by its inhabitants, was considered the capital city of the world. By the middle of the 19th century, the French capital – whose population quadrupled between 1800 and 1900 – had become a symbol of progress in science, the arts, industry and good living. "Unlike other cities, Paris is no longer just a gathering of stones and people," declared one, rather proud contemporary, "it is the metropolis of modern civilisation."[2]

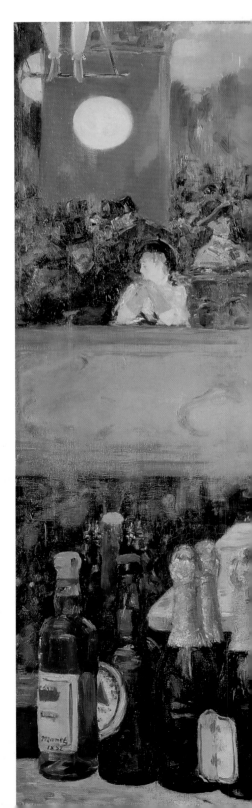

Edouard Manet: A Bar at the Folies Bergère, 1881

# Declaration of love for the capital of the world

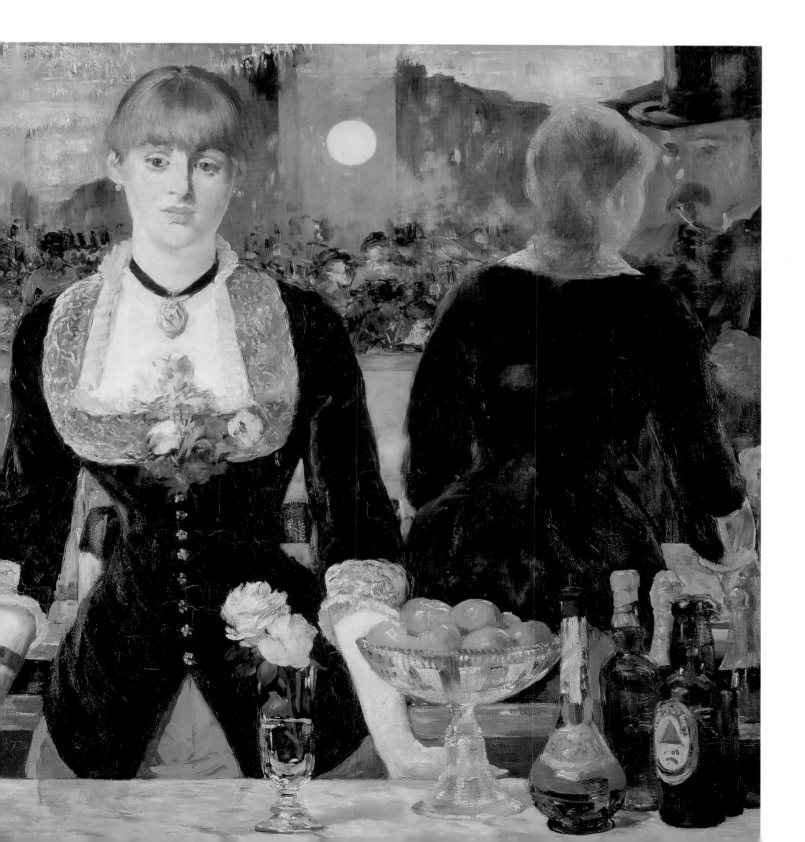

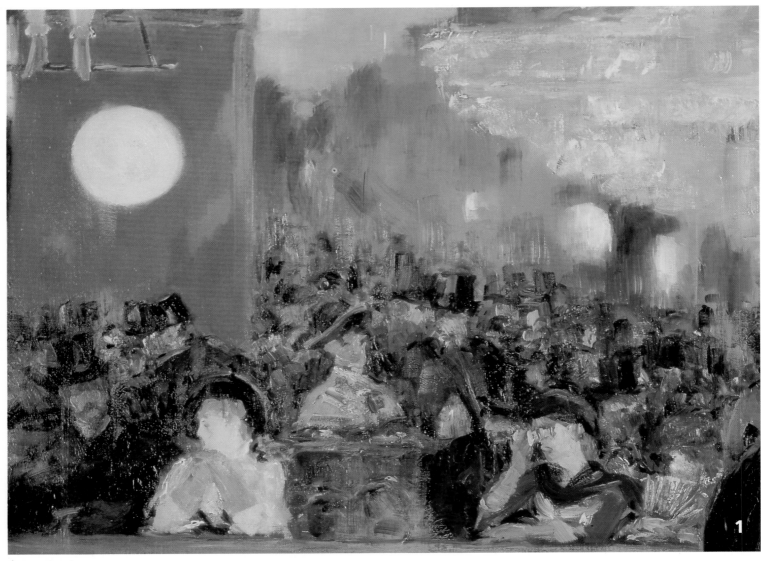

## Society glitz

During the exuberant seventies and eighties, the Folies Bergère was considered the most modern, most exciting place in the whole of Paris. The latest technological advance to be exhibited at the "Electricity Fair" in 1881 had already been installed at the Folies Bergère: bright, electrically lit spheres shone out beside familiar gaslit chandeliers. In keeping with the fashionable Anglomania of the times, the establishment had been modelled on London's Alhambra Theatre and, on opening in 1869, was dubbed Paris's first music-hall – distinguishing it from the more traditional café-chantant.

The company's name did not derive, as is sometimes thought, from the French word for folly or madness (*folie*), but from a term in use during the 18th century to denote a country house hidden by leaves (in Latin, *folia*) where it was possible freely to indulge in various enjoyable pursuits. In the interests of local colour, the pleasant-sounding name of a nearby street, the Rue Bergère, was added.

The balcony of the auditorium, where the smarter members of the audience reserved loge seats, can be seen in the mirror behind the bar. The darkly dressed gentlemen and the ladies in their long gloves and broad-brimmed hats seem more interested in each other, or in the audience in the stalls, than in the trapeze number.

The green bootees may belong to the American artiste Katarina Johns, who performed at the Folies Bergère in 1881. Her show, a typical mélange of daring feats, erotic suggestion and sexual innuendo, attracted swarms of locals and tourists.

The establishment's greatest attraction, however, was its clientele: a nervy gathering of middle-class burghers, dandies and gaudily dressed cocottes. Manet has placed two such ladies, his friends, in loge seats: the lovely demi-mondaine Méry Laurent in a white dress and, behind her in beige, the actress Jeanne de Marsy.

It was *de rigeur* at the time for guests to take a stroll around the premises. They would start in the palm garden on the ground floor, then saunter slowly up the broad, sweeping staircase to do a round or two of the circular promenade. Artists would make their sketches here, and writers like Maupassant and Huysmans described the unique atmosphere of the place. Like Manet, they made the theatre famous, although, according to one delighted contemporary, it was "not a theatre at all – with some two thousand men drinking, smoking and having fun, and some seven or eight hundred women, all dolled up and having a whale of a time".[3]

## Suzon needs no make-up

The young woman's name was Suzon. In fact, she really was working as a barmaid at the Folies Bergère when Manet asked her to sit at his studio. That is all that is known about her. She wears a long, black, velvet bodice over a grey skirt: the uniform dress of the female personnel. In his novel *Bel ami*, which appeared in 1885, the Naturalist writer Guy de Maupassant described "three bar counters…, enthroned behind which were three wilting barmaids; made up to the eyeballs, they were selling drinks and love".[4]

Manet's Suzon is different: her gaze is cautious, her complexion, still young and rosy, needs no make-up. She was probably a girl from one of Paris's rural suburbs, and perhaps it was her youth and freshness that got her the job at the Folies Bergère.

Girls like Suzon served in most of the capital's cafés and restaurants, or sold luxury goods behind the counter of the big Parisian department stores, whose era, at the time, had only just begun. According to the philosopher and historian Hippolyte Taine, serving behind the counter was every true Parisienne's dream: for it was the perfect opportunity to use her talent for twisting men round her little finger. There were thousands of these girls working in Paris, and their modest elegance, their flirtatiousness and snappy repartee contributed enormously to the attractiveness of the metropolis. Cashiers, barmaids and sales-girls were paid miserable wages, however, and many were tempted to employ their "talents" more profitably. They would then join some 30,000 prostitutes in Paris who, preferring to stay clear of the brothels, solicited "on the sly", giving their "one night stands" the illusion of an excitingly unique adventure.

The Folies Bergère was one of the main centres of prostitution, especially of the more luxurious sort. The choice ranged from the classy demi-mondaine Méry Laurent, Manet's girlfriend, who enjoyed the "support" of an American dentist to the tune of 15,000 francs a month, down to the common tart who, for a "petit moment", demanded 20 francs and the price of a coach-ride from the young Charlie Chaplin in the early years of the century. Méry presented herself in the loge; the "cocottes" sailed around the promenade.

The latter were a thrilling sight with their bright colours and generously displayed charms. Tourists, returning home, sung their praises all over Europe: those typical Parisian girls, all sophisticated and pretty. The Folies Bergère and the "cocottes" who frequented it had no small part in contributing to the city's legendary reputation as the "world capital".

The French novelist Huysmans enthused over the Folies Bergère as the only place in Paris "that stinks quite as seductively of the make-up of hired affections".[5] In his memoirs, Charlie Chaplin nostalgically recalls the ladies who worked there: "In those days they were beautiful and courtly."[1] Women unaccompanied by men were only permitted in possession of a special card issued every two weeks to the prettiest, most elegant and most discreet prostitutes by the managing director himself.

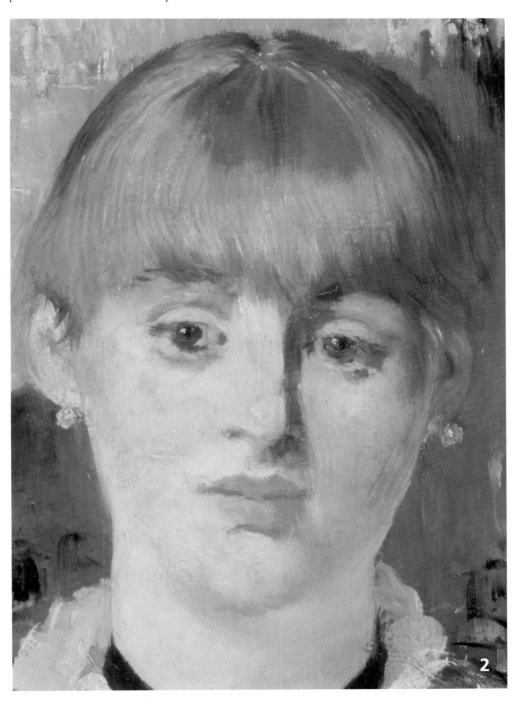

2

The favourite drink of those who visited the Folies Bergère was, of course, champagne. Several bottles, with their characteristic gold paper scarves, are ranged on the counter. The chance discovery of an 1878 winelist showed that there were no fewer than ten different sorts of champagne on offer (from 12 to 15 francs a bottle). Mumm, Heidsieck and Pommery extra-dry were offered as "Grands Vins" at 18 francs, while a standard price covered "Glaces, sorbets et boissons américaines". The peppermint liqueur and (English) pale ale were probably included among the "American drinks". Manet shows the bottles, including an unidentifiable red drink, displayed on the marble counter. It was probably their bright colours that appealed to him.

## Warm champagne for a painting

The painter was less interested in giving an exact rendering of the bar counter – otherwise he should have put the champagne on ice – than in achieving certain painterly effects. This also explains his method of combining Folies Bergère-motifs which, in reality, were situated in totally different parts of the building. The three bars, for example, were in the artificial garden at ground level; it was apparently impossible to see the audience or balcony from there, whether directly or reflected in a mirror.

What is more, Manet has immersed the scene in a wan daylight which cannot have come from the sparkling chandeliers or bright electric lights. It is the light of Manet's studio, where he executed the painting. There, the artist reconstructed the scene from a small number of sketches actually made on the premises.

Manet's sympathies lay with the realists. Like the writers Emile Zola and Guy de Maupassant, he wanted to show what he actually saw, to give an objective picture of the reality of his own times. His paintings of scenes from the cafés and streets of Paris caused a series of scandals. Meanwhile, the critics and public celebrated academic painters who presented "sublime" works with themes based on Classical antiquity. The works to receive the greatest acclaim

while Manet was working on his *Bar at the Folies Bergère* had titles such as *The Recognition of Odysseus and Telemachus* (1880), or *The Anger of Achilles* (1881). Manet was denied success; his work was upbraided as trivial and ugly, in other words: realistic. And yet, according to Manet's friend Jacques-Emile Blanche, "Manet is not a realist, but a Classicist; as soon as he has a spot of paint on his canvas he starts thinking more about paintings than nature".[6] Similarly, a younger painter, able to watch Manet at work on the *Bar* in 1882, said: "Although he had models to sit for him, Manet did not copy nature; I noted his masterly art of simplification… Everything was abridged".[6]

By this time, Manet was already a very sick man. While working, he "tired easily and had to lie down on a low sofa," the same eyewitness reported. During his final years, Manet therefore did smaller formats in pastels, which were less physically demanding: portraits of pretty Parisian girls (he did a profile of Suzon, too), fruit and, above all, small flower arrangements – like the bunches brought to him daily by his friend Méry Laurent, or the posy worn in a Folies Bergère barmaid's bosom. Manet confessed to his art-dealer Vollard that he would have liked to have been "the St. Francis of still-life".[7]

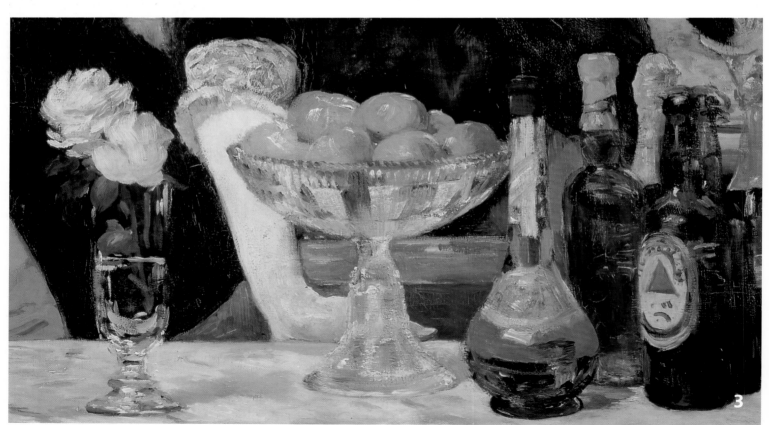

3

## Practically everything is an illusion

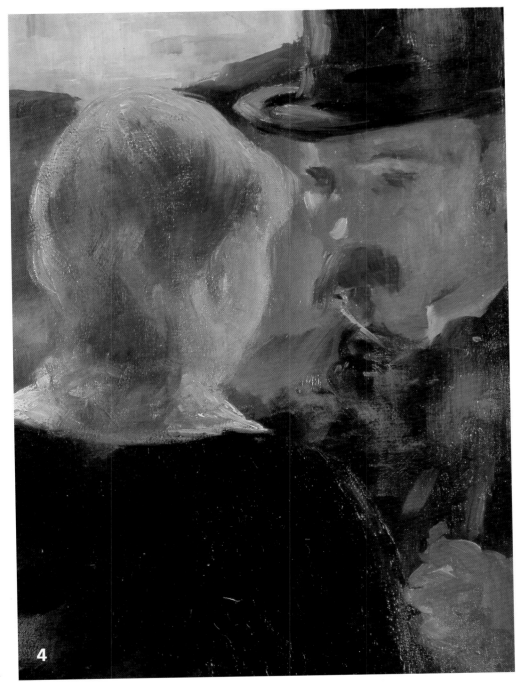

The mirror brings to light what otherwise would remain unseen: the barmaid, although apparently alone, is in fact the object of a gentleman's lustful advances. The man with the top-hat is one of countless dandies, boulevardiers and playboys: like the seductive Parisiennes, stereotypical denizens of Parisian night life.

The painting gives the spectator the strange feeling of being part of the scene: as if the spectator, in the image of the dandy reflected in the mirror at Folies Bergère, were looking at himself. It is an optical illusion and a stroke of genius: Manet purposefully neglects the rules of perspective and optics, painting the reflection as if the mirror at the back of the bar were hanging at an oblique angle to the picture-plane. However, this impression is simultaneously repudiated by the fact that the mirror frame runs parallel to the marble counter.

Suzon's frontal view would normally exclude any reflection of her back, and the customer would only be visible if standing between the bar and the spectator.

Over half of the canvas is taken up by the background mirror; apart from the living, real figure of Suzon, practically everything is unreal, reflection, an illusion – an appropriate symbol for the night life and its manifold wiles.

"Paris is the city of mirrors," wrote the German Walter Benjamin in 1929, "… thus arises the specific beauty of Parisian women. Before a man looks at them, they have already seen themselves reflected ten times. But the man, too, sees himself reflected in mirrors all the time; in cafés, for instance… mirrors are the city's spiritual element, its coat-of-arms."[8]

The quotation is from Benjamin's essay: "A declaration of love by poets and artists for the capital of the world". Half a century separates the German writer from the French painter, but both were equally infatuated with Paris.

Manet was unwilling to leave his native town for any length of time. When his painting friends went to study plein-air painting in the country during the second half of the sixties, Manet stayed in the capital, taking afternoon strolls along the boulevards, frequenting the more fashionable cafés and – an elegant figure with his dandy's cane and black silk top-hat – dropping in at the Folies Bergère in the evening.

"Parisian life," wrote Manet's friend, the poet Charles Baudelaire, "is rich in themes poetical and marvellous. The painter, the true painter we have all been waiting for, will be one who grasps the epic quality of life today, who manages, by colour and drawing, to make us see and understand how grand and poetic we are with our cravats and patent leather shoes."[9] This, precisely, was Manet's achievement in his last great work, in which he took leave of the specifically Parisian pleasures that had meant so much to him. He painted a barmaid in her everyday uniform and surroundings, but did so in such a way that critics have seen in her a "mythical figure, an intensely French high priestess", a symbol of the isolated individual, or the immortal sister of the ancient goddesses.

# Appendix

## Limburg Brothers
**Paul, Jean, Herman Limburg**
**born 1385–90 Nijmegen, died 1416 Bourges.**

February miniature from the "Très Riches Heures du Duc de Berry", c. 1416
15.4 x 13.6 cm
Chantilly, Musée Condé

Literature:
Les Très Riches Heures du Duc de Berry, Introduction et légendes de Jean Lognon et Raymond Cazelles. Chantilly/Paris 1969. – Les Très... Facsimile Edition, Luzern 1984. Commentary: ed. Raymond Cazelles and Johannes Rathofer. – Contamine, Philippe: La vie quotidienne pendant la guerre de cent ans. Paris 1967. – Defourneaux, Marcelin: La vie quotidienne au temps de Jeanne d'Arc. Paris 1957. – Epperlein, Siegfried: Der Bauer im Bilde des Mittelalters. Leipzig 1975.

Notes:
1 from the epic poem "Ysengrimus, the sly fox", c. 1150; cited by Epperlein, p. 61
2 Defourneaux, p. 29
3 Defourneaux, pp. 22, 29
4 Contamine, p. 167/168
5 Epperlein, p. 89

*Jan van Eyck. Probable self-portrait of the artist at the age of 40. Detail of the Mystic Lamb, St. Baaf's Cathedral, Ghent*

## Jan van Eyck
**born c. 1370 near Maastricht, died 1441 Bruges.**

The Virgin of Chancellor Nicolas Rolin, c. 1437
66 x 62 cm
Paris, Musée du Louvre

Literature:
Adhémar, Hélène: Sur la vierge du chancelier Rolin, in: Bulletin Institut Royal du Patrimoine Artistique, XV, 1972, Bruxelles. – Boehm, Laetitia: Geschichte Burgunds. Stuttgart, 1972. – Calmette, Joseph: Les Grands Ducs de Bourgogne. Paris 1949/79. – Dhanens, Elisabeth: Hubert und Jan van Eyck. Königstein 1980. – Périer, Arsène: Un chancelier au XVe s., Nicolas Rolin. Paris 1904. – Roosen-Runge, Heinz: Die Rolin-Madonna des Jan van Eyck. Wiesbaden 1972.

Notes:
1 Roosen-Runge, p. 17
2 Roosen-Runge, pp. 17, 18
3 Hirschfeld, Peter: Mäzene. Munich 1968, pp. 103–108
4 Dhanens, p. 218
5 Dhanens, p. 39
6 Roosen-Runge, p. 29
7 Roosen-Runge, p. 18

## Andrea Mantegna
**born 1431 near Padua, died 1506 Mantua.**

Ludovico Gonzaga and His Family, c. 1470
Mantua, Palazzo Ducale

Literature:
Atti del Convegno: "Mantova e i Gonzaga nella civiltà del Rinascimento". Mantua 1974. – Camesasca, Ettore: Mantegna. Florence 1981. – Coletti, Luigi: La camera degli sposi del Mantegna a Mantua. Milano 1969. – Catalogue: "Splendors of the Gonzaga", Victoria & Albert Museum. London 1981. – Mazzoldi, Leonardo: Mantova, La Storia. Vol. II, Mantua 1961.

Notes:
 1 Catalogue, pp. 27/28
 2 Catalogue, pp. 15/16
 3 Camesasca, pp. 36/37
 4 Camesasca, p. 37
 5 Mazzoldi, p. 20
 6 Catalogue, pp. 21/22
 7 Catalogue, p. 15
 8 Schivenoglia, in Atti, p. 311
 9 Atti, p. 321
10 Equicola, in Coletti, p. 43

*Andrea Mantegna. Probable self-portrait of the artist c. 1470. Detail of the fresco in the Camera degli Sposi (Bridal Chamber) of the Ducal Palace, Mantua*

*Sandro Botticelli. Self-portrait at the age of c. 30. Detail of "Homage of the Magi", Galleria degli Uffizi, Florence*

## Sandro Botticelli
**(Alessandro di Mariano Filipepi)**
**born 1444 Florence, died 1510 Florence.**

The Birth of Venus, c. 1486
184 x 285.5 cm
Florence, Galleria degli Uffizi

Virgin with Child, Four Angels and Six Saints (Detail), c. 1487
Florence, Galleria degli Uffizi

Literature:
Burke, Peter: Culture and society in Renaissance Italy. London 1974. – Clark, Kenneth: The Nude, a study in ideal form. A. W. Mellon Lectures, np 1953. – Levi d'Ancona, Mirella: Botticelli's Primavera, A botanical interpretation including Astrology, Alchemy and the Medici. Florence 1983. – Lightbown, Ronald: Sandro Botticelli, 2 vols. London 1978. – Uffizi, Studi e Ricerche 4: La Nascita di Venere e l'Annunziazione del Botticelli ristaurate. Florence 1987. – Warburg, Aby: Sandro Botticellis "Geburt der Venus" und "Frühling". Eine Untersuchung über die Vorstellung von der Antike in der Frührenaissance. Leipzig 1893.

Notes:
1 Vasari, Giorgio, cited in German in Warburg, p. 1
2 Ghiberti, Lorenzo: Denkwürdigkeiten. trans. J. Schlosser, Berlin 1927, Commentarii III, pp. 86, 89, 138, 139
3 Homeric Hymns, cited in German by Warburg, p. 3
4 Lightbown, p. 58
5 Leon Battista Alberti: Treatise on painting, cited in Uffizi, p. 28
6 Warburg, pp. 1, 5, 6

## Vittore Carpaccio
**born c. 1460 Venice, died 1525/26 Capodistria.**

Miracle of the Relic of the Cross, 1494/95
365 x 389 cm
Venice, Galleria dell'Accademia

Literature:
Cancogni, Manlio/Perocco, Guido: L'opera completa del Carpaccio. Milan 1967. – Kretschmayr, Heinrich: Geschichte von Venedig. 3 Vols., Darmstadt 1964 – Lauts, Jan: Carpaccio, Gemälde und Zeichnungen, Complete catalogue. Cologne 1962. – Ludwig, Gustav/Molmenti, Pompeo: Vittore Carpaccio, La vie et l'œuvre du peintre. Paris 1910.

Notes:
1 Ludwig/Molmenti, p.257
2 both cited by Kretschmayr, pp.362, 360

## Raphael
### (Raffaello Sanzio)
### born 1483 Urbino, died 1520 Rome.

The Fire in the Borgo, 1514–1517
Fresco base 6.97 m
Vatican, Stanze di Raffaello

Literature:
Gregorovius, Ferdinand: Geschichte der Stadt Rom im Mittelalter. Dresden 1930. – Heers, Jacques: La vie quotidienne à la cour pontificale au temps des Borgia et des Médicis. Paris 1986 – Jones, Roger & Penny, Nicholas: Raffael. New Haven/Munich 1983. – Larivaille, Paul: La vie quotidienne en Italie au temps de Machiavel. Paris 1978. – Ullmann, Ernst: Raffael. Leipzig/ Gütersloh 1983.

Notes:
1 Letter by Raphael, cited by Warnke, Martin: Hofkünstler, zur Vorgeschichte des modernen Künstlers. Cologne 1985, p.295
2 Letter by Bembo to Bibbiena, July 1517, cited by Jones, p.147
3 Gregorovius, pp.1179, 1091, 1185
4 Memo by Leo, 1514, in Ullmann, p.253
5 Letter by Raphael to his uncle Simone Ciarla, in Ullmann, p.171
6 Ullmann, pp.259, 171
7 Heers, p.225; Jones, p.199
8 Epigram by Calcagnini, 1519, in: Jones, p.199
9 Paolo Giovio, in: Jones, p.151
10 Letter by Raphael to Castiglione, in: Jones, p.96

*Raphael. Self-portrait (centre). Detail of the fresco "The School of Athens" (1508–11) in the Stanza della Segnatura, Vatican, Rome*

## Hans Holbein the Younger
### born 1497/98 Augsburg, died 1543 London.

The Ambassadors, 1533
207 x 209 cm
London, The National Gallery, reproduced by courtesy of the Trustees

Literature:
Hervey, Mary S.: Holbein's Ambassadors. The picture and the men. A historical study. London 1900. – Jacobs, Eberhard/de Vitray, Eva: Heinrich VIII. von England in Augenzeugenberichten. Düsseldorf 1969. – Pinder, Wilhelm: Holbein der Jüngere und das Ende der altdeutschen Kunst. Cologne 1951. – Salvini, Robert/Grohn, Hans Werner: Das gemalte Gesamtwerk von Hans Holbein d. J. Milan, Lucerne 1971. – Samuel, Edgar R.: "Death in the glass – A new view of Holbein's Ambassadors". In: The Burlington Magazine, vol. CV, pp.718–729, London 1963.

Notes:
1 Dinteville's letter to François I, 23 May 1533, in: Jacobs/de Vitray, p.137
2 Petrus Apianus: "Eyn Newe unnd wolgegründte underweysung…", Ingolstadt 1527. The copy provided by the British Museum has no page numbers.
3 Henrici Cornellii Agrippae: Ungewissheit und Eitelkeit aller Künste und Wissenschaften, in: Bibliothek der Philosophen, Volume 5, Munich 1913, pp.19, 22

*Hans Holbein the Younger. Self-portrait of the artist at the age of 45. Chalk drawing, 1542–43. Galleria degli Uffizi, Florence*

## Paolo Veronese
### (Paolo Caliari)
### born 1528 Verona, died 1588 Venice.

The Marriage at Cana, 1562/63
6.69 x 9.90 m
Paris, Musée du Louvre

Literature:
Lebe, Reinhard: Als Markus nach Venedig kam. Frankfurt 1980. – Lenz, Christian: Veroneses Bildarchitektur. Thesis, University of Munich 1969. – Molmenti, Pompeo: La Storia di Venezia nella Vita Privata. Bergamo 1905–1908, Reprint Triest 1973, vol. 2.

– Pignatti, Terisio: Veronese, catalogue raisonné. Venezia 1976. – Piovene, Guido: L'Opera completa di Veronese. Milan 1968.

Notes:
1 Lenz, p.94
2 Molmenti II, p.44
3 Lebe, p.206
4 Contarini, cited in: Civiltà veneziana del Rinascimento – atti del congresso, Venice 1958, p.99
5 Piovene, p.84
6 Zanetti, cited by Pignatti, p.74
7 Honour, Hugh: Venedig. Munich 1966, p.73

## Pieter Bruegel the Elder
### born c. 1525/30 Breda, died 1569 Brussels.

The Tower of Babel, 1563
114 x 155 cm
Vienna, Kunsthistorisches Museum

Literature:
Claessens, Bob/Rousseau, Jeanne: Unser Bruegel. Antwerp 1969. – Eisele, Petra: Babylon. Berne/Munich 1980. – Guicciardin, Ludwig (Luigi Guicciardini): Beschreibung dess Niderlands ursprung, auffnemen und herkommens. Frankfurt 1582. – Grossmann, Fritz: Bruegel, Die Gemälde, Complete catalogue. Cologne 1966. – Klamt, Johann-Christian: Anmerkungen zu Pieter Bruegels Babel-Darstellungen, in: Pieter Bruegel und seine Welt. Eds. Otto von Simson/Matthias Winner, Berlin 1979. – Seidel, M./Marijnissen, R.H.: Bruegel. Stuttgart 1979.

Notes:
1 Genesis, Chaps. 6, 8 and 11
2 Guicciardin, p.64

## Tintoretto
### (Jacopo Robusti)
### born 1518 Venice, died 1594 Venice.

The Origin of the Milky Way, c. 1580
148 x 165 cm
London, National Gallery, reproduced by courtesy of the Trustees

Jakob Hoefnagel
Origin of the Milky Way, sketch after Tintoretto, c. 1620
Berlin, Staatliche Museen zu Berlin – Preußischer Kulturbesitz, Kupferstichkabinett

Literature:
Evans, Robert John Weston: Rudolf II and his World. A Study in intellectual history. Oxford 1973/84. – Garas, Clara: Le tableau du Tintoret du Musée de Budapest et le cycle peint pour l'Empereur Rodolphe II, in: Bulletin du Musée hongrois des Beaux-Arts no 30, 1967. Gould, Cecil: An X-ray of Tintoretto's Milky Way, in: Arte Veneta XXXII 1975. – Exhibition Catalogue: Prag um 1600, Kunst und Kultur am Hofe Rudolfs II., 2 vols., Essen/Vienna 1988.

Notes:
1 Gould, p.212
2 Ridolfi, cited by Garas, pp. 31, 32, 38
3 Catalogue I, p.39
4 Melchior Goldast, cited in: Erlanger, Philippe: L'Empereur insolite, Rodolphe II de Habsbourg. Paris 1980, p.354
5 Catalogue I, p.39
6 Erlanger, p.222

*Caravaggio. Self-portrait as Bacchus. Detail of "The Sick Bacchus", 1593–94. Galleria Borghese, Rome*

## Caravaggio
### (Michelangelo Merisi)
### born 1571 Caravaggio (near Bergamo), died 1610 Porto Ercole.

Judith and Holofernes, c. 1599
145 x 195 cm
Rome, Galleria Nazionale d'Arte Antica

Literature:
Delumeau, Jean: Vie économique et sociale de Rome dans la seconde moitié du XVI s. Paris 1957. – Hibbard, Howard: Caravaggio. New York 1983. – Hinks, Roger: Michelangelo Merisi da Caravaggio, his life, his legends, his works. London 1953. – Röttgen, Herwarth: Il Caravaggio, ricerche e interpretazioni, Rome 1974.

Notes:
1 Book of Judith, from the Apocrypha of the Lutheran Bible. Ed. Stuttgart 1971, vol. 5, pp.1178/9; Judith. pp.16 ff. in: The Holy Bible, New Revised Standard Version with Apocrypha. New York/Oxford 1989.
2 Lavater Sloman, Mary: Elisabeth I. Zurich 1957, p.359/360
3 Delumeau, p.561
4 Paolo Paruta, 1595, in: Delumeau, p.563
5 Bellori, cited by Röttgen, p.153
6 Floris van Dyck, in: Röttgen, p.152
7 Giovanni Baglione, cited by Hibbard, p.356

## Georges de La Tour
### born 1593 Vic-sur-Seille, died 1652 Lunéville.

The Fortune Teller, after 1630
102 x 123 cm
New York, The Metropolitan Museum of Art, Rogers Fund, 1960

Literature:
Clébert, Jean-Paul: Das Volk der Zigeuner. Vienna 1964. – Erlanger, Pierre: La vie quotidienne au siècle d'Henri IV. Paris 1972. – Catalogue of the La Tour Exhibition. Orangerie, Paris 1972. – Nicolson, Benedict and Wright, Christopher: Georges de La Tour. London 1974. – Rosenberg, Pierre et Macé de Lépi-

nay, François: G.d.L.T., vie et œuvre. Fribourg 1973. – Wright, Christopher: The art of the forger. London 1984.

Notes:
1 Brealey, John and Myers, Peter: The Fortune Teller, in: Burlington Magazine 1981
2 Montaigne, Michel de: Œuvres complètes (Pléiade). Paris 1962, Essais I., chap. 26, p.161.
3 St. Luke 15, 11–23
4 Cervantes, Miguel de: La Gitanilla, in: Novelas Ejemplares, 1613. English: The Little Gipsy Girl, in: Exemplary Stories (trans. C. A. Jones).London 1972, p. 32
5 Catalogue, Orangerie, p.150.
6 Cervantes, op. cit., p.19

## Peter Paul Rubens
### born 1577 Siegen, died 1640 Antwerp.

The Love Garden, c. 1632/34
198 x 283 cm
Derechos reservados © Museo del Prado, Madrid

Literature:
Glang-Süberkrüb, Annegret: Peter Paul Rubens, der Liebesgarten. Thesis, Kiel 1975. – Goodman, E.L.: Rubens "Conversatie à la mode" and the tradition of the "Love Garden". Thesis, Ohio 1978. – Lessing, Erich & Schütz, Karl: Die Niederlande. Die Geschichte in den Bildern ihrer Maler erzählt. Munich 1985. – Warnke, Martin: Peter Paul Rubens, Leben und Werk. Cologne 1977. – Wedgewood, C.V.: Rubens und seine Zeit. Amsterdam 1973.

Notes:
1 Letter by Rubens to a friend, 1634, in: Evers, H. G.: Rubens, Munich 1942, p.337/338
2 Sandrart, cited by Wedgewood, p.122
3 Letter by Rubens, 1630, in: Evers, p.338
4 Wedgewood, p.143
5 Goodman, p.109
6 Evers, p.326
7 Cardinal Infante Ferdinand to the King of Spain Philip IV, cited in: Glück, Gustav: Rubens' Liebesgarten, in: Jahrbuch der kunsthistorischen Sammlung in Wien, vol. 35, 1920, p.64

*Peter Paul Rubens. Detail of "Self-portrait with his Wife Isabella Brant under the Honeysuckle", 1609. Alte Pinakothek, Munich*

*Diego Velázquez. Detail of a self-portrait, c. 1631. Galleria degli Uffizi, Florence*

## Diego de Silva y Velázquez
### born 1599 Sevilla, died 1660 Madrid.

The Surrender of Breda, 1635
307 x 370 cm
Derechos reservados © Museo del Prado, Madrid

Literature:
Defourneaux, Marcelin: La vie quotidienne en Espagne au siècle d'or. Paris 1960. – Hager, Werner: Die Übergabe von Breda, von Diego Velázquez. Stuttgart 1956. – Justi, Carl: Velázquez und sein Jahrhundert. Stuttgart nd, reprint of 2nd ed. of 1903. First ed. 1888. – López-Rey, José: Velázquez, artiste et créateur, avec un catalogue raisonné de son œuvre intégral. Lausanne/Paris 1981. – Ortega y Gasset, José: Velázquez und Goya, Beiträge zur spanischen Kulturgeschichte. Stuttgart 1955.

Notes:
1 Unless otherwise stated, references to Breda in: Justi, pp.351–358
2 Defourneaux, p.238; for lances cf. Justi, p.361/362

## Jacob Jordaens
### born 1593 Antwerp, died 1678 Antwerp.

The King Drinks, 1640/45
242 x 300 cm
Vienna, Kunsthistorisches Museum

Literature:
d'Hulst, Roger Adolf: Jacob Jordaens. Stuttgart 1982. – Meisen, Karl: Die Heiligen 3 Könige und ihr Festtag im volkstümlichen Glauben und Brauch. Cologne 1949. – Pirenne, Henri: Geschichte Belgiens, vol. 4. Gotha 1913. – Van Puyvelde, Leo: Jordaens. Paris/Brussels 1953. – Rooses, Max: Jordaens, Leben und Werk. Leipzig 1898.

Notes:
1 Rooses, p.65
2 cited in: Bazin, Germain: "In vino veritas". Jardin des Arts, Paris, Nov. 1968
3 Rooses, p.67
4 Pirenne, vol. 4, p.560

## Rembrandt
**(Rembrandt Harmenszoon van Rijn)
born 1606 Leiden, died 1669 Amsterdam.**

Jacob Blessing the Sons of Joseph, 1656
173 x 209 cm
Kassel, Staatliche Kunstsammlungen Kassel,
Gemäldegalerie Alte Meister

Literature:
Bar-Efrat, Shimon: Some remarks on Rembrandt's
"Jacob blessing Ephraim and Manasseh", in: Burling-
ton Magazine, September 1987. – Beuys, Barbara:
Familienleben in Deutschland. Reinbek 1980. –
Einem, Herbert von: Rembrandt van Rijn, Der Segen
Jakobs. Stuttgart 1965. – Gerson, Horst: Rembrandt,
Gemälde, Gesamtwerk. Wiesbaden nd. Copyright
1968, Amsterdam. – Hausherr, Reiner: Rembrandts
Jakobssegen. Opladen 1976. – Tümpel, Christian:
Rembrandt, Mythos und Methoden. Königstein
1986. – Valentiner, W.R.: Rembrandt and Spinoza,
London 1962.

Notes:
1 Genesis 27: 29
2 Valentiner, p.26
3 Beuys, p.220; subsequent quotation in: Beuys,
  p.254

*Rembrandt. Self-portrait, 1669, at the age of 63. Mau-
ritshuis, The Hague*

## Antoine Watteau
**born 1684 Valenciennes, died 1721 Paris.**

Love at the French Theatre, 1716–1721
37 x 48 cm
Berlin, Staatliche Museen zu Berlin – Preußischer
Kulturbesitz, Gemäldegalerie

Literature:
Boerlin-Brodbeck, Yvonne: Antoine Watteau und das
Theater. Thesis, University of Basle, 1973. – Cata-
logue of Watteau exhibitions. Washington 1984. –
Meyer, Jean: La vie quotidienne en France sous la
Régence. Paris 1979. – Mongrédien, Georges: La vie

*Watteau, par la nature. Detail of an etching by Fran-
çois Boucher, 1727. Städelsches Kunstinstitut, Frank-
furt*

quotidienne des comédiens au temps de Molière.
Paris 1966. – Textes du Colloque international, Paris
1984: Antoine Watteau, le peintre, son temps et sa lé-
gende. Paris 1987.

Notes:
1 Meyer, p.18
2 Dramatic poet Chappuzeau, cited by Mongrédien,
  p.180
3 Meyer, pp.131, 136
4 Mongrédien, p.21

## Thomas Gainsborough
**born 1727 Sudbury, died 1788 London.**

Mr and Mrs Andrews, 1749
70 x 119 cm
London, The National Gallery, reproduced by
courtesy of the Trustees

Literature:
Hayes, John: The landscape paintings of Thomas
Gainsborough. Critical text and catalogue, London
1981. – Corri, Adrienne: The search for Thomas
Gainsborough. London 1984. – Catalogue: Thomas
Gainsborough. Tate Gallery, London 1980. – Mingay,
G.E.: English landed society in the 18th c. London
1963. – Makowski, Henri und Buderath, Bernhard:
Die Natur dem Menschen untertan. Ökologie im
Spiegel der Landschaftsmalerei. Munich 1983 and
1986.

Notes:
1 Catalogue, p.13
2 Defoe, Daniel: Tour through the Eastern Counties.
  1724
3 Catalogue, p.16
4 Mingay, p.263
5 Mingay, p.30
6 Anon.: A New and complete History of Essex by
  a Gentleman. Chelmsford 1769, vol. II, p.139
7 Catalogue, p.30.

## Giambattista Tiepolo
**born 1696 Venice, died 1770 Madrid.**

The Banquet of Cleopatra, 1746/50
Venice, fresco at Palazzo Labia

Literature:
Battersby, Martin: Trompe l'œil. The Eye deceived.
London 1974. – Grant, Michael: Kleopatra – eine Bio-
graphie. Engl. ed. 1972. Bergisch Gladbach 1977. –
Levey, Michael: Giambattista Tiepolo. His life and
art. New Haven/London. – Levey, Michael: Banquet
of Cleopatra. Newcastle 1965. – Molmenti, Pompeo:
Tiepolo, la vie et l'œuvre du peintre. Paris 1911.

Notes:
1 Cajus Plinius Secundus (23–79 A.D.): Naturge-
  schichte. Stuttgart 1843, p.1093. Cf. also Pliny the
  Elder: Natural History: A Selection from Phil-
  emon Holland's Translation. Ed. J. Newsome,
  1964.
2 Président Charles de Brosses (1709–1777): Lettres
  familières d'Italie, cited in: Levey: Banquet, p.7
3 Plinius, pp.1086/1093
4 de Brosses, in Levey: Tiepolo, p.148
5 Plutarch, cited by Grant, p.96 (Engl. translation by
  Sir Thomas North: Plutarch: Lives. 1579, cited in:
  The Arden Shakespeare, Antony and Cleopatra.
  Ed. M. R. Ridley, London 1965, p.247)
6 cited in Levey: Tiepolo pp.6, 72
7 Graf Algarotti, cited by Molmenti, p.195

## Johann Heinrich Wilhelm Tischbein
**born 1751 Haina, died 1829 Eutin.**

Goethe in the Roman Campagna, 1786/87
164 x 206 cm
Frankfurt a. M., Städelsches Kunstinstitut

Goethe at the Window
Frankfurt a. M., Freies Deutsches Hochstift,
Frankfurter Goethe-Museum

Literature:
Beutler, Christian: J.H.W. Tischbein – Goethe i.d.C.
Stuttgart 1962. – Goethe: Briefe. Ed. Philipp Stein,
vol. 3, Berlin 1902. – Goethe: Italienische Reise. Vol.

*J. H. W. Tischbein. Self-portrait. Goethe Nationalmu-
seum, Weimar*

25/6, Munich 1962. Goethe: Tagebücher 1775–1809. Vol. 43, Munich 1963. – Lenz, Christian: J.H.W. Tischbein – Goethe i.d.C. Series: Kleine Werkmonographie des Städelschen Kunstinstitutes, No. 6, Frankfurt nd. – Städelsches Kunstinstitut und Städtische Galerie Frankfurt: Goethe gemalt von Tischbein – ein Porträt und seine Geschichte. Frankfurt 1974. – Tischbein, Wilhelm: Aus meinem Leben. Ed. Lothar Brieger, Berlin 1922.

Notes:
1 The majority of quotations are from Goethe's *Italian Journey*, Part III; cf. also letters and diaries, commencing October 1786
2 Tischbein, p. 110
3 cited by Beutler, p. 8
4 cited in: Goethe gemalt von Tischbein – ein Porträt und seine Geschichte, p. 9/10
5 Tischbein, p. 156
6 Tischbein, p. 197
7 For Tischbein's silence regarding his portrait of Goethe, we are indebted here to the explanation given in Brieger's introduction to Tischbein's memoires

*Jacques-Louis David. Detail of a self-portrait, 1791. Galleria degli Uffizi, Florence*

### Jacques-Louis David
**born 1748 Paris, died 1825 Brussels.**

The Death of Marat, 1793
165 x 128 cm
Brussels, Musées royaux des Beaux Arts de Belgique

Literature:
Cabanès, Dr.: Marat inconnu, l'homme privé, le médecin, le savant. Paris 1928. – Cordier, Stéphane: Jean-Paul Marat. Paris 1967. – Decours, Catherine: Charlotte Corday. Paris 1985. – Catalogue of the exhibition: Goya, das Zeitalter der Revolutionen. Kunsthalle Hamburg 1980. – Schnapper, Antoine: David und seine Zeit. Würzburg 1981.

Notes:
1 Restif de la Bretonne, cited by Cordier, p. 85
2 Cordier, pp. 31, 44, 45, 52, 56
3 Schnapper, p. 152
4 Schnapper, p. 158
5 Schnapper, p. 162
6 Decours, pp. 285–288
7 Schnapper, pp. 160, 169, 120

### Francisco de Goya
**born 1746 near Saragossa, died 1828 Bordeaux.**

The Duchess of Alba, 1797
210 x 149 cm
New York, Courtesy of the Hispanic Society of America

"Caprichos" (Caprices), Plate No. 61
Hamburg, Hamburger Kunsthalle

Frontispiece to "Caprichos"
Hamburg, Hamburger Kunsthalle

Literature:
Chastenet, Jacques: La vie quotidienne en Espagne au temps de Goya. Paris, 1966. – Ezquerra del Bayo, Joaquín: La Duquesa de Alba y Goya. Madrid, 1928. – Gassier, Pierre & Wilson, Juliet & Lachenal, François: Francisco Goya, sein Leben und Werk. Frankfurt 1971. – Gudiol, José: Goya. New York 1970. – Sánchez-Canton, F.J.: Vida y Obras de Goya. Madrid 1951.

Notes:
1 Lady Holland, cited by Sánchez-Canton, p. 55
2 Marquis de Langle, 1784, cited by Sánchez-Canton, p. 55
3 Ezquerra, p. 61
4 Soler, Dottor Blanco: La Duquesa de Alba y su Tiempo. Madrid 1966, p. 76
5 Gassier, p. 105
6 Sánchez-Canton, p. 55
7 Soler, p. XI
8 for the autopsy, cf. Soler, pp. 104, 129, 132, 154

*Francisco de Goya. Detail of a self-portrait at the age of 69, 1815. Museo de la Real Academia de Bellas Artes de San Fernando, Madrid*

*Caspar David Friedrich at the age of 26. Detail of a drawing in chalk, c. 1800. Kobberstiksamling, Statens Museum for Kunst, Copenhagen*

### Caspar David Friedrich
**born 1774 Greifswald, died 1840 Dresden.**

Chalk Cliffs on Rügen, c. 1818
90 x 70 cm
Winterthur, Museum Stiftung Oskar Reinhart

Self-portrait
Berlin, Staatliche Museen zu Berlin – Preußischer Kulturbesitz, Kupferstichkabinett

Literature:
Arndt, Ernst Moritz: Ein deutsches Schicksal. Aus seinen biographischen Schriften. Berlin 1924. – Carus, Carl Gustav: Lebenserinnerungen und Denkwürdigkeiten, 4 Theile. Leipzig 1856/66. – Börsch-Supan, Helmut/Jähnig, Karl Wilhelm: C.D.F. München 1973. – Hinz, Sigrid: C.D.F. in Briefen und Bekenntnissen. München 1974. – Hofmann, Werner, Ed.: C.D.F. und die Nachwelt. Frankfurt 1974. – Jensen, Jens Christian: C.D.F.: Leben und Werk. Cologne 1974.

Notes:
1 description of a trip to Rügen, in: Carus, 1. Theil, pp. 259–276
2 Lichtenberg: Schriften und Briefe. Ed. Wolfgang Promies, vol. 3, Munich 1972, p. 97/98
3 Arndt, p. 48. For "old German" costume, cf. also Jensen, p. 48/49
4 Hinz, p. 24
5 Schellings Werke. Ed. Manfred Schröter, Suppl. vol. III, Munich 1959, p. 195
6 from "Die Lehrlinge zu Sais", in: Werke und Briefe. Ed. A. Kelletat, Munich 1953, p. 113

*Eugène Delacroix. Self-portrait c. 1842. Galleria degli Uffizi, Florence*

## Eugène Delacroix
**born 1798 Charenton-St. Maurice, died 1863 Paris.**

The Death of Sardanapalus, 1827
395 x 495 cm
Paris, Musée du Louvre

Literature:
Huyghe, René: Delacroix. Munich 1967. – Johnson, Lee: The paintings of Eugène Delacroix. Oxford 1981. – Prideaux, Tom: Delacroix und seine Zeit. Amsterdam 1966. – Praz, Mario: Liebe, Tod und Teufel. Die schwarze Romantik. Munich 1963. – Spector, Jack J.: The Death of Sardanapalus. London 1974.

Notes:
1 Diodorus Siculus (c. 90 – c. 20 B.C.), Bibliothecae Historicae, Book II, 22 – 25
2 cited by Spector, pp. 47, 50
3 Huyghe, p. 173
4 Byrons poetische Werke in 8 Bänden, Stuttgart, nd, volume 5/6 pp. 243, 363
   The Complete Poetical Works of Lord Byron. Ed. E. H. Coleridge and R. E. Prothero, 13 vols. London 1898 – 1904
5 Gautier, cited by Huyghe, p. 10
6 Alfred de Musset: La Confession d'un Enfant du Siècle. 1836, cited by Huyghe, pp. 74, 75
7 Huyghe, pp. 162, 168
8 Prideaux, p. 104
9 Huyghe, pp. 161, 12
10 Sade: Juliette, cited by Praz, p. 84
11 Huyghe, pp. 16, 28

## Adolph Menzel
**born 1815 Breslau, died 1905 Berlin.**

The Flute Concert of Frederick the Great at Sanssouci, 1850/1852
142 x 205 cm
Berlin, Staatliche Museen zu Berlin – Preußischer Kulturbesitz, Nationalgalerie

Literature:
Hofmann, Werner, Ed.: Menzel der Beobachter. Exhibition catalogue, Hamburg/Munich 1982. – Jensen, Jens Christian: Adolph Menzel. Cologne 1982. – Kuehnheim Haug von, Ed.: Aus den Tagebüchern des Grafen Lehndorff. Berlin 1982. – Kugler, Franz, and Menzel, Adolph: Geschichte Friedrichs des Großen. Leipzig 1936 (Edition to commemorate the 150th anniversary of Frederick the Great's death). – Rave, Paul Ortwin: Adolph Menzel: Das Flötenkonzert Friedrichs des Großen. Stuttgart 1956. – Schieder, Theodor: Friedrich der Große, Ein Königtum der Widersprüche. Frankfurt, Vienna, Berlin 1983.

Notes:
1 Kugler/Menzel, p. 244
2 Kugler/Menzel, p. 107 ff.
3 Lehndorff, p. 38
4 Schieder, p. 54
5 Schieder, p. 44
6 Schieder, p. 56
7 Lehndorff, p. 76
8 Lehndorff, p. 60
9 Lehndorff, p. 52 ff.
10 cf. Rummenhöller, Peter: Die musikalische Vorklassik. Munich 1983, p. 52 ff.
11 Rummenhöller, p. 53
12 Kugler/Menzel, Introduction, p. 7

*J.-A.-D. Ingres. Detail of a self-portrait at the age of 24. Musée Condé, Chantilly*

## Jean-Auguste-Dominique Ingres
**born 1780 Montauban, died 1867 Paris.**

The Turkish Bath, 1863
108 cm diametre
Paris, Musée du Louvre

Literature:
Alazard, Jean: Ingres et l'Ingrisme. Paris 1950. – Ebert, Hans: Ingres. Berlin 1982. – Catalogue of the exhibition at the Louvre: Le bain turc d'Ingres. Paris 1971. – Pach, Walter: Ingres. New York 1973.

Notes:
1 Pach, p. 158
2 Catalogue, pp. 4, 5
3 Montagu, Lady Mary: Briefe aus dem Orient, Stuttgart 1962, p. 98/99; Letters and Works. Ed. Lord Wharncliffe, London 1837
4 Delacroix, cited in: Le Bris, Michel: Die Romantik in Wort und Schrift. Geneva/Stuttgart 1981, p. 164
5 Pach, pp. 278, 59, 46, 73
6 Alazard, pp. 117, 30
7 Dr. Laignel-Lavastine: La glande thyroïde dans l'œuvre de M. Ingres, in: Aesculape, Paris 1929
8 Catalogue, p. 20/21

*Portrait of Manet at the age of about 50 by his friend Henri Fantin-Latour. Detail of a drawing. Art Institute of Chicago*

## Edouard Manet
**born 1832 Paris, died 1883 Paris.**

A Bar at the Folies Bergère, 1881
96 x 130 cm
London, Courtauld Institute Galleries,
The Samuel Courtauld Trust

Literature:
Benjamin, Walter: Gesammelte Schriften. Vol. IV, 1: "Paris, die Stadt im Spiegel – Liebeserklärung der Dichter und Künstler an die Hauptstadt der Welt", Berlin 1928. – Corbin, Alain: Les filles de Noce, misère sexuelle et prostitution au 19e s. Paris 1978. – Castle, Charles: The Folies Bergère. London 1982. – Catalogue of the Manet exhibition. Paris 1983. – Ross, Novelene: Manet's Bar at the Folies Bergère and the myth of popular illustration. Thesis, Ann Arbor, Michigan 1982.

Notes:
1 Castle, p. 38
2 Lavallée c. 1845, cited by Ross, p. 37
3 Camille Debours 1889, cited by Castle, p. 28
4 Maupassant Guy de: Bel-Ami, cited in: Catalogue p. 478
5 Huysmans, Joris-Carl: Croquis Parisiens, 1880, cited in: Catalogue, p. 482
6 Jacques-Emile Blanche and Georges Jeanniot, cited in: Catalogue, p. 482
7 Catalogue, pp. 498, 500
8 Benjamin, op. cit. pp. 356 – 359
9 Charles Baudelaire: Le salon de 1845, Le salon de 1846, in: Œuvres complètes (Pléiade), Paris 1976, pp. 407, 496

175

Acknowledgements

The publisher would like to thank the museums, archives and photographers for permission to reproduce photographic material and for their generous support towards the realisation of this book.
Besides the institutions acknowledged in captions for the plates, we are grateful to:
Jörg P. Albers: 64, 104 – 109, 144, 152 – 157;
Raffaelo Bencini: 29;
Blauel/Gnamm – Artothek: 122 – 127;
Ursula Edelmann: 127;
Scala: 20 – 25, 26 – 31, 32 – 37, 38 – 43, 68 – 73, 116 – 121;
© Photo R.M.N.: 14 – 19, 50 – 55, 146 – 151, 158 – 163;
Elke Walford: 137, 139